European Clocks

IN THE J. PAUL GETTY MUSEUM

Gillian Wilson

David Harris Cohen

Jean Nérée Ronfort

Jean-Dominique Augarde

Peter Friess

THE J. PAUL GETTY MUSEUM · LOS ANGELES

In Memory of
DAVID HARRIS COHEN
1949–1992

Christopher Hudson, Publisher
Mark Greenberg, Managing Editor

Cynthia Newman Bohn, Editor
Kurt Hauser, Designer
Amy Armstrong, Production Coordinator
Jack Ross, Photographer
Eileen Delson, Production Artist
Wilsted & Taylor, Compositor

© 1996 The J. Paul Getty Museum

17985 Pacific Coast Highway
Malibu, California 90265-5799

Library of Congress Cataloging-in-Publication Data

J. Paul Getty Museum.
 European clocks in the J. Paul Getty Museum / Gillian
 Wilson . . . [et al.].
 p. cm.
 Includes bibliographical references and index.
 ISBN 0-89236-254-5
 1. Clocks and watches—Europe—Catalogs. 2. Clocks and
watches—California—Malibu—Catalogs. 3. J. Paul Getty
Museum—Catalogs. I. Wilson, Gillian, 1941– . II. Title.
NK7482.M34J185 1996
681.1′13′09407479493—dc20
 95-25489
 CIP

Front and back cover: Long-case Musical Clock (details).
German (Neuwied), circa 1786. 85.DA.116 (see no. XVIII).

Frontispiece: Model for a Mantel Clock (detail). French (Paris),
circa 1700–1715. 72.DB.52 (see no. III).

Printed in Japan

CONTENTS

FOREWORD
vii

PREFACE AND ACKNOWLEDGMENTS
ix

ABBREVIATIONS
xi

CATALOGUE
1

BIOGRAPHIES
163

GLOSSARY OF MOVEMENT TERMS
205

INDEX
207

Foreword

THIS CATALOGUE appears just as we prepare to open a new Getty Museum, whose attractions include sixteen galleries for French furniture and decorative arts—a kind of museum-within-a-museum in which our remarkable collection can finally be shown in the manner it deserves. Designed by Thierry Despont in collaboration with Richard Meier, these galleries and paneled rooms will incorporate clocks as a prominent feature, as they were in rooms of the eighteenth century. To visitors of our century, when time is mostly told by prosaic-looking devices, the clocks of the Baroque, Rococo, and Neoclassical periods are a continual surprise and delight, not only for their beauty but especially for their ingenious fusion of the mechanical, the decorative, and the metaphorical.

The new galleries are above all the achievement of Gillian Wilson, author of this book. It is fitting that she should be the cataloguer of the Getty's clocks. Not only was every one bought on her initiative, but her knowledge of the makers, especially of the cases, is extensive. She has made certain that this catalogue treats both the case-makers and the movements, and Jean Nérée Ronfort and Jean-Dominique Augarde have undertaken new research into the lives of the clock-makers.

I am thankful for the work of all those at the Getty Museum and Getty Trust Publications Services who contributed to the making of this book, in particular the late David Cohen, Associate Curator of Decorative Arts. As for Gillian Wilson herself, without whom there would be neither catalogue nor collection, I am grateful for her keen eye and mind, which are bound to impress the reader throughout the book.

John Walsh
Director

Preface and Acknowledgments

THIS CATALOGUE is a revised and enlarged edition of *French Eighteenth-Century Clocks in the J. Paul Getty Museum*, published in 1976. It describes and discusses nineteen French clocks and two German clocks in the collection, which were acquired between the years 1971 and 1988. The clocks range in date from approximately 1680 to 1798. They were acquired primarily for the superior quality of their cases, and in three instances, for the quality of the larger piece of furniture in which they are set. The majority of the clocks possess fine movements, and while the clocks are no longer kept in working order the movements are described and illustrated. A section is devoted to the biographies of the clock-makers and enamelers represented in the collection, and an index of names of primary makers and previous owners is provided.

The entries for six of the clocks (nos. 15–20) were written by the late David Cohen, who died in October 1992. The remainder were written by Gillian Wilson. The catalogue entries for the long-case musical clock with a movement by J.-F. Dominicé (no. 5) and the nineteenth-century clock on a pedestal (no. 21) were written in collaboration with Jean Nérée Ronfort.

Peter Friess provided the text and diagrams describing the movements, and the biographies of the clock-makers and enamelers were written by Jean Nérée Ronfort and Jean-Dominique Augarde, as was the introduction to this section. Bruce Hoadley identified the various woods, while Brian Considine, Joe Godla, and Gordon Hanlon of the Museum's conservation department provided information on matters of condition and construction.

The photographs were taken by Jack Ross and the book was designed by Kurt Hauser. With great patience Nina Banna typed and retyped the manuscript, which was edited by Cynthia Newman Bohn.

I would like to thank Winthrop Edey for his contribution to the catalogue. It was he who discovered and deciphered many of the inscriptions on the movements and revealed the signatures of the enamelers on the backs of some of the dials. Jean Nérée Ronfort and Jean-Dominique Augarde contributed much invaluable information on the clock cases and generously allowed me access to the photographic archives at the Centre de Recherche Historique sur les Maîtres Ebénistes. Henry Hawley read the manuscript and contributed a number of useful suggestions.

Many other colleagues have contributed information to this catalogue. They include: Daniel Alcouffe, Musée du Louvre, Paris; William J. H. Andrews, the David P. Wheatland Curator of the Collection of Historical Scientific Instruments, Harvard University; Dr. Winfried Baer, Schloss Charlottenburg, Berlin; Christian Baulez, Musée du Château de Versailles, France; Sir Geoffrey de Bellaigue, Surveyor of the Queen's Works of Art, London; Dr. Burkhardt Göres, Schloss Köpenick, Berlin; Rosamund Griffin, James. A. de Rothschild Collection, Waddesdon Manor; Peter Hughes, Wallace Collection, London; Patrick LePerlier, Paris; the late Robert Marsh, Los Angeles; the late Dr. Bruno Pons, Ecole Nationale du Patrimoine, Paris; and Alexandre Pradère, Sotheby's, Paris.

I would also like to thank the two assistant curators of the department of decorative arts, Charissa Bremer David and Jeffrey Weaver, for their help and assistance.

Above all, I am indebted to Theodore Dell, who read the final manuscript in great detail, correcting many

mistakes and contributing new information. His advice was freely given during the formation of the collection and his extensive photographic archive has always been available to me.

To J. Paul Getty I give thanks for his interest and generosity, which led to the acquisition of fourteen of the clocks before his death in 1976, and for making it possible for the Museum to continue to build the collection since that date.

Gillian Wilson
October 1995

Abbreviations Used in This Catalogue

A.N.
Archives Nationale, Paris

Archives Brateau
Manuscripts deposited at the Conservatoire National des Arts et Métiers, Paris

Archives de la Seine
Archives de la Seine, Paris

Augarde 1984
Augarde, J.-D. "L'atelier de Ferdinand Berthoud: ses fournisseurs et ses clients," *Ferdinand Berthoud, 1727–1807: Horloger mécanicien du Roi et de la Marine.* La Chaux-de-Fonds, 1984.

Augarde 1986
Augarde, J.-D. "Jean-Joseph de Saint-Germain (1719–1791): Bronzearbeiten zwischen Rocaille und Klassizismus," in Ottomeyer and Pröschel, *Vergoldete Bronzen.* Munich, 1986.

Augarde 1996
Augarde, J.-D. *Les Ouvriers du temps: La pendule à Paris de Louis XIV à Napoléon premier.* Geneva, 1996.

Baillie 1929
Baillie, G. H. *Watchmakers and Clockmakers of the World.* London, 1929. Rev. ed., 1963.

Ballot 1919
Ballot, M.-J. *Charles Cressent, Sculpteur, Ebéniste et Collectionneur.* Paris, 1919.

Baulez 1989
Baulez, C. "La Pendule à la Geoffrin, Modèle à succès," *L'Estampille* 224 (April 1989).

Béliard 1767
Béliard, F. *Réflexions sur l'Horlogerie en général et sur les Horlogers du Roi en particulier.* The Hague, 1767.

Bellaigue 1974
Bellaigue, G. de. *The James A. de Rothschild Collection at Waddesdon Manor, Furniture, Clocks and Gilt Bronzes.* London, 1974.

Blakey 1780
Blakey, W. *L'Art de faire les ressorts de Montres, Suivi de la manière de faire les petits ressorts de répétitions & les ressorts spiraux.* Amsterdam, 1780.

Bremer David et al., *Decorative Arts*
Bremer David, C., et al. *Decorative Arts: An Illustrated Summary Catalogue of the Collections of the J. Paul Getty Museum.* Malibu, 1993.

Cardinal 1984
Cardinal, C. *Catalogue des Montres du Musée du Louvre.* Vol. 1, *La collection Olivier.* Paris, 1984.

Cardinal 1987
Cardinal, C., and Sabrier, J.-C. *La dynastie des Le Roy, Horlogers du Roi.* Tours, 1987.

Gallon 1776
Gallon, M. *Machines et Inventions approuvées par l'Académie Royale des Sciences depuis son établissement jusqu'à présent avec leur description.* Paris, 1776.

GettyMusJ
The J. Paul Getty Museum Journal

Guiffrey 1915
Guiffrey, J. *Histoire de l'Académie de Saint-Luc.* Archives de l'Art Français, Nouvelle Période, vol. 9. Paris, 1915.

Histoire + year
Histoire de l'Académie Royale des Sciences. Annual publication throughout the eighteenth century.

Lalande 1803
Lalande, J. de. *Bibliographie astronomique.* Paris, 1803.

Le Roy 1737
[Le Roy, J.] Sully, H. *Régle artificielle du Temps. Traité de la Division naturelle & artificielle du Temps, des Horloges et des Montres de différentes constructions, de la manière de les connoître & de les régler avec justesse. Par Mr. Henry Sully, Horloger de Monseigneur Le Duc d'Orléans. De la Société des Arts. Nouvelle Edition corrigée & augmentée de quelques Mémoires sur l'Horlogerie, par M. Julien le Roy, de la même Société.* Paris, 1737.

Lespinasse 1886
Lespinasse, H. de. *Les métiers et corporations de la Ville de Paris.* Paris, 1886.

Liste 1748
Liste des Maîtres Horlogers de la Ville et Faubourgs de Paris avec la Datte de leurs Receptions, et leurs Demeures, pour l'Année MDCCXLVIII.

Liste + year
Liste alphabétique des Noms et Demeures connues de Messieurs les Maîtres Horlogers de la Ville, Fauxbourg et Banlieue de Paris...

Ottomeyer and Pröschel, *Vergoldete Bronzen*
Ottomeyer, H., and Pröschel, P., eds. *Vergoldete Bronzen: Die Bronzearbeiten des Spätbarock und Klassizismus.* Munich, 1986.

Pradère, *Les Ebénistes*
Pradère, A. *Les Ebénistes Français de Louis XIV à la Revolution.* Paris, 1989.

Raillard 1752
Raillard, C. *Statuts des Maîtres-Horlogers de la Ville & Faubourg de Paris.* Paris, 1752.

Ronfort 1986
Ronfort, J. N. "André-Charles Boulle: die Bronzearbeiten und seine Werkstatt im Louvre," in Ottomeyer and Pröschel, *Vergoldete Bronzen.* Munich, 1986.

Ronfort 1989
Ronfort, J. N. "Science and Luxury: Two Acquisitions by the J. Paul Getty Museum," *The J. Paul Getty Museum Journal* 17 (1989).

Sassoon and Wilson, *Decorative Arts: A Handbook*
Sassoon, A., and Wilson, G. *Decorative Arts: A Handbook of the Collections of the J. Paul Getty Museum.* Malibu, 1986.

Tablettes 1775
Chantoisseau, R. de. *Supplément aux Tablettes Royales de Renommées et d'Indications...* Paris, n.d. [1775].

Tablettes 1791
Chantoisseau, R. de. *Tablettes de Renommée ou du Vrai Mérite...* Paris, 1791.

Tardy 1980
Tardy. *Bibliographie Générale de la Mesure du Temps.* Paris, 1980.

Tessin 1963
Tessin [Proschwitz, Gunnar von]. *Tableux de Paris et de la Cour de France, 1739–1742, Lettres Inédites de Carl Gustaf, comte de Tessin.* Paris, 1963.

Thiout 1741
Thiout, A. *Traité d'Horlogerie Méchanique et Pratique.* Paris, 1741.

Verlet, *Les Bronzes*
Verlet, P. *Les Bronzes dorés français du XVIIIe siècle.* Paris, 1987.

Wilson, *Clocks*
Wilson, G. *French Eighteenth-Century Clocks in the J. Paul Getty Museum.* Malibu, 1976.

Wilson, *Decorative Arts* (1977)
Wilson, G. *Decorative Arts in the J. Paul Getty Museum.* Malibu, 1977.

Catalogue

1

Long-case Clock
(*Régulateur*)

French (Paris); circa 1680–1690

Movement by Antoine (I) Gaudron (circa 1640–1714) (see Biog., p. 174); case attributed to André-Charles Boulle (1642–1732)

HEIGHT: 8 ft. 1 5/16 in. (246.5 cm)
WIDTH: 1 ft. 6 ½ in. (48 cm)
DEPTH: 7 ½ in. (19 cm)

88.DB.16

DESCRIPTION

The clock is made in two principal parts: the case and the pedestal which supports it and houses the weights and the pendulum. The rectangular clock case is surmounted by a cushion-shaped pediment with an open grill which houses the bell. The front corners of this pediment are supported by detached columns resting on canted blocks. The main areas of the front and sides of the case are fitted with panes of glass. The remaining surfaces are veneered with a ground of tortoiseshell inlaid with pewter and brass in the form of intertwining leafy scrolls, tendrils, pendants, swags of husks, and rosettes. The marquetry of the columns depicts twining vines. The case's gilt-bronze mounts include a girl seated on the back of a goat, to whom she feeds grapes, and flaming urns on the pediment; Corinthian capitals atop the columns; and collars and moldings of alternating florets and leaves framing the glass panes. The dial is of engraved gilt bronze set with enameled numeral plaques. Below the dial is a gilt-bronze figure of Time, seated and supporting the dial with his raised arms. To his right is an hourglass and an overturned urn spilling coins, to his left a profusion of objects symbolizing the liberal arts (fig. 1a). The plinth on which Time sits is inscribed: *Solem Audet Dicere Falsum* (It dares the Sun to tell a lie), and *Gaudron Aparis*.

The upper stage of the pedestal swells at the area of the glazed viewing hole, while the lower is overlaid at the top by a lambrequin (fig. 1b); the whole rests on a high stepped base. The front and sides of the pedestal are veneered, like the clock itself, with marquetry of brass and pewter on a ground of tortoiseshell, which takes the form of leafy scrolls, husks, swags and pendants, tendrils,

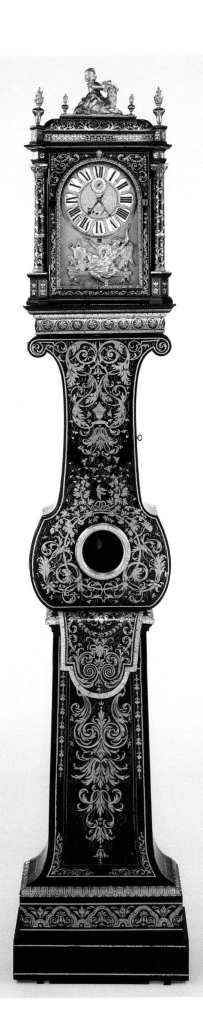

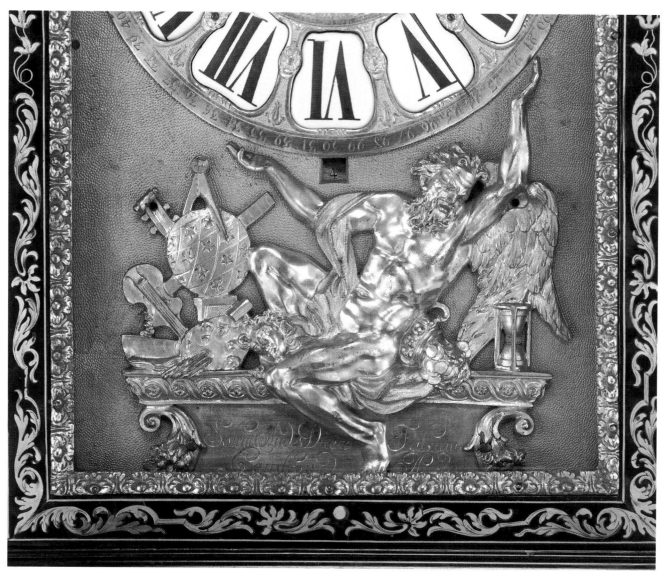

1A

1B

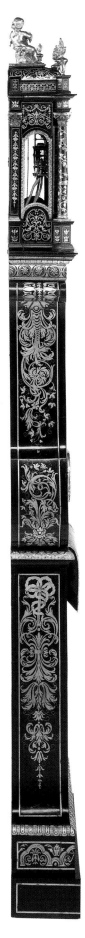

1C

rosettes, and, at the sides, bows (fig. 1c). The intricate scrolling composition around the viewing hole emanates from lion's heads placed on either side. At the top of this composition, a bird in flight attempts to catch a butterfly (fig. 1d). Suspended below the lambrequin is an elaborate tassel-like marquetry composition. Similarly conceived compositions decorate the sides of the pedestal. Pewter stringing frames these panels and defines the profiles of the case.

A gilt-bronze molding encircles the viewing hole and, in the form of fringing, edges the lambrequin. At the tops of the two stages of the pedestal, and at the top of the stepped ebony-veneered base are broad horizontal gilt-bronze moldings. At the back of the clock case is a hinged door that provides access to the movement; the front of the upper stage of the pedestal is also hinged to give access to the weights for winding. The carcase is constructed of oak, alder, walnut, and fir.

MARKS

The face, below the dial, is signed *Gaudron Àparis* and inscribed *Solem Audet Dicere Falsum*. The movement is signed *Gaudron Àparis* (fig. 1e) and there are repair marks on the great wheel, *P. Sauvage Janvier 1950*.

COMMENTARY

It is very probable that the original intention was to cover the rectangular dial plate with black or dark red velvet. Many existing clocks of this period are thus decorated. For some reason the plate was instead gilded and stippled and provided with an elaborately chased central zone. It would also seem that the plate, though contemporary, was not made for the present case. A viewer of normal height cannot see the Latin inscription beneath the dial, nor the signature of Gaudron. Both are hidden by the frame of the glass panel.

The inscription *Solem Audet Dicere Falsum* is a version of a quotation from Virgil's *Georgics* (1.463): "Solem quis dicere falsum audeat" (Who would dare to call the Sun untrue?).[1] The altered Latin phrase was probably used for the first time in Pierre Le Moyne's book on emblems, *De l'Art des Devises* in 1666, where it appears with a pendulum clock with cycloidal cheeks.[2] The text explains that the pendulum clock, a 1657 invention by Christiaan Huygens, runs so accurately that it can be used to demonstrate the irregularity of the sun's orbit.[3]

Many of the decorative elements on the clock—the detached columns wound with ivy, the large gilt-bronze mount beneath the dial, and the form and marquetry of the pedestal—are found on a number of mantel and long-case clocks, all of which are veneered with tortoiseshell, brass, and pewter and contain movements by such

1D

well-known late seventeenth-century makers as Antoine Gaudron, Pierre DuChesne, Balthazar Martinot, and Jacques Thuret.[4]

The case itself, on the basis of the design of the marquetry, can be attributed to André-Charles Boulle. The panels at the front and the sides of the lower stage of the pedestal are very similar in design to those found on the front and sides of a pair of stands in the Victoria and Albert Museum, which are also attributed to Boulle.[5] A piece of paper found within the carcase of one of these is dated 1693, giving a *terminus ante quem* for their manufacture.

The small bird chasing a butterfly is found, both in *première* and *contre-partie* marquetry, on a pair of coffers in the Getty Museum. These are of the same form as a coffer made by Boulle for the Dauphin, which is described in detail in the latter's inventory of 1689.[6] The repeating trefoil marquetry on the base appears in a slightly more complex form on the above-mentioned coffers as well as on a table attributed to Boulle, also in the Getty Museum collection.[7] The mount in the form of a girl feeding a goat with grapes is also found, paired with a similarly seated boy, on firedogs[8] and, in patinated bronze, as paper weights.[9]

OTHER EXAMPLES

The closest comparison that may be made is to a clock now in the Ecole Nationale Supérieure des Beaux-Arts.[10] The case, with a few minor differences, is of the same design and bears marquetry of the same pattern, though in reverse. This clock was cited in the 1718 posthumous inventory of Louis XIV's possessions, where it is described as follows:

> *No. 18 Une pendule de dix huit pouces de haut, marquant les secondes, faite par du Chêne, les cadrons sont de cuivre doré sur velours noir. La böete de marqueterie de cuivre et d'etain sur fond écaille, ayant chaque coin une colonne de même marqueterie d'orde corynthien dont les bazes et chapiteaux sont cuivre doré; le haut est formé et terminé par un dôme. La pendule, portée sur un scabellon aussi de ladite marqueterie, de cinq pieds un pouces de haut*[11]

It was again listed in the royal inventory of 1792, where it was described as "ouvrage de Boulle."[12] In 1797 it was sent to the Académie de Peinture et de Sculpture (later named the Ecole des Beaux-Arts), but on that occasion it was merely described as "le corps en est decoré à la manière de Boulle."[13] Another clock, nearly identical to the Getty example with a movement by Gaudron, differing principally in that its figure of Time is reversed, was recorded at auction in the late nineteenth century.[14]

1E

MOVEMENT
Brass and iron, partly blued

Note: The number in parentheses represents the number of teeth on each wheel. These numbers are repeated again in the drawings of the movement.

The movement (fig. 1f) consists of two trains driven by weights mounted on an endless rope. The clock runs for one week. The going train powers three hands that indicate hours (in roman numerals) and minutes (in arabic numerals) on the main dial and seconds (in arabic numerals) on a subsidiary dial. An opening below the number VI shows the day of the month. The clock strikes the hours and half hours on the same bell.

The going train is connected to the striking train by an endless-rope winding mechanism and has one wheel for the endless rope (72) and three pinion wheels (6/64–8/60–8/30), the last being the escape wheel. The train is regulated by an anchor escapement (recoil escapement) in connection with a seconds pendulum. The arbor of the

third wheel holds the cannon pinion (32), which is part of the motion work (32–32/6–72), and the minute hand. The hour wheel (72) holds the hour hand. The cannon pinion (32) rotates once every hour; it has two pins that release the striking train every half and full hour. The escape wheel holds the second hand; another wheel (24) on the back of the hour wheel drives the wheels (24/48–1/31) that show the day of the month on the front of the dial. When a month has less than thirty-one days, this calendar has to be set forward manually to the first of the following month.

This type of striking train has a count wheel (locking plate). It has one wheel for the endless-rope mechanism (72), three pinion wheels (8/72–6/66–6/60), and a fly vane (6). The second wheel (8/72) has twenty-four pins that move the striking hammer as well as the wheel (12) that drives the count wheel (45).

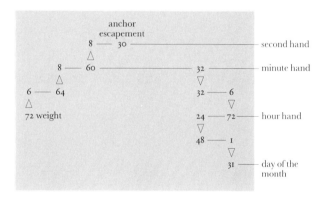

Going train

Striking train

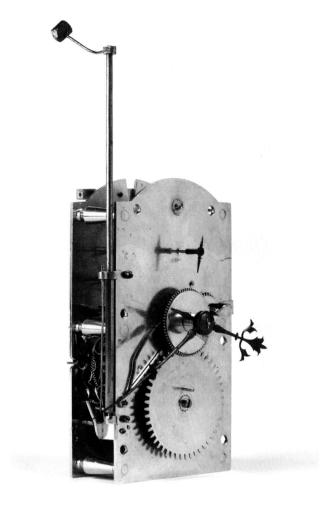

1F Three-quarter view of the movement.

PUBLICATIONS
"Acquisitions 1988," *GettyMusJ* 17 (1989), p. 140, no. 66 (ill.).

PROVENANCE
Jean Durier [dealer], Paris, circa 1945. Private collection, Burgundy. Alain Moatti [dealer], Paris. Acquired by the J. Paul Getty Museum in 1987.

NOTES

1. I am grateful to Marit Jentoft-Nilsen for locating the quote in Virgil's *Georgics* and for providing the correct translation.
2. K. Maurice, *Fine Antique Clocks of the 17th to the 19th Century* (Munich, 1990), pp. 25–27.
3. A medallion struck circa 1700 for the clock-makers' guild expresses a similar idea. It bears the phrase *Solis mendaces arguit horas* (It [the pendulum clock] monitors the deceptive hours of the day), Maurice (note 2), pp. 25–27.
4. Examples of clocks of the same model bearing a large gilt-bronze mount beneath the dial: mantel clock with a movement by DuChesne (sold at Christie's, London, October 13, 1983, lot 24); long-case clock with a movement by Martinot (sold at Sotheby's, Monaco, December 4, 1983, lot 106); mantel clock with a movement by Gaudron (Frederick Victoria and Son, Inc.), *French Clocks in North American Collections*, exh. cat. (New York, Frick Collection, 1982–83), no. 28; long-case clock with a movement by Gaudron (private collection), ibid., no. 27; mantel clock with a movement by N. Hanet (sold on the German market, 1993), *Kunst und Antiquitäten* (June 1993), p. 79.

 Examples of clocks with pedestals of similar form and decoration: a long-case clock with a replaced movement, in the collection of the duke of Buccleuch, Boughton House, Northamptonshire (the viewing hole has been filled with a marquetry plaque bearing the Montagu cypher); a long-case clock with a movement by Langlois virtually identical to the Buccleuch example, although with *contre-partie* marquetry (Kraemer & Cie, Paris, 1992); a long-case clock with a *tête de poupée* hood housing a movement by Thuret (formerly with the Parisian dealer Marc Revillon d'Apreval), *Connoisseur* (September 1957), p. LIV, and S. Faniel and P. Levallois, *Les Dix-septième siècle français* (Paris, 1958), p. 121, fig. 6.

 Examples of clocks with similar detached columns: a clock in the Schloss Rohrau, Niederösterreich, Austria, H. Kreisel, *Die Kunst des deutschen Möbels* (Berlin, 1970), vol. 2, fig. 395 (the form and marquetry of this clock's case and pedestal are similar to those of the Getty Museum's clock; the clock is presumably French and not Austrian as stated; the maker of the movement is not given); a long-case clock (Fersen [dealer], Monte Carlo), advertisement in *Connaissance des Arts* 62 (April 1967), p. 1 (this clock's form and decoration are also similar to the Museum's clock. The maker of the movement is not known); a mantel clock with a movement by DuChesne (Paris, Musée des Arts Décoratifs, inv. D. 14383).
5. Jones Collection (inv. 1025–1882), G. Wilson, "Boulle," *The Journal of the Furniture History Society* 8 (1972), pp. 47–69.
6. 82.DA.209.1–2, G. Wilson, *Selections from the Decorative Arts in the J. Paul Getty Museum* (Malibu, 1986), pp. 12–13, no. 6.
7. 83.DA.22, Bremer David et al., *Decorative Arts*, p. 46, no. 58.
8. Sale, Akram Ojjeh, Sotheby's, Monaco, June 25–26, 1979, lot 172; Messrs Niret-Minet & Coutau-Begarie, Hôtel Drouot, Paris, December 1, 1989, no. 119; Keck Collection, Sotheby's, New York, December 5–6, 1991, lot 188; an example in the possession of Kraemer & Cie, Paris, 1990; and in the Petit Trianon. For the last, see D. Ledoux-Lebard, *Versailles: Le Petit Trianon* (Paris, 1989), p. 167, fig. 3452.
9. Sold, Ader, Picard, Tajan, Hôtel George V, Paris, December 11, 1988, no. 66.
10. J. N. Ronfort, "Le Mobilier royal à l'époque de Louis XIV," *L'Estampille* 180 (April 1985), pp. 38, 39, ill.
11. A.N., O^1 3335.
12. A.N., O^2 388a, fol. 203.
13. A.N., AJ52 58, fol. 30.
14. Sale, Thomassin Frères, Douai, November 19–23, 1883, lot 1, Theodore Dell archives. In the catalogue illustration, the pediment of the clock case housing the bell is missing.

II

Wall Clock
(*Pendule d'alcove*)

French (Paris); circa 1710

Case attributed to André-Charles Boulle (1642–1732); maker of the later English movement unknown

HEIGHT: 2 ft. 4 in. (71.1 cm)
WIDTH: 11¼ in. (28.6 cm)
DEPTH: 4½ in. (11.4 cm)

73.DB.74

DESCRIPTION

The clock is in the form of a lyre. The upper corners are set with ram's heads from which depend floral pendants and a garland (fig. 2a). Below the dial is an androgynous mask, framed by laurel branches tied below with a ribbon knot (fig. 2b). The finial of the clock case takes the form of a berried knop, while the clock terminates below in a larger berried knop, enclosed by scrolling leaves. The flat surface of the case is veneered with a panel of blue painted horn, set with an engraved brass trellis, each square of which is filled with a four-petaled brass rosette. The sides of the clock are decorated with a central ribbon-bound rod flanked by foliate strips. Broad acanthus scrolls encase the lower part of the lyre at the front and sides.

The hollow case contains, at its widest part, a blackened wood box of conforming shape, composed of pieces of white oak, European walnut, and apple or pear. Its brass door is hinged and latched. It is open below to allow for the swing of a pendulum and pierced thrice above to allow for passage of the arms of three bell hammers, now missing. The sides of the clock are pierced to accommodate the strings that, when pulled, would once have activated a repeating mechanism.

COMMENTARY

The present movement is not original to the clock, which once housed a repeating movement, a useful device that enabled one to learn the time at night, in the absence of light.[1] This type of clock, without a striking train, was known as a *pendule d'alcove* and was intended for use in a bedroom.

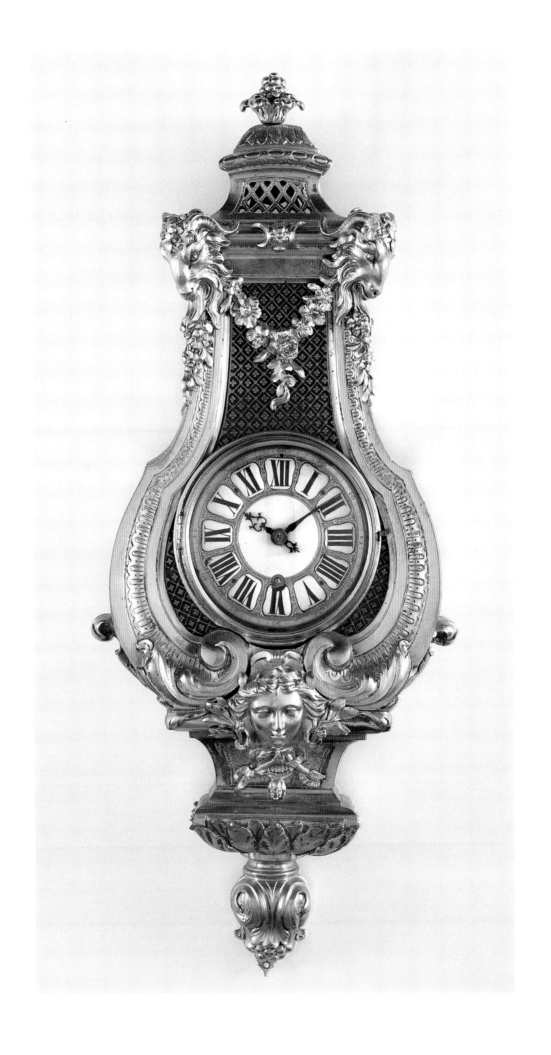

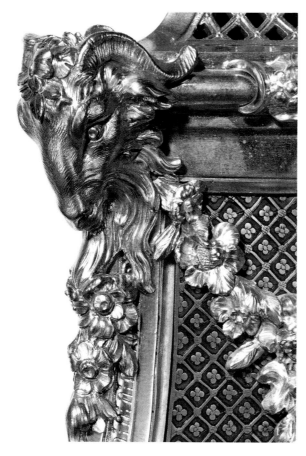

2A

A possible source for the design of the case may be found in a sketch in the Musée du Louvre from Charles Le Brun's studio.[2] It shows a lyre with goat's heads of very similar form, supported by two putti. The sketch was for a lead fountain group made by Pierre Le Gros in 1673–74 for the Théâtre d'Eau at Versailles. The fountains were dismantled in the 1750s, and the group is now in the National Gallery of Art, Washington, D.C.[3] An engraving by Jean I Berain of about 1690 for painted ornament at the Tuileries includes a lyre bearing the heads of griffins;[4] however, in art of this period representations of lyres bearing animal's heads are extremely rare.

OTHER EXAMPLES

A clock of the same model is in the Victoria and Albert Museum, London.[5] Its movement is signed "Mynüel,"[6] and it was acquired by that museum in 1865. Another clock of the same design, but with its finial in the form of a closed bud and the upper area of blue horn overlaid with lyre "strings," is in the Musée des Arts Décoratifs, Paris.

F. J. Britten illustrates another similar clock in *Old Clocks and Watches and their Makers* (6th ed. [London, 1971], p. 467, fig. 610), which belonged, at the time of the first edition (1899), to the Marquis of Hertford.[7] It has a closed-bud finial and a decorated frame for the glass cover. Britten states that the movement is by Thuret.[8]

A clock and a matching barometer of this form were sold by Monsieur M. Rikoff in Paris (Galerie Georges Petit, December 4–7, 1907, lot 255). Again, the design differed in the closed-bud finial and the decorated rim of the glass cover. The panels of horn were decorated with larger brass rosettes set at the crossings of the brass trellis, and the dials were formed of one plaque of enamel. Neither the dials nor the movements of the clock and barometer were signed.

In 1977 Kraemer & Cie (Paris) possessed two wall clocks of this model. Each bore a white enamel plaque between the ram's heads, which was inscribed "THURET." On one example the marquetry of blue horn and brass was in *contre partie*. A lyre-shaped clock, possibly this model, was owned by Paris de Montmartel, who died in 1766. It hung in his bedchamber and was described as being "Une petite pendule . . . dans sa boête en forme de lyre de bronze doré en or moulu."[9]

A clock of the same model is described in the sale of the collection of the comte de Luc (Lieutenant Général des Armées du Roi and Gouverneur de la Citadelle de Marseilles)[10] on December 22, 1777, lot 49, as follows:

Une Pendule, le mouvement à répétition fait par Julien le Roy, la boite de Boule, de bronze doré, en cartel représentant une lyre, à tête de bélier sur chaque angle du haut, & à panneau de mosaïque, sur le devant, renfermant un medaillon à deux faces tournant à pivot, l'un représentant le portrait de Louis XIV, l'autre celui d'Henri IV, mascaron au-dessous du cadran & les côtés régulierement ouvragés.[11]

The attribution here of the case to André-Charles Boulle is interesting, but it should be remembered that by the late eighteenth century this famous *ébéniste*'s name was sometimes used to describe pieces made in his style or was given to pieces decorated with a marquetry of horn, shell, and brass. The medallion portrait of Henry IV and Louis XIV may have been set between the ram's heads.

Another clock of the same model was sold in Paris by the comte de Choiseul-Praslin (March 12, 1866, lot 121) and described thus: "Cartel du temps de Louis XIV, en bronze doré, en forme de lyre. Il présente à sa partie inférieure un mascaron tête de femme et à sa partie supérieure des têtes de bélier."

Another version of the clock, with a movement by J. F. Laissé, was sold by Bourgeois Frères, at Lempertz, Cologne, on October 25, 1904, as lot 829. On this example, the ram's heads at the top corners were replaced by female winged busts, and the knop at the bottom by a shaped plinth, thus converting the wall clock into a mantel clock.

EXHIBITIONS

Detroit Institute of Arts, 1972–1973.

PROVENANCE

The collection of Lord Hillingdon at Vernon House, England. Sold by the trustees of Lord Hillingdon, Christie's, London, June 29, 1972, lot 56. French and Company, New York, 1972. Purchased by J. Paul Getty in 1972.

NOTES

1. For a description of this device, see A. Smith, ed., *The Country Life International Dictionary of Clocks* (London, 1979), pp. 172–173.
2. A. Marie, *Naissance de Versailles, Le Château—Les Jardins*, vol. 1 (Paris, 1968), pl. L1 (Louvre, Cabinet des Dessins, inv. 30162.8190).
3. C. Seymour, Jr., "Versailles' Fountains, two sculptures from the Théâtre d'Eau in America," *Gazette des Beaux-Arts* (October 1942) pp. 41–52, fig. 5. I am grateful to Christophe Leribault for bringing this article to my attention.
4. Inv. 130–1865. See N. Langlois, *Ornemans petits dans les appartemens des Tuileries, dessinez et gravez par Berain* (Paris, circa 1690).
5. A. de Champeaux, *Portefeuille des arts décoratifs*, vol. 5 (Paris, 1886–97), pl. 322.
6. The clock-maker Louis Mynüel (circa 1675–1742) was active between 1693 and 1742.
7. See H. Bouilhet, *L'Orfèvrerie française* (Paris, 1908), p. 5, where the owner of the clock is given as Richard Wallace.
8. Jacques Thuret (died 1739) succeeded his father Isaac as clock-maker to Louis XIV and to the Observatoire in 1694. He also inherited from his father the privilege of possessing lodgings in the Louvre, and he was related to André-Charles Boulle, for whose clock cases he seems to have often provided movements.
9. R. Dubois-Corneau, *Paris de Montmartel* (Paris, 1917), p. 243, quoted in S. Eriksen, *Early Neo-Classicism in France* (London, 1974), pp. 345–346.
10. The comte de Luc was the illegitimate son of Louis XIV. He so closely resembled his father that he was known as "demi-Louis." I am grateful to Jean-Dominique Augarde for this information.
11. I am grateful to Theodore Dell for this information.

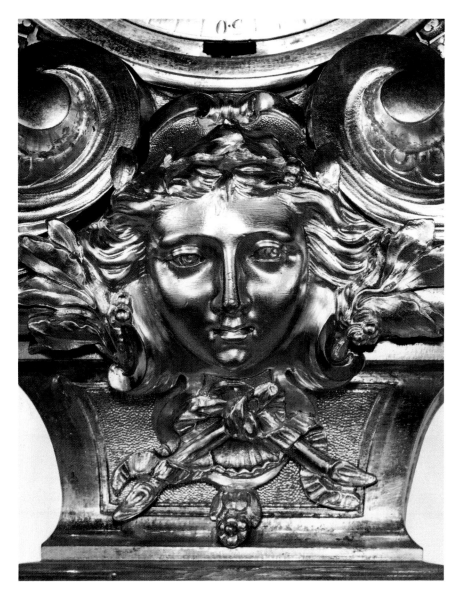

2B

III

Model for a Mantel Clock

French (Paris); circa 1700–1715

Name of maker unknown

HEIGHT: 2 ft. 7 in. (78.7 cm)
WIDTH: 1 ft. 8½ in. (51 cm)
DEPTH: 9½ in. (24.2 cm)

72.DB.52

DESCRIPTION

The model is made entirely of terra cotta with enamel numeral plaques and a ring of gilt bronze around the dial. The elaborate decoration consists of a trellised dome set above a drum girdled with acanthus and strapwork. Pendants of fruit and flowers extend down the drum to the four upper corners of the rectangular case, on which are mounted vases. The front corners are canted and set with female herms bearing baskets of fruit on their heads. Similar herms are found at the back of the clock. Four clawed feet support large scrolls on which are perched winged beasts (fig. 3a). Their webbed and clawed forefeet rest on plinths, while their bifurcate tails extend down the outer surface of the scrolls, to cross and twine at their bases.

Occupying the lower part of the clock, below the dial, is a chariot drawn by four horses. It carries Pluto who clasps Prosperine to him. Her arms are outstretched and her hair is flying (fig. 3b).

The sides of the clock are decorated with shells in arched coves, above tasseled lambrequins. The lobed lower profile of the clock is set with acanthus leaves and a stylized shell (fig. 3c).

The clock rests on a shaped plinth. The back is hollow and there is no door (fig. 3d).

MARKS
None

3A

CONDITION

The original contents of the four vases at the upper corners of the clock are missing. The vases may have held flames.

The heads of the beasts at the back left and front right have broken off, as has the head of the left front horse. Both the horses on the left have lost their hooves, and the front horse on the right has lost its right front hoof. Three corners of the plinth are chipped.

When the clock was acquired it was fitted with a detachable terra-cotta finial in the form of the grieving Demeter, crowned with a wreath of wheat (fig. 3e). Though it is appropriate to the iconography of the clock, this finial is of nineteenth-century date and is not displayed with it. It is likely that the original finial was in the form of Father Time with his scythe, perhaps sitting on a globe, or a figure representing Fame.

COMMENTARY

It is probable that this clock was originally intended as a model, which would have been shown to a client for approval. Very few French eighteenth-century furniture models exist today, and those that do were nearly all made for the approval of Marie-Antoinette.[1] They are always of miniature scale and made of wax, or wax and paper. It is possible that this unique full-size clock model, which dates to about 1700, was made for Louis XIV or a member of the French court.

It is extremely difficult to attribute the work to any one sculptor. In the inventory taken of the objects destroyed in the disastrous fire that swept through the *logement* of André-Charles Boulle in the Louvre in 1720, mention is made of "Models of wax and terra cotta made by Boulle and his children in the course of their profession."[2] Seventy-five clocks are also listed as having been burned, and it is quite possible that the royal cabinetmaker could have been responsible for the fine work exhibited on this piece. On the other hand, models by François Girardon were also destroyed in that fire.[3] He was a neighbor of Boulle's in the *logement* of the Louvre, and it is conceivable that a sculptor of such eminence could have made this model.

The figures of Pluto and Proserpine are somewhat similar to those found on a marble relief by Robert Le Lorraine (1666–1743) in the park at Versailles. Executed in 1696–99, the relief was on a pedestal for the *Enlèvement de Proserpine* by Girardon.[4] The sculptor Jean Cornu (1650–1710) has also been suggested as the author of this clock. Germain Brice, in his *Description de Paris* (1698 and 1706), writes: "Il [Cornu] travaille à présent à des boetes de pendule enrichies de figures de bronze d'une grand beauté." In 1699 Cornu delivered an elaborate clock to Colbert, which was in the form of an allegory of the Peace of Ryswick.[5] Although it is tempting to give this extremely sculptural piece to the hand of one of the prominent sculptors of the day, it is unlikely that any firm attribution will ever be made. It is, however, possible to give as a source for the Pluto and Proserpine group an engraving by Daniel Marot (fig. 3f).[6] While the position of the limbs of the protagonists are dissimilar—Pluto balances himself with his foot firmly planted on the raised front of the chariot, clasping the windswept Proserpine around her waist—the group, in reverse, shows similar agitation and clothing. The print appears to be based on a drawing by Jean (I) Berain (1640–1711), which was engraved as the frontispiece for the 1680 publication of Jean-Baptiste Lully and Philippe Quinault's opera *Proserpine*.[7] The sculptural style of the winged beasts at the lower corners may be compared to that of one of the dragons made by an unknown sculptor of the school of Versailles for the Bosquet du Labyrinthe (1672–74). It is known that Jean-Baptiste Tubi, Etienne Le Hongre, Pierre Le Gros, and the brothers Gaspard and Balthazar Marsy worked on these thirty-nine fountains illustrating Aesop's fables at Versailles, but it is not possible to distinguish among their contributions.[8]

The presence of winding holes is puzzling. The edges of the enamel numeral plaques have been carefully

ground down to make room for them. Such precision would surely have been necessary only if the clock once contained a movement. The same applies to the presence of an aperture for the regulation of the pendulum. It has been suggested that the clock may have been fitted with a movement at a later date, and the winding holes bored into the face at that time.

Henry Hawley, in his review of the 1976 catalogue of the Getty Museum's clocks, was of the opinion that this clock model was made in the nineteenth century as an actual case. He recommended that the terra cotta be tested by means of thermoluminescence. This was done, resulting in a rather broad dating between the seventeenth and eighteenth century.

OTHER EXAMPLES

While a number of clocks of this period exhibit domed tops, vases of flames, and scrolled lower corners supporting female herms, no single clock seems to have survived that has winged beasts set in this position, or, indeed, with a group of Pluto and Proserpine in a horse-drawn chariot. But what must have been a similar clock appeared at auction at Christie's on February 13, 1899, as lot 48, which is described, but not illustrated, in the sale catalogue: "A Louis XIV bracket clock, in scroll-shaped Boulle case mounted with Pluto and Proserpine, and other chasing, and borders of ormolu, and surmounted by a figure of Fame and bracket en suite—50 inches high." The closest in design is a mantel clock at the Château de Chantilly, which stands on the mantelpiece of the Chambre de Monsieur le Prince.[9] It has a domed top with

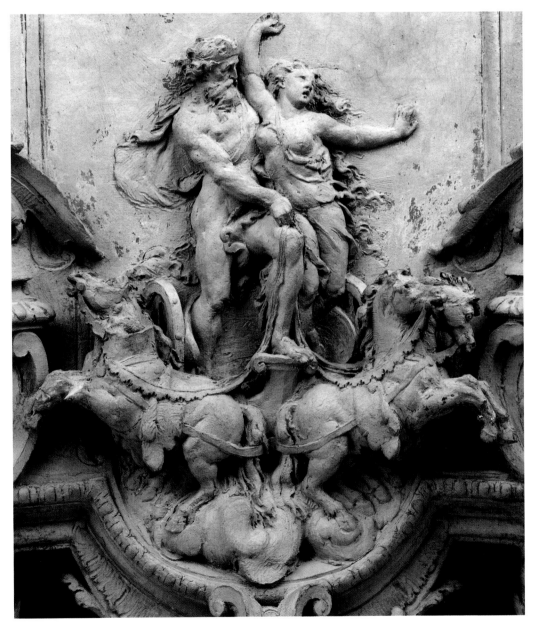

3B

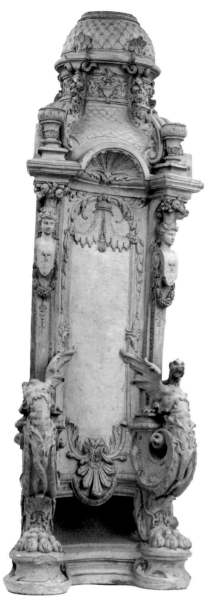
3C

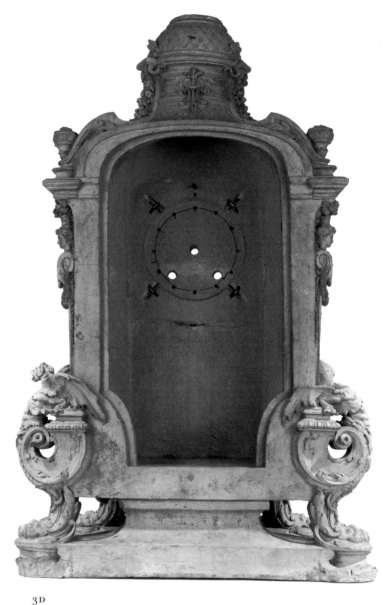
3D

female herms at the canted corners. Winged female busts replace the beasts, and the large gilt-bronze mount below the dial is of a female figure on a winged horse.

A somewhat similar clock was sold from the collection of the Rt. Hon. Viscount Emlyn, Stacpole, Yorkshire (Sotheby's, July 13, 1962, lot 193). It bears a figure representing Fame, finials containing flames at the four upper corners above canted female herms. Below the dial Apollo is shown in a four-horse chariot.

PUBLICATIONS

G. Wilson, "The J. Paul Getty Museum, 6ème partie, Les Meubles Baroques," *Connaissance des Arts* (May 1975), p. 109, ill.; B. Fredericksen, H. Lattimore, and G. Wilson, *The J. Paul Getty Museum* (London, 1975), p. 185, ill.; Wilson, *Clocks*, pp. 8–11, no. 1, ill.; Wilson, *Decorative Arts* (1977), p. 9, no. 6, ill.; H. Hawley, "Book Reviews," *The Decorative Arts Newsletter* (Summer 1977), p. 13; G. Wilson, *Selections from the Decorative Arts in the J. Paul Getty Museum* (Malibu, 1983), pp. 14–15, no. 7, ill.; Sassoon and Wilson, *Decorative Arts: A Handbook*, p. 36, no. 76, ill.; P. Verlet, *Les Bronzes*, p. 164, fig. 200; C. Bremer David et al., *Decorative Arts*, pp. 82–83, no. 128, ill.

EXHIBITIONS

New York, Metropolitan Museum of Art, "Magnificent Time-Keepers," January 4–March 28, 1972, no. 67; Detroit Institute of Arts, 1972–1973.

PROVENANCE

Dalva Brothers, New York. Purchased by J. Paul Getty in 1972.

3E Terra-cotta figure of Demeter, which formed the finial of the clock when it was acquired in 1972. The figure dates from the nineteenth century and is no longer displayed with the clock.

3F Daniel Marot, *Fire*, engraving; one of a series, "The Four Elements," which was printed in Amsterdam circa 1703.

NOTES

1. See, for instance, the wax model of a jewel cabinet made for Marie-Antoinette in 1770, J. Niclausse, "The Jewel Cabinet of the Dauphine Marie-Antoinette," *The Journal of the Walters Art Gallery* 18 (1955), pp. 69–91.
2. The complete inventory is published in A. de Montaiglon, "Documents sur Pierre et André-Charles Boulle, ébénistes de Louis XIII et Louis XIV. Incendie du chantier du Sr. Boulle," *Archives de l'Art Français* 7 (Paris, 1855–56), pp. 334–349.
3. Ibid., p. 347.
4. M. Beaulieu, *Robert Le Lorrain, 1666–1743* (Neuilly-sur-Seine, 1982), p. 102, pl. VII, fig. 10.
5. I am grateful to Jean Nérée Ronfort for this suggestion.
6. The engraving, representing Fire, is one of a set of the Four Elements. It was produced in Holland and was printed circa 1703.
7. The drawing by Berain is in the Musée des Arts Décoratifs, Paris (inv. CD.201).
8. *The Splendid Century: French Art 1600–1715*, exh. cat. (National Gallery of Art, Washington, D.C., 1960), p. 65, fig. 114.
9. Illustrated in A. Guérinet, *Le Château de Chantilly* (Paris, 1900), p. 9.

IV

Mantel Clock

French (Paris); circa 1715–1725

Movement by Paul Gudin (active circa 1739–1755) (see Biog., p. 176); case attributed to André-Charles Boulle (1642–1732)

HEIGHT: 3 ft. 4 in. (101.6 cm)
WIDTH: 1 ft. 8 in. (50.8 cm)
DEPTH: 11¾ in. (29.8 cm)

72.DB.55

DESCRIPTION

The clock has an arched top and rests on a base with four short straight legs. Above is mounted a flying gilt-bronze cupid. Below the dial a large gilt-bronze figure of Time reclines on a swag of tasseled drapery. He holds aloft a balance in his right hand (fig. 4c).

The side (fig. 4a) and front surfaces of the case are veneered with tortoiseshell, brass, and ebony. A recessed panel of blue horn, decorated with a brass trellis enclosing rosettes, is set below the dial. The legs are veneered on all four sides with blue horn inset with pendant scrolls of brass. Gilt-bronze moldings frame all the profiles of the clock and its legs, as well as forming the feet. There is a blank gilt-bronze cartouche beneath the dial. The hipped sides of the clock are set at the front with gilt-bronze acanthus scrolls.

The carcase of the clock is of blackened white oak and walnut. It is fitted at the back with a hinged and latched wooden door.

MARKS

The central plaque of the dial is painted in black GUDIN LE JEUNE APARIS. The movement is similarly engraved in cursive script *Gudin le jeune APARIS* (fig. 4b).

COMMENTARY

While the dial of the clock appears to be contemporary with the case, the movement is not. The blank gilt-bronze cartouche beneath the face may once have borne an enamel plaque inscribed with the name of the maker of the original movement. The present movement by Gudin seems to have been mounted in the case later in the

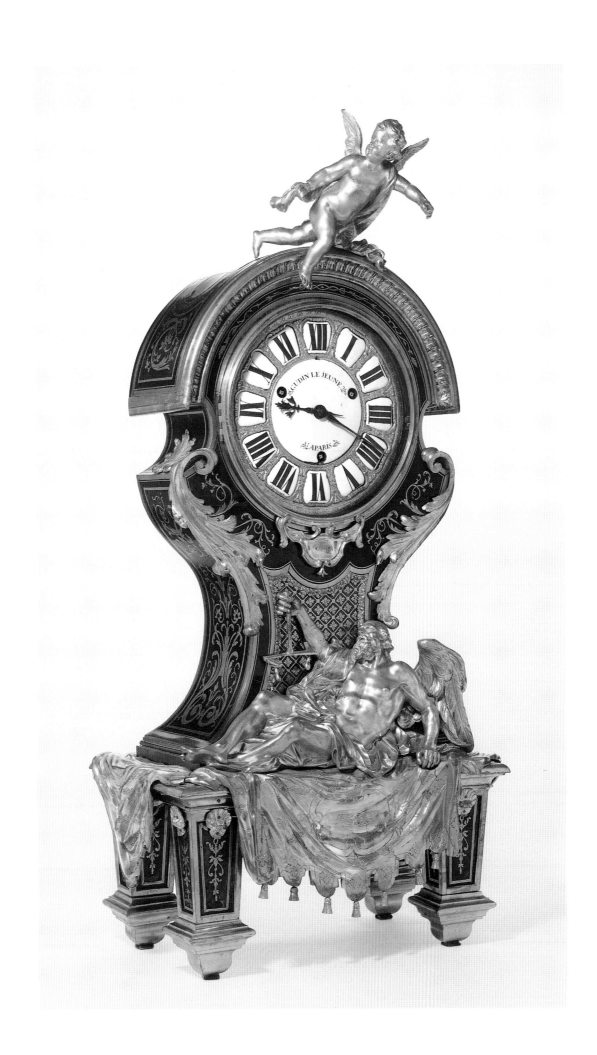

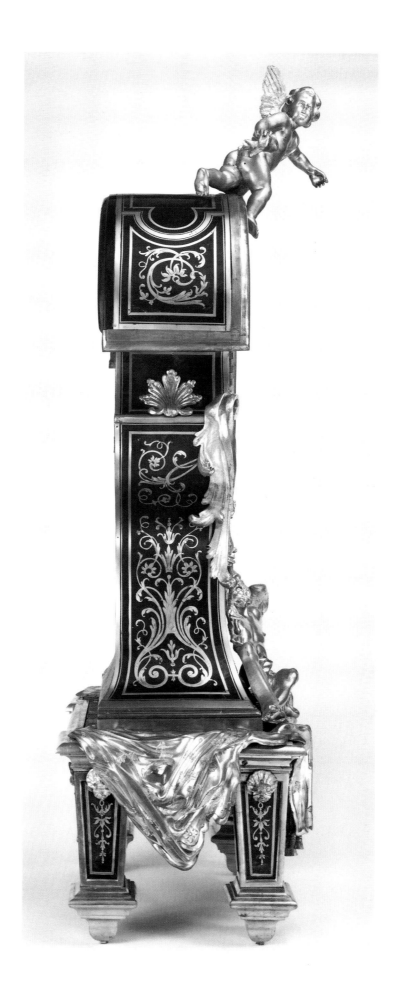

4A

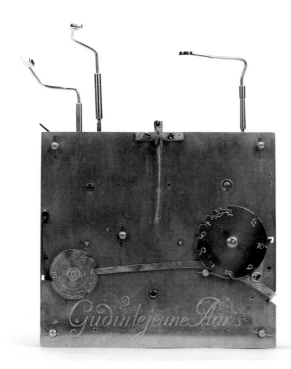

4B

eighteenth century, and at that time Gudin's name was painted on the central enamel plaque.

There is a drawing related to this clock attributed to André-Charles Boulle in the Musée des Arts Décoratifs, Paris.[1] In it, the cupid is shown carrying a long-handled scythe which is missing from the Getty Museum's clock.[2] The clock is shown resting on a wall bracket. Only one clock on a bracket of this design seems to have survived.[3] The drawing also shows masks at the sides of the case, and a dial cast with dancing babies in relief. The attribution of the drawing to Boulle is strengthened by the appearance of a similar clock in Pierre Mariette's publication of Boulle's engraved designs.[4] Here, a clock of the same shape, with the flying cupid but lacking the figure of Time, sits on a *serre-papier* accompanying a *bureau plat*.

The figure of Time is taken from a woodcut that has been attributed to Nicolò Vicentino (fig. 4d).[5] This woodcut, in turn, seems to have been made from a finished study by Giovanni Antonio de Pordenone (1484–1539)[6] for a fresco painted by him circa 1533 on the façade of the Palazzo d'Anna on the Grand Canal in Venice.[7]

It is known that Boulle had a large collection of prints and drawings by the hands of many masters, which were destroyed in the fire that swept through his lodgings and workshop at the Louvre in 1720.[8] It is quite possible that he possessed the woodcut after Pordenone.

In an inventory drawn up after Boulle's death in 1732, in the section devoted to bronze mounts, is the following entry: "Une boëte contenant les modèles de la pendule de Mr. Desmarais dont le Temps couché est de Mr. Girardon pesant ensemble vingt-trois livres, prisés à raison de quatre francs la livre . . ."[9]

Jean-Pierre Samoyault believes that this model of clock is of the same form as the one under discussion and assumes that Mr. Desmarais is Nicolas Desmarets (1648–1721), nephew of Colbert.[10] The inventory description suggests that the model was first made for Desmarets, and if this is so, it was perhaps produced during the time when he was Contrôleur Général des Finances between 1708 and 1715.

Clocks of this design, of which many slightly or widely differing versions survive, were made over a period of twenty or more years, and it was an exceedingly popular model. The inventory's declaration that François Girardon (1628–1715) produced the model of Time is not surprising—models in wax and plaster by the sculptor are listed in the inventory taken of the objects destroyed after the 1720 fire in Boulle's lodgings in the Louvre. It is possible that Girardon also possessed the woodcut after Pordenone.

The clock appears in the background of a number of paintings, especially in the works of Jean-François de Troy (1679–1752). The earliest representation would seem to be a portrait of Gabriel Bernard de Rieux (1687–1745), younger son of the *financier* Samuel Bernard.[11] The painting may be dated after 1714, as the young man is shown wearing the black robes of a councillor of the Parlement de Paris, a post he assumed in that year. It is possible that the clock was in fact the property of the Bernard family. The model appears again in de Troy's *The Garter*, which was exhibited at the Salon of 1725.[12] Perhaps de Troy himself owned the clock, or, having taken a drawing of it when painting Rieux, he simply used it again. The clock in the second painting has the same distinctive base, though here it is shown placed on a bookcase, rather than on the *serre-papier* of a *bureau plat*.

In *A Reading from Molière*, dating from about 1728, the clock appears again, but here the position of Time has been changed, and with his raised arms he supports the dial above him as if it were a globe.[13] This was presumably artistic license, as no cases of this model are known with Time in that position.[14]

OTHER EXAMPLES

Numerous models of this clock exist. Closest to the Museum's example is one of two in the Wallace Collection, London.[15] That clock lacks the tassels on the swag of drapery below Time and the scallop shells at the tops of

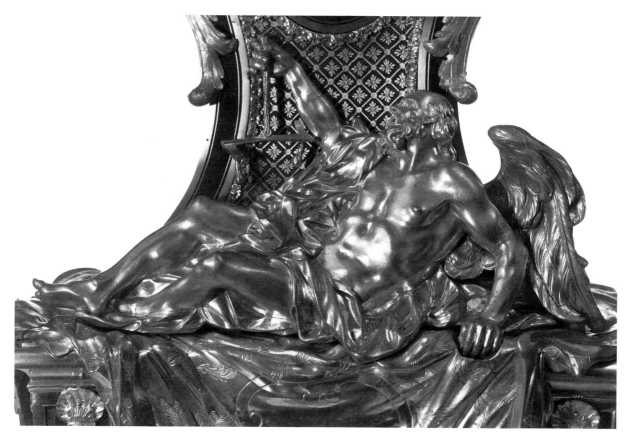

4C

4D Nicoló Vicentino, *Time*, woodcut (Art Institute of Chicago, inv. 1965.22).

the short legs; there are also significant differences in the design of the marquetry. The movement is by Jacques Thuret (1669–1739). A second, closely related clock in the Neues Palais at Sans Souci, while having the same body and marquetry panels as found on the Museum's clock, differs in two apparently unique ways.[16] The cupid above, instead of clutching Time's scythe, holds a feather plucked from his wing. Time himself holds his scythe. This new arrangement seems to be a nineteenth-century invention.[17] Here, Love has no longer conquered Time but merely attempts to slow down its speed. The other unusual feature of this clock is the extension of the dial's glass cover below the face to allow for the viewing of the pendulum. A second clock of this model in the Wallace Collection has a flat base—possibly intended to be positioned on a *cartonnier*—and contains a movement by Claude Martinot, which is signed "C. Martinot aux Galleries du Louvre 1726."[18] Another similar version, resting on the upper section of a *cartonnier* and with a movement signed "1723 by Martinot," was on the Paris market in 1965.[19] Yet other notable versions, probably intended for *cartonniers* or *serre-papiers*, include one with a movement by Charles Le Bon in the Musée des Antiquités, Rouen,[20] and another with a case veneered with kingwood parquetry and a movement signed by Julien Le Roy at Waddesdon Manor.[21]

A slightly differing version has a semicircular barometer set into the swag of drapery, and a moon phase aperture above the dial. In these cases the area containing the dial and the moon phase is oval in shape, and so is the glass that covers it.[22]

Still more complex variants bearing the reclining figure of Time exist. One, in the Gulbenkian Foundation, Lisbon, was made for Cardinal Ottoboni.[23] While of basically the same form, it bears on its plinth an additional figure of a winged cupid supporting a medallion with a relief portrait of the cardinal; above the clock is a winged figure of Fame holding a shield emblazoned with the cardinal's arms and two cupids holding up his tasseled hat. It is dated 1712.

The same figure of Fame with a shield surmounts a clock of this model that forms the upper section of a *régulateur* made in 1717–18 for the comte de Toulouse and now in the Musée du Louvre.[24] The cresting here perhaps represents Fame triumphant over Time. A mantel or table clock of this series, mounted with the arms of the Elector of Bavaria on its stele-like superstructure and housing a movement by Thuret, is in the Zähringer Museum in Baden-Baden.[25]

Two distinct models of Time are found on these clocks. That which appears, for instance, on the Wallace Collection's Martinot clock of 1726 has the fingers of the left hand held straight and not bent into a fist. The wing is longer and sweeps farther out at the base. The draped cloth does not so fully cover the thighs, and it does not fill a gap between the legs. It has been suggested that the original Girardon model was destroyed in the 1720 fire, and that this second model was made to replace it.[26] But as we have seen, the Girardon model still existed in 1732. Nevertheless, the model with the extended fingers may be a later version, and clocks bearing it may well have been made in the later decades of Boulle's long career.

MOVEMENT
Brass and iron, partly blued

Note: The number in parentheses represents the number of teeth on each wheel. These numbers are repeated again in the drawings of the movement.

The movement (fig. 4e) consists of three trains driven by mainsprings; each train runs for about two weeks. The going train provides power for the hands, which indicate the hours in roman numerals and the minutes in arabic numerals on the main dial. The clock strikes every full hour on one large bell and each quarter hour on two smaller bells.

The going train has one rotating barrel (84), which holds the mainspring and four pinion wheels (14/80–8/72–6/66–6/29), the last being the escape wheel. This train is regulated by a crown wheel (verge escapement) in connection with a pendulum. The pendulum can be adjusted while the clock is running by lifting or lowering its silk suspension. The second wheel holds the cannon pinion (36), a part of the motion work (36–36/6–72), and the minute hand. The hour wheel (72) holds the hour hand. The cannon pinion (36) rotates once every hour; it has four pins that release the striking trains every quarter of an hour.

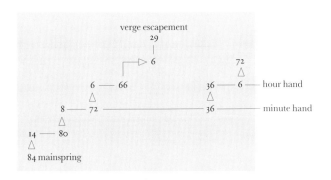

Going train

This clock has two striking trains. To the right of the going train is the striking train for the quarters of an hour. To the left of the going train is the striking train for the hours. Both trains use locking plates (count wheels). The striking train for the quarter hours has a rotating barrel (84), which holds the mainspring, four pinion wheels (14/52–8/72–6/60–6/48) and a fly vane (6). The third wheel (8/72) has twelve pins that move the striking hammer. Every full hour the locking plate of this train releases the striking train for the hours. The second striking train also has a rotating barrel (84), which holds the mainspring, four pinion wheels (14/80–7/70–7/66–6/48), and a fly vane (6). The third wheel (7/70) has ten pins that move the striking hammer.

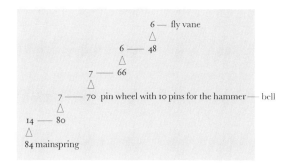

Striking train for the hours

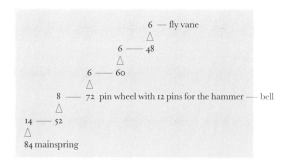

Striking train for the quarters of an hour

4E Three-quarter view of the movement.

EXHIBITIONS

Paris, Hôtel George V, "Haute Joaillerie de France," June 11–20, 1971. Detroit Institute of Arts, 1972–1973. New York, Frick Collection, *French Clocks in North American Collections*, November 1982–January 1983, no. 38, ill. p. 46.

PUBLICATIONS

B. Fredericksen, H. Lattimore, and G. Wilson, *The J. Paul Getty Museum* (London, 1975), p. 150, ill.; G. Wilson, "The J. Paul Getty Museum, 6ème partie, Les Meubles Baroques," *Connaissance des Arts* (May 1975), p. 106, ill.; Wilson, *Clocks*, pp. 22–25, no. 4, ill.; Wilson, *Decorative Arts* (1977), p. 16, no. 17, ill.; A. Smith, ed., *The Country Life International Dictionary of Clocks* (London, 1979), p. 90, fig. 6; W. Edey, *French Clocks in North American Collections* (New York, 1982), p. 46, no. 38; M. D. Schwartz, "Boulle Furniture," *Art and Antiques* (April 1983), p. 75, ill.; W. Edey, "Time for Boulle," *House and Garden* (March 1985), p. 82, ill.; Sassoon and Wilson, *Decorative Arts: A Handbook*, p. 36, no. 78, ill.; Ronfort 1986, vol. 2, p. 478; also vol. 1, p. 40, ill.; C. Bremer David et al., *Decorative Arts*, pp. 85–86, no. 132.

PROVENANCE

Graf János Pálffy; sold, Bad Pistyan (Czechoslovakia), June 30–July 1, 1924, lot 285 (ill.). Etienne Lévy & Cie, Paris, 1971. French and Company, New York, 1972. Purchased by J. Paul Getty in 1972.

NOTES

1. Ottomeyer and Pröschel, *Vergoldete Bronzen*, vol. 1, p. 38, fig. 1.2.1.
2. When the clock was sold from the collection of Graf János Pálffy in 1924, the illustration in the sale catalogue showed that the scythe was then still with the clock.
3. Ex coll. Sir Valentine Abdy, P. Verlet, *French Furniture and Interior Decoration of the 18th Century* (London, 1967), p. 202, pl. 173. Sold, Sotheby's, Monaco, June 22–23, 1991, lot 519.
4. André-Charles Boulle, *Nouveaux Deisseins de Meubles et Ouvrages de Bronze et de Marqueterie Inventés et gravés par André-Charles Boulle* (Paris, n.d.), pl. 4; reproduced in J.-P. Samoyault, *André-Charles Boulle et sa famille* (Geneva, 1979), p. 217, fig. 9.
5. *The Genius of Venice 1500–1600*, exh. cat. (Royal Academy of Arts, London, 1983), pp. 335–336, no. 35.
6. Ex coll. Duke of Devonshire; sold, Christie's, London, March 7, 1984, lot 36. Illustrated in Ottomeyer and Pröschel, *Vergoldete Bronzen*, vol. 2, p. 475, fig. 4.
7. A drawing of the façade is in the Department of Prints and Drawings at the Victoria and Albert Museum, London.
8. The inventory of objects destroyed in Boulle's fire, including all the works of art, is reproduced in A. de Montaiglon, "Documents sur Pierre et André-Charles Boulle, ébénistes de Louis XIII et Louis XIV. Incendie du chantier du Sr. Boulle," *Archives de l'Art Français* 7 (Paris, 1855–56), pp. 334–349.
9. Quoted in J.-P. Samoyault, *André-Charles Boulle et sa famille* (Geneva, 1979), p. 137, no. 17. See also pp. 14, 147.
10. Samoyault (note 9), p. 172, n. 121.
11. P. Hunter-Stiebel, *Chez Elle, Chez Lui*, exh. cat. (Rosenberg & Stiebel, Inc., New York, 1987), p. 14, fig. 3.
12. E. Fahy and F. J. B. Watson, *The Wrightsman Collection* (New York, 1973), vol. 5, pp. 280–283, no. 29.
13. P. Verlet (note 3), p. 105, pl. 71.
14. However, a drawing by G. M. Oppenord in the Cooper-Hewitt Museum, New York (inv. 1911.28229), shows a figure of Time in this position. See Ottermeyer and Pröschel, *Vergoldete Bronzen*, vol. 1, p. 34.
15. F. J. B. Watson, *Wallace Collection Catalogues, Furniture* (London, 1956), pp. 20–21, pl. 47, no. F43. A similar model with a movement by Louis Mynüel was sold at European Fine Arts Limited, Hong Kong, April 13, 1981, lot 147.
16. R. Dohme, *Moebel aus den koeniglichen Schloessern zu Berlin und Potsdam* (Berlin, 1889), pl. 15. The face is signed "Henry Illaire, Berlin." The movement is not signed.
17. According to Ilse Baer, the quality and gilding of the feather differs considerably from the other gilt-bronze mounts on the clock and is not thought to be authentic.
18. Watson (note 15), pp. 18–19, pl. 47, no. F41.
19. Palais Galleria, Paris, June 11, 1965, lot 29.
20. Samoyault (note 9), p. 227, fig. 19a.
21. G. de Bellaigue, *The James A. de Rothschild Collection at Waddesdon Manor: Furniture, Clocks and Gilt Bronzes* (London, 1974), vol. 1, pp. 48–50.
22. Private collection, San Francisco, and Baron Guy de Rothschild: J. Richardson, "Le Style Rothschild," *House and Garden* (April 1984), p. 112.
23. Inv. 256, Ronfort 1986, vol. 2, p. 477, fig. 6.
24. Inv. OA 6746, with a movement by Le Bon, Ottomeyer and Pröschel, *Vergoldete Bronzen*, vol. 1, p. 40, fig. 1.2.6.1.
25. Ottomeyer and Pröschel, *Vergoldete Bronzen*, vol. 2, p. 478, figs. 7a and 7b.
26. J. M. Hurt, "An Eighteenth-Century Bronze Saturn as a Figure of Time," *North Carolina Museum of Art Bulletin* 10, 3 (March 1971), p. 22.

V

Long-case Musical Clock

French (Paris); circa 1712

Movement by Jean-François Dominicé (1694–died after 1754) (see Biog., p. 168); musical movement by Michel Stollenwerck (circa 1700–1768; master 1746) (see Biog., p. 195); case attributed to Alexandre-Jean Oppenordt (1639–1715), possibly after designs by Gilles-Marie Oppenord (1672–1742), with later alterations also after designs by Oppenord

HEIGHT: 8 ft. 9 in. (266.7 cm)
WIDTH: 3 ft. 5 in. (104.1 cm)
DEPTH: 1 ft. 3½ in. (39.4 cm)

72.DB.40

DESCRIPTION

The clock is divided into two parts: a large clock case above, which contains both the clock and the musical movement, and a supporting pedestal, which houses the weights and the pendulum.

A bronze figure of Fame stands on the domed top of the clock. On the canted corners below, winged dragons are seated on an openwork grill composed of floral swags and scrolls. Beneath them, an arched bronze molding supports at its center Fame's plumed helmet flanked by crossed trumpets. At the four corners of the case are bronze figures of the Four Continents: Africa (fig. 5a), Europe (fig. 5b), Asia (fig. 5c), and the Americas (fig. 5d). The dial is formed by five enamel segments with hour and minute indications, an arched enamel plate for the equation of time, and a central gilt-bronze plate with apertures for the month and the day. The area below the dial is fitted with a brass grill engraved with geometric designs filled with allegorical symbols: Time/Saturn (the Saturnian scythe linked by a small ring bearing zodiacal signs to the serpent Ouroboros biting its tail); War/Mars (helmets topped by dragons); Mercury (caducei and a winged hat); Love/Venus (bows and quivers of arrows); Jupiter (an eagle); a rising sun (in the lower central triangular cartouche); two small crescent moons entwined with oak leaves and acorns (in the lower corners) (fig. 5e). All these symbols correspond more or less to the seven classical planets.

Between the engraved grill and the area in front of the compartment containing the musical movement is a small bronze platform, which supports a seated bronze figure of Apollo, his left arm holding a lyre and his feet

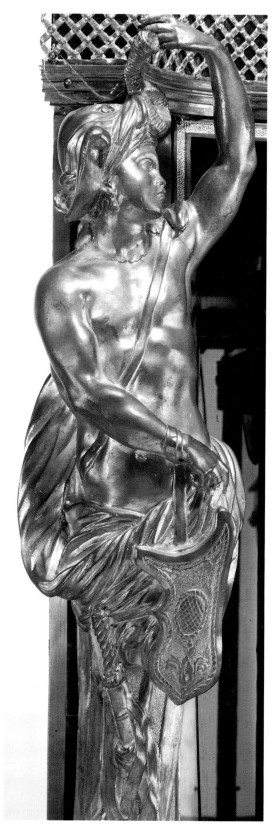 5A Africa

 5B Europe

5C Asia

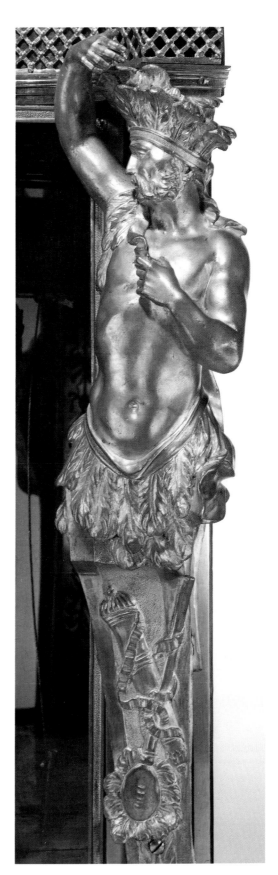

5D The Americas

LONG-CASE MUSICAL CLOCK 31

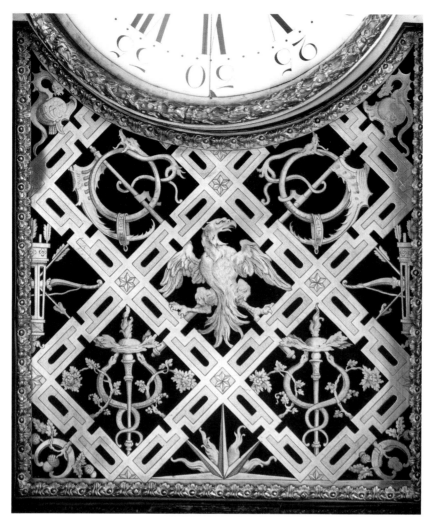

5E

resting on the dragon Python, whom he slew in his youth (fig. 5f). Below the platform is the head of a laughing bearded satyr that partly covers a panel of brass and tortoiseshell marquetry, which depicts a rocky ground occupied by a rabbit, a flying bird, and a dragonfly. The lower corners rest on ram's heads and are in the form of inverted consoles set with female masks.

The interior of the clock case is veneered with marquetry of tortoiseshell and brass. The inner surface of the back door bears marquetry in *contre partie* composed of strapwork, C-scrolls, and tendrils (fig. 5g). The floor is decorated with a panel of figural marquetry, which is the *contre-partie* version of that found on the front of the compartment housing the musical movement (fig. 5h). At the interior corners are vertical panels of marquetry composed of simple musical trophies, surmounted by *contre-partie* versions of the marquetry scenes found on the sides of the music box.

The area between the clock case and the pedestal is filled with a wood-veneered alcove set with short brass-filled flutes. The underside of the case is fitted with a wooden *cul-de-lampe* decorated with bronze acanthus leaves and a bronze pine cone pendant. Similar pendants are attached beneath the sides.

The front and the sides of the pedestal are veneered with brass and red-ground tortoiseshell in a combination of *première* and *contre-partie* marquetry. The tapering panel at the front and the concave panels at the sides are decorated with a Berainesque design incorporating squirrels, birds, baldachins, and strapwork. At the center front, above a large glazed viewing aperture, is a large bronze mount centered by a blank cartouche, which is decorated at the top with a mantling of acanthus leaves. A crescent moon decorates the lower part of the frame of the aperture. Bronze mounts composed of auricular forms centered by cabochons are placed at the canted corners (fig. 5i). They are set over the upper part of long pilasters, ornamented with illusionistic marquetry *cannelures* that run to the base.

The base of the pedestal is supported by four hairy paws which are topped with acanthus. In its center is a large lion's mask, from which depend five guttae. These

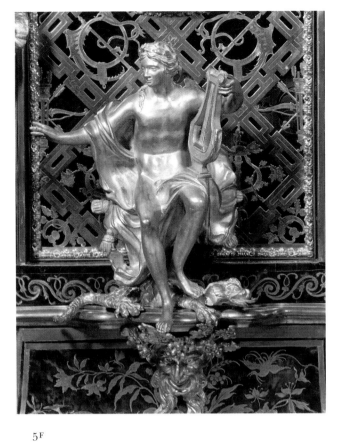

5F

5G Interior surface of the back door of the clock case.

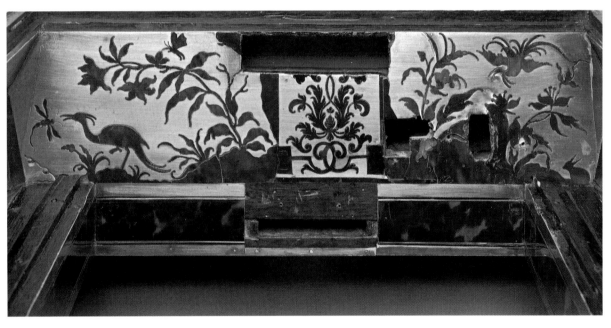

5H Floor of the clock case's interior.

LONG-CASE MUSICAL CLOCK 33

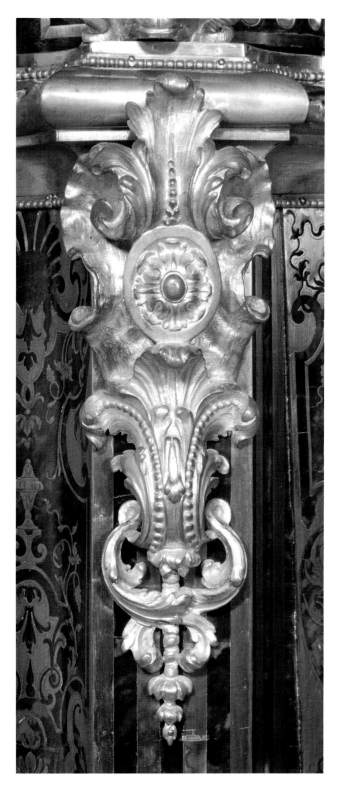

51

mounts are all placed over panels of tortoiseshell and brass marquetry. The whole rests on a two-tiered wooden platform of conforming shape, which is painted black and fitted with wooden rollers.

The back of the clock case and the pedestal are fitted with three doors, giving access to the movement, to the musical movement below, and to the interior of the pedestal. The carcase is of blackened oak.

MARKS

The dial is engraved *Lepaute* (for Pierre-Basile Lepaute, 1750–1843); the back plate of the movement is signed *J. F. Dominicé Æparis* (fig. 5j); the outside of the front plate is inscribed *fait par Stollenwerck / dans l'abbaye / St. Germain / a Paris* and *Bouchez 1829 le 16 / avrille in London*; the inside of the front plate is inscribed *Il y a De La fidelite / et de fort bonne idée / dans cette ouvrage* and *Blaine Jewelers / 246 Thomas St / Newport RI / CCH 12-2-57 / John Foster*; on the back plate are repairers' marks, *M8340 BL-12-3-57 CCH J Foster*; the barrel of the striking train (fig. 5k) is inscribed *je suits tres aise que M. Thiery ait repare cette piece en 1754 / Thiery nettoyez Cette piece aux moy de decembre 1758 / Quant a moi je la netoye et ajoute un cadran d'email et des equilles en 1773 mois d'octobre—Lepaute neveu / je suis satisfait d'avoire netoyé je [le] reparé tout la pandulle entiere le 15 avrille 1829 à Bouchez a London / W. Jones 2/71 / Karrel Solle 1888 208/10 / Cette piece et eté de Montée le 4 Fevrier 1754 par Thiery demeurant aux n . . . t / a diminuyez tous les petit pignon qui et [?] trop gra . . . [grand?]*; the back of the dial plate is signed *en H Lepaute / 1785* and there are graffiti on various parts of the musical movement, *John Lamb / June 26, 1800 / Tourbieu / BL 12-4-57 / CCH John Foster / Newport / àBouchez 1829 le 16 avrille in London / BL 12-3-57 / CCH John W. Foster / Newport RI / Netoye en 1773 au mois d'octobre par F [?] Lepaute*.

From the marks and signatures on the movement we can gather the following: The clock was repaired by a M. Thiery in 1754 and again by him in 1758.[1] In 1773 Pierre-Basile Lepaute changed the face and the hands and cleaned the movement.[2] In 1785 Pierre-Henry, called Henri-Lepaute, also seems to have worked on it. By 1800 the clock was in England, as in that year the musical movement was with one John Lamb.[3] A repairer called Bouchez repaired the clock in London in 1829 (just after its sale by the first Lord Gwydir).[4] In 1888, presumably after it was sold by the Marquess of Exeter, the movement was in the hands of Karel Solle.[5] The latest inscription is that of John Foster of Blaine Jewellers, who cared for the clock in Newport, Rhode Island, in 1957.

Stollenwerck's signature, which appears on the movement's front plate, in all likelihood refers to the musical movement as Jean-Dominique Augarde has pointed out (see the biography of Stollenwerck in this volume).

CONDITION

Small areas of tortoiseshell and brass are missing and were replaced with brown mastic and gold paint, before the clock's acquisition by the Getty Museum. The engraving of the tortoiseshell was originally filled with a transparent wax mixed with powdered gold. This remains in a few areas at the sides of the pedestal. It is possible that this elaborate decorative technique was infrequently employed and has rarely survived the rigors of time. The bronze mounts are not gilded.[6]

COMMENTARY

A careful examination of the clock, which included the dismantling of many of its mounts, was carried out in 1993 (fig. 5l). As a result it was concluded that the clock case had originally been constructed to house a short pendulum movement with a compartment below for a musical movement, the clock case set on the existing pedestal. It was later changed to a long-case musical clock with a long pendulum and weights housed in the formerly empty base. When the engraved grill is removed, the interior of the case, entirely veneered with marquetry of brass, ebony, and tortoiseshell, is visible. The removal of the framing mount with its crescent from the front of the pedestal showed that the viewing hole for the pendulum bob had been cut out of the marquetry panel. Similarly, the removal of the fluted alcove and its *cul-de-lampe* incorporating a pine cone pendant between the clock and the pedestal revealed that part of the marquetry-covered surface of the top of the pedestal had been crudely cut away to allow for the swing of the pendulum and the suspension of the ropes for the weights, as had the marquetry floor of the clock case above (see fig. 5h).

From the existence of various drawings, archival references, and similar mounts and marquetry found on other objects, we can surmise that the clock and the pedestal were made by Alexandre-Jean Oppenordt before his death in 1715, and that the alterations were carried out by his son Gilles-Marie Oppenord after that date.

The figures of the Four Continents on the present clock were cast from the same *modellos* as those found on clocks bearing oval faces at the Arsenal, in Paris; the Wallace Collection, London; Waddesdon Manor, in Aylesbury, England; and the Detroit Institute of Arts. Jean Nérée Ronfort has observed that the *modellos* for these four slightly later clocks have been elongated at their bases to fit a case of greater height. This would lead one to presume that the Four Continents on the clock under discussion take the original form of these mounts.

At the corners of the pedestals of the aforementioned series of clocks are long gilt-bronze mounts, with bifurcated scrolled tops above acanthus consoles, their

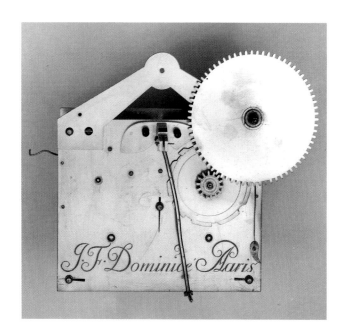

5J

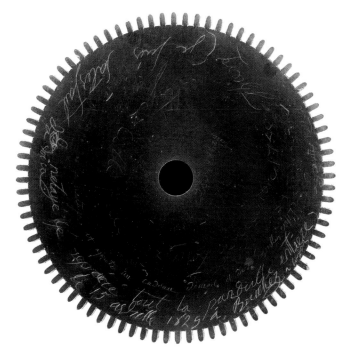

5K

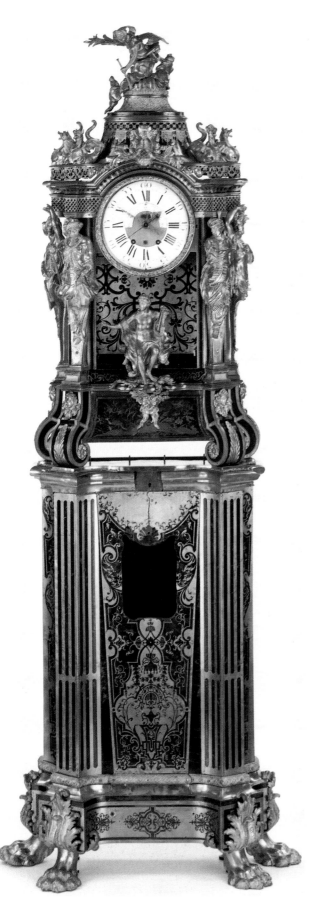

5L The clock, partly dismantled, as it may have appeared before it was converted into a long-case musical clock by Gilles-Marie Oppenord at some point after 1715.

lengths centered by bound rods. These mounts, inverted so that the scrolls form feet and topped by horned ram's heads, are also found at the front corners of several commodes,[7] which Ronfort has attributed to Alexandre-Jean Oppenordt, noting that their surfaces are veneered in part with the same design in tortoiseshell and brass as that found on the surface of the desk delivered by Oppenordt to Louis XIV in 1685.[8] An engraving by Oppenord on the title page of *DIXIEME LIVRE des Oeuvres de G. M. Oppenord Contenant des Guaisnes et gravé par Huquier* shows one side of a pedestal similarly decorated with a mount topped by a horned ram's head and ending in a large scroll.[9]

The marquetry on the front of the pedestal is a *contre-partie* version of that found on the front of the tapering pedestal of the Apollo clock at Fontainebleau, which is attributed by Ronfort to Oppenordt.[10] Moreover, the Apollo with his lyre, now seated on the small platform of the Getty clock, is cast from the same *modello* as the figure of Apollo driving the sun-chariot on the Fontainebleau clock. Mounted at the top of the Fontainebleau pedestal is a large gilt-bronze female mask set above a palmetto-like collar, and it is likely that a similar mount was once attached to the Getty Museum's pedestal where a blank area of brass of conforming shape is found. Other pedestals have appeared on the market in recent years bearing marquetry of the same design.[11]

The removal of the lion's mask set with guttae at the base of the pedestal revealed a small panel of marquetry, and it would seem therefore that this mount is probably a later addition. The gilt-bronze feet, on the other hand, appear to be part of the original configuration, as the acanthus leaves cover small panels of marquetry that have been placed somewhat awkwardly on their sides.

At the death of Alexandre-Jean Oppenordt in 1715, the empty clock case and its pedestal would have passed to Gilles-Marie Oppenord, who shared his father's lodgings in the Louvre and was his sole heir.[12] By that date Gilles-Marie had designed the Le Bas de Montargis clock, dated 1712 and now in the Musée National des Techniques, Paris,[13] for which he owned the *modellos* of the early rococo corner mounts of the stand and of the cartouche-shaped mount that framed the barometer. A drawing signed by Gilles-Marie Oppenord for the Montargis pedestal, with these mounts, is in Berlin (fig. 5m).[14] Casts from the *modellos* were made and attached to the upper part of the pedestal of the Museum's clock. The younger Oppenord also seems to have added the lion's mask with guttae at the base, the design of which is typical of the early classical period of his *oeuvre*.

Whether in order to sell the clock, or to keep it for himself (which was to be the case), Gilles-Marie appar-

ently decided to convert the clock case from a short pendulum one to a clock with a more accurate long pendulum which hung down into the pedestal. In order to view the swing of the pendulum bob it was necessary to cut an aperture into the face of the pedestal, removing part of the marquetry panel. He then framed this aperture with a mount of his design which included a crescent moon, the whole arranged in such a way as to follow, at its lower edge, the design of the marquetry.[15] Overlapping the top of the pendulum aperture he added a casting of the former framing mount of the Le Bas de Montargis barometer, with the open center filled.

The movement he installed is by Jean-François Dominicé, who was not active in Paris before about 1721. It includes the indications of the equation of time, which are not found on French clocks before 1715–17. The use of the long pendulum and weights was certainly the reason why the grill, cut and engraved after a drawing by Gilles-Marie Oppenord (fig. 5n), was installed below the dial to cover the unsightly ropes and pendulum bar.[16] Unfortunately this grill also obscures from view not only the marquetry in brass and tortoiseshell on the inside surface of the clock case but also the marquetry floor and the vertical marquetry trophies in the interior of the case.

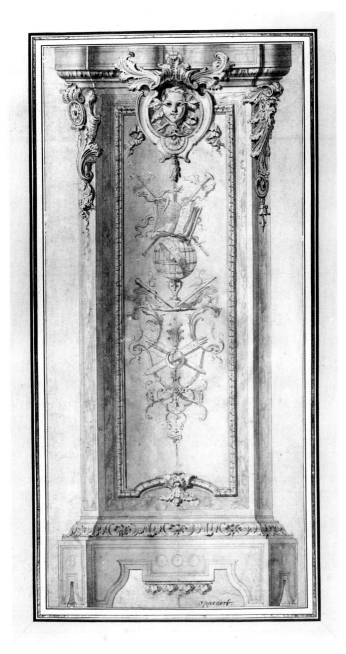

5M Gilles-Marie Oppenord, drawing for the pedestal of a clock (Berlin, Kunstbibliothek, inv. Hdz 6575).

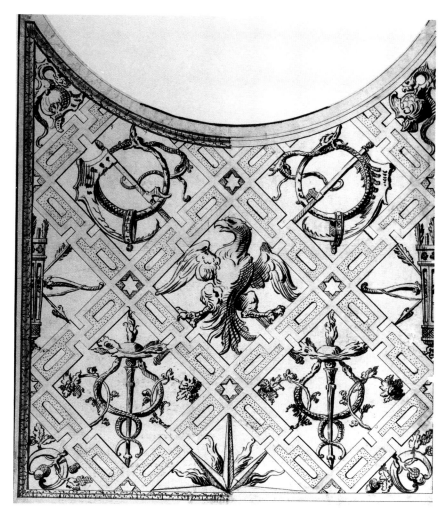

5N Attributed to Gilles-Marie Oppenord, drawing for the grill of cat. no. 5 (Berlin, Kunstbibliothek, inv. Hdz 3986).

The musical movement was inserted into the existing compartment. It was then necessary to change the vertical position of one of the weight ropes to the horizontal by means of two pulleys.

In the inventory taken at the death of Gilles-Marie Oppenord in May 1742 a clock is listed whose description fits well with the Getty Museum's example: "Item une grande pendule sonnante les heures avec carillon marquant le jours des mois, le retard et l'avance du soleil, à minutes et secondes, avec son pied et boeste de marquetterie ornée de figures, pilastres et ornemens de bronze avec son chapiteau de marquetterie orné aussi de figures de bronze prisée et estimé la somme de six mille livres, cy . . . 6,000 livres."[17]

When the clock was sold from the collection of Vincent Donjeux in 1793,[18] it was described as being surmounted by the figure of Apollo, which is now placed, perhaps more suitably, above the terrace that holds the Python that Apollo slew. Whether or not the present position of the god is that intended by Oppenord is impossible to determine. Undoubtedly the figure hides a major part of the fine grill. The height of the clock in 1793 was given, very specifically, as *8 pieds, 4 pouces*. The present height of the clock is a little higher than the eighteenth-century measurement, and this difference can perhaps be explained by the later addition, possibly in London about 1800, of the pine cone pendants, ram's heads, and the *cul-de-lampe* with its fluted alcove, all of which raise the clock case up from the pedestal somewhat. All of these mounts and the wooden structure are of very poor quality. One assumes that the fluted alcove was added to hide both the unsightly hole cut into the top of the pedestal and the ropes and pendulum bar, but it may equally replace some other obscuring device that Gilles-Marie Oppenord devised.

MOVEMENT

Brass and iron, partly blued

Note: The number in parentheses represents the number of teeth on each wheel. These numbers are repeated again in the drawings of the movement.

The movement (fig. 50) consists of three trains. The going train is driven by a weight; the striking train and the

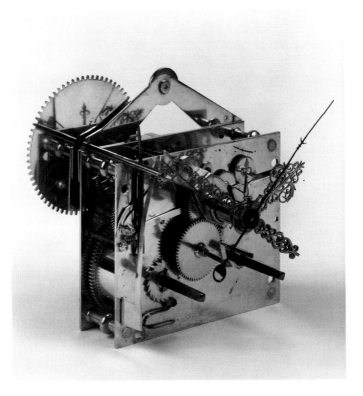

50 Three-quarter view of the movement.

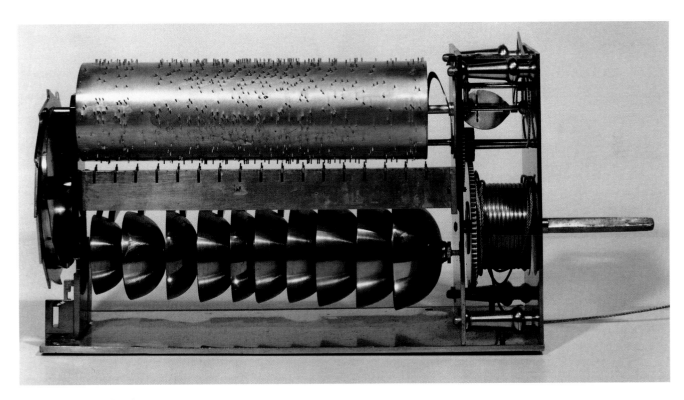

5P The musical train.

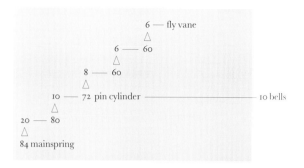

Musical train

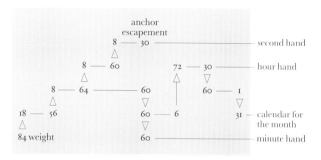

Going train

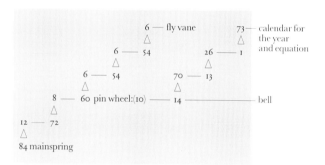

Striking train

musical train are driven by mainsprings. Each train runs for about one week. The going train provides power for the hands, which indicate the hours in roman numerals and the minutes in arabic numerals on the main dial. There are two subsidiary dials which indicate the days of the month at VI and the days of the year at XII; a third subsidiary dial indicates the equation of time (± 16 minutes) during the year. The clock strikes the full hours on one bell. The musical train runs every hour, or on demand.

The going train has one barrel that carries the weight (84) and four pinion wheels (18/56–8/64–8/60–8/30), the last being the escape wheel. This train is regulated by an anchor escapement in connection with a seconds pendulum. The arbor of the third wheel holds a wheel (60) that drives the motion work, which is divided into two parts: one drives the hour hand (60–60/6–72) and the other the minute hand (60–60–60). The escape wheel holds the second hand. The arbor of the hour wheel also carries a wheel (30) that drives the monthly calendar (30–60/1–31). The motion work releases the striking train every hour.

The striking train is to the left of the going train. It is driven by a mainspring and controlled by a count wheel (locking plate). It has a rotating barrel (84), which holds the mainspring, four pinion wheels (12/72–8/60–6/54–6/54), and a fly vane (6). The third wheel (8/60) has ten pins that move the striking hammer. The count wheel carries on its arbor another wheel that drives the indicator for the days of the year and the mechanism for the equation (14–70/13–26/1–73).

The musical train (fig. 5p) is driven by a weight and is released by the going train every hour. This train has a barrel that carries the weight (84), three pinion wheels (20/80–10/72–8/60–6/60), and a fly vane (6). The third wheel (72) drives the pin cylinder, which has ten tracks that release the striking hammers. Seventeen hammers and ten bells allow for the playing of twelve melodies (chosen manually).

PUBLICATIONS

B. Fredericksen, H. Lattimore, and G. Wilson, *The J. Paul Getty Museum* (London, 1975), p. 151, ill.; G. Wilson, *Clocks*, pp. 26–33, no. 5, ill.; Wilson, *Decorative Arts* (1977), p. 23, no. 28, ill.; Sassoon and Wilson, *Decorative Arts: A Handbook*, p. 37, no. 80, ill.; Ronfort 1986, vol. 2, p. 491. Bremer David et al., *Decorative Arts*, p. 84, no. 130; J. N. Ronfort, "Vie et oeuvres retrouvées d'Alexandre-Jean Oppenordt (1639–1715)," *L'Estampille* (forthcoming).

EXHIBITIONS

Detroit Institute of Arts, 1972–1973.

PROVENANCE

Probably in the possession of Gilles-Marie Oppenord until his death in 1742. (?) Vincent Donjeux [dealer], sold, Paris, April 29, 1793, lot 562. Peter Burrell, 1st Lord Gwydir, Grimsthorpe Castle, Cokayne; by descent to Peter Burrell, 2nd Lord Gwydir, sold, Christie's, London, March 11–12, 1829, lot 103, to Samuel Fogg [dealer], London, for 147 *guineas*.[19] William Alleyne Cecil, 3rd Marquess of Exeter; by descent to Brownlow Henry George, 4th Marquess of Exeter, Burghley House,[20] sold, Christie's, London, June 7–8, 1888, lot 261,[21] sold to Charles Davis [dealer], London, for 1,655 *guineas*. Cornelius Vanderbilt II, New York. William K. Vanderbilt II, New York. Countess Laszlo Széchényi, née Gladys Vanderbilt, New York and The Breakers, Newport, Rhode Island (circa 1926–27). Rosenberg and Stiebel [dealers], New York, 1971. French and Company, New York. Purchased by J. Paul Getty in 1972.

NOTES

1. Probably Jean-Baptiste Thiery, who lived and worked in the rue Saint-Denis in 1780 with the clock-maker Liger (Archives de la Seine, cart. 55, balance sheet of Seigneuret, March 20, 1780). Information provided by Jean-Dominique Augarde. See also Tardy, *Dictionnaire des Horlogers Français* (Paris, 1972), p. 611.
2. It is likely that the replaced enamel dial by Lepaute is a copy of an original dial made of *carton*. This delicate material was used by clock-makers from time to time but has rarely survived. A long-case clock with a similar movement by Dominicé was sold in Paris in 1984 (Nicolaÿ, July 11, no. 86). It possessed a dial of the same configuration in *carton*. I thank Jean-Dominique Augarde for this information.
3. Three John Lambs are listed in G. H. Baillie, *Watchmakers and Clockmakers of the World*, 3rd ed. (London, 1966), p. 186. One lived in Fetter Lane in 1775, another in Newman Street in 1820, and a third in Cockspur Street around 1830.
4. Probably W. Boucher, who was working at 4 Long Acre, London, in 1820. See F. J. Britten, *Old Clocks and Watches and their Makers*, 7th ed. (London, 1956), p. 338.
5. See the cat. no. 21, note 1.
6. Bronze mounts often were not gilded but were instead dipped in acid to produce a gold-like color and then lacquered. The process was called *mise en couleur d'or*.
7. See cat. no. 21, note 8.
8. J. N. Ronfort, "Le mobilier royal à l'époque de Louis XIV, 1685, Versailles et le Bureau du Roi," *L'Estampille* (April 1986), pp. 44–51.
9. The engraving is illustrated in Christie's, London, June 15, 1995, lot 50.
10. A. Guérinet, ed., *Les Palais de Fontainebleau*, vol. 4, *Les Bronzes, Objets d'Art etc.* (Paris, 1908), title page, and Tardy, *La Pendule française, 1ère partie, des origines au Louis XV* (Paris, 1974), p. 110. The clock has a movement by Mynuel.
11. Christie's, London, December 3, 1981, lot 85. See also another pair on the Paris market in 1992.
12. A.N., Min., IV, 412, Acte de Notorieté, February 28, 1720, indicates that no inventory was made: "Il n'a été fait aucun inventaire et qu'ils [ses parents] n'ont laissé pour leur seul et unique heritier que Sieur Gilles Marie Oppenord, leur fils, directeur général des Bâtiments et Jardins de S. A. R. Monseigneur le duc d'Orléans, Régent du Royaume."
13. Ronfort 1986, vol. 2, p. 486, fig. 12.
14. Inv. Hdz 6575. See E. Berckenhagen, *Die Französischen Zeichnungen der Kunstbibliothek Berlin* (Berlin, 1970), p. 176.
15. The prominence on the pedestal of the bronze crescent moon, the military and religious symbol of the Ottoman Turks, may indicate that the clock was originally intended for export to the Middle East, which throughout the eighteenth century was a good market for clocks made in Paris. A similar crescent is included in the marquetry in the design by Oppenord for the Le Bas de Montargis pedestal. That part of the design was not carried out, and the moon's presence in the drawing and on the Getty Museum's clock may be coincidental.
16. See Berckenhagen (note 13), p. 172 (inv. Hdz 3986; not illustrated). The drawing is described as possibly having been made for a ceiling. We are grateful to the late Bruno Pons for having brought this drawing to our attention.
17. A.N., Min., IV, 517. See also the *partage* of September 25, 1749 (A.N., Min., V, 450).
18. Paris, April 29, no. 562: "Une grande pendule à secondes, dans sa böete, enrichie des 4 heures du jour; le haut couronné par un figure d'Apollon; le corps, en gaine est enrichie d'ornemens de genre chantourné et posant sur quatre griffes de Lion. Le tout élévé sur un socle de bois noirci. Haut 8 pieds 4 p. larg. 2 pieds." It seems that the Four Continents were misunderstood by the cataloguer, who took them for the Hours of the Day.
19. The entry in the Gywdir sale catalogue reads: "A Superb Parisian Clock about eight feet high, the upper part supported by caryatid figures representing the four quarters of the globe, the lower part enriched with foliage in scroll work, and the brass work in high relief." The sale was held after the death, in 1828, of Lord Gwydir's wife, Lady Willoughby de Eresby.
20. According to John Culverhouse, the administrator of Burghley House (correspondence with Gillian Wilson, July 9, 1993), inventories of the house in that period were made only for the years 1796 and 1892. Thus the clock does not appear in either of these, having been acquired about 1829 and sold in 1888.
21. The Marchioness of Exeter, wife of the 2nd Marquess, was present at the Gwydir sale since lots 16 and 24 were sold to her. In the Exeter sale catalogue the clock is illustrated and described as follows: "A Louis XIV clock, in case of red Boulle, the upper part supported by caryatid figures representing the four quarters of the globe, the lower part enriched with scroll foliage of or-moulu in high relief— 8 feet high." We are grateful to Hugh Roberts for supplying this information.

VI

Wall Clock

French (Chantilly); circa 1740

Movement by Charles Voisin (1685–1761; master 1710) (see Biog., p. 199); case made at the Chantilly porcelain manufactory

HEIGHT: 2 ft. 5½ in. (74.9 cm)
WIDTH: 1 ft. 2 in. (35.6 cm)
DEPTH: 4⅜ in. (11.1 cm)

81.DB.81

DESCRIPTION

The wall clock is composed of Chantilly soft-paste porcelain, fired in two sections. A winged dragon is set above the dial (fig. 6a), with its tail extending down the right side, ending below in a flourish. A goose perches at upper left (fig. 6b). A monkey sits below the dial among branches of leaves and flowers which form the entire mass of the clock case (fig. 6c). He is held in position by a brass clamp around his right leg, which attaches to a brass plate that forms the back of the clock. An undulating gilt-bronze garland of leaves and berries surrounds the entire clock, while the rim of the dial is set all around with single gilt-bronze flowers backed by leaves. There is a pierced circular door mounted in the back of the case which gives access to the movement.

MARKS

The dial is painted in black CHARLES VOISIN APARIS, and the back plate of the movement is engraved C^{les} *Voisin APraris* (fig. 6d). One of the main wheels of the movement is engraved with a number of inscriptions, most of which are indecipherable, but the words *Nettoyez* and *Netoy* can be read, as can the dates 1756, 1768, 1817, and 1854 (fig. 6e).

CONDITION

Considering the extreme fragility of the porcelain elements, the case is in remarkably fine condition. The edges of a few of the petals and leaves are chipped, but there are no major losses.

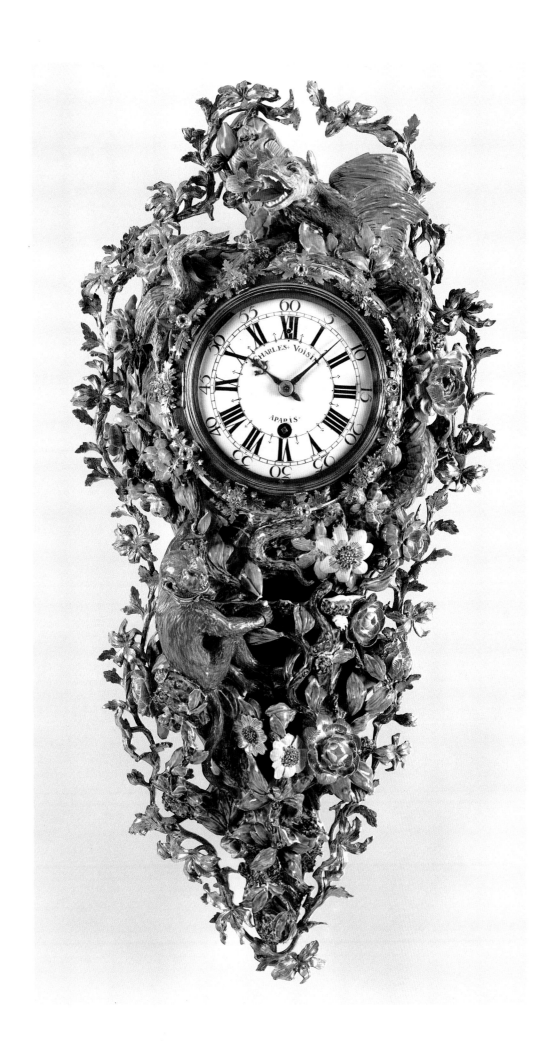

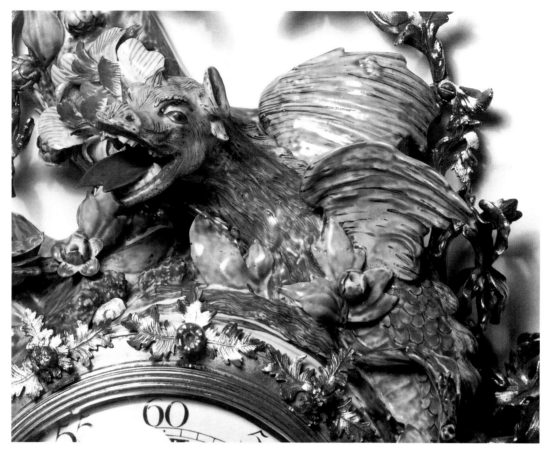
6A

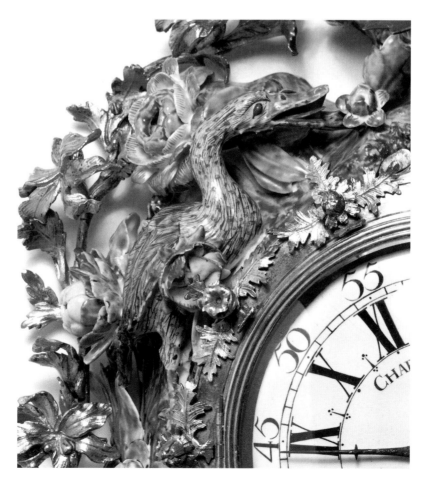
6B

6c

COMMENTARY

The clock, of a type sometimes known as a *pendule d'alcove*, has a striking movement that can be activated to the nearest quarter hour by pulling a string which protrudes through the porcelain case at the bottom right. In this way one could tell the time in the dark without lighting a candle. Clocks bearing such devices were often hung in bed alcoves—hence their name.

The porcelain case, which is tin glazed, was made at the Chantilly manufactory. The factory was set up in 1725 by Louis-Henri, duc de Bourbon and seventh prince de Condé. It was given a royal charter in 1735 and operated until 1800. Its first director was Ciquaire Cirou; under his direction, the factory exclusively used an opaque tin glaze rather than the translucent lead glaze commonly used at other French porcelain manufactories. This practice had almost ceased by Cirou's death in 1751.

The prince de Condé had a large collection of Japanese porcelain, and the early wares of the factory often copied Japanese forms and decoration. It is possible to see a lingering influence of the Orient in the case of the Getty Museum's clock, with its exotic dragon and monkey, though it is also true that these animals are often found as elements of the rococo repertoire. Such an ingenious and exuberant piece may well have been made as a special commission for the *chambre à coucher* of one of the members of the Condé family at the Château de Chantilly, or at the Palais de Bourbon in Paris.

OTHER EXAMPLES

Only one other French wall clock with a case made wholly of Chantilly porcelain is known to exist. Formerly in the collection of Mr. and Mrs. Jack Linsky, it is now in the Metropolitan Museum of Art, New York.[1] The case, which is considerably smaller than the Getty Museum's example, is set with three Chinese figures, and its movement is by Etienne Le Noir.

Also at the Metropolitan Museum is a mantel clock made of Chantilly porcelain.[2] The case of this clock consists of two oriental figures supporting a porcelain drum

6D

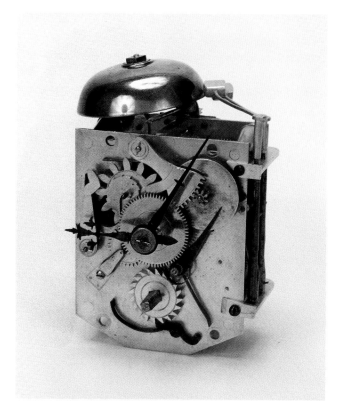

6F Three-quarter view of the movement.

6E Main wheel with signatures and dates inscribed by various repairers.

that holds the movement. The dial, which is also of Chantilly porcelain, appears to be unique.

Other clocks with porcelain cases are known, but they were mainly produced by German manufactories. One of the earliest was made at Meissen in 1727 by Fritzsche and Kirchner.[3] Another, made at Frankenthal by J. W. Lanz in 1760, is in the high rococo style.[4] Such clocks were also produced in faïence, notably at Strasbourg.[5] The Sèvres manufactory produced at least one porcelain clock case in the late rococo period—a tall-legged mantel clock made for Madame de Pompadour in the early 1760s as part of a garniture.[6] In later decades the manufactory made a number of biscuit clocks in the Neoclassical style.

MOVEMENT
Brass and iron, partly blued

Note: The number in parentheses represents the number of teeth on each wheel. These numbers are repeated again in the drawings of the movement.

The movement (fig. 6f) consists of two trains driven by mainsprings. The going train, which runs for about a week, provides power for the hands, which indicate the hours in roman numerals and the minutes in arabic numerals on the main dial. This type of striking train is called a repeating train. It is not released by the going train but is loaded by pulling on a string. The hours are

struck by the first hammer on one bell; the quarter hours are struck on the same bell by the second hammer (the first hammer then "repeats" the hour).

The going train has one rotating barrel (80), which holds the mainspring and four pinion wheels (12/80–8/80–6/60–6/35), the last being the escape wheel. The going train is regulated by a crown wheel (verge escapement) in connection with a pendulum. The pendulum can be adjusted while the clock is running using a key inserted in a hole in the dial at number XII. When the key is turned a silk thread is wound around a square rod, changing the length of the pendulum. The third wheel holds the cannon pinion (30), a part of the motion work (30–30/6–72), and the minute hand. The hour wheel (72) holds the hour hand.

To the left of the going train is the repeating train. This train has a non-rotating barrel (72), which holds the mainspring, two pinion wheels (6/60–6/60), and a fly vane (6). The barrel wheel (72) carries eighteen pins that move the striking hammer. Twelve pins are used for striking the hours, six pins for striking the quarters.

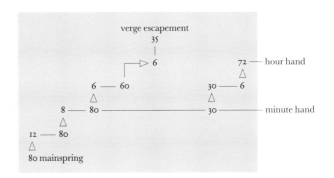

Going train

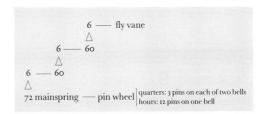

Repeating (striking) train

PUBLICATIONS

G. Wilson, "Acquisitions made by the Department of Decorative Arts, 1981," *GettyMusJ* 10 (1982), pp. 66–71; "Some Acquisitions (1981–82) in the Department of the Decorative Arts, the J. Paul Getty Museum," *Burlington Magazine* (May 1983), p. 326; G. Wilson, *Selections from the Decorative Arts in the J. Paul Getty Museum* (Malibu, 1983), pp. 26–27, no. 13; Sassoon and Wilson, *Decorative Arts: A Handbook*, p. 39, no. 84; Bremer David et al., *Decorative Arts*, p. 135, no. 87.

PROVENANCE

Reputedly from a Hungarian private collection. Jacques Kugel [dealer], Paris. Acquired by the J. Paul Getty Museum in 1981.

NOTES

1. Inv. 1982.60.84, *The Jack and Belle Linsky Collection in the Metropolitan Museum of Art* (New York, 1984), pp. 238–239, no. 147.
2. Inv. 1974.28.91. The movement is signed "GRAY & VULLIAMY."
3. P. W. Meister and H. Reber, *La Porcelaine Européenne du XVIIIe siècle* (Fribourg, 1980), p. 138, fig. 200.
4. Meister and Reber (note 3), p. 138, fig. 201.
5. Tardy, *La Pendule française, 1ère partie, des origines au Louis XV* (Paris, 1974), p. 184, figs. 1, 2.
6. *Musée du Louvre, Nouvelles acquisitions du département des objets d'art 1980–1984* (Paris, 1985), pp. 136–139, no. 79.

VII

Clock and Barometer on Brackets

French (Paris); circa 1755
(barometer), circa 1758 (clock)

Movement by Jean Romilly
(1714–1796; master 1752)
(see Biog., p. 193); maker of the
modern mechanism of the
barometer unknown; cases of both
clock and barometer attributed to
Charles Cressent (1685–1768);
bracket of clock by Jean-Joseph de
Saint-Germain (1719–1791; master
1748); bracket of barometer
probably by Saint-Germain

71.DB.115 (clock)
71.DB.116 (barometer)

Clock:
HEIGHT: 2 ft. 8 ½ in. (82.5 cm)
WIDTH: 1 ft. 4 in. (40.7 cm)
DEPTH: 8 in. (20.3 cm)

Bracket:
HEIGHT: 1 ft. 5 in. (43.2 cm)
WIDTH: 1 ft. 6 ½ in. (47.0 cm)
DEPTH: 7 ½ in. (19.1 cm)

OVERALL HEIGHT: 4 ft. 1 ½ in.
(125.7 cm)

Barometer:
HEIGHT: 2 ft. 10 in. (86.2 cm)
WIDTH: 1 ft. 3 in. (38.1 cm)
DEPTH: 7 ½ in. (19.1 cm)

Bracket:
HEIGHT: 1 ft. 5 in. (43.2 cm)
WIDTH: 1 ft. 6 in. (45.7 cm)
DEPTH: 7 ¼ in. (18.4 cm)

OVERALL HEIGHT: 4 ft. 3 in.
(129.4 cm)

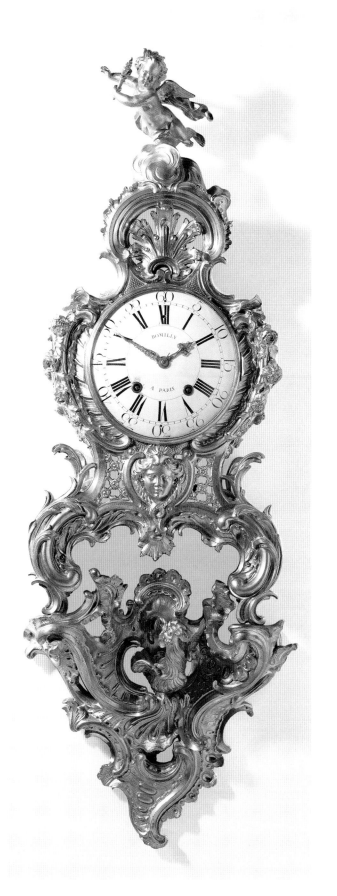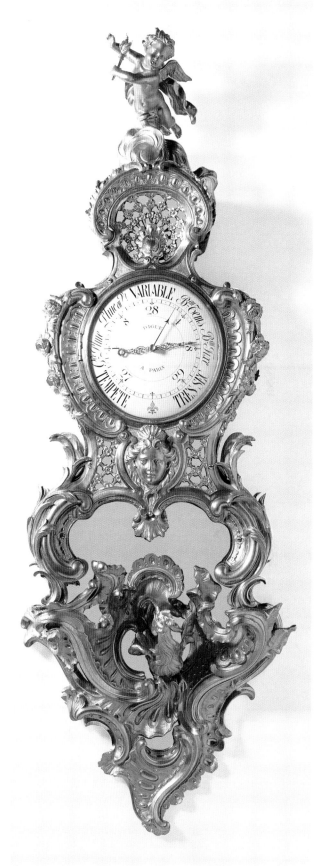

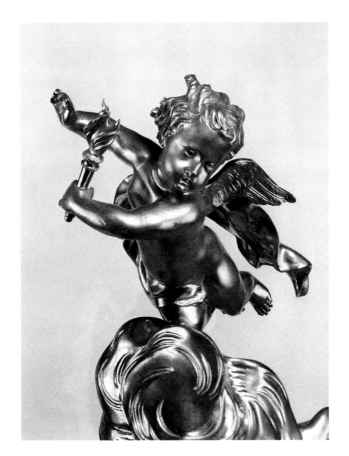

7A

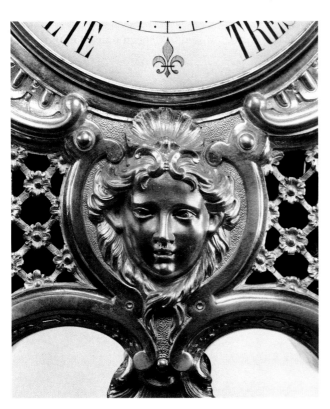

7B

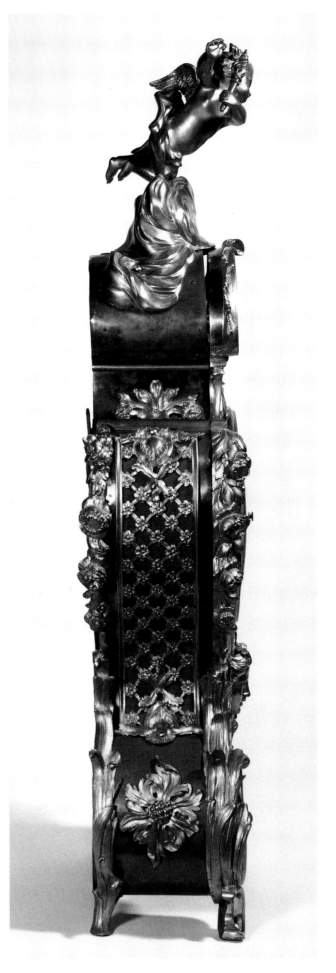

7C

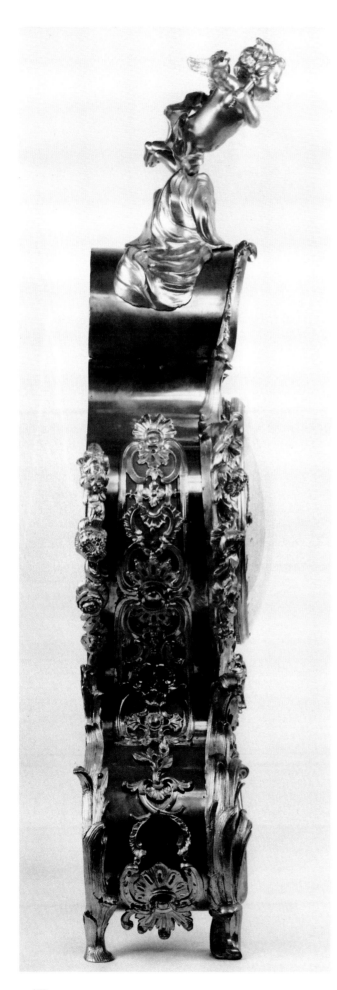

7D

DESCRIPTION
Barometer

The entire façade of the case is made of one piece of gilt bronze. The sides and the top are veneered with brass sheets. The carcase is of white oak, painted and stained black. Surmounting the whole is a gilt-bronze flying cupid (fig. 7a), above an open bell case capped by a lunette decorated with repeating cabochons on a rosetted grill that radiates from a central palmette.

The enamel dial is covered by a convex glass to which is attached a second manually operated hand which serves as an indicator of past barometric pressure. To either side of the dial is a border filled with a repeating tongue motif, overlaid at its edges by floral pendants. Below the dial is a female mask topped by a shell motif (fig. 7b). To either side of the mask are grills of rosetted trellis. The case is supported on incurving legs decorated with rushlike leaves that are set on small C-scrolled feet.

The sides of the barometer case are mainly occupied by panels of pierced trellis similar to those at the front (fig. 7c). Below, at the level of the legs, are placed large leafy rosettes. Pendants of flowers above rushlike leaves outline the back edge. The back is fitted with a hinged and latched door. The interior of the oak carcase has been cut away to provide space for the swing of a pendulum—the case having originally been that of a clock. The wooden division between the large and small interior compartments has been cut to allow passage for the arm of a bell hammer. The bell would have been housed in the upper compartment.

Clock

Although the case is of the same form as that of the barometer it has been cast from entirely different models. It differs principally in the following areas: The lunette of the top is not cast with repeating cabochons, and the pierced area below is filled with a symmetrical spray of acanthus leaves rather than a trellis grill. To either side of the dial a flame motif replaces the tongue border, while this motif is also found on the inner surfaces of the legs. On the sides of the clock case the pierced panels are formed of shell, rosettes, leaves, flame borders, strapwork, and cabochons, rather than the simpler panel of trellis (fig. 7d).

Brackets

The virtually identical gilt-bronze brackets are of asymmetrical form and composed of C- and S-scrolls, auricular forms, guilloche, and flamelike motifs. Apart from the central cockerel, each is cast as one piece of bronze. The upper front corners are provided with short pins which insert into the front legs of the case above.

MARKS

Barometer

The dial is signed DIGUE A PARIS; there are no other marks or signatures.

Clock

The bracket is signed ST. GERMAIN (fig. 7e), the dial is enameled ROMILLY APARIS, and the movement is engraved *Romilly Paris* (fig. 7f). Each of the attached gilt-bronze elements, including that forming the front of the case, is stamped on its back with the letter E. The carcase of the clock bears two red wax seals, the lettering on which is indecipherable. The spring of the going train of the movement is inscribed *Blakey 1758* (fig. 7g). As the movement appears to be original to the case, the case would most likely also have been made in that year. The front plate is inscribed *HL a Cobiel au fermye 91 / Willard Murs 1851 / A. J. Noordanus Los Angeles 24 Mar 1976*

CONDITION

The barometer and its enamel dial are modern replacements; the latter is possibly a copy of an eighteenth-century original. These alterations were made under the direction of the Duveen brothers, dealers who acquired the present case and barometer in 1933 through B. Fabre, Paris. Their intention was to convert it into a barometer to form a pair with the clock, which they had sold to Anna Thomson Dodge a year earlier. Both were to be placed in the entrance hall of Rose Terrace, Mrs. Dodge's newly constructed house in Grosse Pointe Farms, Michigan.[1]

COMMENTARY

The design and manufacture of the case of the barometer is traditionally given to Charles Cressent. A case of the same model as the Museum's barometer case is described by Cressent in the catalogue for the auction of his works in 1757 as "une pendule à face de bronze sur son pied tout de bronze; elle est coeffé d'un enfant sur un nuage; au pied, il y a deux dragons, avec une tête de lyon qui sort par un trou. On laisse aux curieux à en dire leur sentiment; dorée d'or moulu, avec son mouvement; de quatre pieds de hauteur."[2] It is possible that the model first appeared in the early 1730s. In 1733 various works were confiscated from Cressent's workshop by the corporation of *fondeurs-ciseleurs*, and it is probable that it is this model which is described in their *procès verbal* as follows: "une porte de pendule de cuivre doré d'or moulu, avec sa lunette aussy de cuivre doré d'or moulu, la charnière de ladite lunette, quatre bouts de moulure, une faux, les deux pieds de derière avec les deux chuttes de ladite pendulle, la nuée et l'enfant pour mettre dessus, le tout de cuivre doré d'or moulu, plus le pied de ladite pendulle de cuivre doré d'or moulu."[3] The bracket which

7E

7F

7G The spring of the going train, signed *Blakey 1758*

7H Maurice-Quentin de La Tour, *Portrait of Gabriel Bernard de Rieux*, 1739–1741 (JPGM, acc. no. 94.PC.39); detail showing a clock of similar model to the Getty Museum's clock.

7I The back of the clock case.

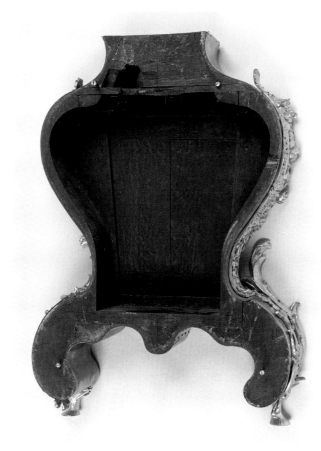

7J The back of the barometer case.

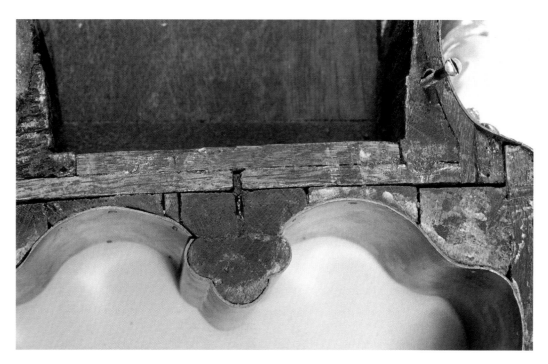

7K Detail of the back of the barometer case showing the tri-lobed *cul-de-lampe*.

supports the Museum's clock is stamped by Jean-Joseph de Saint-Germain.[4] Jean-Dominique Augarde has suggested that Saint-Germain was responsible for the design and execution of the clock case as well.[5] But this seems unlikely as a clock of this model appears in the background of the large pastel portrait of Gabriel Bernard de Rieux by Maurice-Quentin de la Tour (fig. 7h), which was exhibited in the Paris Salon of 1741 and may have been executed as early as 1739, when Rieux inherited the estate of his father, Samuel Bernard.[6] In 1741 Saint-Germain was only twenty-two years old. In addition, although a number of the other brackets are stamped with Jean-Joseph de Saint-Germain's mark none of the other cases are, although two examples do bear, on their wooden carcases, the stamp of his *ébéniste* father Joseph de Saint-German, possibly struck in his capacity as a restorer.[7] Given the evidence of the above-mentioned La Tour portrait, it would seem that Cressent had produced a reworked set of casting models for the clock, incorporating stylish rococo flourishes, as early as the late 1730s.

The gilt-bronze façade of the Museum's barometer case differs in two ways from all the other cases of this model, which are considerable in number. The *cul-de-lampe* below the mask is not trilobate but follows exactly the motif found in the same position on the Museum's updated clock case. The front legs, instead of taking the form of small stemlike feet from which spring palm leaves, are in the form of C-scrolls, as found on the clock case. These two differing elements have not been brazed onto the façade but are part of the whole cast. No other Cressent case of this earlier model bears either of these two features. Possibly it represents an initial stage in the evolution of this model, with the casting models for the whole case being reworked soon after.

Further differences between the Getty clock and barometer can be observed both in the construction of their wooden carcases and in the finishing of some of their mounts, with the carcase of the stylistically earlier barometer being composed of a greater number of pieces less tightly joined (figs. 7i and j). This case is also marginally wider at the waist and slightly narrower above and below. There is also evidence that it may have once been fitted with another gilt-bronze façade—perhaps in the process of experimentation—as there are at least three screw holes for attachment which now serve no purpose. The part of the carcase that backs the *cul-de-lampe* is trilobate (fig. 7k), thus following the outline for the original *cul-de-lampe* of this model. Possibly in the construction of these clocks the carcases were made in groups, with some being kept in reserve for later use. On the barometer's case the cupid lacks chasing and exhibits the same smoothness as the bracket; this too may be the result of this practice.

OTHER EXAMPLES

A large number of such cases exist, all mounted with clock movements and most with brackets either of Cressent's initial, essentially symmetrical, design incorporating dragons and a lion's head (as described in the catalogue of the 1757 sale), or with the Saint-Germain version composed of asymmetrical scrolls within which a cockerel is perched. Examples that have cases similar to the earlier "barometer" case include a clock in the collection of Neil Phillips, New York (sold, Sotheby's, London, 1964, June 5, lot 24), with a movement by Etienne Baillon, which has a case and bracket struck with crowned C tax stamps that date them precisely between 1745 and 1749. The bracket of this clock, though following the Cressent design, is centered not by a lion's head but with the same cockerel that appears on the Saint-Germain bracket.[8] The cupid holds a bow which probably replaces a scythe, or flaming torch. A clock in the Grog-Carven collection, Musée du Louvre, has the Cressent bracket and a movement by Audinet.[9] A clock in the Musée des Arts Décoratifs has the Cressent bracket.[10] A clock in the Château de Versailles, with a movement by Baillon, was delivered to Versailles in February 1745 for the *chambre à coucher* of the Dauphine Marie-Thérèse of Spain and described in the *Journal* of the Garde-Meuble de la Couronne under no. 42.[11] A clock sold anonymously in Paris (Galerie Georges Petit, June 17, 1921, lot 91, and later at the Galerie Charpentier, March 29, 1955, lot 75) has the Cressent bracket and a dial signed "Guiot A Paris."

Examples having the later clock case include: a clock formerly in the possession of Dalva Brothers, New York, which has the Saint-Germain bracket and a dial signed "ROBIN Hᵉʳ DU ROY," a clock sold anonymously in Paris (Galerie Charpentier, March 19, 1953, lot 62) with the Saint-Germain bracket and a dial signed "BOULARD APARIS," a clock sold anonymously in Paris (Galerie Charpentier, April 2, 1954, lot 148) with the Saint-Germain bracket and an unsigned dial, and a clock sold anonymously in Paris (Galerie Charpentier, March 17, 1956, lot 63) with the Saint-Germain bracket and a dial signed "DUCOROY APARIS."

Examples with no brackets, intended as mantel or table clocks, include: a clock in the British Royal Collection, Windsor Castle, with a dial signed "GUDIN APARIS,"[12] a clock in the Swedish Royal collection at Drottningholm Slott, with a dial signed "NICOLAS BRODON APARIS,"[13] a clock in the Residenzmuseum, Munich, with a dial signed "J. Bᵗᵉ BAILLON APARIS,"[14] and a clock formerly in Mme de Pompadour's Hermitage at Fontainebleau, now owned by a member of the de Noailles family.[15]

MOVEMENT
Brass and iron, partly blued

Note: The number in parentheses represents the number of teeth on each wheel. These numbers are repeated again in the drawings of the movement.

The movement (fig. 71) consists of two trains driven by mainsprings, each of which runs for one week. The going train provides power for the hands which indicate the hours in roman numerals and the minutes in arabic numerals on the main dial. The clock strikes the hours and half hours on the same bell.

The going train has one rotating barrel (80), which holds the mainspring and four pinion wheels (12/80–8/66–6/60–6/33), the last being the escape wheel. The going train is regulated by an anchor escapement (deadbeat escapement) in connection with a pendulum. The pendulum can be adjusted while the clock is running by lifting or lowering it via its silk suspension. The second wheel holds the cannon pinion (30), a part of the motion work (30–30/6–72), and the minute hand. The hour wheel (72) holds the hour hand. The cannon pinion (30) rotates once every hour; it has two pins that release the striking train every half and full hour.

This type of striking train has a locking plate (count wheel). This train has one rotating barrel (80), which holds the mainspring, four pinion wheels (12/72–8/60–6/54–6/48), and a fly vane (6). The second wheel (8/60) has ten pins that move the striking hammer.

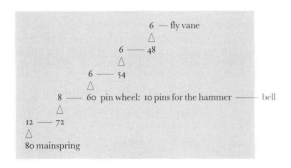

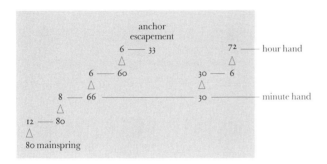

Going train

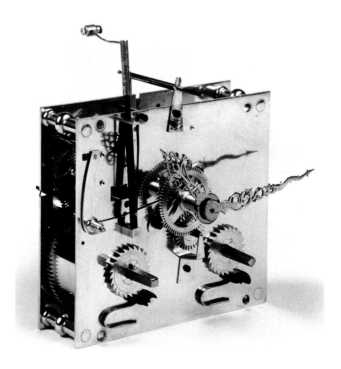

71 Three-quarter view of the movement.

56 CLOCK AND BAROMETER

EXHIBITIONS

Detroit Institute of Arts, 1971–1973.

PUBLICATIONS

Detroit Institute of Arts, *A Catalogue of Works of Art of the 18th Century in the Collection of Anna Thomson Dodge* (Detroit, 1933), ill.; T. Dell, "The Gilt-Bronze Cartel Clocks of Charles Cressent," *Burlington Magazine* (April 1967), pp. 210–217; B. Fredericksen, H. Lattimore, and G. Wilson, *The J. Paul Getty Museum* (London, 1975), p. 187; Wilson, *Clocks*, pp. 44–51, nos. 8–9, ill.; Wilson, *Decorative Arts* (1977), p. 47, no. 61, ill.; Sassoon and Wilson, *Decorative Arts: A Handbook*, p. 38, no. 82, ill.; Ottomeyer and Pröschel, *Vergoldete Bronzen*, vol. 1, p. 79, ill.; Bremer David et al., *Decorative Arts*, p. 89, no. 139.

PROVENANCE

George Jay Gould, Georgian Court, Lakewood, New Jersey; sold from the premises on April 23, 1924 (clock only). B. Fabre [dealer], Paris (barometer only). Duveen Brothers, New York, 1933 (barometer only). Mrs. Anna Thomson Dodge (then Mrs. Hugh Dillman), Rose Terrace, Grosse Pointe Farms, Michigan, 1932 (clock), 1933 (barometer); sold at the Anna Thomson Dodge sale, Christie's, London, June 24, 1971, lot 40. Purchased at that sale by J. Paul Getty.

NOTES

1. This information was provided by Theodore Dell.
2. M.-J. Ballot, "Charles Cressent, Sculpteur, Ebéniste, Collectionneur," *Archives de l'art français, nouvelle période (1916–1918)*, vol. 10 (Paris, 1919), p. 217. For more information on Charles Cressent, see T. Dell, "The Gilt-bronze Cartel Clocks of Charles Cressent," *Burlington Magazine* (April 1967), pp. 210–217, fig. 39; G. de Bellaigue, *The James A. de Rothschild Collection at Waddesdon Manor: Furniture, Clocks and Gilt Bronzes*, vol. 2 (London, 1974), pp. 868–869; and Pradère, *Les Ebénistes*, pp. 128–139.
3. A.N., Y 11296. Cressent stated that this new model had been made for the king of Portugal, João V (Bibliothèque Nationale, Ms. Joly de Fleury 2016, fol. 60).
4. Jean-Joseph de Saint-Germain (1719–1791) was a *bronzier* and the son of the *ébéniste* Joseph de Saint-Germain with whom he worked. He is mentioned in the *Almanach Général des Marchands* in 1747, and again in 1772, as living in the rue Saint-Nicolas in the faubourg Saint-Antoine. On July 15, 1748, he was registered as a *maître fondeur en terre et sable*. He was elected as a *juré* of the guild in 1765, and his name appears as a co-signatory on the bronze founders' copyright resolution, which was ratified in 1766. He was one of the few *bronziers* to sign his works and a number of clock cases signed "ST. GERMAIN" exist. See Jean-Dominique Augarde, "Jean-Joseph de Saint-Germain (1719–1791), Bronzearbeiten zwischen Rocaille und Klassizismus," in Ottomeyer and Pröschel, *Vergoldete Bronzen*, vol. 2, pp. 521–538.
5. This re-attribution to the Saint-Germains was first proposed by Jean-Dominique Augarde in 1986 and published in *Les Ouvriers du temps: La pendule à Paris de Louis XIV à Napoléon premier* (Geneva, 1995). I am grateful to him for his comments on this matter.
6. The pastel was acquired by the J. Paul Getty Museum in 1994 (94.PC.39). It is illustrated in P. Verlet, *French Furniture and Interior Decoration of the Eighteenth Century* (London, 1967), p. 15.
7. One example, with a movement by Gudin, is in the British Royal Collection at Windsor Castle; another, with a movement by Ferdinand Berthoud, was sold from the collection of Ernest W. Beckett, Christie's, London, May 8, 1902, lot 93; and a third, with a movement by Viger, was sold at Christie's, London, June 20, 1985, lot 35.
8. T. Dell (note 2), fig. 32.
9. D. Alcouffe, *Petit Journal* (Musée du Louvre) (1973), fig. 5.
10. T. Dell (note 2), pp. 210–217, fig. 32.
11. See *Cinq années d'enrichissement du Patrimoine national, 1975–1980*, exh. cat. (Grand Palais, Paris, 1980), no. 96.
12. See F. J. Britten, *Old Clocks and Watches and their Makers*, 6th ed. (reprint, London, 1971), p. 472, fig. 618.
13. See J. Böttiger, *Frän de Kungliga Slotten* (Stockholm, 1925), pl. 19.
14. See L. Seelig, "Eine Pendule Charles Cressent," *Kunst und Antiquitäten* 5 (1985), pp. 42–45, figs. 1–3.
15. See "Un Royal Ermitage à Fontainebleau," *Connaissance des Arts* (August 1958), p. 66. The clock then stood on the mantelpiece in the grand salon.

VIII

Wall Clock
(*Pendule à répétition*)

French (Paris); circa 1735–1740

Movement by Jean-Jacques Fiéffé (circa 1700–1770; master 1725) (see Biog., p. 170); case by an unknown maker possibly after a design by Juste-Aurèle Meissonnier (1695–1750)

HEIGHT: 4 ft. 4½ in. (133.4 cm)
WIDTH: 2 ft. 2½ in. (67.3 cm)
DEPTH: 5⅝ in. (14.4 cm)

72.DB.89

DESCRIPTION

The wall clock is composed of eight separate pieces of gilt bronze which have been bolted to a white oak board of conforming shape. The dial is surrounded by a broad asymmetrical swirling flame motif. Perched above, on an S-shaped scroll, is a winged cupid holding an hourglass (fig. 8a). To the left a second cupid lies on the flame motif, holding a scythe in his left hand (fig. 8b). Beneath the dial a winged figure of Time reclines on a cloud. Both his hands support the flame motif which partly covers him (fig. 8c). Below, held by a ribbon, is a trophy of Time's globe, protractor, and dividers. The case terminates in branches of palm and berried laurel, the leaves of which rise and emerge to either side of the trophy, extending up the left side of the case to emerge at the top behind the uppermost cupid.

The backboard has no door. The dial and movement are hinged so that they can be swung forward for adjustment.

MARKS

The central enamel plaque of the dial is painted FIEFFÉ DELOBSERVATOIR, and the backplate of the movement is engraved *Fieffé APariy* (fig. 8d). The back of the dial is faintly engraved *J. E. Villamarina*, which is probably the name of a later restorer, and *le Bon Alphonse de Rothschild*. Repairers' marks are also found on the barrel of the going train: *M Te 4368/3*, the backplate: *5225/2*, and the barrel of the striking train: *Bon Alphonse / Gunther*. The pendulum suspension is stamped BROCOT·CIE, and the bob is stamped *1977*.

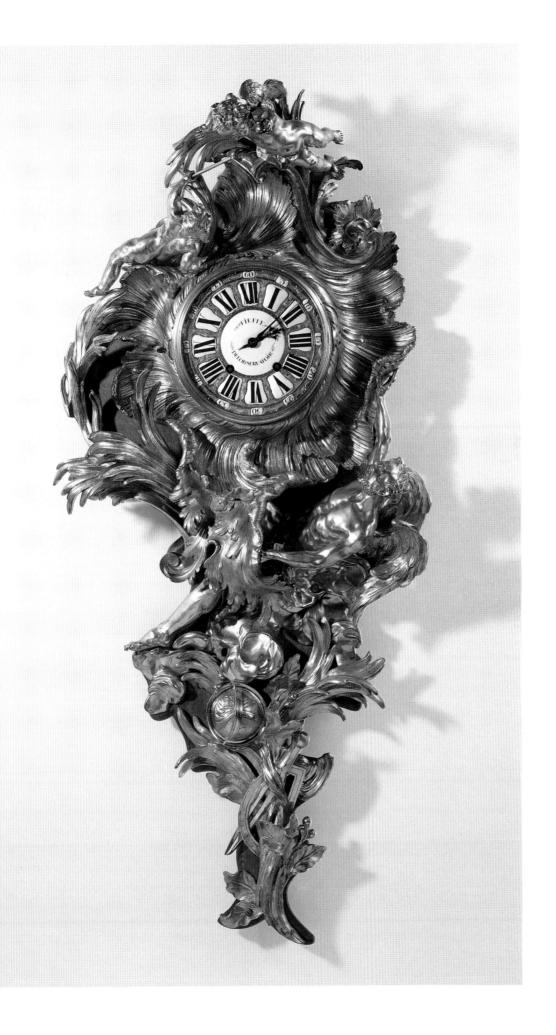

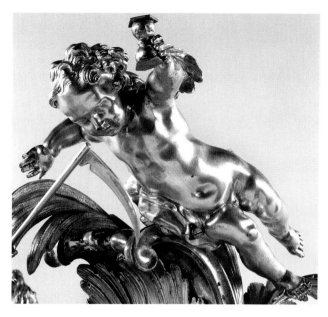

8A

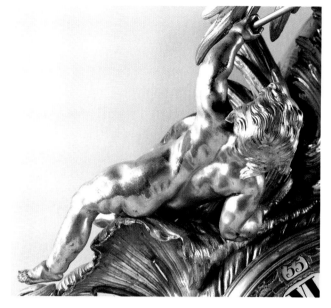

8B

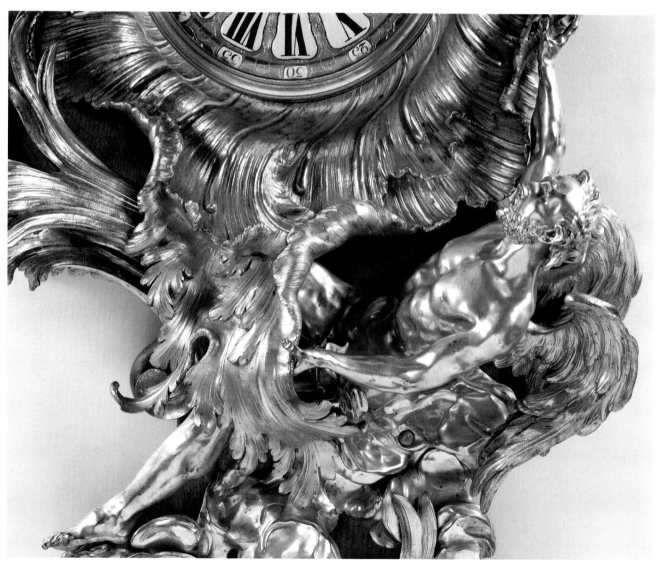

8C

8D

COMMENTARY

The entire back of the clock is covered with a shaped board of oak which has no door for access to the movement. This problem has been solved in the following way. The dial and its attached movement are secured by four screws to a ring behind the hinged glass cover. This ring, when a winged rod is removed, can be swung forward with the dial and movement attached to it. However, it would appear that the present dial and movement are not original to the case. Other screw holes, set at an angle, are found in this inner ring; these also pierce the body of the clock and would have thus held the works firmly in place. One could surmise from this apparently later adjustment that the present wooden backing replaces one that possessed a door. When the Fiéffé movement was added the back too was changed to a solid board, necessitating the present arrangement of access from the front.

It is obvious that, from its inception, a fairly stout backing of some sort would have been provided for the clock in order to hold all the various elements of the case together. The figure of Time is only attached to the clock at his right hand and, without the support of the oak backing, he, and the trophy below him, would swing loose. It is also possible that the separate elements were originally attached directly to one of the panels of a *boiserie* or to a mirror.

While the theme of Love conquering Time is frequently portrayed on French clocks of this period, both the design and the peculiar construction of this clock are unique.

The name of Charles Cressent has been suggested as the *bronzier* responsible for both the design and the manufacture of this clock.[1] Indeed two of Cressent's documented wall clocks are somewhat similar to the Museum's clock in the elements of their composition. One, at the Metropolitan Museum of Art, described in his inventory of 1749, bears above a single cupid with an hourglass while Time, carrying his scythe, lies below the dial on a pile of rocks, the latter representing "le cahos du Monde."[2] In the second example, the positions of Time and the cupid have been reversed.[3] Both these compositions are tightly controlled, whereas that of the Museum's clock is more loosely arranged and more rococo in style with its swirling forms and total asymmetry, while the figure of Time is more languidly posed than that of Cressent. Furthermore, a wall clock of the design of the Museum's clock is not found among the very complete contemporary documents describing Cressent's works.

While the name of the *bronzier* must, for the moment, remain unknown, the design may be attributed to the *ornemaniste* Juste-Aurèle Meissonnier (1695–1750). Folio 5 in the edition of Meissonnier's *Oeuvres* published by Gabriel Huquier (1695–1772) about 1750 shows a cross section of the second and third floors of a house.[4] On the wall of the *antichambre* is a sketchy rendition of a large clock which bears a figure, probably of Time, reclining below the dial in a similar position to that on the Museum's clock (fig. 8e).

An engraving for a barometer, inscribed "Cadran à vent de Mr. le Duc de Mortemar en 1724," shows a similarly positioned figure, here representing Wind, with wings of precisely the same form (fig. 8f).[5] A further engraving, entitled "Project d'une grande Pendule placée sur un paneau," shows a wall clock generally designed with the same vigorous, swirling loose asymmetry, the rococo elements both supporting and partially enclosing the figures.[6] A design for a painted ceiling for the Chapelle de la Viérge of Saint Sulpice, Paris, depicts winged angels flying among the clouds supporting the Virgin, three of whom much resemble those found on the clock.[7]

The clock was originally intended as a *pendule à répétition*. The repeating train is now missing. Such clocks, also known as *pendules d'alcove*, were usually of small size, suitable for a bed alcove (see cat. nos. 2 and 6). This is perhaps the largest example known, indicating that it was made for an extremely grand interior. The scythe is a modern replacement.

8E Gabriel Huquier, engraving after a drawing by Juste-Aurèle Meissonnier showing a cross section of a house designed for Léon de Bréthous in the mid-1730s, published in Meissonnier's *Oeuvres*, circa 1750.

8F Gabriel Huquier, engraving after a drawing by Juste-Aurèle Meissonnier for a wind indicator designed for the duc de Mortemar in 1724, published circa 1750.

OTHER EXAMPLES

A clock of the same model was sold in New York in 1982.[8] It possessed a later movement by Robert Robin (1742–1799), which included the phases of the moon and the days of the week and month. The backboard was lacquered black and fitted with a door for access to the movement.

MOVEMENT

Brass and iron, partly blued

Note: The number in parentheses represents the number of teeth on each wheel. These numbers are repeated again in the drawings of the movement.

The movement (fig. 8g) consists of two trains driven by mainsprings, each of which runs for about one week. The going train provides power for the hands which indicate the hours in roman numerals and the minutes in arabic numerals on the main dial. The clock strikes the hours and half hours on the same bell. Originally the clock had an additional train for a repeater; this part of the movement is missing.

The going train has one rotating barrel (84), which holds the mainspring and four pinion wheels (14/84–8/84–7/70–7/37), the last being for the escape wheel. The train is regulated by an anchor escapement (deadbeat escapement) in connection with a pendulum (originally the clock had a verge escapement). Originally the clock had a pendulum with a silk suspension; this has been replaced by a so-called Brocot suspension (after the famous Parisian horologist Achille Brocot [1817–1878] who invented it). This type of pendulum can be adjusted while the clock is running by using a key inserted in a hole in the dial at the number XII. When the key is turned the working length of the pendulum is changed. The third wheel holds the cannon pinion (36), a part of the motion work (36–36/7–84), and the minute hand. The hour wheel (84) holds the hour hand. The cannon pinion (36) rotates once every hour; it has two pins that release the striking train every half and full hour.

The striking train is to the left of the going train. This type of striking train has a locking plate (count wheel). This train has one rotating barrel (84), which holds the mainspring, four pinion wheels (14/72–8/60–6/60–6/48), and a fly vane (6). The second wheel (8/60) has ten pins that move the striking hammer.

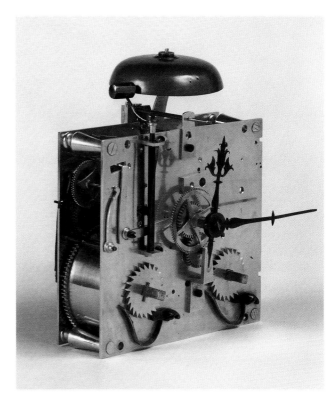

8G Three-quarter view of the movement.

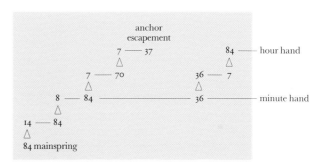

Going train

Striking train

EXHIBITIONS
Detroit Institute of Arts, 1972–1973.

PUBLICATIONS
E. Schlumberger, "Caffieri, le bronzier de Louis XV," *Connaissance des Arts* (May 1965), ill. p. 83; Wilson, *Decorative Arts* (1977), p. 31, no. 40; G. Mabille, *Le Style Louis XV* (Paris, 1978), p. 175; Sassoon and Wilson, *Decorative Arts: A Handbook*, pp. 38–39, no. 83; Ottomeyer and Pröschel, *Vergoldete Bronzen*, vol. 1, p. 111, fig. 2.3.4; Bremer David et al., *Decorative Arts*, p. 86, no. 133.

PROVENANCE
Baron Mayer Alphonse de Rothschild (1827–1905), Château de Ferrières, Tarn, France; Baron Edouard de Rothschild (1868–1949), Château de Ferrières; Baron Guy de Rothschild, Château de Ferrières. Sold, Sotheby's, London, November 24, 1972, lot 7. Purchased at that sale by J. Paul Getty.

NOTES

1. This attribution is given in the catalogue of the 1972 Sotheby's sale, and in subsequent publications. For biographies of Charles Cressent, see M.-J. Ballot, "Charles Cressent, Sculpteur, Ebéniste, Collectionneur," *Archives de l'art français, nouvelle période (1916–1918)*, vol. 10 (Paris, 1919), pp. 1–96; G. de Bellaigue, *The James A. de Rothschild Collection at Waddesdon Manor: Furniture, Clocks and Gilt Bronzes*, vol. 2 (London, 1974), pp. 868–869; and Pradère, *Les Ebénistes*, pp. 129–139.
2. M.-J. Ballot (note 1), p. 200, no. 25:
 > *Une magnifique pendule de bronze, dont la composition et du meilleur goût; il y a sur le haut un Amour qui est assis sur des nuages, il appuye son coude sur un sable. Au-dessous du cadron est la figure du Tems, tenans sa faulx, et posé sur le cahos du monde, les pieds sont formés par deux grands arbres, le tout parfaitement bien sizelé, doré d'or moulu; de quatre pieds trois pouces de haut.*

 See T. Dell, "The Gilt-bronze Cartel Clocks of Charles Cressent," *Burlington Magazine* (April 1967), pp. 210–217. In this article the model discussed is illustrated as fig. 34. Other examples of this model are at the Musée du Louvre, Paris (inv. OA 9586), and the Wallace Collection, London (inv. F92).
3. Dell (note 2), fig. 33. The example illustrated is in the William Rockhill Nelson Gallery, Kansas City. Another example is in the Rijksmuseum, Amsterdam. See Ballot (note 2), p. 202, no. 47:
 > *Une pendule à face de bronze, le corps de bois en marqueterie; sa composition représente un Tems volant, avec sa faulx, prêt à trancher le fil de la vie à un enfant qui est dans un rocher qui, en appercevant le Tems, abandonne son carquois et son arc; l'effroi qui paroît sur le visage de cet enfant fait un effet des plus singulier. Les ornemens qui renferment le cartel sont d'un goût tout extraordinaire à toutes les autres pendules, faites par les gens les plus expérimentés en cet art, pourquoi l'on peut se flatter de l'approbation des connoisseurs; elle porte trois pieds de haut et est dorée d'or moulu.*
4. See D. Nyberg, *Meissonnier, the Eighteenth-Century Maverick* (New York, 1969), folio 5; the house was designed for a "Sieur Brethous."
5. Ibid., folio 56.
6. Ibid., folio 55.
7. Ibid., folio 65. I am grateful to Theodore Dell for pointing out to me the relationship between these engravings by Huquier after Meissonnier and the Museum's clock.
8. Christie's, New York, November 20, 1982, lot 55. The clock previously had been sold at Christie's, London, July 17, 1886, lot 140. The sale catalogue stated that it was formerly in the Hôtel de Ville, Paris.

IX

Mantel Clock

French (Paris); circa 1742

Movement by Julien Le Roy (1686–1759; master 1713) (see Biog., p. 185); dial enameled by Antoine-Nicolas Martinière (1706–1784; master 1720) (see Biog., p. 190); maker of the case unknown

HEIGHT: 1 ft. 6 11/24 in. (47 cm)
WIDTH: 1 ft. ½ in. (32 cm)
DEPTH: 8⅛ in. (20.6 cm)

79.DB.4

DESCRIPTION

The gilt-bronze clock case is in the form of a palm tree growing from a rocky ground that is set with tufts of grass and small shrubs (fig. 9a). From the ground also emerges a single branch of laurel, the leaves and berries of which mingle with the palm leaves to the left and right of the dial. Above, the pelt of a lion is draped on a bifurcate scroll. The hinged and latched gilt-bronze back door is pierced with an oval of holes (fig. 9b).

MARKS

The dial is painted in black JULIEN·LE ROY·DE LA SOCIÉTÉ DES ARTS· The movement is engraved *Julien Le Roy Æparis* (fig. 9c). The back of the enamel dial is painted in black *a·n·martiniere 1742* (fig. 9d). The back of the dial plate is engraved with the graffiti of various repairers; these are mostly indecipherable with the exception of some of the names and dates, which may be read as follows: *P. Heller 1843*; *G. Paolini 28/10.1893*; *Jon (Shalberg) 3/72*; *A. Mazzenumy*; *W. Sutten*.

COMMENTARY

The enameler Antoine-Nicolas Martinière (1706–1784) became *Emailleur et Pensionnaire du Roi* in 1742 (see Martinière biography in this volume). As this title does not appear on the dial we may assume that it was enameled early in that year, before he received his position. As it is unlikely that the anonymous case-maker would have kept Le Roy movements in stock, it is almost certain that the case is of the same date as the dial. (For another dial signed by Martinière, see cat. no. 10.) The maker of the case remains unknown.[1]

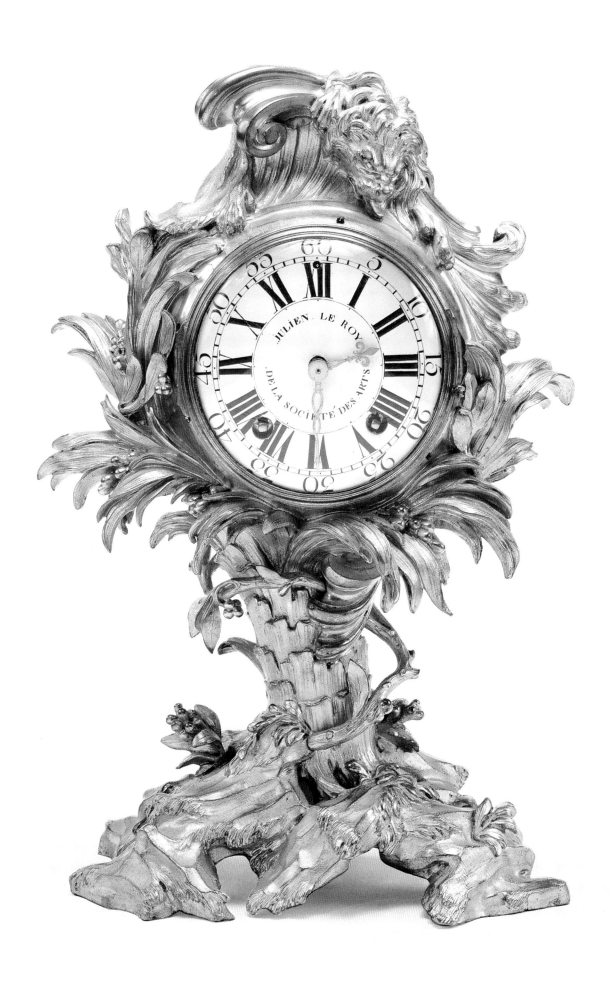

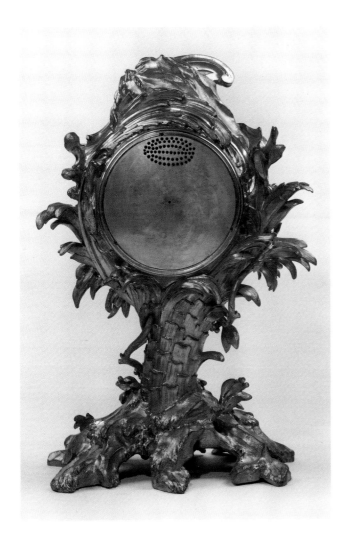

9A

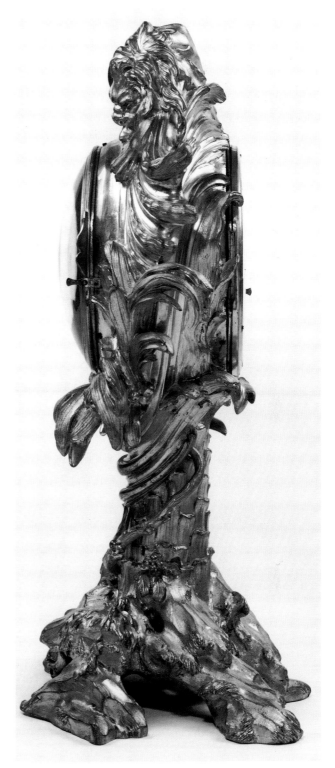

9B

MANTEL CLOCK 67

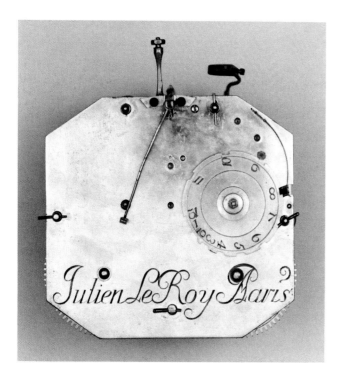

9C

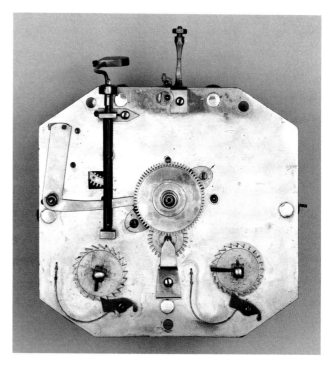

9E Front plate of the movement, showing the winding mechanism and the dial train.

9D The signature of Antoine-Nicolas Martinière on the back of the dial.

OTHER EXAMPLES

The model of this case is apparently unique; no others are known. It may be compared to a clock in the Schloss Nymphenburg, Munich, which, though of a more elaborate model with three musicians at its base, has a palm tree with a trunk of the same form and similarly modeled leaves.[2] The cases were probably made by the same unidentified maker.

MOVEMENT
Brass and iron, partly blued

Note: The number in parentheses represents the number of teeth on each wheel. These numbers are repeated again in the drawings of the movement.

The movement (figs. 9e and f) consists of two trains driven by mainsprings, each of which runs for one week. The going train provides power for the hands which indicate the hours in roman numerals and the minutes in arabic numerals on the main dial. The clock strikes the hours and half hours on one bell.

The going train has one rotating barrel (72), which holds the mainspring and four pinion wheels (12/80–?/?–6/70–6/33), the last being the escape wheel. The going train is regulated by a crown wheel (verge escapement) in connection with a pendulum. The pendulum can be adjusted while the clock is running using a key inserted in a hole in the dial at the number XII. When the key is turned a silk thread is wound around a square rod,

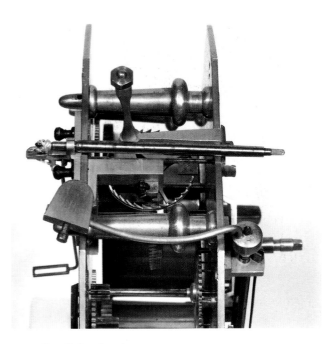

9F Detail showing the escapement.

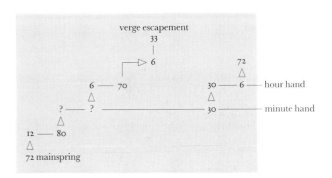

Going train

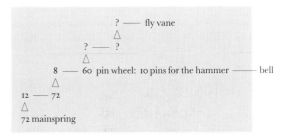

Striking train

changing the length of the pendulum. The arbor of the now-missing third wheel holds the cannon pinion (30), a part of the motion work (30–30/6–72), and the minute hand. The hour wheel (72) holds the hour hand. The cannon pinion (30) rotates once every hour; it has two pins that release the striking train every half and full hour.

The striking train is to the left of the going train. This type of striking train has a locking plate (count wheel). This train originally had one rotating barrel (72), which held the mainspring, three pinion wheels (12/72–8/60–?/?), and a fly vane (?). The last wheel and the fly vane are missing. The third wheel (8/60) has ten pins that move the striking hammer. The bell is not original.

EXHIBITIONS
French Clocks in North American Collections, The Frick Collection, New York, November 1982–January 1983.

PUBLICATIONS
G. Wilson, "Acquisitions made by the Department of Decorative Arts, 1977 to mid-1979," *GettyMusJ* 6/7 (1978–79), pp. 37–52, no.14; W. Edey, *French Clocks in North American Collections*, exh. cat. (New York, 1982), p. 58, no. 52 (ill. p. 13); Sassoon and Wilson, *Decorative Arts: A Handbook*, p. 39, no. 85; Bremer David et al., *Decorative Arts*, pp. 87–88, no. 135.

PROVENANCE
Jacques Kugel [dealer], Paris. Acquired by the J. Paul Getty Museum in 1979.

NOTES
1. In the 1979 catalogue the author tentatively attributed the case to Jean-Pierre Latz (see *GettyMusJ* 6/7 [1978–1979], pp. 50–51, no. 14, citing "un palmier en pendule" listed in the inventory of Latz's workshops drawn up in 1754 and 1756. That attribution is now discounted.
2. Inv. Res Mü U 75. The clock contains a movement by Gudin and dates to about 1745.

X

Clock for a Corner Cupboard

French (Paris); circa 1744

Movement by Etienne II Le Noir (1699–1778; master 1717) (see Biog., p. 177); dial enameled by Antoine-Nicolas Martinière (1706–1784; master 1720) (see Biog., p. 190); design attributed to Nicolas Pineau (1684–1754); maker of the gilt-bronze case unknown

HEIGHT: 2 ft. 2½ in. (67.4 cm)
WIDTH: 2 ft. 8½ in. (82.5 cm)
DEPTH: 9½ in. (24.2 cm)

79.DA.66

DESCRIPTION

A female figure, probably representing Astronomy, is seated on a cloud at the top of the clock (fig. 10a).[1] She holds a globe in her left hand and carries a torch (the flame of which is missing) in her right. Her head is encircled with stars, and a sunburst is placed on her chest. In front of her stands an eagle whose head is turned in her direction, away from the viewer. The dial is surrounded by a flame motif, which is contained by large S-scrolls that continue down the sides of the clock to join the widely splayed and scrolled legs. The feet are overlaid with acanthus leaves, which rise and mingle with a garland of flowers to either side of the clock. Beneath the dial a broad flame motif depends from addorsed leafy C-scrolls.

The gilt-bronze case is in the form of a façade. It has no back and only two legs (fig. 10b) and is supported by an S-shaped iron bar. This bar is attached to the case below the dial and to the top of the corner cupboard by means of an L-shaped iron plate to which it is bolted. The two feet of the case are attached to iron plates that are screwed to the top of the corner cupboard.

The major part of the clock is cast in two pieces: the figure above, including the cloud on which it sits, the eagle, and the globe; and the rest of the case below. The two floral swags to either side of the dial are cast as separate pieces. The windswept section of the figure's cloak and the right-hand palm branch are brazed into place.

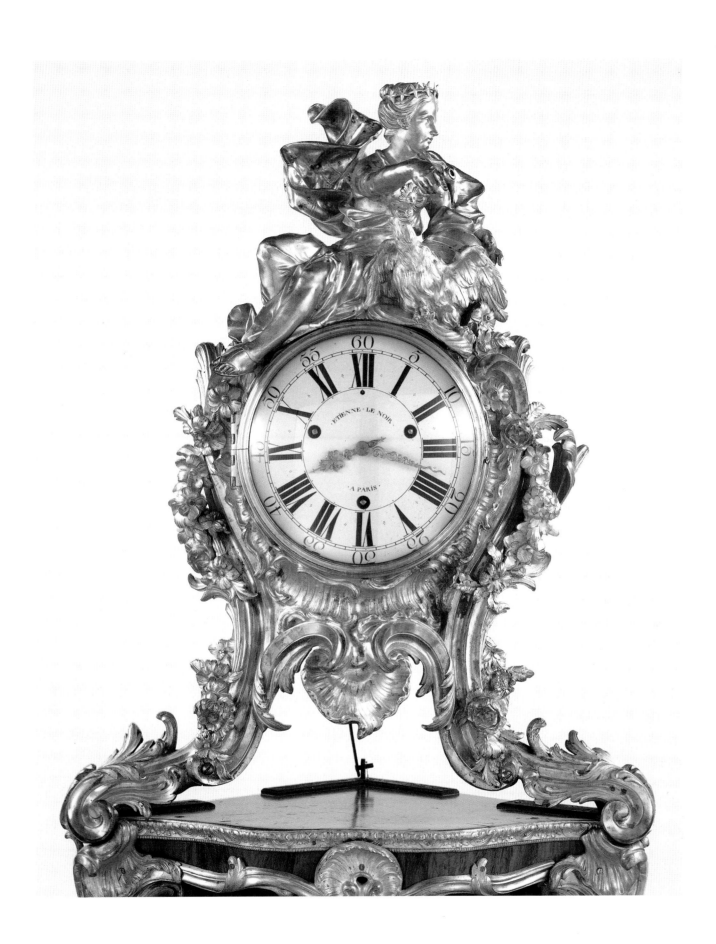

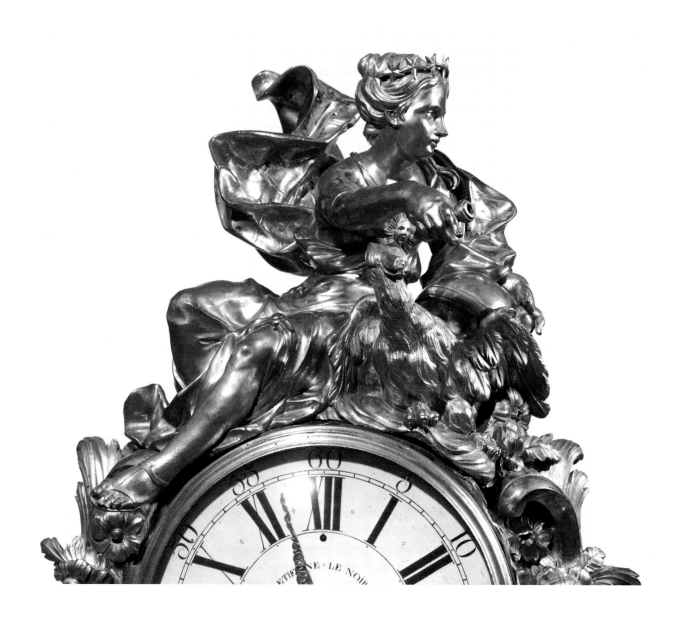

10D The signature of Antoine-Nicolas Martinière on the back of the dial.

10E The spring of the striking train, signed *Buzot aout 1744*

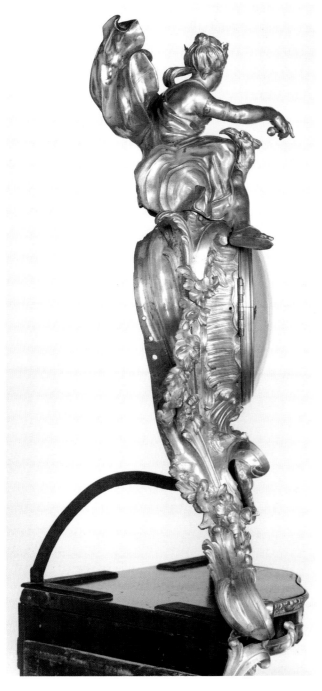

10B

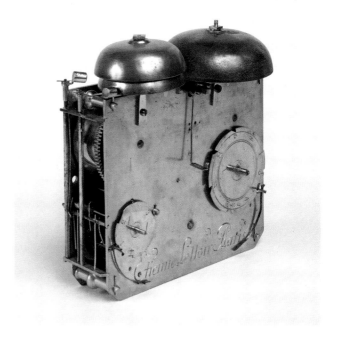

10C

MARKS

The dial is signed · ETIENNE · LE · NOIR · A PARIS · The back plate of the movement is inscribed *Etienne LeNoir AParis* (fig. 10c). The back of the dial is signed *a· n· martiniere, 1744·-7· bre* (fig. 10d). The spring of the striking train is signed *Buzot aout 1744* (see Biog., p. 167) (fig. 10e). Graffiti on the front plate read *RK. 1788 ie 28 Aprilis Kurkhausy*, and on the dial plate, *metez / cinq / pieds / gros / troux / Etienne Le . . . / A . . . S/17/77*.

COMMENTARY

The corner cupboard to which the clock is fixed is stamped I. DUBOIS for Jacques Dubois (1694–1763; master 1742) (fig. 10f).[2] The cupboard, in its basic design, follows a drawing made by the *ornemaniste* Nicolas Pineau some twenty years earlier.[3] The clock, however, is completely different from that drawn by Pineau.

The case may have been cast from Dubois's own model. He, like a number of the more prominent cabinetmakers of the mid-eighteenth century, retained his own models. In an inventory drawn up at his death in 1763, a large number of mounts are listed: "432 livres pesant de modèles de bronze, prisés 1080 l[ivres]" and "228 livres pesant de fontes brûtes."[4] Alexandre Pradère suggests that this indicates that Dubois was anxious to protect the exclusivity of his bronze models and thus stocked quantities of unchased mounts for use on his furniture and for supplying to chasers and gilders. The constant use of his own models would perhaps preclude the manufacture of the clock case by an outside craftsman.

CLOCK FOR A CORNER CUPBOARD 73

10F Corner cupboard made by Jacques Dubois (1694–1763; master 1742) for Count Jan Clemens Branicki between 1744 and 1753.

10G Nicolas Pineau, drawing for a corner cupboard, circa 1730 (Paris, Musée des Arts Décoratifs, inv. 4504).

It is possible that Nicolas Pineau may have been involved in the design of the case, updating that shown on his original drawing (fig. 10g). It has been suggested that he was involved in the commission of this corner cupboard for Jan Clemens Branicki, whom he may have met during his long sojourn in Russia.[5] In this case he would have been concerned with both the cupboard's manufacture and its design. The cupboard still retains the mounts of babies on lions shown in his drawing; and it seems likely that Pineau may have provided Dubois with detailed drawings for those mounts.

The clock case can be dated to around 1744, the year that the dial was enameled by Martinière. The dial is of exceptionally large size (diameter: 9¾ in. [24.8 cm]) and was obviously designed specifically for the case.

OTHER EXAMPLES

The clock case is apparently of unique form and decoration.

MOVEMENT

Brass and iron, partly blued

Note: The number in parentheses represents the number of teeth on each wheel. These numbers are repeated again in the drawings of the movement.

The movement (fig. 10h) consists of three trains driven by mainsprings, each of which runs for one week.

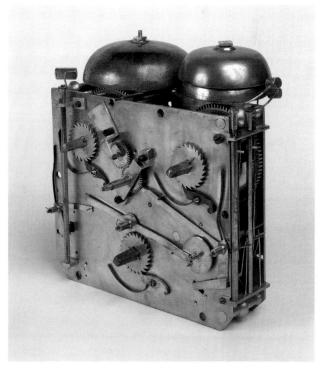

10H Three-quarter view of the movement.

CLOCK FOR A CORNER CUPBOARD 75

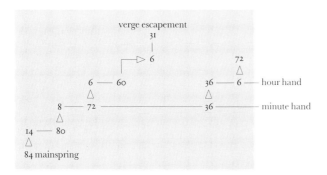

Going train

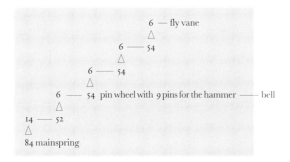

Striking train for the hours

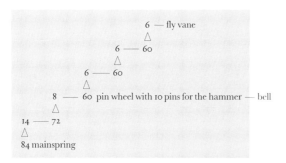

Striking train for the quarters of an hour

The going train provides power for the hands which indicate the hours in roman numerals and the minutes in arabic numerals on the main dial. The clock strikes the hours on the largest bell and the quarter hours on two smaller bells.

The going train has one rotating barrel (84), which holds the mainspring and four pinion wheels (14/80–8/72–6/60–6/31), the last being the escape wheel. This train is regulated by a crown wheel (verge escapement) in connection with a pendulum. The pendulum can be adjusted while the clock is running by lifting or lowering its spring suspension. The arbor of the third wheel holds the cannon pinion (36), a part of the motion work (36–36/7–84), and the minute hand. The hour wheel (84) holds the hour hand. The cannon pinion (36) rotates once every hour; it has four pins that release the striking trains every quarter of an hour.

This clock has two striking trains. To the right of the going train is the striking train for the quarter hours. To the left of the going train is the striking train for the hours. They are both arranged upside down. Both striking trains use locking plates (count wheels). The striking train for the quarter hours has a rotating barrel (84), which holds the mainspring, four pinion wheels (14/72–8/60–6/60–6/60), and a fly vane (6). The third wheel (8/60) has ten pins (six on one side and four on the other) that move the striking hammer. Every full hour the locking plate of this train releases the striking train for the hours. This train also has a rotating barrel (84), which holds the mainspring, four pinion wheels (14/52–6/54–6/54–6/54), and a fly vane (6). The third wheel (6/54) has nine pins that move the striking hammer.

PUBLICATIONS

E. Molinier, *Le Mobilier au XVIIe et au XVIIIe siècle* (Paris, 1896), pp. 146–147, pl. XIII; R. Schmidt, *Möbel* (Berlin, 1920), p. 169, ill.; A. Feulner, *Kunstgeschichte des Möbels* (Berlin, 1926), pp. 321, 445, ill.; F. de Salverte, *Les Ebénistes du XVIIIe siècle* (Paris, 1927), pp. 104–105, pl. XVIII; A. Feulner, *Kunstgeschichte des Möbels seit dem Altertum* (Berlin, 1927), pp. 330–331 (Pineau's design illustrated on p. 321); C. Packer, *Paris Furniture* (Newport, Monmouthshire, 1956), p. 34, fig. 40; F. J. B. Watson, *Wallace Collection Catalogues, Furniture* (London, 1956), p. 69; A. Boutemy, "Des Meubles Louis XV à grands succes: les encoignures," *Connaissance des Arts* 91 (September 1959), pp. 36, 41, ill.; J. Meuvret, *Les Ebénistes du XVIIIe siècle français* (Paris, 1963), pp. 100–101, ill.; P. Verlet, *French Cabinetmakers of the Eighteenth Century* (Paris, 1963), p. 102; F. J. B. Watson, *The Wrightsman Collection* (New York, 1966), vol. 1, p. 231; vol. 2, p. 54; A. Gonzales-Palacios, *Gli Ebanisti del Luigi XV* (Milan, 1966), p. 67; C. Frégnac, *Les*

Styles français (Paris, 1975), pl. 2; P. Kjellberg, *Le Mobilier français du moyen age à Louis XV* (Paris, 1978), pp. 192–193, no. 217; P. Kjellberg, "Jacques Dubois," *Connaissance des Arts* (December 1979), p. 115, ill.; G. Wilson, "Acquisitions Made by the Department of Decorative Arts, 1979 to mid-1980," *GettyMusJ* 8 (1980), pp. 1–3, ill.; G. Wilson, *Selections from Decorative Arts in the J. Paul Getty Museum* (Malibu, 1983), pp. 42–43, no. 21, ill.; P. Hunter-Stiebel, "Exalted Hardware, the Bronze Mounts of French Furniture, Part I," *Antiques* (January 1985), p. 236, ill.; Sassoon and Wilson, *Decorative Arts: A Handbook*, p. 17, no. 38, ill.; P. Kjellberg, *Le Mobilier français du XVIIIe siècle: Dictionnaire des ébénistes et des menuisiers* (Paris, 1989), pp. 267, 273, 275, ill.; Pradère, *Les Ebénistes*, p. 173, figs. 153, 154; G. Wilson, "Dalla Raccolta del Museo J. Paul Getty," *Casa Vogue Antiques* 8 (May 1990), pp. 114–119, ill.; S. Boiron, "Jacques Dubois, Maître du Style Louis XV," *L'Objet d'Art* 237 (June 1990), pp. 42–59, ill.; Bremer David et al., *Decorative Arts*, pp. 31–32, no. 35, ill.

PROVENANCE

Count Jan Clemens Branicki, Warsaw, Poland (ordered by General Mokronowski through Monsieur Lullier of Warsaw circa 1744); probably inherited by Branicki's sister Christine; by descent to Marianna Szymanowska (née Potocka), Christine Branicka's granddaughter, 1820s. Baron Nathaniel de Rothschild, Vienna, before 1903. Baron Alphonse de Rothschild, Vienna. Baroness Clarice de Rothschild, Vienna and New York, 1942. Rosenberg and Stiebel [dealers], New York, 1940s (?). Georges Wildenstein, [dealer], New York. Bought for $75,000, 1940s by Daniel or Georges Wildenstein, New York. Akram Ojjeh, Paris, 1978. Sold, Sotheby's, Monaco, June 25–26, 1979, lot 60. Acquired by the J. Paul Getty Museum in 1979.

NOTES

1. According to J. B. Boudard, *Iconologie tirée de Divers Auteurs* (Vienna 1766), p. 47, Urania, the Muse of Astrology, is represented with seven stars encircling her head, measuring a point on a celestial globe with a pair of compasses. The inclusion of an eagle in such a representation is not known elsewhere. The eagle is the heraldic symbol of Poland, and if this piece was indeed made to the specifications of a Polish client, it may have been included for that reason.
2. For information on Jacques Dubois, see Pradère, *Les Ebénistes*, pp. 168–175.
3. The drawing is in the Musée des Arts Décoratifs, Paris (inv. 4869). See G. Wilson, "Acquisitions made by the Department of Decorative Arts, 1979 to mid-1980," *Getty MusJ* 8 (1980), p. 3, fig. 3. There is also an engraving by Pierre Mariette after Pineau. Since Mariette ceased being involved with engravings in 1734, this plate must have been issued before that year. See Pradère, *Les Ebénistes*, p. 172.
4. Pradère, *Les Ebénistes*, p. 170.
5. At this date Poland was more or less a protectorate of Russia.

XI

Clock for a *Cartonnier*

French (Paris); 1746

Movement by Etienne (II) Le Noir (1699–1778; master 1717) (see Biog., p. 177); dial enameled by Jacques Decla (active circa 1742–1764) (see Biog., p. 168); maker of case unknown

HEIGHT: 1 ft. 5 ½ in. (44.5 cm)
WIDTH: 1 ft. 11 ¼ in. (59 cm)
DEPTH: 7 ¾ in. (19.5 cm)

83.DA.280

DESCRIPTION

The clock case is veneered with alder which has been painted with black European *vernis* (lacquer). The *vernis* is decorated with scattered flower heads and branches of flowers and leaves all in gold. Painted bronze figures of a Chinese woman with a tambourine and a man with a horn (fig. 11a) are seated on the broad shoulders of the case, while two painted bronze children are seated above (fig. 11b). All are dressed in black robes lined with red.

The scrolling symmetrical mounts, which surround the dial and the aperture below and outline the profiles of the clock, are set with laurel, berries, and garlands of flowers.

The carcase is of white oak which has been blackened. The concave back is set with a hinged and latched door (fig. 11d).

MARKS

The dial is enameled ETIENNE LE NOIR A PARIS. The movement is engraved *Etienne Le Noir Æparis* (fig. 11e). The spring of the striking train is inscribed *Buzot 9BRE 1746* (fig. 11f) (see Biog., p. 167) and that of the going train *Richard Mai 1752* (see Biog., p. 193). The dial plate has graffiti on both sides: the front is inscribed *Edmond de Rotchild* [sic] and the back, *Wilson/Dec 30 1839/Jwb Oct 82*. There are repair marks on the front plate, *M. Journe/Le 13 Nov 1971/a Paris/F P JOURNE DEC 1976/A Paris/Le 23 juin 1777/B*. The bell, which is of nineteenth-century date, is inscribed in ink *Le[?] Dreves/[P]aris*. The dial is signed in black on its reverse · *decla* · *1746* (fig. 11g). Some of the gilt-bronze mounts are struck with crowned C's.

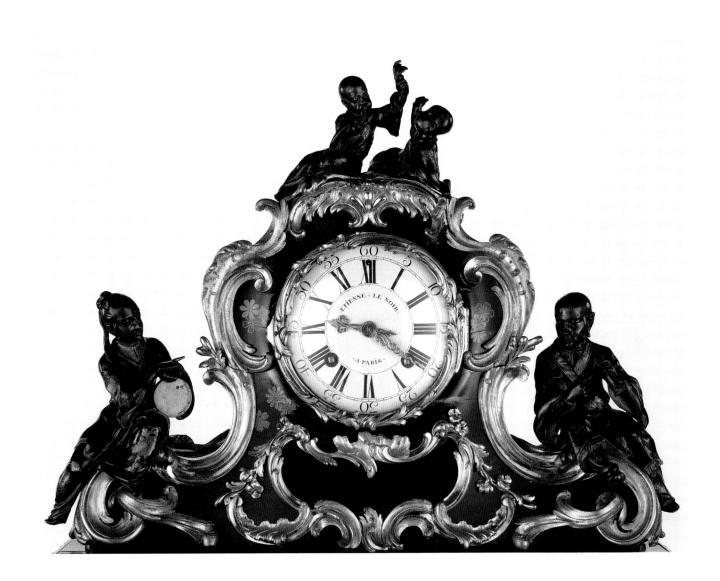

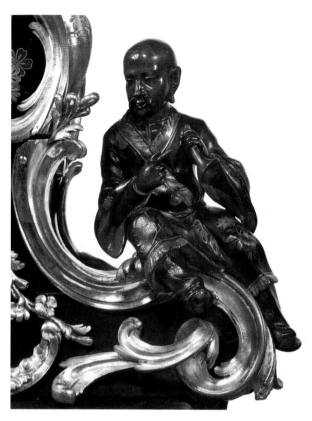

11A

11C

CONDITION

The top of the clock was once set with a gilt-bronze palm tree. It can be seen in the photograph of the *cartonnier* in a Christie's sale catalogue of 1922.[1]

COMMENTARY

It is apparent that the clock was not made by Bernard (II) van Risenburgh whose stamp appears on the *cartonnier* (fig. 11h). The mounts of the clock bear no similarity in any respect to those on the *cartonnier* and the lacquer, consisting of simple motifs, painted flat without raised gesso, would seem to be by a different hand than that of the *vernisseur* who worked on the *cartonnier*.

It is possible that the *cartonnier* was commissioned by Thomas-Joachim Hébert, the *marchand-mercier* for whom van Risenburgh worked. Van Risenburgh seems to have made very few clock cases and none are known that bear his stamp.[2] However, if Hébert had commissioned another maker to furnish him with the clock case, it would presumably have been set with mounts of a similar model and lacquered by the same *vernisseur* who worked on the *cartonnier*.

The clock is not fixed to the *cartonnier* and the surface on which it rests is entirely covered with black *vernis* which shows no signs of any previous attachment.[3] The back of the clock is concave, and this peculiarity seems to emphasize the fact that the clock was not made for the *cartonnier*.[4]

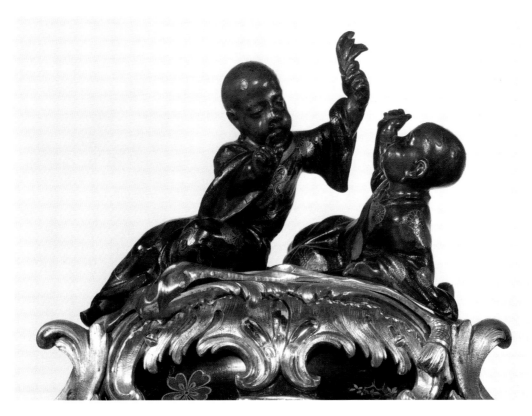

11B

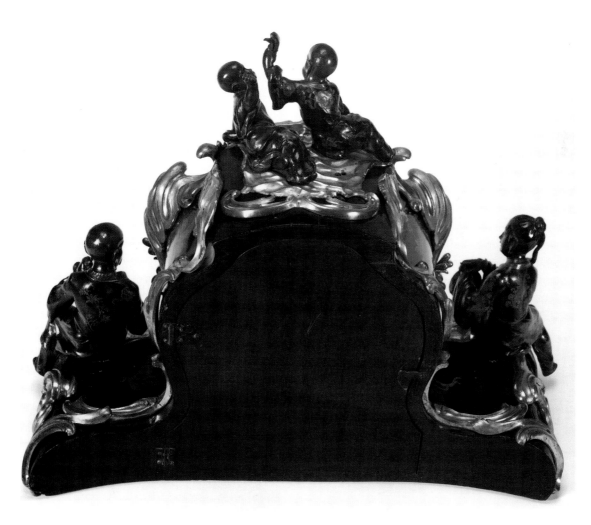

11D

CLOCK FOR A *CARTONNIER* 81

11E

11G The signature of Decla on the back of the dial.

11F The spring of the striking train, signed *Buzot 9 BRE 1746*

It is merely a happy assemblage, the date of which is not known. The name of the maker of the clock case is unknown.

Chinese figures similar to the four on this clock are found, variously clothed and posed, on clocks and candelabra that date from the mid-eighteenth century. Pierre Verlet, discussing a similarly mounted clock in the Residenzmuseum, Munich, suggests that such work was a specialty of the Martin brothers,[5] who probably invented the figures and had a near monopoly on their supply to the *marchands-merciers*.[6]

OTHER EXAMPLES

A table with a *cartonnier* is described as being in the *Petit Cabinet* of the duc de Bourbon in the 1740 inventory of the Château de Chantilly. The clock on this *cartonnier* bore "pagodes" in *vernis* and may well have resembled the clock under discussion.[7] The clock case appears to be of unique form and decoration.

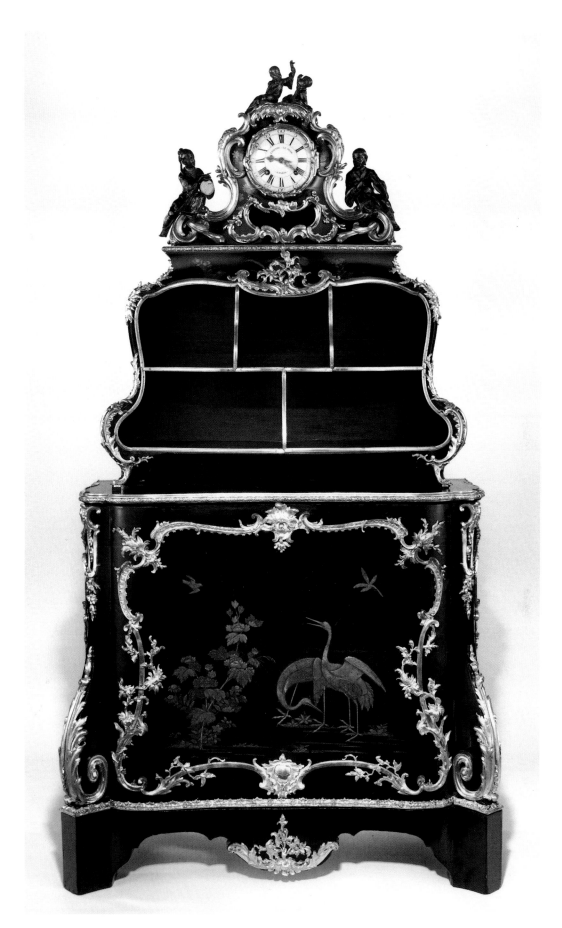

11H *Cartonnier,* circa 1745, by Bernard (II) van Risenburgh (after 1696–circa 1766; master before 1730).

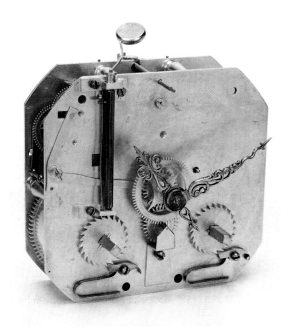

11I Three-quarter view of the movement.

11J Detail showing the escapement.

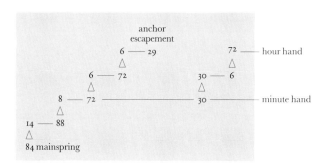

Going train

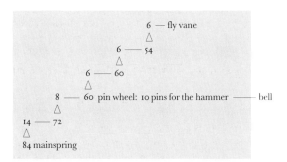

Striking train

MOVEMENT
Brass and iron, partly blued

Note: The number in parentheses represents the number of teeth on each wheel. These numbers are repeated again in the drawings of the movement.

The movement (figs. 11i and j) consists of two trains driven by mainsprings, each of which runs for about two weeks. The going train provides power for the hands which indicate the hours in roman numerals and the minutes in arabic numerals on the main dial. The clock strikes the hours and half hours on the same bell.

The going train has one rotating barrel (84), which holds the mainspring and four pinion wheels (14/88–8/72–6/72–6/29), the last being the escape wheel. The train is regulated by an anchor escapement (recoil escapement) in connection with a pendulum. Originally the clock probably had a silk suspension. This has been replaced by a Brocot suspension, which can be adjusted while the clock is running using a key inserted in a hole in the dial at the number XII. When the key is turned the working length of the pendulum is changed. The arbor of the now-missing third wheel held the cannon pinion (30), a part of the motion work (30–30/6–72), and the minute hand. The hour wheel (72) holds the hour hand. The cannon pinion (30) rotates once every hour; it has two pins that release the striking train every half and full hour.

The striking train is to the left of the going train. This type of striking train has a locking plate (count wheel).

This train has one rotating barrel (84), which holds the mainspring, four pinion wheels (14/72–8/60–6/60–6/54), and a fly vane (6). The third wheel (8/60) has ten pins that move the striking hammer. The bell and the cock that holds the bell in position are later replacements.

PUBLICATIONS

A. Sassoon, "*Cartonnier* and *Serre-Papier* with Clock," *GettyMusJ* 12 (1984), pp. 193–197, ill.; "Acquisitions/ 1983," *GettyMusJ* 12 (1984), pp. 263–264, ill.; Sassoon and Wilson, *Decorative Arts: A Handbook*, p. 5, no. 10, ill.; J.-D. Augarde, "1749 Joseph Baumhauer, ébéniste privilegié du roi," *L'Estampille* (June 1987), p. 25, no. 204; Pradère, *Les Ebénistes*, p. 196, fig. 188; Bremer David et al., *Decorative Arts*, pp. 17–18, no. 10.

PROVENANCE

(?) Harriot Mellon, widow of Thomas Coutts, later Duchess of St. Albans; her step-granddaughter, Angela, Baroness Burdett-Coutts, London (probably given to her in 1835 on her twenty-first birthday); by descent to her husband, William Ashmead Bartlett-Burdett-Coutts, M.P., 1906. Sold, Christie's, London, May 9, 1922, lot 144, to H. and J. Simmons [dealers]. Alexandrine de Rothschild, Paris. Confiscated by the Germans during the occupation of Paris in 1940. Baron Edmond de Rothschild, Paris, 1972. José and Vera Espirito Santo, Lausanne, Switzerland, after 1972. Acquired by the J. Paul Getty Museum in 1983.

NOTES

1. Sale cat., collection of the late Baroness Burdett-Coutts, Christie's, London, May 4–5 and 8–12, 1922, lot 144 (May 9).
2. However, in the list of works sold by Bernard (II) van Risenburgh to his son Bernard (III) on October 18, 1764, mention is made of "deux bâtis de pendule à serre-papiers garnis de bronzes" (see Pradère, *Les Ebénistes*, p. 199). These are the only clocks listed among the thirty-seven pieces of *ébénisterie*.
3. It should be noted, however, that clocks are rarely found attached to *cartonniers*.
4. Another clock, of similar but larger form, with a concave back, was on the Paris market in 1991. Neither the case nor the movement bore a maker's mark or signature. It is possible that this concavity provided manual access to the movement.
5. The first generation of the Martin family consisted of the brothers Robert (died 1765), Guillaume (died 1749), Julien (died 1752), and Etienne-Simon (died 1770). In 1730 Guillaume and Etienne-Simon acquired a royal patent to protect the lacquer (*vernis*) that they had invented and in 1744 received a further patent for their lacquer work "en relief dans le goût du Japon et de la Chine." By 1748 they had opened their Manufacture Royale de vernis de la Chine.

 The second generation of the family were Guillaume-Jean (born 1713), Etienne-François (died 1771), Jean-Alexandre (1748–1825), and Antoine-Nicolas (born 1742). Jean-Alexandre was the last member of the family to be engaged in the trade. See H. Huth, *Lacquer of the West* (Chicago, 1971), pp. 95–98.
6. Verlet, *Les Bronzes*, p. 21, fig. 7. On page 180, while discussing the Martin brothers, Verlet records that the 1768 Gaignat sale contained:

 No. 188: Une très belle et grand pendule . . . (au nom de Pierre Le Roy) . . . Elle est ornée de plusieurs figures de cuivre représentant des magots vernis par Martin, imitant le laque; ils sont richement habillés et ouvrages de divers ors, sur une terrasse dont partie en roche et partie dorée et décorée de feuillages et de fleurs de Vincennes

 No. 189: Une paire de bras de cheminée à trois branches, d'un beau modèle bein ciselé et doré. Dans chaque bras est une figure de magot, vernie en laque et richement habillée dans le goût du Japon, par Martin.
7. A.N., XCII, 504: "Un bureau a Ecrire de Verny aussi Japon a pieds de biches orné de bronze doré d'or moulu et son dessus de velours vert avec son serre-papiers aussy de verny du Japon et une pendulle dessus faite par Jullien Le Roy à Paris dans sa boête à Pagodes de verny le tout orné de bronze doré d'or moulu prisés ensemble mil livres, cy . . . 1000 livres." I am grateful to Jean-Dominique Augarde for pointing this out to me.

XII

Wall Clock

French (Paris); circa 1747

Movement by Julien Le Roy (1686–1759; master 1713) (see Biog., p. 185); case by Jacques Caffieri (1678–1755; master 1714)

HEIGHT: 2 ft. 6 ½ in. (77.5 cm)
WIDTH: 1 ft. 4 in. (40.6 cm)
DEPTH: 4 ½ in. (11.4 cm)

72.DB.45

DESCRIPTION

The wall clock is of asymmetrical form and made entirely of gilt bronze. A helmeted figure of Minerva is seated above on a cloud (fig. 12a). On the left, below a hipped scroll set with an oak branch with acorns, is a winged putto who points to the dial (fig. 12b). The remaining area of the case is composed of scrolls, palm and laurel leaves, and flowers.

The back of the clock is formed of a sheet of brass conforming in shape to the case. It is hinged on the left and fastened to the right with a latch. There is no wooden carcase.

CONDITION

Minerva once held a shield, supported by her left arm. It is probable that the putto once held a scythe in his left hand. The aperture below the dial, now closed by a plate of modern glass, was possibly originally fitted with a gilt-brass grill.

MARKS

The clock face is signed ·JULIEN · LE · ROY· and the movement engraved ·*Julien Le Roy AParis* (fig. 12c). The case is signed, in the cartouche below the dial, *fait par Caffiery* (fig. 12d). The case is also struck with a large crowned C on the brass back plate and on the upper left surface of the scroll on which Minerva sits, while Minerva herself is struck with a small crowned C on her back.[1] The back of the dial is inscribed *a·n· martiniere Pr*[ivilig]*é Du R*[oy] *1747* (fig. 12e) (see Biog., p. 190). The graffiti on the front of the dial plate is difficult to read but may be interpreted as *Biwentt / Dublin*; that on the back seems to read *Lot Leitunn / Dan Hompuoni*, and, in another hand, *12, 7, 87, FZ / 12, 11, 89, IZ*.

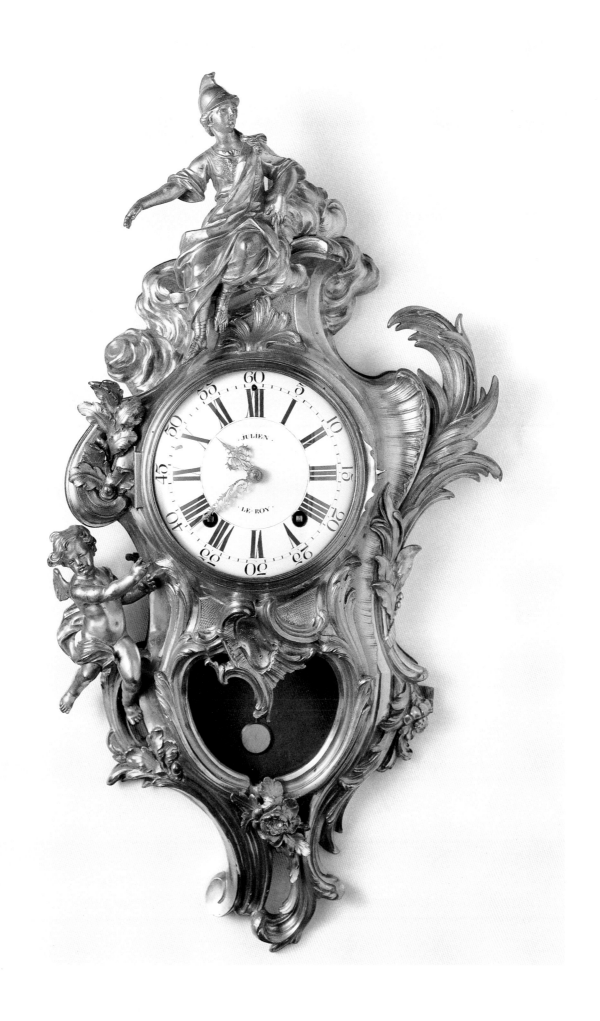

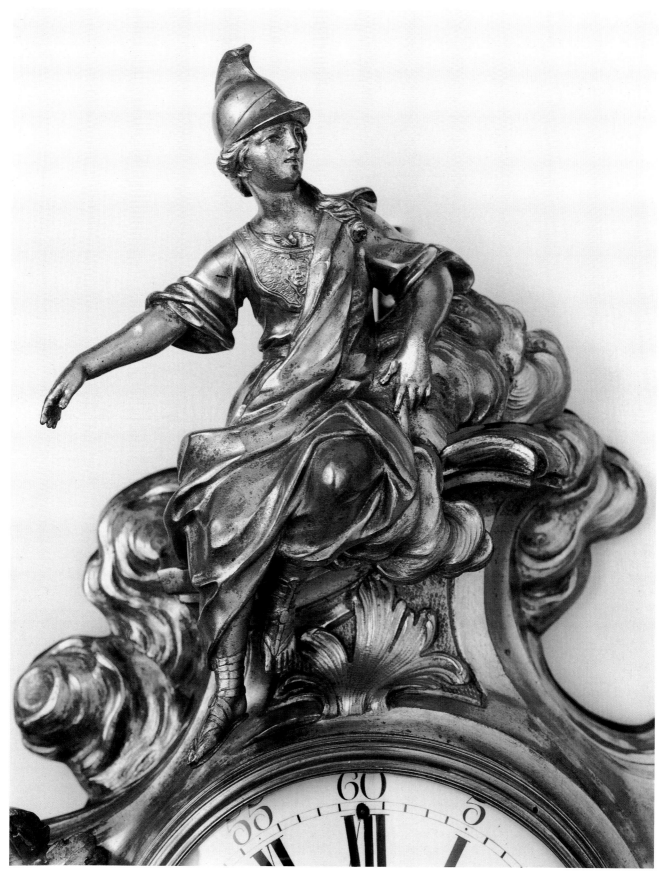

12A

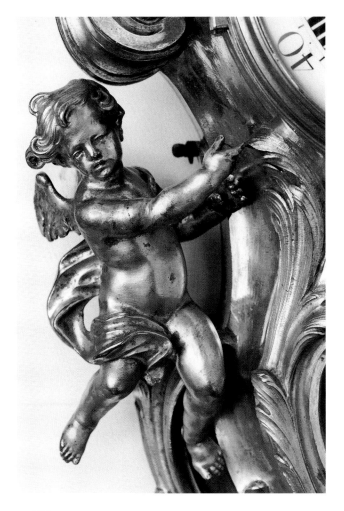

12B

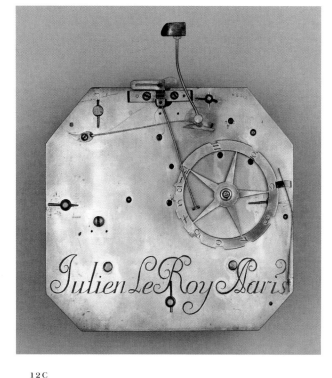

12C

COMMENTARY

Even though a first name does not accompany the signature of Caffieri on the case, it is certain that it was made by the famous *ciseleur* Jacques Caffieri.[2] In 1747 his son Philippe entered into partnership with his father. At that time, a detailed inventory was made of Jacques Caffieri's models for wall lights, firedogs, candlesticks, clocks, etc. Among the clocks, a model for a cartel is described as bearing a figure of Minerva on the cresting with, lower down on one side, a figure of Cupid holding a scythe. At Jacques Caffieri's death in 1755 another, less detailed, inventory was drawn up, and the same model appears again, showing that clocks of this model were probably still being produced. The presence of the crowned C places the construction of this clock between 1745 and 1749, furthermore the signature of the enameler Martinière is followed by the year 1747. Thus the case was made in the first year of the partnership of father and son.

The signature below the dial has been engraved somewhat carelessly in comparison with the high quality of the work elsewhere on the case, and it does not fit the cartouche happily. However, this is not unusual on Caffieri's signed works. As Geoffrey de Bellaigue points out, the same carelessness may be seen in the signature on one of the mounts of the commode made by Antoine Gaudreau for Louis XV's bedroom at Versailles and on one of the chandeliers dated 1751, both in the Wallace Collection.[3]

OTHER EXAMPLES

An identical clock hangs in the Chambre de Commerce at Bordeaux.[4] Another was sold at the Hôtel Drouot in Paris, on December 15, 1924, lot 278. The movement of the latter was by Julien Le Roy, and the case was signed "Caffieri à Paris." This clock was sold again at the Galerie Charpentier from the collection of "Monsieur F..." on November 26, 1935, lot 35. In this example, Minerva still retained her shield.

A third example, the main body in patinated bronze, is in a New York private collection.[5] Its dial is signed "Julien Le Roy." The figure of Minerva, Cupid, an oak branch, and the palm branch are all gilt, and Minerva has a plume in her helmet and has lost her shield. The

12D

12E The signature of Antoine-Nicolas Martinière on the back of the dial.

grill for the aperture below the dial is missing, and the case is signed in the cartouche below the dial: "Caffieri fecit." Another clock of precisely the same form as the Museum's example, also with a movement by Julien Le Roy and a case inscribed "FAIT PAR CAFFIERI A PARIS" and struck with a crowned C, was sold from the collection of Ricardo Espirito Santo at the Pavillon Gabriel, Paris, on June 14, 1977, lot 84.

Another, also with a movement by Julien Le Roy, the case unsigned, was sold from an Aberdeenshire collection at Christie's, London, April 12, 1984, lot 46. The entry in the sale catalogue does not give the clock a date. A late nineteenth-century copy of the model was sold at auction in 1990.[6] The entire composition was reversed and the figure of Minerva was replaced by that of a seated Roman warrior.

MOVEMENT
Brass and iron, partly blued

Note: The number in parentheses represents the number of teeth on each wheel. These numbers are repeated again in the drawings of the movement.

The movement (fig. 12f) consists of two trains driven by mainsprings, each of which runs for about two weeks. The going train provides power for the hands which indicate the hours in roman numerals and the minutes in arabic numerals on the main dial. The clock strikes the hours and half hours on the same bell. The hands are not original.

The going train has one rotating barrel (72), which holds the mainspring and four pinion wheels (10/70–10/76–7/76–7/30), the last one being the escape wheel. The train is regulated by an anchor escapement (recoil escapement) in connection with a pendulum. The pendulum can be adjusted while the clock is running using a key inserted in a hole in the dial at number XII. When the key is turned the working length of the pendulum is changed. The third wheel holds the cannon pinion (32), a part of the motion work (32–32/6–72), and the minute hand. The hour wheel (72) holds the hour hand. The cannon pinion (32) rotates once every hour; it has two pins that release the striking train every half and full hour.

The striking train is to the left of the going train. This type of striking train has a locking plate (count wheel). This train has one rotating barrel (84), which holds the mainspring, four pinion wheels (12/72–8/60–6/60–6/48), and a fly vane (6). The third wheel (8/60) has ten pins that move the striking hammer. An unusual feature of this clock is the hole in the dial at the number X, which allows access to a lever that releases the striking train.

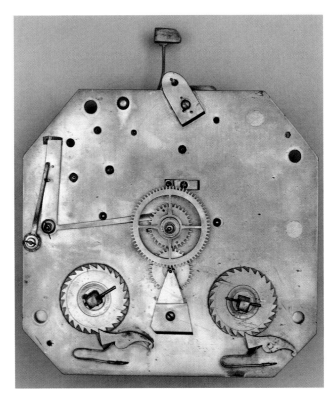

12F The movement.

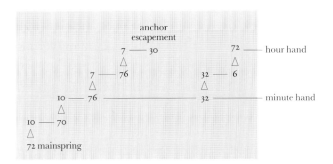

Going train

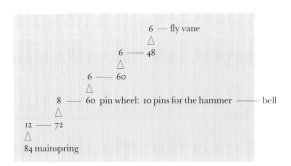

Striking train

EXHIBITIONS

Detroit Institute of Arts, 1972–1973.

PUBLICATIONS

A. Smith, ed., *The Country Life International Dictionary of Clocks* (London, 1979), p. 237, fig. 2; Ottomeyer and Pröschel, *Vergoldete Bronzen*, vol. 1, p. 114, fig. 2.5.2; Sassoon and Wilson, *Decorative Arts: A Handbook*, p. 40, no. 87; Bremer David et al., *Decorative Arts*, no. 137, p. 88, ill.

PROVENANCE

Sold anonymously at Christie's, London, July 15, 1971, lot 21. French and Company, New York. Purchased by J. Paul Getty in 1972.

NOTES

1. For information on the crowned C, see cat. no. 13, note 3.
2. For a biography of Jacques Caffieri, see G. de Bellaigue, *The James A. de Rothschild Collection at Waddesdon Manor: Furniture, Clocks and Gilt Bronzes* (London, 1974), vol. 1, pp. 81–82; vol. 2, pp. 848–850.
3. Ibid., vol. 1, pp. 81–82. For the commode and the chandelier, see F. J. B. Watson, *The Wallace Collection Catalogues, Furniture* (London, 1956), pp. 48–51, pl. 37, no. F83 (chandelier); pp. 53–55, pls. 40, 41, no. F86 (commode).
4. See P. Verlet, *La Maison du XVIIIe siècle en France* (Paris, 1966), p. 40, fig. 24. It is impossible to tell from the photograph whether or not Minerva still possesses her shield and Cupid his scythe, or to distinguish the name on the face of the clock.
5. W. Edey, *French Clocks in North American Collections* (The Frick Collection, 1982), p. 59, no. 54 (not illustrated).
6. Christie's, London, November 29, 1990, lot 106.

XIII

Planisphere

French (Paris); circa 1745–1749

Movement (now missing) by Alexandre Fortier (circa 1700–1770) (see Biog., p. 171); case attributed to Jean-Pierre Latz (circa 1691–1754)

HEIGHT: 9 ft. 3 in. (282 cm)
WIDTH: 3 ft. 1 in. (94 cm)
DEPTH: 1 ft. 3 in. (38.1 cm)

74.DB.2

DESCRIPTION

The case is divided into two parts. The front of the upper element, which formerly contained the movement, is mainly occupied by a large dial, above which are four subsidiary dials (see below). The main dial is covered by a circular convex glass, the smaller dials by a shaped panel of flat glass. On top of the case is a gilt-wood orrery, and there is a viewing hole below the main dial. The sides are fitted with solid doors which lower on hinges (fig. 13a). The remaining areas of the case are veneered with kingwood, and panels of trellis parquetry are set below the dial and on the sides. Bronze moldings frame the glass panels and the sides of the doors and form a broad arched pediment beneath the orrery.

Elaborate bronze mounts are set on the upper corners and at the edges of the widest part of the circular area below. Another mount surrounds the viewing hole, and large complex mounts set with shells, cabochons, and vine branches form the feet of the case (fig. 13b).

At the center front the projecting base is fitted with a large mount consisting of a blank cartouche on which is perched an eagle with outstretched wings. To either side are sprays of palm, oak, and laurel above stylized shells (fig. 13c). The hollow lower section of the base is of bombé form and raised on short cabriole legs. It is veneered with kingwood and *bois satiné*, the front and sides bearing panels of trellis parquetry. Horizontal bronze moldings are placed at the top of the bombé section and at its juncture with the legs. Bronze mounts composed in the main of cabochons and acanthus leaves are set along the front corners and on the legs. There are three mounts on the center front: an elaborate mount composed of C-scrolls,

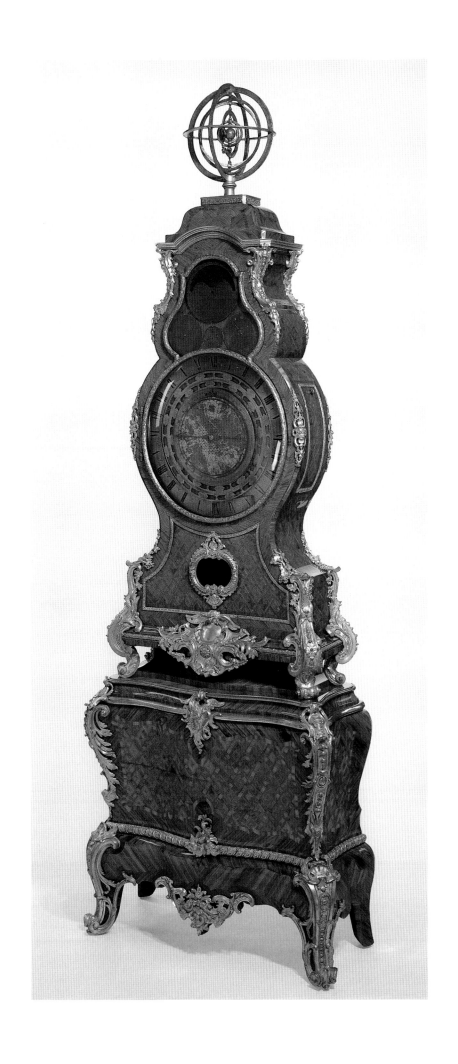

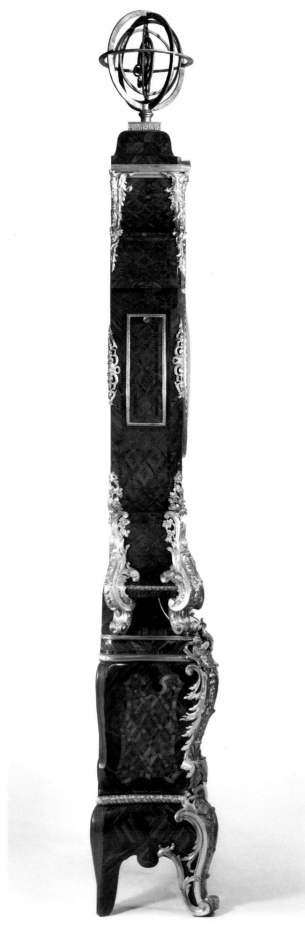

13A

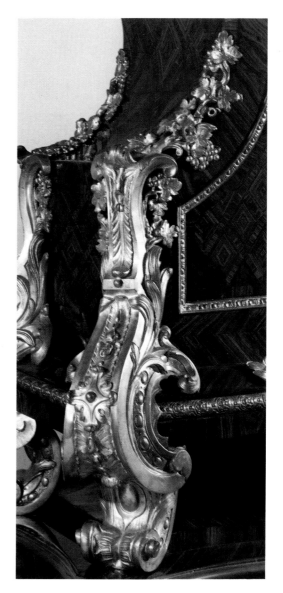

13B

acanthus, and a feathered wing above a smaller mount that carries a seed pod, and a large apron mount composed of shells, leaves, C-scrolls, and a pair of feathered wings (fig. 13d).

The back of the upper part of the case is fitted with a large door, which is hinged and latched. The carcase throughout is of white oak.

Behind the uppermost subsidiary dial was originally fitted a revolving disk painted with the moon—the phases of which could thus be seen through the crescent-shaped aperture. Below this dial are three more dials. The left-hand dial is engraved with the numbers one to forty-two and the words: *Eclipses du Ier Satellite de Jupiter* (fig. 13e). The center dial is engraved with the days of the week and the words: *Inventé par A. Fortier* (fig. 13f). The right-hand dial bears the roman numerals I to XII and the names of the following French and British ports, read clockwise: *Dunkerque, Nieuport, Ostende/Isle de*

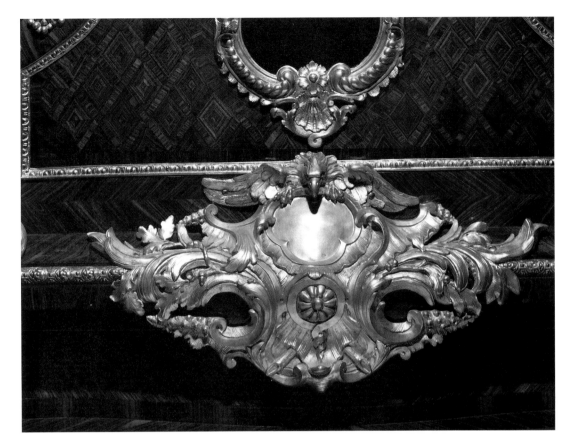

13C

13D

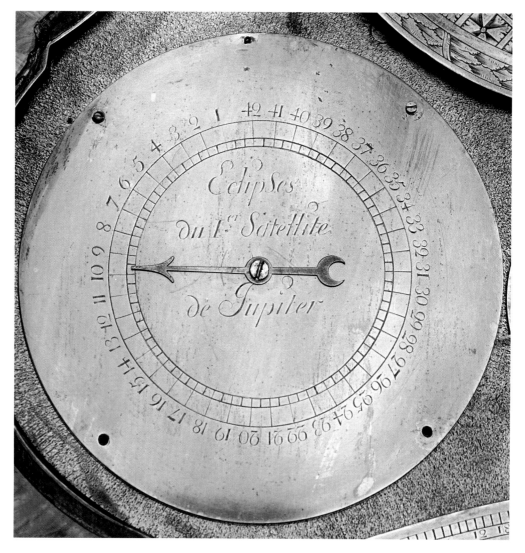

13E

Zetlande / Belle Isle / Penmark / Isle de Rhé / St. Poldeleon / Kinsale / St. Malo, Milfort, St. Davids / Barneville / Isigny / LeHavre / Fescamp / Dieppe / St. Valery (fig. 13g). Each of these three dials has one hand.

The main dial has an outer twenty-four-hour chapter ring with the minutes marked in arabic numerals. Set inside this is another ring which is pierced. The latter is engraved with the months, the signs of the zodiac (with their divisions), and the names of the corresponding constellations. In the center of the dial are two superimposed disks. The lower and larger disk is engraved with the equation of time, with roman numerals I through XII and arabic numerals one to twenty-nine and one-half. The uppermost disk is engraved with the names of the main oceans and of various cities and countries around the world. Reading clockwise, they are:

Tremesni Madrid Brest / Maroc Lisbonne Irelande / Madere Ides Canaries Ier Meridien / I du Cap Verd I Tercere / Saint Salvador au Bresil / Maragnan au Bresil / Para au Bresil / Cayenne Terre Neuve / La Martinique Accadie / S. Domingue Quebec / Lima Le Chile Virginie / Panama La Havana / Guatimala Floride / Mexico en Noule Espagne / Nouveau Mexique / La Californie / Isle S. Thomas d'Amerique / Isle Rocca Partida / Isle S. Pierre dela L'Equateur / Isle Voisine ou Vexina / Isle des Chiens / Isle des Mouches / Isle Solitaire / I S. Pierre dela L'Equateur / Isle Sainte Croix / Isle de Cocos / Isle d'Hoorn / Isle S. Bartelmy / Isles de Marie Anne ou des Larrons / Jendo au Japon / Bungo au Japon / I Philippines et Moluques / Pequing et Macao en Chine / Batavie Cochinchine / Saim Malacca / Pegu Achem / Metiapur Golcolde le Mogol / Goa Calicut Surate / Samarcand en Gde Tartarie / Ormus en Perse / Hispahan Astracan / La Mecque Erzeron / Jerusalem Cypre Mozambique / Constantinople Alexandrie / Stockholm Varsovie Lepante Barca / Vienne Rome Malthe / Hambourg Milan Tunis / Anvers Londres, and in descending order toward the center of the dial: *PARIS / Orleans / Limoges / Gaors / Toulouse / Barcelone / Alger* all encircled by *Europe, Ocean Amerique, Mer du Sud ou Mer Pacifique, Asie* [the latter repeated four times] (fig. 13h).

96 PLANISPHERE

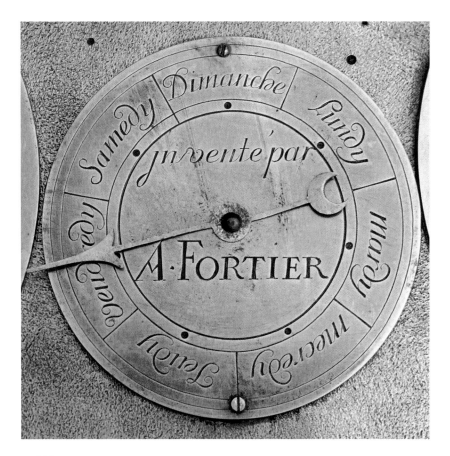

13F

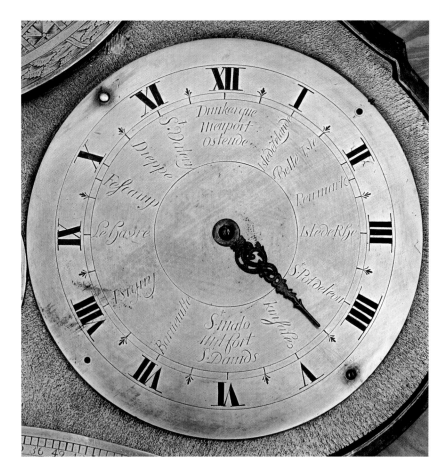

13G

PLANISPHERE 97

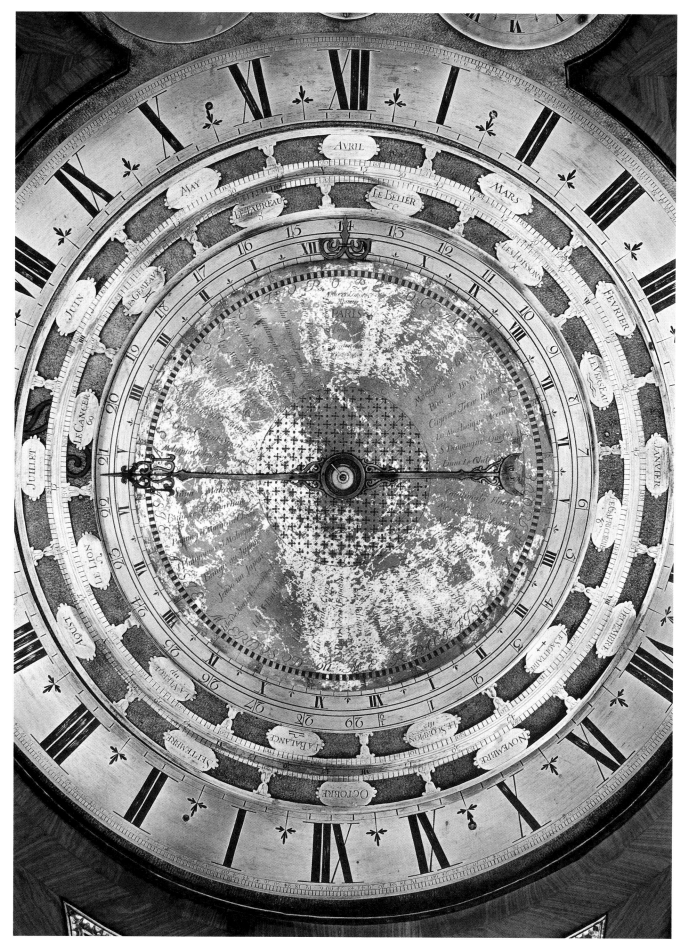

13H

98 PLANISPHERE

The divisions marked 0 to 42.5 on the upper left-hand subsidiary dial represent the orbital period of Io (the *Ier satellite*) around Jupiter. The fact that this period is 42.48 hours was well established by the mid-eighteenth century. In order to keep track of Io's eclipses, which could be observed through a common telescope, one would set the hand to zero at the moment of the eclipse; the next eclipse would occur, with a deviation of eight minutes, when the hand reached zero again. This mechanism was used to determine longitudes.[1]

The upper right-hand subsidiary dial was almost certainly a tidal dial for the northern part of France, and it suggests that the clock was made for an owner living in that area. The latitudes and longitudes of the various cities range from 47°20′ N, 3°10′ W to 50°11′ N, 2°55′ E.

The smallest and innermost dial on the main face indicates the local times of different cities and areas throughout the world. The larger dial behind it shows the ages of the moon and also probably provided the apparent night ascension of the moon, that is, its position in the sky, east to west.

The pierced dial shows the months and the position of the sun in the ecliptic with the zodiacal signs. The outermost dial was intended to provide mean solar time. The outer hand is the mean solar time hand, while that in the center is the lunar hand.[2]

MARKS

The case is not stamped with a maker's name. All the mounts on the lower section of the clock, with the exception of the moldings, are struck with a small stamp in the form of a crowned C. This was a stamp used on alloys containing copper to denote that a tax had been paid—the C stands for *cuivre*—between the years 1745 and 1749.[3]

CONDITION

The upper area of the glass cover is a modern replacement. The central part of the main dial was originally silvered but is now very worn. All the hands are later replacements. Although it once opened, the frame of the viewing hole for the pendulum is now nailed shut. The movement is entirely missing, along with the pendulum, weights, and bells. The opening for the bells has been covered over with paper that bears printing in French. The bronze mounts are not gilded.

The wood orrery covered, in part, with gilded paper may replace one of gilt bronze, which would have been more suitable for this elaborate piece. However, there are no signs of a previous attachment in the wooden platform to which it is fixed.

COMMENTARY

The case is attributed to the cabinet-maker Jean-Pierre Latz (circa 1691–1754).[4] Latz was born in Cologne and emigrated to Paris in 1719. By this date he was at least twenty-eight years old and, therefore, had probably received his training in Germany. In 1741 he was appointed *Ebéniste Privilégié du Roi*. After his death in 1754, his wife, Marie-Madelaine, continued to operate the large workshops until she died two years later. It appears that the making of clock cases was the chief occupation of Latz's workshops.

In the inventory taken at his death one hundred and seventy clocks are mentioned, while only forty-eight pieces of case furniture are listed.[5] However, only four clocks which bear his stamp are known today.[6] The attribution of this case to Latz rests mainly on a comparison of the mounts to those on pieces stamped with his name or securely attributed to him. With the majority of cabinet-makers this would be a vague method of attribution as bronze mounts were, by law, made by a separate Paris guild. However, it is known from various documents that Latz designed and made his own mounts, at least until 1749 (after the date of construction of this piece). In that year members of the guild of *fondeurs-ciseleurs* visited his workshops to determine whether or not Latz was illegally engaging in their trade.[7] They recorded considerable evidence that he was. Although the outcome of the litigation is not known, it is probable that from then on Latz used outside workers to produce his mounts, though it is likely that they worked from his own models.

The mount around the viewing hole on the upper section of the planisphere appears on several unstamped long-case clocks, all of similar form, profusely mounted and veneered with ebony.[8] The mounts of one of these clocks are stamped with the crowned C, and it is thus probable that this framing mount was also produced in the latter part of the 1740s. It is not found elsewhere on Latz's work and may be an instance of his use of a mount not made to his own design. Nevertheless, this mount has been simplified on the Museum's planisphere by the removal of small decorative elements above and below.

Only two of the mounts on the lower section of this piece appear on other clocks by Latz. The first is the gourd-shaped seed pod supported by leaves above the apron of the base. This can be found on two long-case clocks stamped with his name: one at the Cleveland Museum of Art[9] and the other in the James A. de Rothschild Collection at Waddesdon Manor, England.[10] The second mount—on the front corners of the base—is found again at the upper corners of the pedestal of a clock exhibited at Schloss Moritzburg near Dresden, which has been firmly attributed to Latz by Henry Hawley.[11]

The style and elements of the mounts also strongly support the attribution of this case to Latz. The use of feathered wings, auricular forms, and massive mounts flanked by small flickering scrolls that break up the solidity of the form as well as the pronounced asymmetry are all very characteristic of this maker's work. Also typical are the clear horizontal structural divisions, confining the areas of parquetry or marquetry within definite boundaries.[12]

It is possible that this planisphere originally belonged to the prince de Conti. In the catalogue of the sale held after his death, in 1777, there is a piece described as follows: "Un planisphere inventé par feu M. FORTIER, Notaire, marquant l'heure qu'il est dans les différentes contrées de la terre, pareillement l'heure des marées, les signes du Zodiaque, le quantieme & les phases de la lune, les jours de la semaine, le quantieme du mois & c."[13] Among the known planispheres designed by Fortier, only the Museum's clock bears a dial indicating the times of the tides.[14]

OTHER EXAMPLES

There are two other complete eighteenth-century planispheres known to exist today. One, with an even more elaborate case, is in the Wallace Collection, London.[15] It was made for the *financier* Jean Paris de Monmartel (1690–1766) circa 1750. It still retains its complex movement by Alexandre Fortier and Michel Stollenwerck (see Biog., p. 195). Another, dated 1760, which has a much simpler case but a more elaborate movement and probably belonged to Fortier himself, is in a private collection in New Jersey.[16]

In the Conservatoire National des Arts et Métiers, Paris, there is another planisphere movement which bears on its dials precisely the same cities and parts of the world as those found on the Museum's example, spelled and arranged in the same way. It is engraved: *Horloge Astronomique inventée et faite par Mathieu Kriegseissen à Paris. / Aprouvée par Messieurs de l'Academie Royale des Sciences à Paris, le 10 Juillet 1726.*[17] It is possible that a common printed source was used by the dial engravers.[18]

EXHIBITIONS

New York, Metropolitan Museum of Art, *The Grand Gallery* (La Confederation internationale des negociants en oeuvres d'art [CINOA]), October 19, 1974–January 5, 1975, p. 50, no. 44.

PUBLICATIONS

"The Grand Gallery," *Connoisseur* (October 1974), p. 122; G. Wilson, *Selections from the Decorative Arts in the J. Paul Getty Museum* (Malibu, 1983), pp. 36–37, no. 18, ill.; Sassoon and Wilson, *Decorative Arts: A Handbook*, p. 40, no. 86; P. Verlet, *Les Bronzes*, p. 115, fig. 144; Bremer David et al., *Decorative Arts*, pp. 88–89, no. 138.

PROVENANCE

(?) Louis-François de Bourbon, prince de Conti. Baron Gustave de Rothschild, Paris. Charles Davis sale, Christie, Manson & Woods, Ltd., London, June 29, 1906, lot 132 (to Stettiner). Sold from the collection of Monsieur X . . . [Maurice Ephrussi], Galerie Georges Petit, Paris, May 22, 1911, lot 63. Sold as "The Property of a Lady of Title," Sotheby's, London, November 24, 1972, lot 34. Rosenberg and Stiebel, New York, 1974. Purchased by J. Paul Getty in 1974.

NOTES

1. I am grateful to Dr. Torrance Johnson for this information.
2. I am grateful to William Andrews for this information.
3. For the complete text of the tax edict, see H. Nocq, "Quelques Marques Le C Couronne," *Le Figaro Artistique* (April 17, 1924), pp. 2–4. See also G. de Bellaigue, *The James A. de Rothschild Collection at Waddesdon Manor: Furniture, Clocks and Gilt Bronzes*, vol. 1 (London, 1974), pp. 31–37.
4. For a monograph on Jean-Pierre Latz and his work, see H. Hawley, "Jean-Pierre Latz, Cabinetmaker," *Bulletin of the Cleveland Museum of Art* (September/October 1970), pp. 203–259, and Pradère, *Les Ebénistes*, pp. 152–161.
5. A.N., Min., XXVIII, 338, inventory after death of Jean-Pierre Latz, August 9, 1754.
6. For two of the clocks, owned respectively by the Cleveland Museum of Art and Waddesdon Manor, see Hawley (note 4), p. 216, pls. 1 and 2. A third clock, also a long-case model and elaborately veneered with brass, horn, and mother-of-pearl, is in the Schloss Charlottenburg, Berlin. It has a movement by Stollenwerck. See W. Baer, "Some Clocks of Frederick the Great," *Connoisseur* (May 1977), pp. 22–29, fig. 1 and color plate. The fourth clock, in the Staatliche Kunstsammlungen, Dresden, which resembles the unstamped clock in the Schloss Moritzburg, illustrated as number 11 in Hawley's article (note 4), is not only stamped by Latz but also dated 1739.
7. A.N., Y 10 992. Procès verbal, pour la Communauté des fondeurs, Jean-Pierre Latz, December 2, 1749.
8. Hôtel Drouot, Paris, December 13, 1963, lot 137, with a movement by Derblours; Sotheby Parke Bernet, Monaco, February 8, 1981, lot 265, with a movement by Admirault; Etude Courturier Nicolaÿ (Hôtel Drouot), Paris, December 20, 1988, lot 102, with a movement by Jean-André Lepaute; Pierre Cornette de Saint Cyr (Hôtel Drouot), Paris, April 6, 1994, lot 134, with a movement by Louis-François Normand.
9. Inv. 49.200, Hawley (note 4), p. 215, no. 1, fig. 1.

10. See de Bellaigue (note 3), pp. 84–88, no. 11.
11. See Hawley (note 4), pp. 219–220, no. 6, fig. 6.
12. Hawley (note 4), p. 206.
13. Pierre Remy, Paris, April 8 and days following, 1777, lot 2008. I am grateful to Theodore Dell for this information.
14. This information has been kindly supplied by Jean-Dominique Augarde.
15. See F. J. B. Watson, *Wallace Collection Catalogues, Furniture* (London, 1956), pp. 65–67, pls. 50, 51, no. F98, and P. Hughes, *French Eighteenth-Century Clocks and Barometers in the Wallace Collection* (London, 1994), pp. 44–45.
16. Sold from the collection of Léon Mascart, Galerie Charpentier, Paris, May 30, 1948, lot 89. The dial is engraved *Inventé par Alexandre Fortier, Fait par Stollewerck 1760*. Number 161 in the sale of Alexandre Fortier's effects held on April 12, 1770, was described as: "Une grande Pendule astronomique, du Système de Copernic, marquant le tems vrai & le tems moyen, les mois, les jours, heures, minutes & secondes, avec le cours des planetes, le lever du soleil: dans sa boëtte & dans sa gaine de bois de violette, garnie en bronze. Ce savant morceau est fait par Stolwerck, Horloger à Paris." I am grateful to Jean Nérée Ronfort for this reference.
17. Inv. 7492, Conservatoire National des Arts et Métiers, *Catalogue du Musée, Section J.B.: Horologerie* (Paris, 1949), pp. 132–135, figs. 36, 37, no. JB 33:4.
18. See, for example, Dom Pierre de Sainte Marie Magdeliene, *Traite d'Horologie Contenant Plusiers Manieres de Construire sur Toutes Surfaces, Toutes Sortes de Lignes horaires; & autres Cercles de la sphere*, 2nd ed. (Paris, 1645).

XIV

Mantel Clock

French (Paris), circa 1763

Movement by Etienne (II) Le Noir (1699–1778; master 1717) in partnership with his son Pierre-Etienne Le Noir (born circa 1725, date of death unknown; master 1743) (see Biog., p. 177); case attributed to Robert Osmond (1720–1789; master 1746)

HEIGHT: 1 ft. 9½ in. (54.6 cm)
WIDTH: 1 ft. 5¾ in. (45.1 cm)
DEPTH: 9¼ in. (23.5 cm)

73.DB.85

DESCRIPTION

The mantel clock is of gilt bronze, with the exception of the patinated bull that carries the drum-shaped clock case on its back. Seated above is a figure of Europa, while below two women are seated to either side on an elaborately scrolled base (fig. 14a). All three figures are dressed in loosely fitting long dresses; that of Europa leaves her right shoulder exposed.

The surface of the base is covered with shallow rockwork, which is set with plants, sprays of flowers, bull rushes, and a tree stump. Europa holds a garland of flowers which falls to either side of the clock, one end held by the female figure on the left while the other end falls over the head of the bull.

The gilt-bronze back of the clock case is hinged and takes the form of an elaborately pieced grill (fig. 14b).

MARKS

The dial, which is a replacement and was probably made in the first half of the nineteenth century, is enameled *Etienne Le Noir Æparis*; the back of the movement is similarly inscribed, with the addition of *N°. 396* (fig. 14c). The back of the dial is painted with the words *Pareil au modele / Etienne L[e] Noir / AParis / batarde / Debruge / 5.9* (fig. 14d).

The signature of Debruge (see Biog., p. 167) has been found on the backs of dials intended for clocks of nineteenth-century date. The various other words can be understood as instructions for the painting of the signature on the face of the dial; the word "batarde" describes the style of the calligraphy. The signature follows precisely the same form as that inscribed on the movement of

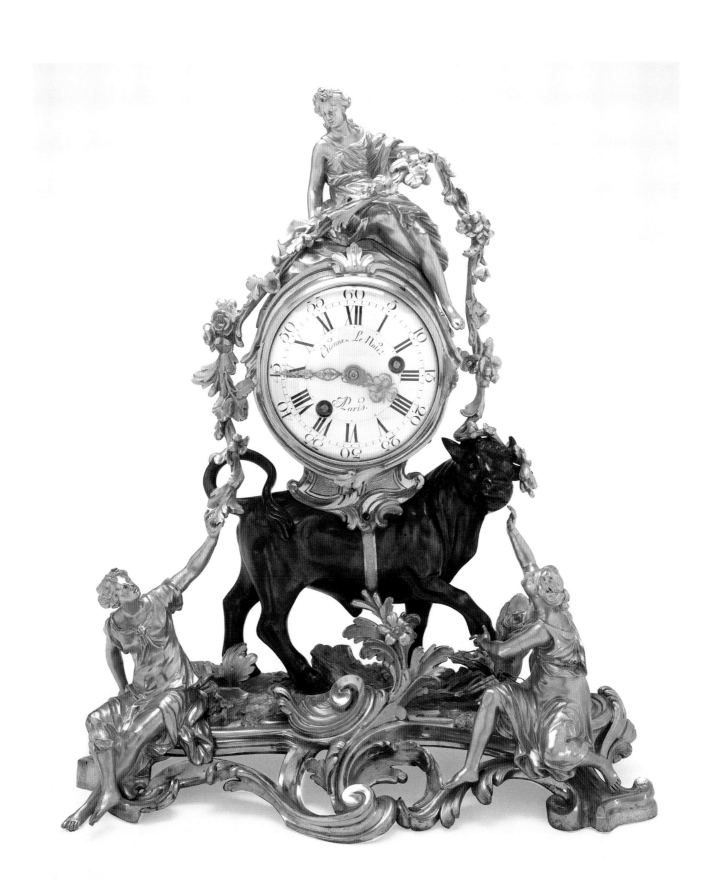

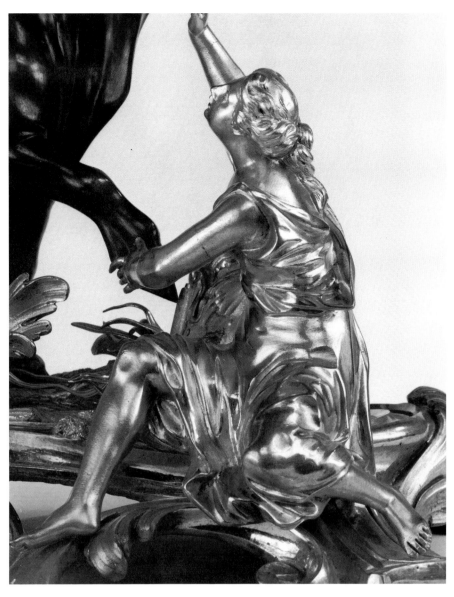

14A

the clock, which one can assume therefore to be the "modele" provided.¹ The dial is inscribed in ink around the bezel collar *Alibert*. The springs of the going and striking trains are signed *Masson* (for Joseph-Antoine Masson; see Biog., p. 192) and are dated *Janvier* and *Fevrier 1763* (fig. 14e). As the movement is original to the case, the latter can also be dated to around this year.

CONDITION

The unblemished patina on the bull would appear to be fairly modern. It either replaces the original patina, or the bull was formerly gilt.

COMMENTARY

Drum-shaped clocks supported on animals were popular in the mid-eighteenth century. Those having elephants and bulls are most commonly found, and sometimes the elephants are of Meissen porcelain.² Rhinoceri, horses, and boars were also used and, more rarely, donkeys and camels. Such clocks were sometimes placed on elaborately mounted caskets containing musical movements.

OTHER EXAMPLES

A number of similar clocks exist. Four have the name "OSMOND," referring to the *bronzier* Robert Osmond, stamped on their bases. One of these clocks was sold from the collection of Lucien Surmont at the Hôtel Drouot (Paris, May 13, 1912, lot 100). It stood on a marble base, had a movement by Viger, and was signed "OSMOND" at the left corner of the base. A second clock, also stamped, was sold from the collection of Madame de Polès in 1936 (Paris, Gallerie Charpentier, November 17–18, lot 151). It too had a movement by Viger.³ A third clock stamped by

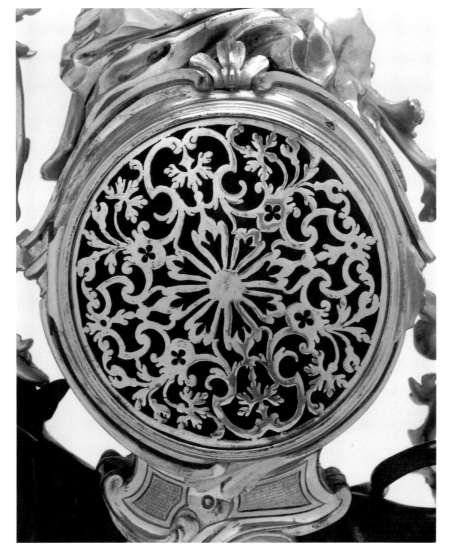

14B

14C

14D The inscriptions on the back of the dial.

14E The spring of the striking train, signed *Masson Fevrier 1763*

Osmond with a movement by Boucher was in the Edward Arnold collection.[4] Another, of precisely the same model with a patinated bronze bull marked "OS," as a partial stamp for Osmond, is in Schloss Johannisburg at Aschaffenburg.[5] The dial of this clock is signed "VIGER APARIS."

A closely comparable clock with a slightly differing base is in the British Royal Collection at Buckingham Palace.[6] The figures, though positioned in the same way, are more stiffly draped. The base of the case is signed "OSMOND" on the right, and the movement and dial were replaced by Vulliamy in 1817.

A clock of the same model with a movement by Etienne Le Noir and apparently not signed by Osmond was sold at the Galerie Charpentier, Paris, December 2, 1952, lot 192 (listed in the section entitled "Divers amateurs"). Other clocks of the same model with movements by Le Noir can be mentioned. One was sold at auction in Paris in 1991,[7] and another was with a Parisian dealer in the same year. Another clock of this model, with a movement signed "Lenoir," was sold at the Hôtel Drouot in 1989 (April 26, lot 74). This movement, while old, was apparently a replacement. A clock with a movement by Gilles *l'aîné* was sold from the collection of Madame Chainaut (Sotheby's, London, December 10, 1936, lot 116). Tardy illustrates a clock bearing a rhinoceros with a mandarin above the drum, which has a base of the same form.[8] All of these unsigned clocks, together with that in the Getty Museum's collection, may be given to the *bronzier* Osmond.

A clock of very similar design is in the Musée du Louvre.[9] The position of the bull is reversed, and three female figures are in different poses. Its base is signed "ST. GERMAIN." Another clock, identical to this and also signed "ST. GERMAIN" was formerly in the Pelham Galleries, London. The *bronzier* Jean-Joseph de Saint-Germain, having been made a master in 1748, was a contemporary of Robert Osmond. He was a craftsman of superior skill and inventiveness, and it is possible that it was he who first used this theme of Europa and the Bull, and that the model was then modified by Osmond.

MOVEMENT
Brass and iron, partly blued

Note: The number in parentheses represents the number of teeth on each wheel. These numbers are repeated again in the drawings of the movement.

The movement (figs. 14f and g) consists of two trains driven by mainsprings, each of which runs for more than two weeks. The going train provides power for the hands which indicate the hours in roman numerals and the minutes in arabic numerals on the main dial. The clock strikes the hours and half hours on the same bell.

The going train has one rotating barrel (78), which holds the mainspring and five pinion wheels (12/78–8/63–9/48–8/48–10/20), the last being the escape wheel. The going train is regulated by an anchor escapement (recoil escapement) in connection with a pendulum. The pendulum can be adjusted while the clock is running by

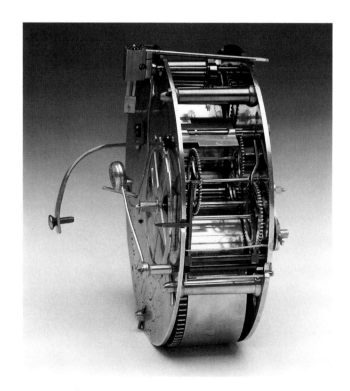

14F Three-quarter view of the movement.

14G Detail showing the escapement.

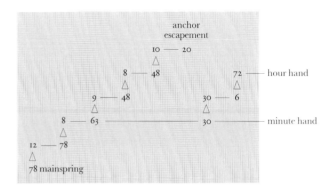

Going train

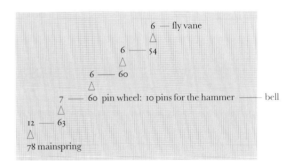

Striking train

lifting or lowering its spring suspension. The arbor of the third wheel holds the cannon pinion (30), a part of the motion work (30–30/6–72), and the minute hand. The hour wheel (72) holds the hour hand. The cannon pinion (30) rotates once every hour; it has two pins that release the striking train every half and full hour.

This type of striking train has a locking plate (count wheel). This train has one rotating barrel (78), which holds the mainspring, four pinion wheels (12/63–7/60–6/60–6/54), and a fly vane (6). The third wheel (7/60) has ten pins that move the striking hammer.

The barrels of the going train and the striking train are very unusual in construction. Normally the barrel carries teeth which drive the following pinion in the train. In this case the barrels consist of two parts: a plain barrel and a separate wheel which is fixed to the barrel with screws. This construction appears to be original. The dial is not original to the clock. The holes for winding the clock and the hole for the hour and minute hands were drilled in the dial after it was enameled (as is typical of nineteenth-century dials).

EXHIBITIONS
Detroit Institute of Arts, 1972–1973.

PUBLICATIONS
Wilson, *Clocks*, pp. 56–59, no. 11, ill.; Wilson, *Decorative Arts* (1977), p. 51, no. 67, ill.; Sassoon and Wilson, *Decorative Arts: A Handbook*, p. 41, no. 88, ill.; Bremer David et al., *Decorative Arts*, p. 90, no. 140, ill.

PROVENANCE
(?) Louis François Armand de Vignerot du Plessis, duc de Richelieu; sold, Paris, December 18, 1788.[10] Sold, Christie's, London, July 5, 1973, lot 31. Purchased by J. Paul Getty at that sale.

NOTES
1. I am grateful to Jean-Dominique Augarde for deciphering these inscriptions.
2. For a mantel clock with a porcelain elephant, see G. de Bellaigue, *The James A. de Rothschild Collection at Waddesdon Manor, Furniture, Clocks and Gilt Bronzes*, vol. 1 (London, 1974), pp. 100–103, no. 16.
3. Madame de Polès owned another clock of this model, apparently unsigned, with a movement by Henry Blondel. See de Polès sale, Galerie Georges Petit, Paris, June 22–24, 1927, lot 192.
4. See F. Rutter, *The Edward Arnold Collection* (London, 1921), no. 11. This clock was formerly in the Demidoff collection.
5. Inv. Asch. Var 2, Ottomeyer and Pröschel, *Vergoldete Bronzen*, vol. 1, p. 125.
6. See J. Harris, G. de Bellaigue, and O. Millar, *Buckingham Palace* (London, 1968), p. 200. The musical box on which the clock now stands is not original to the piece.
7. Hôtel Drouot, Paris, December 6, 1991, lot 43.
8. Tardy, *La Pendule française, Ière partie, des origines au Louis XV* (Paris, 1974), p. 169, fig. 2.
9. Inv. OA 5168, CD–323, C. Dreyfus, *Catalogue sommaire du mobilier et des objets d'art* (Paris, 1922), p. 68, no. 323, ill. VII.
10. A clock is described in the sale catalogue as "692 Une Pendule, mouvement d'Etienne le Noir, dans sa boîte terminée par une figure, et soutenue par un taureau en bronze en couleur antique, aussi accompagné de figures sur terrasse à rinceau." It is possible that this clock and the Museum's example are one and the same. However, it has been noted that this model seems to have been fitted with movements by Etienne Le Noir fairly frequently. I am grateful to Jean-Dominique Augarde for this information.

XV

Wall Clock on a Bracket

French (Paris); circa 1764

Case by Antoine Foullet (1710–1775); movement by Lapina (dates unknown)

Clock:
HEIGHT: 2 ft. 8½ in. (82.5 cm)
WIDTH: 1 ft. 4½ in. (41.9 cm)
DEPTH: 8 in. (20.3 cm)

Bracket:
HEIGHT: 1 ft. 2¼ in. (36.2 cm)
WIDTH: 1 ft. 7½ in. (49.5 cm)
DEPTH: 11¼ in. (28.6 cm)

75.DB.7

DESCRIPTION

The clock is topped by a gilt-bronze urn placed on a wooden plinth veneered with horn that is painted green on its underside. The plinth is surrounded on three sides by a freestanding brass fret pierced with a greek key pattern.

The white enamel dial is centered in the main octagonal area. Above is a lion's mask with a ribbon bow in its mouth. At the two front corners are smiling satyr's faces set on consoles with scrolling tops and flutes (fig. 15a). Suspended by ribbon bows from the base of these consoles is a swag of oak leaves with acorns, caught up at the center below the dial. The concave surface of the case around the dial is veneered with brass sheeting with geometric cutouts inset with red, green, and cream-colored horn.

The outcurving base of the clock is occupied at its center by a glass panel of trapezoidal shape. The panel is partially covered by a flaming urn with a length of drapery threaded through its handles to hang loose at the sides. The canted lower front corners are set with acanthus leaves and leafy buds and end in rectangular blocks decorated on the sides with a greek key and on the front with a rosette. The remaining surface of the case is veneered with brass sheeting with geometric cutouts inset with red, green, and cream-colored horn.

The sides of the clock are decorated with three panels of pierced brass of trellis design with rosettes at the crossings (fig. 15b). Each is surrounded with a frame of brass and horn marquetry cut with a greek key pattern. At the level of the movement is a glass viewing panel. Towards the rear is a console decorated with a scrolled top set with

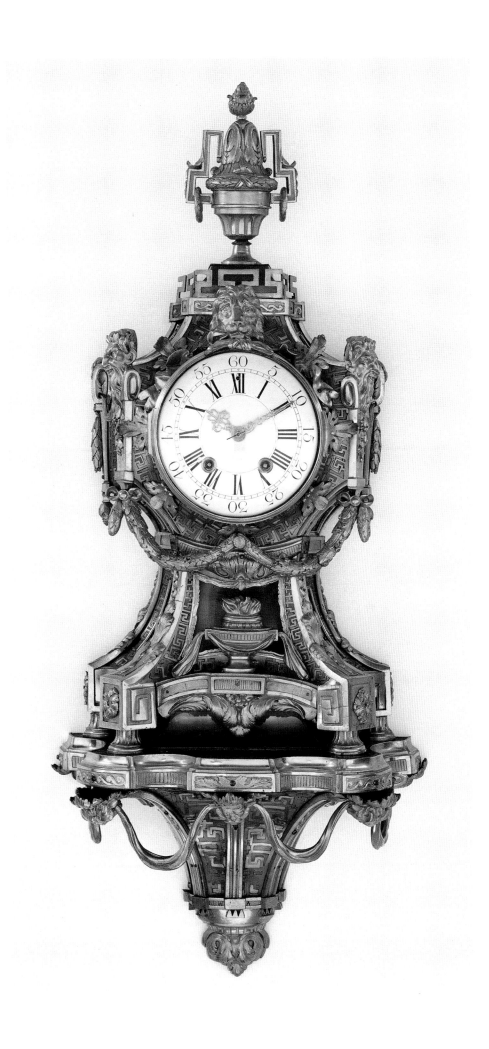

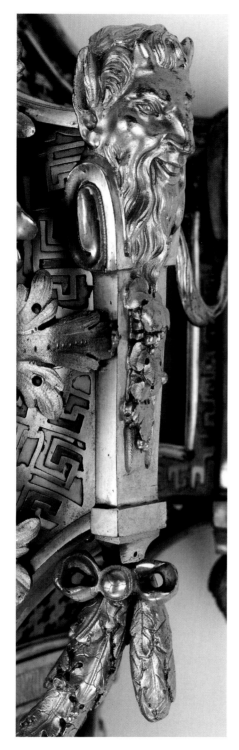

15A

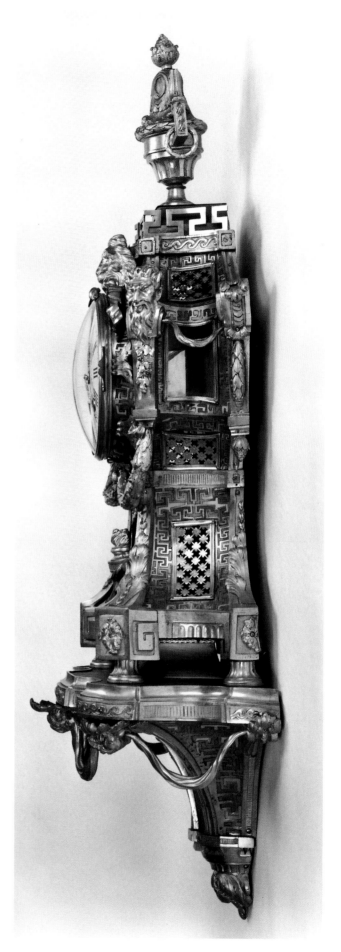

15B

110 WALL CLOCK

an acanthus leaf and *piasters*. Below, each lower edge is decorated with a half rosette above which is an acanthus leaf halved down its length.

The carcase of the clock and the bracket are of oak, painted red. The octagonal hinged door of the former is covered on its inner surface with a sheet of brass. Another hinged door, for access to the pendulum, is similarly decorated.

The clock is supported on four short, fluted feet which rest on the bracket; the latter is fitted on its top with a rectangular plinth with concave sides veneered with brass. The upper edge of the bracket is mounted with a broad gilt-bronze molding decorated with Vitruvian scrolls alternating with panels of vertical grooves. Below, five gilt-bronze consoles separate the fan-shaped bracket into four panels, each veneered with brass sheeting with geometric cutouts inset with red, green, and cream-colored horn. Goat's heads decorate the front three consoles, with a ribbon swag suspended between these and the two back consoles (fig. 15c). The bracket terminates in a large acanthus bud. The top of the bracket bears two stout iron rings for attachment to the wall.

MARKS

The clock case is stamped on its underside and the bracket on its upper surface, toward the back: ANT·/ FOVLLET/JME (fig. 15d). The movement is signed *Lapina/ A·PARIS* (fig. 15e). The spring of the going train is inscribed *Richard X de 1764 Mouvement foulé M Ebeniter*. The spring of the striking train is inscribed *Richard X* (see Biog., p. 193) *de 1764 Sonnerie A foulé Eben*. The back of the enameled dial plate is inscribed *dia- metre / du cadran au / santre de la / lentille 8 P / A. foule* and *A J. Noordanus for J. Paul Getty / 1 May 1976*.

COMMENTARY

The clock-maker Lapina is not recorded. He was possibly a minor clock-maker or journeyman who has inscribed his name in a somewhat amateurish way. Another clock with a movement signed by Lapina was sold at public auction in 1902; it was described as a Louis XVI clock with a horizontal dial.[1]

Antoine Foullet (1710–1775; master 1749; *juré* 1756), whose name is stamped on both the case and the bracket and is inscribed twice on the springs of the movement and once on the back of the enamel dial, was a well-known *ébéniste*. His comparatively large workshop on the rue du Faubourg Saint-Antoine contained six benches and two vises as indicated in the inventory drawn up after his death on September 24, 1775.[2] Also listed are forty clock cases and twenty-four clock brackets, all incomplete, and approximately twenty completed clock cases, some entirely of bronze. The same documents indicate that Foullet was in debt to the clock-maker Louis Musson [Masson] in 1775 and to the Swiss clock-maker Abraham-Louis-Humbert Droz in 1767. The *bronziers* Caron *père* and Claude-Bernard Héban's widow, as well as the *ciseleur* Boullanger, among others, are also indicated as debtors at the time of Foullet's death.

15D The stamp of Antoine Foullet.

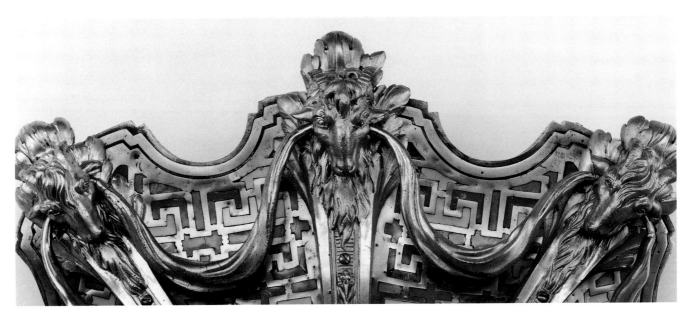

15C

15E

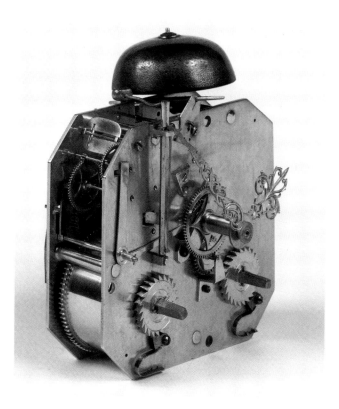

15F Three-quarter view of the movement.

Antoine Foullet is generally thought to have worked almost exclusively in the rococo style, though his death inventory indicates that a few of the clocks in his workshop were "à la grec" or "à l'antique," terms which would apply to the design of the Museum's clock.³ Although the style of the Getty clock case is more in character with the work of his son Pierre-Antoine, Antoine Foullet definitely had clock cases in the *goût grec* style in his workshop at the time of this death.

A drawing of this clock without the elaborate inlays of colored horn has recently been discovered. It is inscribed "Cabinet d'ebenisterie a la grecque . . . Foulet."⁴

OTHER EXAMPLES

Two similar clocks and brackets with plain veneers have been sold at auction, the first, with a dial signed "Josselin / A Paris," in 1925,⁵ the second, with no signature, in 1982.⁶ A third example was on the Paris art market in 1987 (it is not known whether the dial of the latter was signed).

Another example, also with plain veneers and possibly identical to one of those already mentioned above, was recorded in 1955 as being in the Washington residence of the French ambassador, Henri Bonnet.⁷

A bracket similar to the Museum's example, but veneered with tulipwood and purplewood, was sold at auction in 1975.⁸

```
                      anchor
                    escapement
             6 —— 31            72 —— hour hand
             △                  △
             6 —— 60            30 —— 6
             △                  △
         8 — 72 ———————————— 30 —— minute hand
         △
     12 — 84
     △
   80 mainspring
```

Going train

```
                                 6 —— fly vane
                                 △
                            6 —— 54
                            △
                       6 —— 60
                       △
                 8 —— 60  pin wheel: 10 pins for the hammer —— bell
                 △
            12 — 72
            △
          80 mainspring
```

Striking train

MOVEMENT
Brass and iron, partly blued

Note: The number in parentheses represents the number of teeth on each wheel. These numbers are repeated again in the drawings of the movement.

The movement (fig. 15f) consists of two trains driven by mainsprings, each of which runs for one week. The going train provides power for the hands, which indicate the hours in roman numerals and the minutes in arabic numerals on the main dial. The clock strikes the hours and half hours on the same bell.

The going train has one rotating barrel (80), which holds the mainspring and four pinion wheels (12/84–8/72–6/60–6/31), the last being the escape wheel. The going train is regulated by an anchor escapement (recoil escapement) in connection with a pendulum. The pendulum can be adjusted while the clock is running by lifting or lowering it via its silk suspension. The arbor of the third wheel holds the cannon pinion (30), a part of the motion work (30–30/6–72), and the minute hand. The hour wheel (72) holds the hour hand. The cannon pinion (30) rotates once every hour; it has two pins that release the striking train every half and full hour.

This type of striking train has a locking plate (count wheel). This train has one rotating barrel (80), which holds the mainspring, four pinion wheels (12/72–8/60–6/60–6/54), and a fly vane (6). The third wheel (8/60) has ten pins that move the striking hammer.

The stop work for both barrels is missing.

EXHIBITIONS
Detroit Institute of Arts, on loan, June 16–October 31, 1975.

PUBLICATIONS
G. Wilson, *Clocks*, pp. 60–63, no. 12, ill.; Wilson, *Decorative Arts* (1977), p. 65, no. 85, ill.; Sassoon and Wilson, *Decorative Arts: A Handbook*, p. 41, no. 89, ill.; Ottomeyer and Pröschel, *Vergoldete Bronzen*, vol. 1, p. 158, ill.; Verlet, *Les Bronzes*, pp. 112–113, fig. 137; Pradère, *Les Ebénistes*, p. 275; Bremer David et al., *Decorative Arts*, p. 90, no. 141.

PROVENANCE
A Cornish private collection, England. Alexander and Berendt, Ltd., London. Purchased by J. Paul Getty in 1974.

NOTES
1. From the collection of the Hon. W. F. B. Massey-Mainwaring, Christie's, London, July 2, 1902, lot 255.
2. A.N., Min., XXVIII, 452. Document dated September 30, 1775. See Pradère, *Les Ebénistes*, p. 279, where the inventory is partially reprinted. Svend Eriksen (*Early Neo-Classicism in France* [London, 1974], pp. 181–182) discusses the inventory, though he states there were two inventories after Foullet's death and at least seven benches listed in the workshop.
3. A commode in the Nationalmuseum, Stockholm, in the transitional style generally associated with the work of Foullet's son Pierre-Antoine (circa 1732–circa 1780, master 1765), is stamped "ANT. FOULET," for the father, and "BOUDIN," for Léonard Boudin. Alexandre Pradère has stated (letter to the author, dated July 25, 1990) that this commode was made by the son and passed on to the father for repayment of certain debts. The father stamped the commode in order to sell it, and then passed it on to Boudin, again in repayment of certain debts. Boudin would also finally have had to stamp the commode in order to sell it.
4. Bibliothèque Doucet, Paris, VI E Rés. fol. 8.
5. Galerie Georges Petit, Paris, December 4, 1925, lot 26.
6. Kunsthaus Lempertz, Cologne, May 24–26, 1982, lot 1711. Illustrated in Ottomeyer and Pröschel, *Vergoldete Bronzen*, vol. 1, p. 90.
7. *Maison et Jardin* 33 (December 1955–January 1956), p. 104.
8. New York, Sotheby Parke Bernet, November 1, 1975, lot 227 (not illustrated). Acquired at that auction by Dalva Brothers, New York.

XVI

Mantel Clock

French (Paris), circa 1772

Movement by Etienne-Augustin Le Roy (1737–1792; master 1758) (see Biog., p. 183); case by Etienne Martincourt (died after 1791; master 1762)

HEIGHT: 2 ft. 4 in. (66 cm)
WIDTH: 1 ft. 11½ in. (59.7 cm)
DEPTH: 12¾ in. (32.4 cm)

73.DB.78

DESCRIPTION

The case is constructed entirely of gilt bronze. The movement is contained in an ovoid urn, girdled by a band of rosette-filled guilloche. At the center of each side, rectangular brackets hold loose rings (fig. 16c). The body of the urn is decorated with four large acanthus leaves set within burnished frames between which rise rods that terminate above in leafy buds. Wreaths of laurel leaves, tied at the top with a ribbon, surround the dial and the hinged door at the back.

The fluted stem of the urn ends in a laurel-wreath base, which rests on a simple square base which is in turn placed on a high plinth with incurvate corners decorated with panels of rosette-filled trellis. At either side of this plinth is seated a female figure. That on the left, representing Astronomy, holds a globe in one arm (fig. 16a), while that on the right, representing Geography, holds a scroll of paper (fig. 16b). Both wear loosely girdled robes.

The entire sculpted composition thus formed rests on a rectangular platform, the semicircular ends of which are decorated with panels of studded guilloche, and the front and back with reeded gadrooning. This platform in turn rests at either end on a recessed semicircular substructure boldly modeled with a modified egg-and-dart motif. The front and back corners of the rectangular central section rest on turned feet. The hinged and latched door at the back is elaborately pierced (fig. 16e).

MARKS

The dial is signed CHARLES LE ROY/A PARIS. The movement is engraved *Ch^(les) LeRoy Æparis* and stamped "2417" on the back plate (fig. 16d); two springs are signed

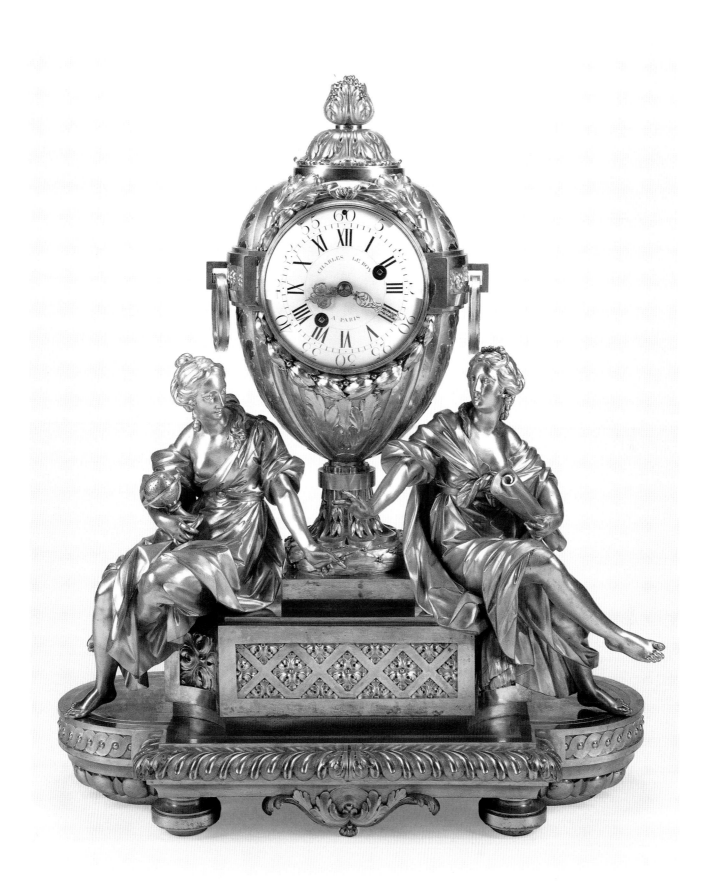

and dated *Richard fevrier 1772* (fig. 16f) (see Biog., p. 193). The following repairer's marks are found on the dial plate: *Grandperrin fils fevrier 1826 / G Bonnefont neveu / 20 Juine 1889*. The cock for the bell is marked with the number "1962."

COMMENTARY

The clock case is a remarkably fine example of gilt-bronze work from the second half of the eighteenth century. The body is composed of a number of separate, fairly massive elements: the ovoid urn housing the movement, the former's finial, its stem and base, the two figures and the plinth on which they sit, the platform and the feet. With the exception of the rings and their brackets, all the decoration of the urn, the plinth, and the platform is cast complete with the section on which it is placed and is not attached with pins or screws. The chasing, gilding, and burnishing are of the highest quality, with the heavy layer of gilding showing virtually no wear.

A drawing of this clock, shown standing on a large musical base, has recently been discovered (fig. 16g).[1] It is signed "Martincourt" for the *bronzier* Etienne Martincourt. Jean-André Lepaute also associated Martincourt's name with a clock with similar characteristics, which he described in his book *Description de plusieurs ouvrages d'Horlogerie* (Paris, 1764), under number 6:

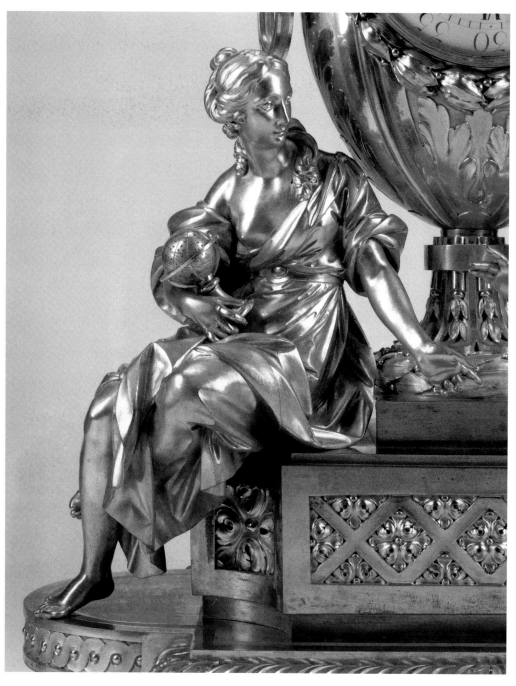

16A

Une Pendule de 27 pouces de hauteur & de 22 pouces de large, placée dans un beau vase de forme antique couronné par des fruits & des fleurs, accompagné de ses anneaux avec des impostes ornés d'entrelas. Le Cadran qui a 5 pouces & demi, est placé dans une lunette qu'entourent des guirlandes de laurier, le vase se termine en oeuf, il est soutenu sur une base ronde ornée de canelures, dans lequelles sont des feuilles de laurier, son tore est aussi enrichi d'ornemens.

Deux figures placées noblement & richement drapées sont assises sur un grand socle qui porte la Pendule & sa base, elles expriment l'Astronomie & la Géographie; le socle est orné d'une mosaïque garnie en rosaces.

Cet assemblage est placé sur un grand plateau de bronze qui a une partie quarrée, terminée par deux demi-cercles avec des retours en équerre; ce plateau est orné de moulures formant quart de rond, quarré & cavet, le quart de rond est orné de canaux & feuilles d'eaux dans les milieux & dans les angles; les parties cintrées sont ornées par des frises, au milieu desquelles sont des doubles entrelas; le total est porté sur six pieds ornés d'oves, & il en résulte un tout d'une forme nouvelle, noble & gracieuse. Je ne suis entré dans le détail des ornemens & des petites parties; que pour faire voir qu'on les a composés avec choix & avec dessein. Ce modèle est de M. Martincourt, *très-habile Ciseleur, aussi-bien que le suivant. La Pendule vaudra 3000 liv. quand elle sera dorée en entier: mais quand les figures seront seulement en couleur de bronze, 2700 liv.*[2]

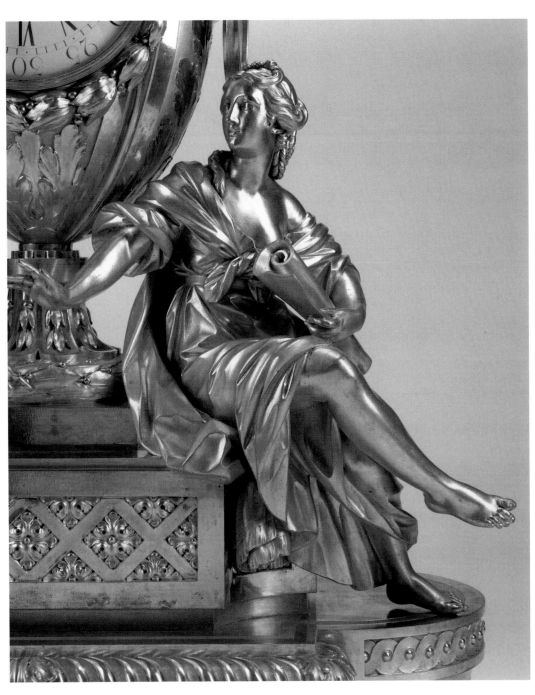

16B

The latter part of the description closely resembles the base of the clock under discussion. Lepaute clearly states that "this model is by the *ciseleur* Martincourt." In subsequent clock descriptions in the same list, Lepaute shows himself to be very precise as to what each workman was responsible for—mentioning the designer Cauvet[3] and the *bronzier* Osmond.[4] With this information and the evidence of the signed drawing, there can be little doubt that Martincourt or his workshop was responsible for at least the model if not the actual making of the case.

It has been suggested, almost certainly incorrectly, that the figures of Astronomy and Geography were designed by Augustin Pajou (1730–1809),[5] who is known to have worked on a number of clock designs during his long career.[6] However, the recent publication of the clock delivered in 1755 for the bedroom of Louis XV at Fontainebleau would tend to discount this attribution.[7] That clock is decorated with allegorical figures of "La Force" and "La Prudence," the latter of which is virtually identical to the figure of Astronomy on the Museum's clock dating at least ten years later.[8] Pajou was a student at the French Academy in Rome from 1751 to 1756 and therefore probably would not have been asked by the Menus-Plaisirs for such designs. Whoever was responsible for the design of the figures on the Museum's clock, it is obvious that he was someone of talent like Pajou.

A pencil and wash drawing of a different clock with identical figures, attributed in 1970 to Jean-Démosthène Dugourc (1749–1825) with scant foundation, is in the Kunstbibliothek, Berlin.[9] Three eighteenth-century examples of this later clock are known, all with figures of Astronomy and Geography identical to the Getty example in patinated rather than gilt bronze.[10]

It has been assumed that Charles Le Roy, who signed both the dial and the back plate of the Getty clock, was himself responsible for its movement. However, the fact that the two mainsprings, which are probably original, are signed and dated "Richard fevrier 1772" would make this impossible since Charles Le Roy died the year before. Therefore, the movement must have been made in his workshop under the supervision of his son Etienne-Augustin, who continued to use his father's name, as was the accepted custom at the time.

Since the clock bears no inventory marks, tracing its early history has proved difficult. Etienne-Augustin Le Roy was attached to the personal household of the Dauphin, later Louis XVI, who purchased six clocks from the younger Le Roy between September 1773 and January 1777. Since the Getty clock is the only example known with a dial painted with the name of Charles Le Roy it is assumed that it is the one described in the 1790 inventory of the Salle du Conseil at the Tuileries:[11]

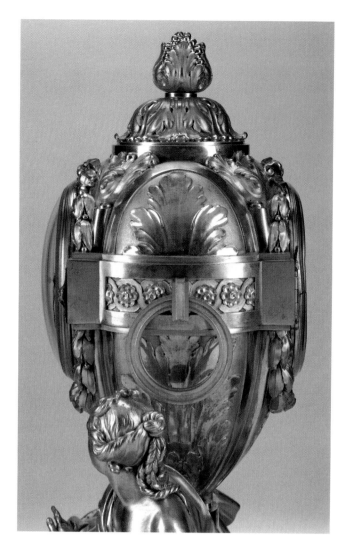

16c

16d

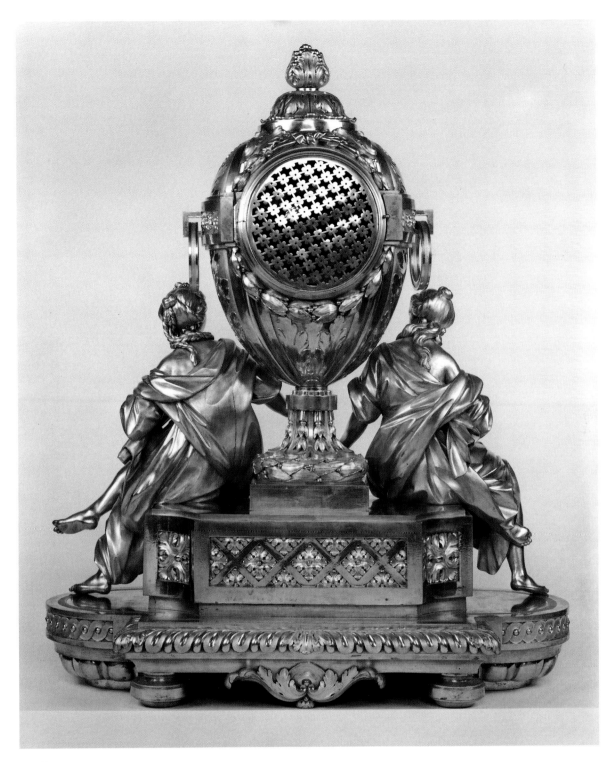

16E

16F The spring of the going train, signed *Richard fevrier 1772*

MANTEL CLOCK 119

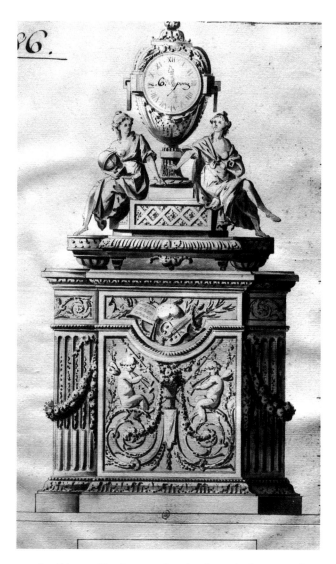

16G Etienne Martincourt, drawing for a clock on a musical base (Paris, Bibliothèque Doucet, inv. VI E Rés, fol. 86).

Une pendule de 26 po. de haut compris le socle, de 22 po. de large représentant un vase soutenu par 2 femmes, l'une tenant une sphère, l'autre une carte geographique; le vase orné de fleurs d'ornements, le mouvement de Charles Le Roy.[12]

The Tuileries was sacked on August 10, 1792, and much of its contents was transported to the Maison Coigny. The above-mentioned clock is described as coming from that depot in a document dated 24 Prairial An II (June 12, 1794).[13] It was subsequently moved to the *cabinet de physique* at the Louvre, from where, on 24 Brumaire An IV (November 15, 1795), it was requested with twenty-three other clocks by Pierre Bénézech, ministre de l'Intérieur, for the decoration of the apartments of the Directorate at the Palais de Luxembourg.[14] All the clocks were delivered to the clock-maker Robert Robin by 27 Brumaire An IV (November 18, 1795),[15] to the Garde Meuble by 29 Frimaire An IV (December 20, 1795),[16] and finally to the service of the Directoire Exécutif at the Luxembourg on 7 Ventose An IV (February 26, 1796).[17]

The subsequent history of the clock is uncertain. The lack of inventory numbers would seem to indicate that it had left the French public collection by 1832, when a general inventory of all the royal residences was completed (this entailed new numbers being placed on all the objects following the coronation of Louis-Philippe two years earlier). A similar inventory and numbering was done under the Second Empire. The clock can possibly be identified as lot 1 in the 1861 auction of the possessions of the marquis de Saint Cloud.[18]

OTHER EXAMPLES

At least three other eighteenth-century examples of the same form as the Museum's clock are known. One, its case identical except for the bezel surrounding its dial, was auctioned in Paris in 1994, having been owned, like the Getty clock, by Kraemer & Cie in the early 1970s.[19] Its dial bore the names of the clock-maker Lepaute—probably Jean-André Lepaute—and the enameler Georges-Adrien Merlet. A second clock, its dial enameled with the name Pierre Le Roy (1717–1785) and containing a later movement, was auctioned in London in 1959.[20] A third, bearing no makers' names, is owned by the Cooper-Hewitt Museum, New York, and is on extended loan to the Detroit Institute of Arts.[21] That clock differs from the Getty example in that its platform base is of red marble rather than gilt bronze and the frieze plaque above depicts disporting cherubs rather than trellis. The crisper chasing of its two figures, together with the red marble base and the swags of flowers enameled around its dial, suggests that it dates far later in the eighteenth century.

A possible fourth example, consisting of the central urn on a slightly differing stem, was sold in Paris in 1995.[22] Its dial was enameled, like the clock auctioned in London in 1959, "PIERRE LE ROY A PARIS," and its movement was similarly a replacement. Threaded holes on the underside of its base suggest that it was once attached to something and that it too started life as a complete version. The possibility that it is the central section of the 1959 clock cannot be ignored.

Various other versions of the present example can be seen in published interior views,[23] but given the great number of later copies made, it is impossible to date any of these from small-scale illustrations. Among the nineteenth-century *bronziers* known to have made copies of this highly admired model are Henri Dasson,[24] Ferdinand Barbedienne,[25] Denière,[26] Delafontaine,[27] and Victor Paillard.[28] A number of such examples were paired with candelabra.

MOVEMENT

Brass and iron, partly blued

Note: The number in parentheses represents the number of teeth on each wheel. These numbers are repeated again in the drawings of the movement.

The movement (figs. 16h, i, and j) consists of two trains driven by mainsprings, each of which runs one week. The going train provides power for the hands which indicate the hours in roman numerals and the minutes in arabic numerals on the main dial. The clock strikes the hours and half hours on the same bell.

The going train has one rotating barrel (72), which holds the mainspring and four pinion wheels (12/80–8/72–6/66–6/32), the last being the escape wheel. The train is regulated by an anchor escapement (recoil escapement) in connection with a pendulum. The pendulum can be adjusted while the clock is running using a key inserted in a hole in the dial at number XII. When the key is turned the working length of the pendulum is changed. This so-called Brocot suspension is a later addition to the clock; it is stamped with the number *620*. Originally the clock probably had a silk suspension. The third wheel holds the cannon pinion (30), a part of the motion work (30–30/6–72), and the minute hand. The hour wheel (72) holds the hour hand. The cannon pinion (30) rotates once every hour; it has two pins that release the striking train every half and full hour.

The striking train is to the left of the going train. This type of striking train has a locking plate (count wheel). This train has one rotating barrel (72), which holds the mainspring, four pinion wheels (12/72–8/60–6/54–6/48), and a fly vane (6). The third wheel (8/60) has ten pins that move the striking hammer.

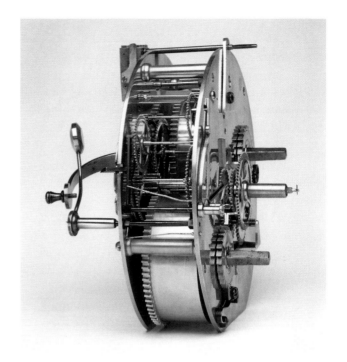

16H Side view of the movement.

16J Detail showing the Brocot escapement.

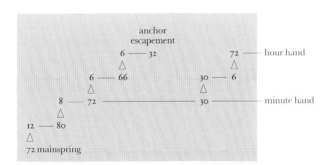

Going train

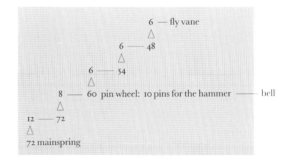

Striking train

EXHIBITIONS

Paris, Grand Palais, "VIeme Biennale Internationale des Antiquaires et Décorateurs," 1972(?); Detroit Institute of Arts, 1972–1973; New York, The Frick Collection, "French Clocks in North American Collections," November 1982–January 1983, no. 63.

PUBLICATIONS

B. Fredericksen, H. Lattimore, and G. Wilson, *The J. Paul Getty Museum* (London, 1975), p. 165; Wilson, *Clocks*, pp. 64–66, no. 13; Wilson, *Decorative Arts* (1977), p. 70, no. 94; W. Edey, *French Clocks in North American Collections*, exh. cat. (New York, The Frick Collection, 1983), p. 67; Sassoon and Wilson, *Decorative Arts: A Handbook*, pp. 41–42, no. 90; Ottomeyer and Pröschel, *Vergoldete Bronzen*, vol. 1, p. 181; *The J. Paul Getty Museum Handbook of the Collections* (Malibu, 1988), p. 169; J.-D. Augarde, "L'Ameublement du Palais Directorial du Luxembourg," *De Versailles à Paris* (Centre Culturel du Panthéon, Paris, 1987), pp. 140, 146, fig. 1; Bremer David et al., *Decorative Arts*, p. 91, no. 142.

PROVENANCE

Louis XVI, Salle du Conseil, Château des Tuileries, 1790. (?) Sold from the collection of the marquis de Saint Cloud, Hôtel Drouot, Paris, February 25–26, 1861, lot 1. Kraemer & Cie, Paris, circa 1972. French & Company, New York, 1973. Acquired by the J. Paul Getty Museum in 1973.

NOTES

1. Bibliothèque Doucet, Paris, Vi E Rés. fol. 86: Ottomeyer and Pröschel, *Vergoldete Bronzen*, vol. 1, p. 181, fig. 3.7.9.
2. *Description de plusiers ouvrages d'Horologerie par LE PAUTE, Horologer du Roi, rue Saint-Honoré, près la Croix du Trahoir, A PARIS* (1764), pp. 6–8. I am indebted to Jean-Dominique Augarde for providing the information from this rare book.
3. Gilles-Paul Cauvet (1731–1788), architect and designer to Monsieur, brother to the king.
4. Robert Osmond (1720–1789).
5. See the description of a clock of this model, which was placed at auction (Paris, November 29, 1824, and following days, lot 143) as part of the contents of the "Galerie de M. Feuchère *père*." There the movement is said to be by Lepaute, the figures by Pajou, the execution of the case by Martincourt and the caryatids of the musical base by Stouf (1742–1826). The object apparently did not sell, as it reappeared with an expanded description in the catalogue of the Paris sale of Feuchère *père* on January 19, 1829, and following days, lot 61.
6. See H. Stein, *Augustin Pajou* (Librairie Centrale des Beaux Arts, Paris, 1912). The author mentions six clock models or drawings. The first was commissioned in 1765 by the king of Denmark; the drawing for this clock was exhibited in the Salon of that year (pp. 201–203, 399, pl. X). In 1770 Pajou was commissioned to create a clock model to celebrate the marriage of the Dauphin to Marie-Antoinette (pp. 98, 403, fig. 43). A year later Pajou exhibited at the Salon a drawing of a clock with the figures of Time and the Four Seasons (pp. 101, 404). In 1775 the prince de Condé commissioned a clock model from Pajou which again depicted Time and the Four Seasons (pp. 201, 334–335, 407). Finally, two versions of the clock commemorating the birth in 1781 of the first Dauphin (pp. 101–103, 405) were made in bisque by the porcelain factory at Sèvres.
7. P. Verlet, *Les Bronzes*, pp. 285, 287, ill. This clock was formerly in the collection of Edmund de Rothschild and was sold by Christie's, London, July 3, 1975, lot 52. The catalogue states that the dial is signed "Jn. MARTINOT/DE L'HOROLOGERIE DU PALAIS" and that the back plate is inscribed "J. Martinot Hgr du Roi Sept 1755."
8. Prudence is holding a mirror around which is wrapped a serpent. The Getty Museum's figure is holding a celestial globe. There is also a difference in the way the drapery falls on the two figures.
9. Inv. Hdz 2862, E. Berckenhagen, *Die Französischen Zeichnungen der Kunstbibliotek Berlin* (Berlin, 1970), p. 393.
10. One with an undecorated *bleu turquin* counterbase and a dial signed "Lepaute" was sold from the collection of Princesse Murat and the Prince Joachim Murat at Palais Galliera, Paris, on March 2, 1961, lot 64. Another with a white marble base decorated with a gilt-bronze guilloche frieze and a dial signed "J. B. Duterte AParis" was sold at Sotheby's, Monaco, June 14, 1982, lot 473, while a final unpublished example, closest to the Berlin drawing, with *bleu turquin* marble and a zodiacal dial signed by Lepaute and the enameler Joseph Coteau, is preserved in the Catherine the Great Palace at Pushkin, having been in Saint Michael's Palace, Saint Petersburg, in the nineteenth century. A nineteenth-century example with patinated figures and a dial enameled "Fd. Berthoud Paris" was auctioned at the Auktionsverk, Stockholm, November 14–17, 1989, lot 259.

11. Information supplied by Jean-Dominique Augarde, who also suggests (letter to the author, dated April 17, 1991) that the Museum's clock was purchased through the Menus-Plaisir.
12. A.N., O^1 3418, fol. 124. Inventory dated May 21, 1790. Information kindly supplied by Christian Baulez.
13. A.N., T 1077.1 *Etat des instruments de physique en depot a P . . . [?] section de physique et provenant de la Maison Coigny. Le 24 prairial an 2. [. . .] No. 22*: "Une pendule a vase avec deux figures representant la geographie et l'astronomie en bronze dore d'or moulu. Mouvement ordinaire de Charles le Roi." Information provided by Patrick Leperlier.
14. A.N., O^2 444. Letter from the Minister of the Interior to Citoyen Charles, Conservateur du Cabinet de Physique au Louvre. Information supplied by Jean-Dominique Augarde.
15. A.N., O^2 444. Letter from Jacques-Alexandre-César Charles to the Minister of the Interior. The clock is also described in the *Etat des Pendules Remises au C. Robin en vertu de l'ordre du ministre de l'Intérieur 10*: "Pendule a vase avec deux figures de la géographie et l'astronomie doré d'or moulu par Charles le Roi. Inv. Coigni, n° 22, au comité de division" (A.N., Paris, O^2 444). It is possible that Robert Robin had previously had possession of this clock. In the *Etat de l'horlogerie particulière du cy-devant Roy, en 1793*, it is described under number 5 as follows: "Une pendule en forme de vase ornée de deux figures représentant l'astronomie et la géographie, le tout en cuivre doré et or moulu, le mouvement à sonnerie—2 pieds de haut et 1 pied 6 po de large—par Charles Le Roi, Chez M. Robin." Information provided by Guy Kuraszewski.
16. A.N., O^2 444. Letter from Bayard, Inspecteur du Garde-Meuble National, to the Minister of the Interior.
17. A.N., O^2 413, fol. 107. *Garde Meuble, Journal des Sorties de Meubles*. Information supplied by Jean-Dominique Augarde.
18. Hôtel Drouot, Paris, February 25–26, 1861, lot 1: "Magnifique pendule ancienne du temps de Louis XVI, en bronze doré. Elle est en forme de vase richement orné de feuilles d'acanthe et de guirlandes; le socle, orné de rosaces, supporte deux figures de femmes allégoriques. Cette pièce remarquable est, en ce genre, l'une des plus belles productions de cette époque. Mouvement de Charles Leroy, à Paris."
19. Etude Couturier Nicolaÿ, Hôtel Drouot, Paris, March 31, 1994, lot 73.
20. Sotheby's, London, July 3, 1959, lot 109 (not illustrated).
21. Inv. 1947–129–1, J. Mannheim, *Catalogue of the Rodolphe Kann Collection: Objets d'Art*, vol. 2, *Eighteenth Century* (Paris, 1907), no. 184, ill. facing p. 68.
22. Etude Tajan, Hôtel Drouot, Paris, July 4, 1995, lot 75.
23. See, for example, the photograph of a clock on the mantelpiece in the grand salon of the Hôtel Bouligneux (H. Soulange-Bodin, *Le Quartier Sainte-Avoye*, vol. 15 of *Les Vieux Hôtels de Paris* [Paris, 1923], pl. 39) as well as that photographed circa 1915 on the mantelpiece of the Königskammern, Schloss Berlin (A. Geyer, *Geschichte des Schlosses zu Berlin* [Berlin, c. 1992], p. 74, pl. 107).
24. Liquidation sale of H. Dasson et Cie, Hôtel Drouot, Paris, December 10–12, 1894, lot 26. Information kindly supplied by Jean-Dominique Augarde.
25. Sotheby's, Amsterdam, December 21, 1993, lot 492.
26. Laurin, Guilloux, Buffetaud & Tailleur, Palais d'Orsay, Paris, April 3, 1979, lot 78.
27. Jean Gérard-Tassel and Robert Juge, Succession Réthoré, Château de la Mercerie à Magnac-Lavalette, Angoulême, June 24–25, 1987, lot 2.
28. A clock of this model with gilded figures and a dial signed "Victor Paillard / Ft. De Bronzes / A Paris" is in the collection of the Italian *bronzier* Mascaro Renato, Treviglio (Bergamo). According to Tardy (*Dictionnaire des Horlogers Français*, p. 499), Paillard was active in Paris between 1840 and 1870. Renato, who owns a second example with patinated figures and a dial signed "Lafontaine / Bronzes / Paris," has made his own reproductions curiously mounted with dials painted with streams, bridges, and figures.

XVII

Mantel Clock

French (Paris); circa 1785

Case attributed to Pierre-Philippe Thomire (1751–1843); design attributed to Jean-Guillaume Moitte (1746–1810); rings enameled by H. Fr. Dubuisson (died circa 1823; master 1769) (see Biog., p. 169); maker of movement unknown

HEIGHT: 1 ft. 8⅞ in. (53 cm)
WIDTH: 2 ft. 1⅛ in. (63.8 cm)
DEPTH: 9¼ in. (23.5 cm)

82.DB.2

DESCRIPTION
The mantel clock is in the form of bronze figures performing a classical libation. Two patinated bronze female figures tend the flame, one pouring a libation into a flame atop a white marble drum-shaped altar. The altar, which houses the movement, is fitted with horizontal enameled and jeweled hour and minute rings (fig. 17a) and decorated below with a gilt-bronze relief depicting a sacrificial procession. The altar is topped by a broad molding of milled gilt bronze with two gilt-bronze ram's heads at either side; behind these pass the enameled chapter rings. The white marble disk that forms the top of the altar is centered by a gilt-bronze brazier containing the sacrificial flame. At the front a gilt-bronze floral spray falls over the edge of the altar to mark the time.

The patinated bronze figures rest upon a rectangular white marble plinth with semicircular ends, upon which are also placed a gilt-bronze basket of flowers (Fig. 17b), a patinated bronze urn across which is a draped cloth (at left), and a low gilt-bronze brazier decorated with ringed lion's masks and issuing clouds of patinated bronze smoke (at right). The plinth, which rests on four bun-shaped feet, is inset with a gilt-bronze openwork frieze across the front and gilt-bronze garlands at each end.

MARKS
The interior of the hour ring is signed by the enameler Dubuisson behind the numeral VI. The spring of the striking train is signed: SANDVIK/*Sweden*. The following graffiti are found on the dial plate: *Repar of AJG . . . pe 1811 d . . . of Stockholm* and the numbers *H4733/H5522/H6098*. The pendulum suspension is signed by Achille Brocot.

17A

COMMENTARY

The two female figures represent vestals tending the flame of the Temple of Vesta, the goddess of the hearth. The clock would have been placed on a mantelpiece and thus the classical theme would have been suitably related to the hearth beneath it.

A clock of the same model appears in a watercolor drawing in the Musée des Arts Décoratifs, Paris (fig. 17c), that represents a mantelpiece set with various objects.[1] The two halves of the drawing differ, and it would seem that it was intended as a scheme for alternate arrangements. The clock is placed on the center of the mantelpiece. It does not have bun-shaped feet but a solid counterbase. The artist has also indicated liquid spilling from the libation bowl held by the standing figure.

Most of the objects shown in the drawing are known to exist and all are known to be by, or have been attributed to, the *bronzier* Pierre-Philippe Thomire (1751–1843).[2] Examples of the candelabrum on the right end of the mantelpiece are found in Sweden[3] and in the Getty Museum (86.DF.521). The writing figure on the oil lamp is known as *La Philosophie* and was designed in about 1780

17B

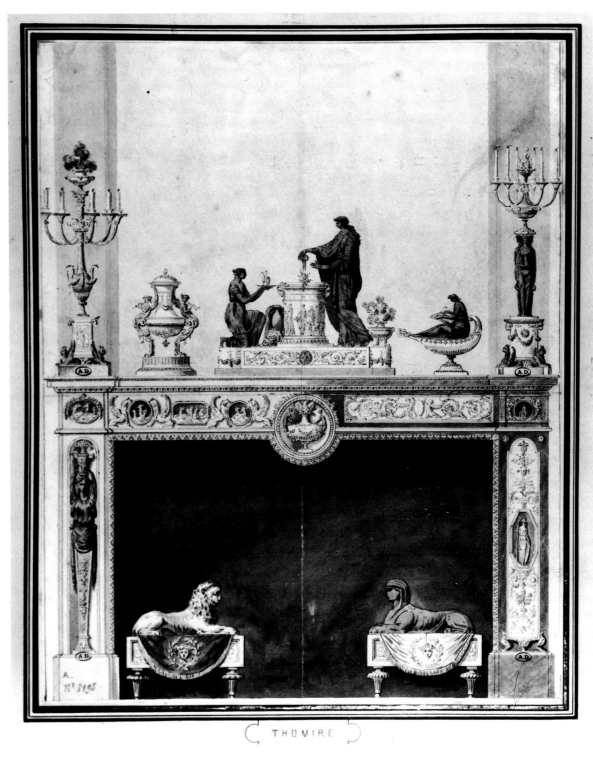

17C Attributed to Pierre-Philippe Thomire, drawings for a mantelpiece with alternate designs, supporting a clock, vases, and candelabra (Paris, Musée des Arts Décoratifs, inv. 8195).

by Louis-Simon Boizot (1743–1809).[4] In that year, Boizot sold the model to the porcelain factory at Sèvres along with the companion figure *L'Etude* (Reading). Many examples of these two figures have survived either in bronze or biscuit porcelain.[5]

An example of the candelabrum on the left is not known, though the tripod base with winged griffins closely resembles the bronze and Sèvres tripod altar used by Thomire on the clock he made in 1788 for the bathroom of Marie Antoinette at the Tuileries.[6] Even more telling is the comparison of the candelabrum in the drawing to a pair of similar candelabra from 1790–1791 signed by Thomire and now in the Royal Palace in Madrid.[7] These also bear the same Sèvres tripod with bronze griffins.

The firedogs shown on the hearth also exist. The one with the sphinx resembles the pair made in 1786 for the Salon des Nobles de la Reine at Versailles for which Thomire chased the figure of the sphinx and supplied the model of the face in the frieze on the front.[8] In the same year, Thomire was also working on another pair of firedogs which resemble the firedog with a lion. They were made for the Salon de la Paix at Versailles, where they now are exhibited.[9] Another pair, also at Versailles, shows great similarities with the lion example, even to having a mask in the center of the front frieze.[10]

The fireplace in the drawing also has a possible connection with Thomire. He is known to have supplied virtually all the gilt-bronze mounts for porcelain made at and sold by Sèvres. In 1789 and again in 1791, Thomire mounted fireplaces with Sèvres porcelain plaques, one of which was sold to the duc d'Orléans, the other to the princesse Kinski, each for 6,000 *livres*.[11]

It is possible that Jean-Guillaume Moitte (1746–1810) provided the design for this clock.[12] Both he and Thomire were part of a small but influential group of artists who were much sought after in Paris before the Revolution. Moitte was one of the foremost exponents of the fashionable Etruscan and Roman styles during the last decade of the ancien régime. Many of his drawings deal with classical subjects and demonstrate his consummate skill in this medium. One of these, now owned by the E. B. Crocker Art Gallery in Sacramento possibly inspired the original design of the Getty clock.[13] It shows a circular altar to the left of which stand a man and a woman who together pour a libation from a shallow dish onto a small fire, thus creating billowing smoke. To the right, a kneeling woman offers a garland of flowers to the couple, on either side of her are an overturned basket of flowers and an urn. The major difference between the drawing and the Getty clock is that the former shows both a man and a woman pouring the libation. If one combines the woman's body with the man's arms, the combination would be extremely close to the standing figure. According to Richard James Campbell, Moitte exhibited at the Salon of 1785 a work described as: "Une vestale faisant l'aspersion de l'eau, modele en plâtre de 3 pieds de tout."[14] This subject might well be that of the figures on this clock.

It has been suggested that the gilt-bronze frieze on the base of the Getty Museum's clock was designed after the frieze which runs around the roof line of the Temple of Antoninus and Faustina in the Roman Forum.[15] It certainly would have been possible for Moitte to have studied this building while he was a student in Rome. The same published source suggests that the design for the standing figure at the altar might have been inspired by drawings executed by Jacques Louis David while in Rome and to which his students later had free access. A drawing by David representing the funeral of a warrior, now in the E. B. Crocker Art Gallery, has also been suggested as a possible source for the design of this clock in general, if not for the frieze around the altar drum in particular.[16]

Unfortunately, many of the artists working in Paris during the ten or so years before the Revolution produced similar drawings from identical sources. It is therefore impossible to point to David's drawings as the source of inspiration. Moitte himself is known to have designed similar friezes, notably the one he executed in 1783 for the prince de Salm-Kyrbourg at the Hôtel de Salm in Paris.[17] A close comparison of the frieze with the clock reveals many similarities, notably the presence of a sacrificial bull being led to slaughter and the identical shape of the altar with ram's heads at the top. On a different façade of the Hôtel de Salm, the sculptor Philippe-Laurent Roland (1746–1816) supplied a pair of friezes representing sacrificial processions which display much of the same imagery and could also be thought to have inspired the *bronzier*.[18]

The specific sources for the sacrificial procession around the altar of the clock have not as yet been located.

OTHER EXAMPLES

Four other examples of the same model are known. All are slightly different from the Getty clock and none bear the jeweling on the hour and minute rings nor the patinated bronze cloth over the marble vase to the left of the altar. The most similar clock is in the collection of Andrew Ciechanowiecki in London and was exhibited in 1972 in "The Age of Neo-Classicism."[19] In this example the smoke from the brazier on the right is in gilt bronze rather than patinated bronze.

Another example, sold by Sotheby's, Monaco, in 1980, has blue enameled hour and minute rings. Gilt-

bronze swags caught up by ribbons rather than the sacrificial procession surround the altar, which is itself made of *bleu turquin* marble.[20]

The third example is owned by the Marquess of Bath at Longleat.[21] Here the drum is made of enameled metal and supports a disk of gilt bronze rather than white marble. The body of the tripod incense burner to the right is made of patinated bronze with the legs and moldings in gilt bronze. The smoke emanating from the urn is made of gilt bronze. A small gilt-bronze flower basket has been added in front of the standing figure. The counterbase is of *griotte* marble and conforms to the shape of the white marble base. The movement is by Lépine.

The final example is in the Musée Masséna, Nice.[22] The altar and its lid are made of green *griotte* marble. The smoke emanating from the urn is made of gilt bronze. The frieze across the front of the white marble base does not include griffins as on the Getty clock but is made up of swags with two bull's heads and a large trophy in the center. It is the only clock of this model to contain the two hanging trophies at the end of the frieze, which appear to be identical to those on the front of the Getty clock.[23] The gilt-bronze decoration on the semicircular ends also differs and consists of swags and hanging trophies rather than garlands. There is also a counterbase of *griotte* marble with a gilt-bronze molding around its top. The feet are *toupie*-shaped.

MOVEMENT
Brass and iron, partly blued

Note: The number in parentheses represents the number of teeth on each wheel. These numbers are repeated again in the drawings of the movement.

The movement (figs. 17d and e) consists of two trains driven by mainsprings, each of which runs for about one week. The going train provides power for two enameled rings which indicate the hours in roman numerals and the minutes in arabic numerals. The clock strikes the hours and half hours on the same bell.

The going train has one rotating barrel (80), which holds the mainspring and four pinion wheels (12/80–8/84–67/64–6/30), the last being the escape wheel. The train is regulated by an anchor escapement (deadbeat escapement) in connection with a pendulum. The pendulum can be adjusted while the clock is running by moving a hand located on the top of the movement. When the hand is turned the working length of the pendulum is changed. This so-called Brocot suspension is a later addition to the clock. It was originally made for a vertical clock and later altered for use in this clock. The third wheel holds the cannon pinion (30), a part of the motion work

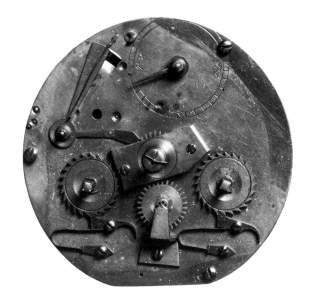

17D The movement from above.

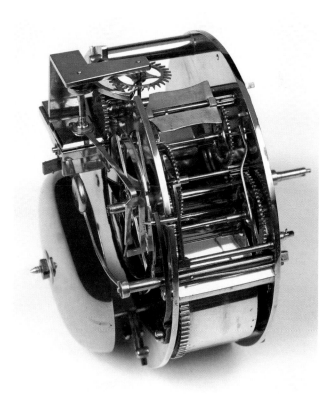

17E Side view of the movement, showing the escapement.

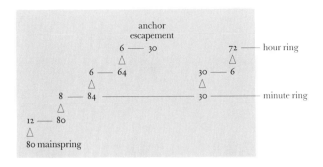

Going train

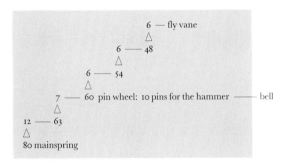

Striking train

(30–30/6–72), and the minute ring. The hour wheel (84) holds the hour ring. The cannon pinion (30) rotates once every hour; it has two pins that release the striking train every half and full hour.

This type of striking train has a locking plate (count wheel). This train has one rotating barrel (80), which holds the mainspring, four pinion wheels (12/63–7/60–6/54–6/48), and a fly vane (6). The third wheel (7/60) has ten pins that move the striking hammer.

The pendulum is modern.

PUBLICATIONS

G. Wilson, "Acquisitions Made by the Department of Decorative Arts, 1981," *GettyMusJ* 10 (1982), pp. 79–84, ill.; "Some Acquisitions (1981–82) in the Department of Decorative Arts, The J. Paul Getty Museum," *The Burlington Magazine* (May 1983), illustrated on p. 322 and on the cover; A. Gonzalez-Palacios, *The Adjectives of History: Furniture and Works of Art 1550–1870* (P. & D. Colnaghi and Co., London, 1983), pp. 44–45; G. Wilson, *Selections from the Decorative Arts in the J. Paul Getty Museum* (Malibu, 1983), pp. 84–85, no. 42, ill.; Sassoon and Wilson, *Decorative Arts: A Handbook*, p. 42, no. 91, ill.; Ottomeyer and Pröschel, *Vergoldete Bronzen*, vol. 1, p. 299, ill.; Bremer David et al., *Decorative Arts*, p. 92, no. 144, ill.

PROVENANCE

In Sweden by 1811. Baron de Klingspor, Stora Sundby Castle, Sweden. Sold, Sotheby's, London, December 11, 1981, lot 99. Acquired by the J. Paul Getty Museum at that sale.

NOTES

1. Inv. 8195, Cliché 5193. The drawing has traditionally been given to Pierre-Philippe Thomire. This attribution can be seriously questioned since this artist is not known to have drawn objects or rooms. Jean-Demosthene Dugourc (1749–1825) has also been suggested as the drawing's author. This is certainly more likely, though no substantial proof has been offered. For the time being, therefore, the artist must remain anonymous. Christian Baulez has suggested that this drawing comes from a catalogue by the *marchand-mercier* Dominique Daguerre (circa 1740–1796).
2. For a biography of Thomire, see J. Niclausse, *Thomire* (Paris, 1947), and D. H. Cohen, "Pierre-Philippe Thomire–Unternehmer und Künstler," in Ottomeyer and Pröschel, *Vergoldete Bronzen*, vol. 2, pp. 657–665.
3. Stockholm, Husgerådskammaren HGK 68, Ottomeyer and Pröschel, *Vergoldete Bronzen*, vol. 1, p. 298, no. 4.18.7.
4. See R. Savill, *The Wallace Collection: Calatogue of Sèvres Porcelain*, vol. 3 (London, 1988), pp. 967–969.
5. The Getty Museum owns one set of these bronze figures (88.SB.113). They were sold at auction by Sotheby's, Monaco, February 5, 1978, lot 20. The bronzes were also used to decorate clocks. Many of these have passed through the art market. A pair were sold at the Hôtel Drouot, Paris, June 28, 1989, lot 111.
6. Musée des Arts Décoratifs, Paris (dial signed by Robert Robin), Verlet, *Les Bronzes*, p. 326, fig. 360.
7. See Verlet, *Les Bronzes*, pp. 41, 47, ill.
8. Ibid., pp. 214, 215, figs. 241, 242. The firedogs were created under the direction of Jean Hauré. Louis-Simon Boizot was responsible for the sphinx models; the *fondeur* was probably Pierre-Auguste Forestier; the gilding was done by Claude Galle; Boivin supplied the model for the cornucopiae frieze across the front; and Coutelle supplied the *frise en poste* for the semicircular ends.
9. Inv. V.3329, Château de Versailles, Verlet, *Les Bronzes*, p. 369, fig. 380. Some of the same artists worked under Hauré in the making of these firedogs as for the ones previously discussed.
10. Inv. Vmb. 1389, Château de Versailles.
11. See Verlet, *Les Bronzes*, p. 80.
12. It has been suggested without documentation that the designer of the clock was Louis-Simon Boizot. See *The Age of Neo-Classicism* (The Royal Academy, London, 1972), p. 759, no. 1620.
13. Inv. 1871.451, S. Howard, ed., *Classical Narratives in Master Drawings Selected from the Collection of the E. B. Crocker Art Gallery* (Davis and Sacramento, 1972), p. 25, no. 21, where it was renamed "Ritual Marriage Preparation." Moitte's drawing might have been inspired by the so-called Aldobrandini Wedding fresco. The frieze-like format of the fresco was a great inspiration to many of the students and artists who studied in Rome at this time. Moitte could have seen the fresco while he was a *pensionnaire* at the French Academy in Rome from 1771 to 1773. His subsequent designs demonstrate his affinity for this type of pictorial structure. The processional frieze around the altar of the clock conforms well to this prototype.
14. R. J. Campbell, *Jean-Guillaume Moitte: The Sculpture and Graphic Arts 1785–1799* (University Microfilms International, Ann Arbor, Mich., 1984), p. 12.
15. A. Gonzalez-Palacios, *The Adjectives of History: Furniture and Works of Art 1550–1870*, exh. cat. (P. & D. Colnaghi and Co., London, 1983), pp. 44–45.
16. Inv. 408; S. Howard, *Sacrifice of a Hero: The Roman Years—A Classical Frieze by Jacques Louis David*, E. B. Crocker Art Gallery Monograph Series (Sacramento, 1975).
17. Still in situ. See A. Guérinet, *Monographie du Palais de la Légion d'Honneur—Style Louis XVI* (n.d.), pl. 11. See also H. Thirion and L. Bernard, *Le Palais de la Légion d'Honneur—Ancien Hôtel de Salm—Dépenses et Mémoires Relatifs à sa Construction et à sa Décoration* (Versailles, 1883), pp. 76–78 (for the original expenses submitted by Moitte).
18. Guérinet (note 17), pls. 5 and 6. Both friezes are still in situ. See Thirion and Bernard (note 17), p. 78 (for the related expenses submitted by Roland).
19. See *The Age of Neo-Classicism* (note 12). Also illustrated in *Connaissance des Arts* 295 (September 1976), p. 13.
20. May 27, 1980, lot 656. It is now in a Parisian private collection. In 1994 a "jardinière" made of *bleu turquin* and mounted on one side with a gilt-bronze sacrificial procession similarly cast and chased to the frieze on the Getty clock sold at Christie's, New York, March 24, lot 13. It is possible that the frieze was once attached to the aforementioned clock, and that the gilt-bronze swags and ribbons are later replacements. The bases of a pair of candelabra in the Musée municipal Masséna, Nice, are also decorated with this gilt-bronze procession. They are in the Empire style and are unpublished (see photo by D. Cohen, Photo Archive, J. Paul Getty Center for the Arts and Humanities).
21. See J. Bourne, "Many Questions, Some Answers: French Furniture in British Collections," *Country Life* (October 24, 1985), p. 1261, fig. 1.
22. Illustrated in A. Guérinet, *Le Mobilier, style du premier empire, au Musée municipal Masséna à Nice* (Paris, 1922), pl. 28.
23. These trophies also appear on the plinth of a mantel clock signed by Thomire in the British Embassy in Paris, J. Vacquier, *Le Style Empire*, vol. 1 (Paris, 1920).

XVIII

Long-case Musical Clock

German (Neuwied); circa 1786

Case by David Roentgen (1743–1807); gilt-bronze mounts by François Remond (1747–1812; master 1774); movement by Peter Kinzing (1745–1816); musical mechanism by Johann Wilhelm [Jean Guillaume] Weyl (1756–1813)

HEIGHT: 6 ft. 3 in. (190.5 cm)
WIDTH: 2 ft. 1½ in. (64 cm)
DEPTH: 1 ft. 11½ in. (54.5 cm)

85.DA.116

DESCRIPTION

The clock is made up of two parts, both of rectangular form, and is veneered with burr maple over a carcass of oak. The upper section contains the movement. The dial is set within a recessed rectangular panel of stippled gilt bronze and is supported by a figure of Time who kneels on his left knee and steadies the dial on his left shoulder with his outstretched left arm and his left wing. He holds a scythe in his right hand (fig. 18b). Above the dial a ribbon ties the ends of two garlands composed of flowers, wheat, grapes, and holly, which symbolize the Four Seasons.

Above is a wide frieze set with gilt-bronze triglyphs and guttae, alternating with four metopes with gilt-bronze disks decorated with the heads of Day and Night (fig. 18a). The pediment is inset with a gilt-bronze plaque decorated with a lyre and cupids (fig. 18c).[1] A gilt-bronze balustrade, with an urn set on the pier at each corner, surrounds the top.

The remaining three sides of the upper section are architecturally consistent with the front, though decorated with simpler gilt-bronze mounts (fig. 18d). The two sides are fitted with doors, containing panels of fabric, that allow access to the movement. A door at the back is inset with a shallow brass drum with a glass disk through which the movement and part of the musical mechanism can be seen. The base of this upper section consists of a stepped plinth veneered with mahogany above a single gilt-bronze molding.

18A

18B

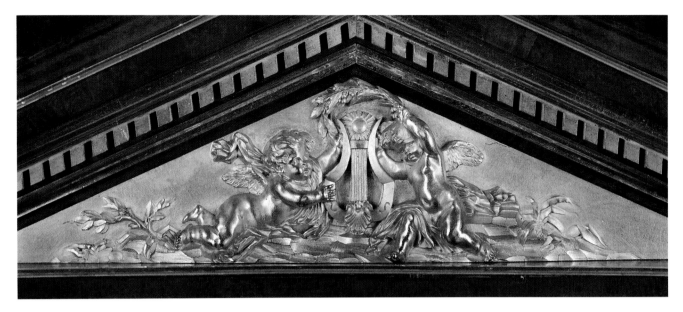

18c

The front and the two sides of the lower section have recessed panels framed, at the front, with two gilt-bronze moldings, and at the sides, with a plain wooden molding. The whole rests on a stepped plinth topped with a simple wide gilt-bronze molding.

MARKS

The bracket holding the pinned barrel cylinder is inscribed *Roentgen et Kinzing à Neuwied* (fig. 18e). There are two penciled inscriptions. The first, found on the bellows, reads *Jean Guillaume Weyl. Fait a Neuwied / le 16 May 1786 / No. 18* (fig. 18f).[2] The second, found on the wind chest, reads *I W Weyl fait 1786 / Nº 18*.[3]

COMMENTARY

A large gilt-bronze figure of Apollo playing his lyre would almost certainly have been placed on top of the clock where the holes for an attachment can still be seen. In 1784 Roentgen delivered to Catherine the Great a clock of the same model (but of different wood) with a figure of Apollo on top. It is described in an invoice submitted in that year, entitled "L'Etat des meubles achetés au Maître Roentgen [David]," as number three:

> *Grande pendule avec [jeux de] flûtes et [de] clavecins dans une boîte de bois gris ondé. Ornements de bronze doré, consistant en un fronton, une galerie, des corniches, quatre vases, des guirlandes [autour du cadran] et une figure représentant le Temps. Au haut de la boîte, la figure assise sur un rocher représente Apollon jouant de la lyre; il est sur un socle de bronze doré (1784).*[4]

Many of the comparable examples mentioned below also include the figure of Apollo, as does a slant-front desk, which was one of the earliest pieces of furniture delivered by Roentgen to Catherine the Great in 1783.[5] Two anonymous watercolor drawings of a closely comparable long-case clock show the same figure of Apollo with his lyre.[6]

The figure of Apollo, together with the mount on the pediment of the clock of two children with a lyre, and the entire face with the figure of Time were among the mounts that were supplied to Roentgen by François Remond between the years 1785 and 1787. The figure of Time was modelled by Simon-Louis Boizot.[7]

Roentgen's journeyman, David Hacker (active circa 1770–1802), seems to have copied the design of this clock. After Roentgen closed his Neuwied workshop in 1791, he requested permission from the Prussian government to allow Hacker to establish a workshop in Berlin. This was granted and by 1794 at the latest, Hacker was working in that city. A year later, in 1795, the periodical *Berliner Damenzeitung* published an engraving of a very similar long-case clock design by Hacker.[8]

OTHER EXAMPLES

Judging by the number of extant examples, this model seems to have been the most popular one made by Roentgen. The Hermitage in St. Petersburg owns two examples, both with the same model of Time (both lacking scythes), though only one has the crowning figure of Apollo with his lyre.[9] Another example, with the variant figure of Time and no crowning Apollo, was also in the Hermitage until 1927, when it was transferred to the Kremlin in Moscow.[10]

18D

18E

18F The signature of Jean-Guillaume Weyl, found on the bellows of the musical movement.

Two others were sold by the Soviet government in 1928.[11] The first, lot 80, came from Pavlovsk, had the variant Time figure, and retained the Apollo figure on top. A gilt-bronze amatory trophy of doves, arrows, and musical instruments was mounted on the front of the base. This appears to be unique to this clock. The clock brought 24,000 marks and was bought by the Kreismuseum, Neuwied, where it remains today.[12]

The second clock, lot 81, also had the variant Time figure, though it did not retain the Apollo figure on top. It brought 16,000 marks[13] and was possibly purchased at the auction by the Berlin dealer Margraf & Company, who owned it a year later.[14]

Denis Roche illustrates another example at Pavlovsk with the same figure of Time as on the Getty clock and also with the figure of Apollo on top.[15] In his description, he states that there was yet another in the Pachkevitch Collection in St. Petersburg. The present whereabouts of this clock is unknown, though it is possibly the clock mentioned in 1928 as being in the Pourtalès Collection, St. Petersburg, and destroyed in 1914.[16]

Two other clocks with the Getty figure of Time and with no crowning Apollo are known, the first in the Kunstgewerbemuseum at Köpenik in Berlin,[17] the second in a German private collection.[18] Another example has been reported at Schloss Ludwigslust,[19] though more recent scholarship has not been able to confirm this.[20]

Several examples have passed through the art market. One is described in a Paris auction in 1886[21] and was later apparently in the Oppenheimer Collection.[22] Though it is a distinct possibility, it is impossible to say with certainty that this clock is the Getty clock. Another, with the variant Time figure and no Apollo on top was sold by Sotheby's, London, from the estate of the late Sir E. H. Scott in 1940.[23] Another example, ascribed to the Roentgen workshop and dated 1790–1795, was sold in Germany in 1956. In this clock a panel of gray marble replaces the panel of bronze into which the dial is set. The same gray marble also replaces the front panel of the bottom section. Furthermore, the figure of Time upholding the dial is made of alabaster, and there is no bronze plaque inset into the pediment.[24] In 1993 a clock of similar form was with a Munich dealer.[25] In that example, the dial was not set within a panel of stippled gilt bronze but was surrounded by veneered wood. The ribbon-tied garlands were composed of berried laurel, and the figure of Time was replaced by a large gilt-bronze pierced mount, centered by a lyre and set on a panel of gilt bronze.

MOVEMENT
Brass and iron, partly blued

Note: The number in parentheses represents the number of teeth on each wheel. These numbers are repeated again in the drawings of the movement.

The movement (figs. 18g and h) consists of three trains, all of which are driven by weights. Each train runs for one week. The going train provides power for the hands, which indicate the hours in roman numerals and the minutes and seconds in arabic numerals on the main dial. The clock strikes every hour and half hour on the same bell. At every full hour a melody is played on several flutes and a dulcimer (the latter is now missing).

The going train has three wheels/pinions (88–8/88–8/60) and one wheel for the deadbeat escapement (8/30); the arbor of the escape wheel holds the second hand. The train is regulated by an seconds pendulum with no temperature compensation. When the clock is wound, i.e., the weight is raised by a crank handle, the power to the going train is maintained by a mechanism called a maintaining power. The pinion (8) of the third wheel (8/60) drives the wheel (64) of the motion work (64/24–48/10–60). The cannon pinion (64/24) holds the minute hand;

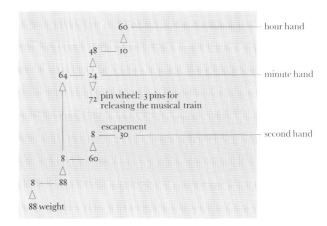

Going train

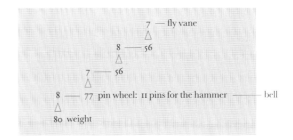

Striking train for the hours

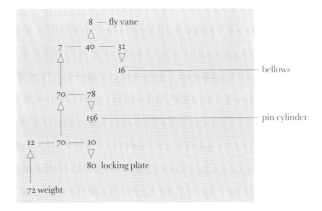

Musical train

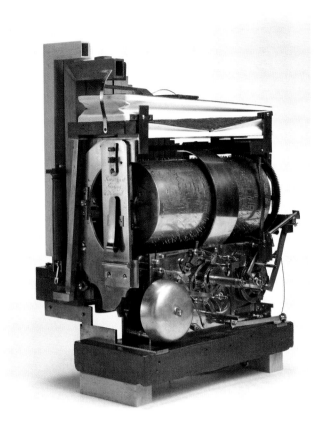
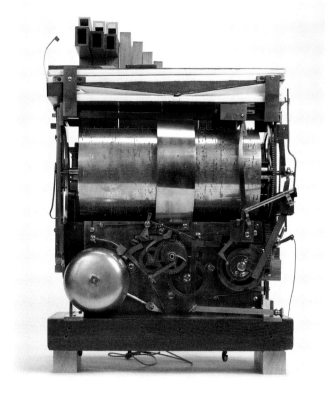

18G Three-quarter view of the movement.

18H Side view of the movement.

the hour wheel (60) holds the hour hand. The minute wheel with pinion (48/10) has two pins that release the striking train every hour. The cannon pinion (24) also drives a wheel (72) with three pins that release the musical movement every hour.

The striking train is to the left of the going train. This type of striking train is called a rack striking work. The striking train has four wheels/pinions (80–8/77–7/56–8/56) and a fly vane (7). The second wheel (8/77) holds eleven pins that move the striking hammer. This train is released by the going train every hour. The number of blows struck on the bell is controlled by the position of a snail. Miscounting cannot occur.

The musical movement consists of forty flutes that play the main melody, in piano and forte, accompanied by a dulcimer. A pin cylinder determines the melody. This cylinder can be replaced by others. Every cylinder has four melodies. Although the clock normally only plays one piece every hour or every three hours, it can be set to play all the pieces on a cylinder at random. Unfortunately only one cylinder, which has the engraved inscription *Partie 2*, has survived for this clock. For another clock of the same type (in Schloss Burgk near Magdeburg, Germany) seven cylinders have survived; their melodies, however, have not yet been deciphered. Only one piece on the many musical clocks by Roentgen, Kinzing, and Weil has been identified: "Reigen seliger Geister" from the opera *Orfeo ed Euridice* by Christoph Willibald Gluck. The musical movement has four wheels in a direct line from the barrel to the fly vane (72–12/70/[10]–70–7/40/[32]–8/fly vane). The second wheel (12/70/[10]) together with the ten-tooth wheel moves another wheel (80) that slides the pin cylinder with the musical program horizontally—one revolution of the cylinder, which takes about half a minute, corresponds to one melody. The pins of the cylinder touch fifty-one sound levers, twenty of which control the forty flutes, and thirty of which controlled the hammers of the now missing dulcimer. The dulcimer had sixty strings; consequently, one hammer struck two strings. The fifty-first lever operated the piano/forte switch, which shifted the register by blocking the air current to the forte flutes and at the same time opening the air current to the piano flutes. In addition this lever pressed a felt-covered rod against the strings of the dulcimer to soften its volume. The frequency of play can be set by means of a lever that can be placed in three positions: (a) music mechanism off, (b) one melody to be played every hour, and (c) one melody to be played every third hour. The musical mechanism can also be released by hand, in which case the melody is chosen by means of a turn-

table. The third wheel (70) drives another train (78–156) that causes the rotation of the pin cylinder. The fourth wheel (7/40/[32]) together with the thirty-two-tooth wheel drives another wheel (16) that pumps the bellows.

PUBLICATIONS

"Acquisitions 1985," *GettyMusJ* 14 (1986), p. 249, no. 208, ill.; Bremer David et al., *Decorative Arts*, p. 233, no. 404.

PROVENANCE

Edward Joseph, London, sold, Christie's, London, May 8, 1890, lot 374 (for £400 to "Payne"). French private collection. Aveline [dealer], Paris, 1984. Acquired by the J. Paul Getty Museum in 1985.

NOTES

1. A gilt-bronze mount of the same model, with a pierced ground, is in the collection of the Musée des Arts Décoratifs, Paris, L. Metman and J.-L. Vandoyer, *Le Métal. Deuxième partie: Le Bronze, Le Cuivre, L'Etain, Le Plomb* (Paris, 1910–12), pl. CIV, no. 1017.
2. Though born in Germany, Weyl frequently gallicized his name.
3. The first inscription was discovered by Robert Marsh during conservation of the musical mechanism, the second by Peter Friess.
4. D. Roche, *Le mobilier français en Russie, meubles des XVIIe et XVIIIe siècles et du commencement du XIXe, conservés dans les palais et les musées impériaux et dans les collections privées* (Paris, 1913), vol. 2, pl. 77.
5. Hermitage, inv. 5089, *Mebel' Davida Rentgena v Ermitazhe: katalog vystavki (The Furniture of David Roentgen in the Hermitage)*, exh. cat. (The State Hermitage, St. Petersburg, 1980), no. 1, illustrated opposite p. 29, and H. Huth, *Roentgen Furniture* (London and New York, 1974), fig. 63.
6. Both watercolor drawings are in the Kunstbibliothek, Berlin. For further information on Johann Wilhelm Weyl, see D. Fabian, *Kinzing und Roentgen Uhren aus Neuwied* (Bad Neustadt, 1984), pp. 66, 77, 130, 147, 155, fig. 140. The designs of the two clocks differ slightly and both are shown from the front and the side.
7. From 1780 Roentgen's name appears frequently in François Remond's *Journal de Commerce*. For the figure of Apollo Remond charged between 1,500 and 2,000 *livres*. See Verlet, *Les Bronzes*, pp. 216, 236. In 1786 Remond charged 384 *livres* for ". . . 2 bas-reliefs de frontons, composés de deux enfants, une lyre et couronne de laurier à fond très riche . . ." A third example was delivered in 1787. In 1785 Remond delivered ". . . 3 cadrans portés pour une figure du temps et entourés de guirlande composée de fleurs analogue aux quatre saisons, avec couronne de roses." Two more were sent in 1786, and a sixth in 1787—which noted further that the garlands consisted of "fleur, vigne, houx et ble." Each clock face cost between 1,200 and 2,000 *livres*. See Christian Baulez, "Toute l'Europe tire des bronzes de Paris," in *Bernard Molitor*, exh. cat. (Luxembourg, 1995), pp. 82–83.
8. Huth (note 5), p. 81, fig. 257, no. 257. The clock was described as being of "grey maple wood, stained silver to resemble marble," and decorated with various bronze mounts. "The empty areas to be decorated with suitable paintings." It is interesting that the color of the clock delivered to Catherine the Great in 1784 was described as "gris ondé" and that the Hacker clock was "grey maple wood, stained silver to resemble marble." Only one of the known clocks of the Getty model displays this silver or gray coloration (see note 24 below). Also, one of the already mentioned drawings in the Kunstbibliothek, Berlin (inv. Hdz 4353), appears to have a silver/gray wash. Hacker, as one of Roentgen's more skilled journeymen, would certainly have been aware of the model produced in Neuwied and must have used Roentgen's clock as inspiration for his own.

 This author has been unable to locate a copy of *Berliner Damenzeitung* of 1795 to confirm this information.
9. Inv. E-3030 and E-6198, Fabian (note 6), p. 324, fig. 50, and p. 325, fig. 53.
10. In the Kremlin Armory Museum. See Fabian (note 6), p. 325, fig. 52.
11. Rudolph Lepke's Kunst-Auktions-Haus, Berlin, November 6–7, 1928, lots 80 and 81.
12. H. Huth, *Abraham und David Roentgen und Ihre Neuwieder Möbelwerkstatt* (Berlin, 1928), p. 69, no. 58 (left). See also C. Cornet, "A Long-Case Musical Clock by David Roentgen and Peter Kinzing, Neuwied, Germany," *Studies in the Decorative Arts* (The Bard Graduate Center for Studies in the Decorative Arts) 3, 1 (Fall-Winter 1996), pp. 51–68.
13. Huth (note 12), p. 69, no. 58 (left).
14. Information from Theodore Dell.
15. The Pavlovsk clock is still in that collection. See D. Roche, *Trésors d'art en Russie* (St. Petersburg, 1902), pl. LXXVII. See also Fabian (note 6), p. 324, fig. 49, and A.N. Kuchumov, *Pavlovsk Palace & Park* (Leningrad, 1975), fig. 189 (where the clock is placed in the Crimson Room).
16. Huth (note 12), p. 69, no. 58 (left).
17. See Fabian (note 6), p. 326, no. 54. The movement and musical mechanism were apparently stolen during the war.
18. See Fabian (note 6), p. 325, no. 51.
19. See Huth (note 12), p. 69, no. 58 (left).
20. Letter from Dietrich Fabian, dated July 25, 1986.
21. Sold from the collection of M. Auguste Sichel, Paris, Hôtel Drouot, March 2–5, 1886, lot 6. It did not have the figure of Apollo on top.
22. See Huth (note 12), p. 69, no. 58 (left).
23. May 3, 1940, lot 112. It brought £46.00.
24. Sold at Weinmüller, Munich, May 2–4, 1956, lot 1114. See note 6 for further information on models with wood stained the color of gray marble.
25. With Daxer & Marschall, Munich. Illustrated in *Kunst und Antiquitäten* (June 1993), p. 80.

XIX

Mantel Clock
(*Pendule squelette*)

French (Paris); circa 1790–1800

Movement by Nicolas-Alexandre Folin (circa 1750–after 1815; master 1789) (see Biog., p. 171); case enameled by Georges-Adrien Merlet (born 1754, date of death unknown) (see Biog., p. 192)

HEIGHT (WITH GLASS COVER): 1 ft. 7 3/8 in. (49.2 cm); (WITHOUT GLASS COVER): 1 ft. 6 in. (45.7 cm)
WIDTH: 10 3/4 in. (27.3 cm)
DEPTH: 2 1/2 in. (62.2 cm)

72.DB.57

DESCRIPTION

The gilt-bronze skeleton clock has four white enamel dials. The uppermost dial indicates the phases of the moon (fig. 19a). The main dial is formed by a white enamel chapter ring. Within the central area of this ring is a five-pointed openwork gilt-bronze star though which the movement can be seen. On either side of the main dial are two smaller dials, each containing a five-pointed openwork gilt-bronze star in the center. The left dial indicates the days of the month, the right the days of the week (fig. 19b).

The whole is supported on double arched legs; the outer surface of this support is set with a strip of dark blue enamel strewn with flowers. The legs stand on rectangular plinths of gilt bronze which are faced with dark blue enamel plaques painted with violets in natural colors. The back is undecorated (fig. 19c).

The sides of the white marble base are set with recessed panels of gilt-bronze cast with a fine basket-weave motif, and the front is set with a gilt-bronze plaque decorated in relief with a pair of billing doves and cupids cavorting on clouds. At either end is a flaming torch and a bow with a quiver of arrows (fig. 19d).

The modern gilt-bronze pendulum bob is formed by two branches of laurel tied with a ribbon on which are perched two billing doves. The clock is protected by a rectangular glass cover with an arched top.

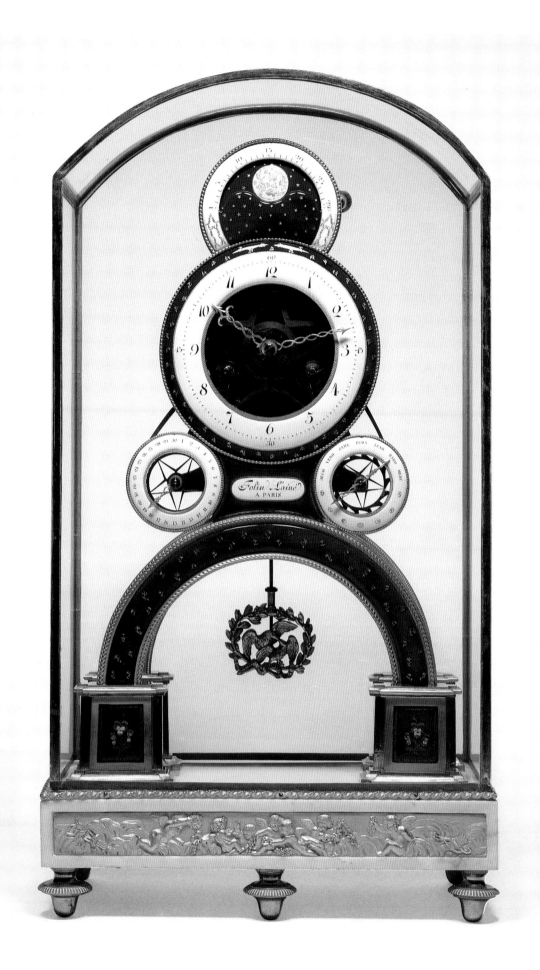

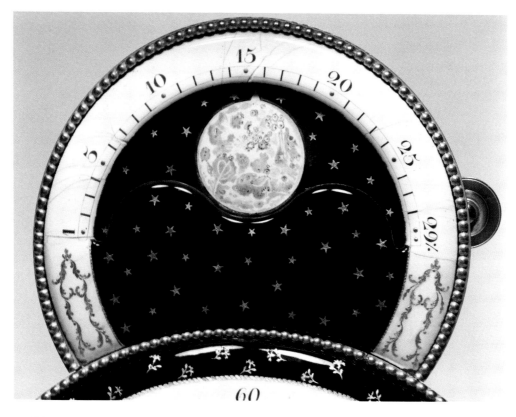

19A

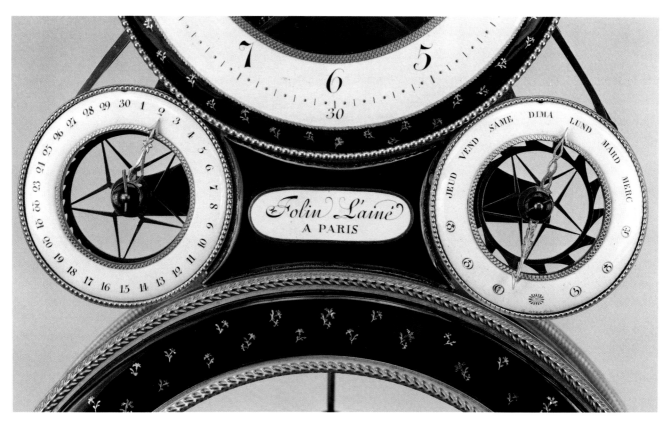

19B

142 MANTEL CLOCK

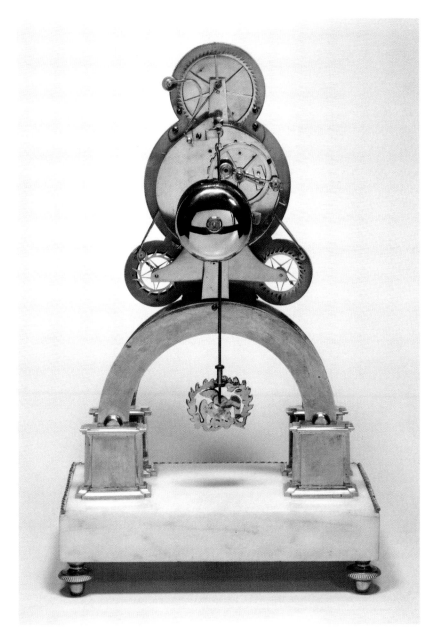

19C

MARKS

The signature *Folin L'aîné* A PARIS appears below the main dial and the signature *G. Merlet* (fig. 19e) appears on the smaller dial indicating the days of the week (fig. 19e). On the back of the dial plate is the graffito: *A J Noordanus / 21 July 1975*.

COMMENTARY

This clock with its exposed movement is of a type known as a *pendule squelette*. It became a popular form during the last decade of the ancien régime. The movement itself is seen as an object of beauty, to be enjoyed as much as the case which would have formerly concealed it.

Tardy lists four clock-makers by the name of Folin working in Paris in the late eighteenth and early nine-teenth centuries. The one responsible for the Getty clock is Nicolas-Alexandre Folin, who became a master in 1784. Several known *pendules squelettes* are signed by this Folin.[1]

Only two other *pendules squelettes* by the enameler Georges-Adrien Merlet of approximately the same date as the Getty example are known. One had three enamel dials by Merlet, a movement signed by the clock-maker E. Mugnier, and a splayed support. It was sold in London in 1989.[2] The other, with a single dial signed by Merlet and a movement by Ridel, was sold in London in 1994.[3] Merlet also signed the enamel dial of a long-case clock in the British Royal Collection with a movement by Lepaute (Jean-Baptiste?) and a case by Nicolas Petit. This clock can be precisely dated as the front plate is punched *juin 1780* and also has repairer's marks for June 1784.[4]

MANTEL CLOCK 143

Another clock with an enamel dial signed by Merlet includes, like the Getty clock, the phases of the moon. It dates from the last quarter of the eighteenth century and was sold from the Bensimon collection in Paris in 1981. The gilt-bronze case represents Venus in a chariot pulled by doves.[5] Merlet's name is also found on the dial of a clock supplied to the comte d'Artois by the *bronzier* François Rémond on December 31, 1781, for a *salon turc*, and which cost the large sum of 5,500 *livres*.

The modern pendulum bob is a copy of one which was on the clock at the time of purchase by the Getty Museum but which was subsequently lost while the clock was on loan to another institution. It is possible that this bob was not the original one since the majority of other skeleton clocks of comparable design have pendulum bobs formed by a sunburst centered by an Apollo mask. The glass cover is possibly original. It was the custom to use covers of this type, especially for clocks with exposed movements. George IV is known to have used such glass boxes to cover his clocks. Also, the Parisian *bronzier* Pierre-Philippe Thomire supplied a fairly large number to the imperial household for use on clocks.

OTHER EXAMPLES

Many *pendules squelettes* similar to the Getty clock have survived, but all differ in some way, either in the number of dials, the type of supporting arch, or the enamel decoration used. One of the most similar, in addition to the one signed by Merlet already mentioned above, is a late eighteenth-century four-dial example sold in Geneva in 1981, on which an enameled rectangular plaque with incurved sides below the main dial is signed "Ridel à Paris."[6] The subsidiary dial marking the days of the week (which are included on the main dial) was replaced with one indicating the months of the year. There are also differences in the bases of the arches and the decoration of the white marble plinths.

Another very similar clock with four dials supposedly by Houdin *fils* was recently re-published by the Spanish Patrimonio Nacional.[7] The enameled rectangular plaque with incurved sides below the main dial of this clock is decorated with an unsigned white shield. It has considerably more gilt-bronze openwork around the dials, and, rather than being strewn with gold flowers, the supporting arch is decorated with garlands of gold flowers on dark blue enamel. It is also decorated with *navette*-shaped reserves decorated with figures instead of violets on the plinths at the base of the supporting arch. The white marble plinth is set with a gilt-bronze plaque similar to the one on the Getty example. This plaque seems to be fairly common on *pendules squelettes* of this period.[8] Holes for the attachment of a missing strip of gilt bronze around the top edge of the marble as on the Getty example can be seen in the published photograph. A clock with the same frieze of cupids is illustrated by Emile Molinier in *Le Mobilier royal français aux XVII et XVIII siècles*, vol. 2 (Paris, 1902), no. 8, pl. 113. It was formerly in the Bibliothèque de Versailles.[9]

MOVEMENT
Brass and iron, partly blued

Note: The number in parentheses represents the number of teeth on each wheel. These numbers are repeated again in the drawings of the movement.

The movement (fig. 19f) consists of two trains driven by mainsprings, each of which runs for one week. The going train provides power for the hands which indicate the hours in roman numerals and the minutes in arabic numerals on the main dial. Below the main dial are two

19D

19E

144 MANTEL CLOCK

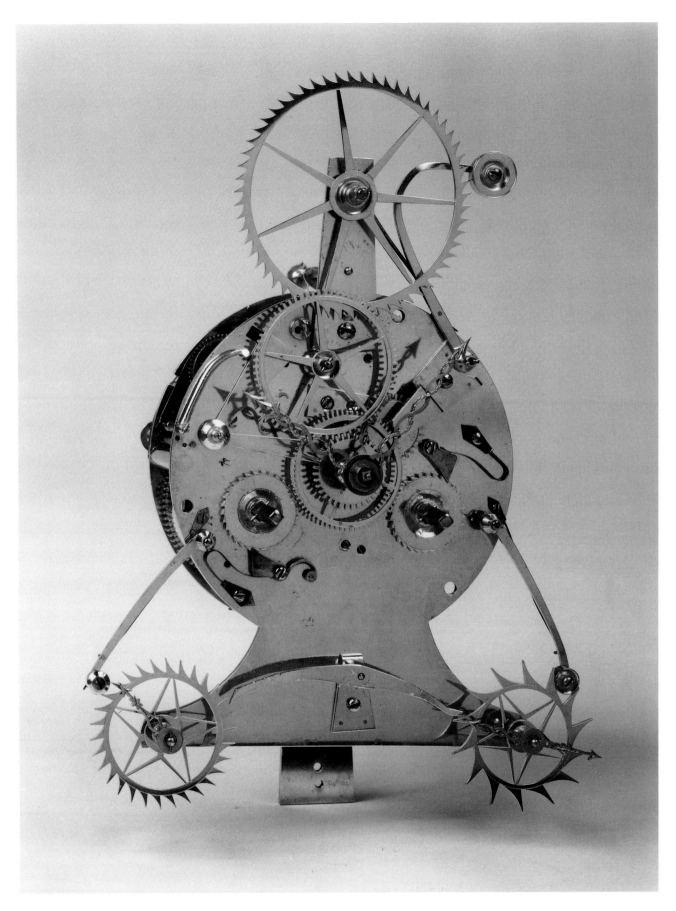

19F

MANTEL CLOCK 145

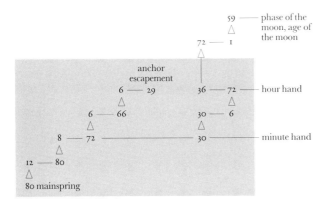

Going train

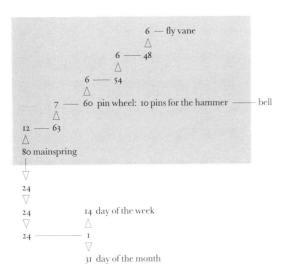

Striking train

subsidiary dials which indicate the days of the week on the right side (using abbreviations that begin with *Jeud* and end with *Merc*, as well as the symbols for the days, for instance a sun for *dimanche* [Sunday]) and the days of the month on the left side. A third subsidiary dial above the main dial indicates the age (1 to 29½ days) and phases of the moon. The clock strikes the hours and half hours on the same bell.

The going train has one rotating barrel (80), which holds the mainspring and four pinion wheels (12/80–8/72–6/66–6/29), the last being the escape wheel. The going train is regulated by an anchor escapement (recoil escapement) in connection with a pendulum. While the clock is running the pendulum can be adjusted by lifting or lowering it via its silk suspension. The arbor of the third wheel holds the cannon pinion (30), a part of the motion work (30–30/6–72), and the minute hand. The hour wheel (72) holds the hour hand. The cannon pinion (30) rotates once every hour; it has two pins that release the striking train every half and full hour.

The striking train is to the left of the going train. This type of striking train has a locking plate (count wheel). This train has one rotating barrel (80), which holds the mainspring, four pinion wheels (12/63–7/60–6/54–6/48), and a fly vane (6). The third wheel (7/60) has ten pins that move the striking hammer.

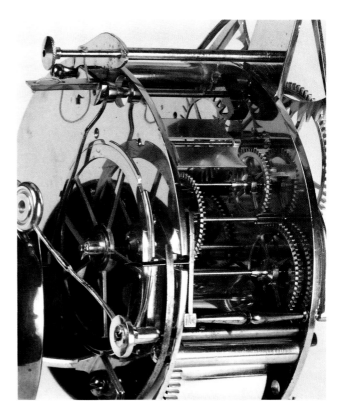

19G

The hour wheel of the going train also drives a gear (72/36–72/1–59) that indicates the age and phases of the moon. The calendar for the days of the week and the days of the month is driven by the barrel of the striking train (24–24–24/1–31 and 14). At midnight the hands of both dials jump into the position for the next day. For those months that have less then thirty-one days the hand for the days of the month has to be moved forward manually.

EXHIBITIONS

Detroit Institute of Arts, 1972–1973.

PUBLICATIONS

B. Fredericksen, H. Lattimore, and G. Wilson, *The J. Paul Getty Museum* (London, 1975), p. 80, ill.; G. Wilson, "The J. Paul Getty Museum, 7ème partie, Le Mobilier Louis XVI," *Connaissance des Arts* (June 1975), p. 96, ill.; Wilson, *Clocks*, pp. 68–71, no. 14, ill.; Wilson, *Decorative Arts* (1977), p. 99, no. 129, ill.; Sassoon and Wilson, *Decorative Arts: A Handbook*, p. 42, no. 92, ill.; Bremer David et al., *Decorative Arts,* p. 92, no. 145, ill.

PROVENANCE

Sold anonymously, Palais Galliera, December 10, 1971, lot 35. French and Company, New York, 1971. Purchased by J. Paul Getty in 1972.

NOTES

1. Sotheby Parke Bernet, Monaco, November 22, 1979, lot 201 (a three-dial clock); Christie's, Amsterdam, June 22, 1990, lot 127 (a single-dial clock); *Gazette de l'Hôtel Drouot* 18 (May 4, 1990), p. LI (a three-dial example sold on May 20, 1990, at the Hôtel des Ventes, Bayeux); and Sotheby's, London, June 2, 1993, lot 98 (another three-dial example).
2. Christie's, London, March 22, 1989, lot 35. The dial is signed *Mugnier ÀParis,* which probably refers to Mugnier *l'aîné*. See Tardy 1980, vol. 2, p. 482.
3. Sotheby's, London, March 3, 1994, lot 215.
4. I would like to thank Geoffrey de Bellaigue for this information.
5. Paris, Hôtel Drouot, November 18–19, 1981, lot 33.
6. Antiquorum, Galerie d'Horlogerie Ancienne, Geneva, *Connoisseur* vol. 207, no. 831 (May 1981), p. 64. I would like to thank Winthrop Edey for this information. The clock-maker Ridel is listed in Tardy, *Dictionnaire des Horlogers Français*, vol. 1 (Paris, 1972), as working in the rue aux Ours in 1800.
7. See J. Ramón Colón de Carvajal, *Catálogo de Relojes del Patrimonio Nacional* (Madrid, 1987), p. 95, no. 78 (which states that the clock-maker is unknown). This clock was first published in *El Palacio Real de Madrid* (Editorial Patrimonio Nacional, Madrid, 1975), p. 196 (where the caption says the clock is the work of Houdin *fils*).
8. For a few examples with the identical bronze plaque, see Partridge Fine Arts, London, *Summer Exhibition 1990,* pp. 96–97, no. 40, ill. See also Hôtel Drouot, Paris, December 6, 1989, lot 55 *bis*.
9. Many other examples have been found. One of the more interesting is a clock now at the Palace of Pavlovsk near St. Petersburg. It has three dials, much more elaborate enameling, and a splayed support. It is not known whether the clock is signed. The front of the white marble base is inset with a long rectangular bronze plaque with putti cavorting on clouds. The putti to the extreme right and left seem to be identical to the ones decorating the Getty example. Another clock of this same type with only two dials is in the Musée des Arts Décoratifs, Paris, with enameling signed by Coteau. Tardy, *French Clocks the World Over* (Paris, 1981), pls. 47–51, illustrates a third, in the Ecole d'Horlogerie de Dreux, with a splayed support, two dials, and enameling signed by Coteau. The Musée Carnavalet, Paris, owns another three-dial example with splayed feet, a movement signed by "Laurent ÀParis," and enameling by Coteau. Two *pendules squelettes* were sold by Sotheby's at Mentmore on May 18, 1977. The first, lot 6, was signed by Coteau, had a splayed support, two dials, and a later enamel miniature which might have originally been the replacement for another dial. The second, lot 30, had two dials and was signed "Laurent ÀParis" with enameling attributed to Coteau.

XX

Clock in a *Secrétaire*

German (Berlin); circa 1798

Secrétaire by Johann Andreas Beo;[1] movement by Christian Möllinger (1754–1826)

DIAMETER (OF DIAL): 4 in. (10 cm)
WIDTH (OF DIAL, WITH HINGE AND FLANGE): 4⁵⁄₁₆ in. (11 cm)

84.DA.87

DESCRIPTION
The clock is set into the upper section of the *secrétaire* (fig. 20a). The dial consists of a white enameled ring through the open center of which can be seen various wheels of the movement, making this a type of *pendule squelette*. The dial is protected by a convex glass cover held by a gilt-bronze frame composed of a single row of pearl beading and two rows of braided molding. It has a thumb flange on the right and a hinge on the left.

MARKS
The dial is signed *Möllinger à Berlin*. The spring of the going train bears the inscription *Habernig Fritz / July / 1975*. On the back plate appear the following graffiti: *L 856 / Lu.y.12 / Bell*.

COMMENTARY
Although simple in appearance, this clock was produced by one of the most accomplished makers in Berlin, Christian Möllinger. It was once attached to a musical movement which was probably activated by a lever tripped by the striking train. Physical evidence within the *secrétaire* shows that a rod extended down the left side of the back to the musical movement, which was housed in the bottom section. Two side panels which are now inset with wood originally held fabric to allow the sound to be heard. The lower back of the *secrétaire* still retains a fabric panel for this purpose.

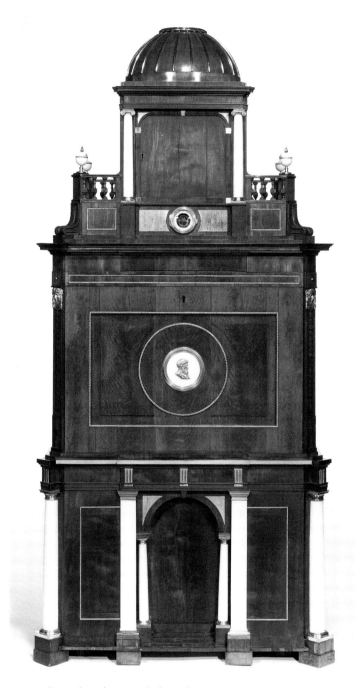

20A *Secrétaire*, circa 1798, by Johann Andreas Beo. Bought by Frederick William III circa 1802 for Schloss Potsdam, Berlin.

MOVEMENT
Brass and iron, partly blued

Note: The number in parentheses represents the number of teeth on each wheel. These numbers are repeated again in the drawings of the movement.

The movement (fig. 20b) consists of two trains driven by mainsprings, each of which runs for one week. The going train provides power for the hands which indicate the hours in roman numerals and the minutes in arabic numerals on the main dial. The clock strikes the hours and half hours on one bell.

The going train has one rotating barrel (72), which holds the mainspring and four pinion wheels (12/72–8/72–6/66–6/33), the last being the escape wheel. The going train is regulated by an anchor escapement in connection with a pendulum. The arbor of the third wheel holds the cannon pinion (32), a part of the motion work (32–32/6–72), and the minute hand. The hour wheel (72) holds the hour hand. The cannon pinion (32) rotates once every hour; it has two pins that release the striking train every half and full hour.

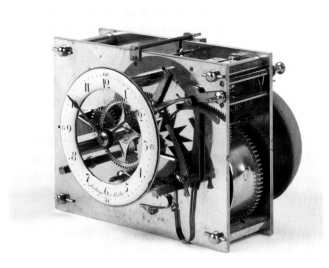

20B Three-quarter view of the movement.

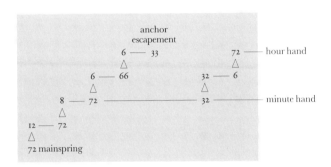

Going train

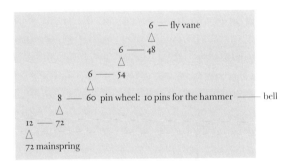

Striking train

The striking train is to the left of the going train. This type of striking train is called a rack striking work. This train has a rotating barrel (72), which holds the mainspring, four pinion wheels (12/72–8/60–6/54–6/48), and a fly vane (6). The third wheel (8–60) has ten pins that move the striking hammer. The number of blows struck on the bell is controlled by the position of a snail. Miscounting cannot occur.

PUBLICATIONS

H. Kreisel and G. Himmelheber, *Die Kunst des deutschen Möbels*, vol. 3 (Munich, 1973), fig. 262; *Art-Price Annual 1974–1975* 30 (Munich, 1975), p. 91; C. Freytag, *Bruckmann's Möbel-Lexicon* (Munich, n.d.[1978?]), p. 180, no. 86; M. Stürmer, *Handwerk und höfische Kultur Europäische Möbelkunst im 18. Jahrhundert* (Munich, 1982), pl. 102, p. 193; D. Fabian, *Die Entwicklung der Roentgen-Schreibmöbel* (Bad Neustadt, 1982), pp. 54–55, fig. 77d-g; East Side House Settlement, New York, *Winter Antiques Show*, exh. cat. (January 21–29, 1984), p. 254; D. Fabian, *Kinzing & Roentgen Uhren aus Neuwied* (Bad Neustadt, 1984), p. 147; G. Wilson, "Selected Acquisitions Made by the Department of Decorative Arts," *GettyMusJ* 13 (1985), pp. 83–88; "Acquisitions/1984," *GettyMusJ* 13 (1985), p. 184, no. 68; Sassoon and Wilson, *Decorative Arts: A Handbook*, p. 114, no. 240; D. Fabian, *Roentgenmöbel aus Neuwied* (Bad Neustadt, 1986), pp. 305, 312, figs. 724–727; Bremer David et al., *Decorative Arts*, p. 230, no. 398, ill.

PROVENANCE

Friedrich Wilhelm III of Prussia (purchased circa 1802 for Schloss Potsdam). Private collection, Berlin. Ragaller [dealer], Berlin. Sold Weinmüller [auction house], Munich, May 2–4, 1956, lot 1111. Sold to Neumeister [auction house, formerly Weinmüller], Munich, October 23–24, 1974, lot 861. F. Tamms, Munich. Juan Portela [dealer], New York. Acquired by the J. Paul Getty Museum in 1984.

NOTE

1. Burkhardt Göres has identified Johann Andreas Beo as the maker of this *secrétaire*. He has also kindly provided its early provenance.

XXI

Pedestal Clock

French (Paris); late nineteenth century (copy of an example made circa 1725, probably in the Boulle workshop, after a design by Gilles-Marie Oppenord)

Makers of case and movement unknown

HEIGHT: 9 ft. 4 in. (223.5 cm)
WIDTH: 2 ft. 3½ in. (68.6 cm)
DEPTH: 1 ft. 1 in. (33 cm)

74.DB.1

DESCRIPTION

The pedestal clock is made in two parts: the clock case and its supporting tapering pedestal. The domed top of the clock case supports a gilt-bronze winged cupid (fig. 21f). The four corners below are fitted with gilt-bronze figures of the Four Continents: Africa, Europe, Asia, and the Americas (fig. 21a-d). The oval dial is of gilt bronze, set with enamel plaques painted with numerals. The remaining surfaces of the front and the sides of the case are veneered with tortoiseshell, that on the front is further decorated with a trellis pattern in brass. The interior of the door at the back of the case is veneered with a panel of marquetry of tortoiseshell and brass composed of large scrolls, acanthus leaves, vines, and tendrils (fig. 21g). A gilt-bronze mount in the form of a smoking *cassolette* is attached to the base of this panel. The interior floor is veneered with a geometric marquetry of diamonds diminishing in size toward a central rosette.

The dial is covered with a convex glass, with a frame which is hinged and snaps shut. A gilt-bronze cartouche below is set with an enamel plaque painted with the name "JULIEN LE ROY." The clock stands on scrolled feet which are overlaid with auricular mounts.

The four corners of the pedestal are set at the top with large double-scrolled foliate mounts. They are linked to lion's paw feet by flat moldings cast at the center with a vertical ribbon-bound rod. The top of the front of the pedestal is set with a circular plaque cast with Hercules relieving Atlas of the weight of the Heavens. The plaque is suspended from a gilt-bronze ribbon bow (fig. 21h). The sides are mounted with pendants of flowers above, and with rising acanthus spikes below, at the

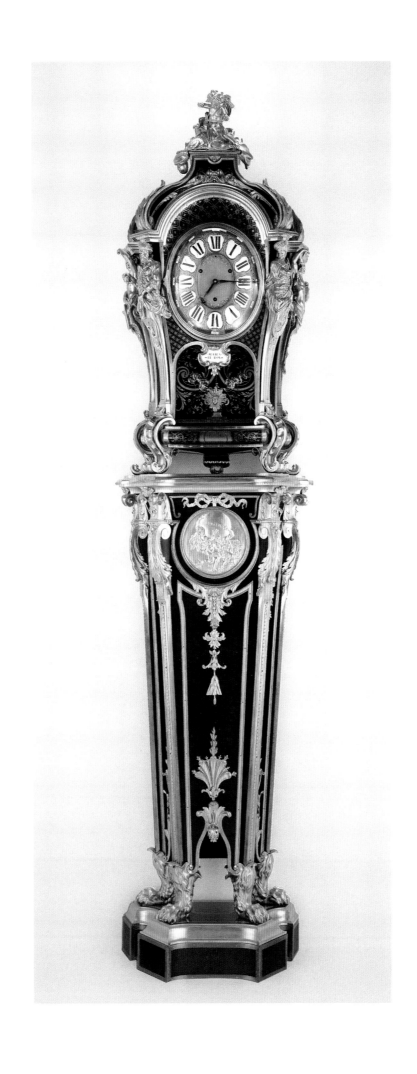

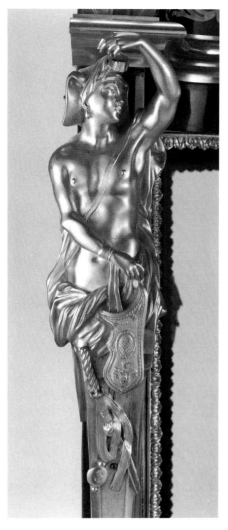
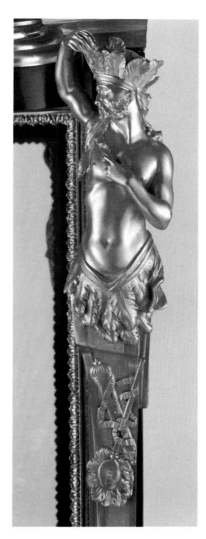
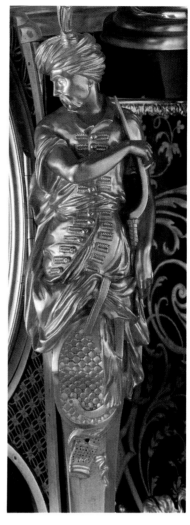

21A Africa 21B The Americas 21C Asia

juncture of the feet. The entire surface is veneered with tortoiseshell.

The irregularly shaped base is also veneered with tortoiseshell, set with borders of brass strips. The carcase is of poplar, veneered with blackened oak.

MARKS

The case is not stamped with a maker's name. The enamel plaque beneath the dial is painted JULIEN LE ROY. The back plate of the movement is engraved *julien Leroy Paris* (fig. 21i), and the interior surface of the back plate is stamped *52055*. The following repairers' marks are found on the wheels of the striking trains: *(2)/G*; *4/b/ Karel Solle 1846*; *4869*; *5(3)*.[1] One spring is stamped BROCOT & CIE.

COMMENTARY

When the clock was acquired by the Getty Museum in 1974 it was considered to be of early eighteenth-century date and of the same model as three other clocks in the collections at the Wallace Collection, London,[2] at Waddesdon Manor, Buckinghamshire,[3] and the Bibliothèque de l'Arsenal, Paris.[4]

The clock in the Bibliothèque de l'Arsenal, Paris, has a movement signed by Gilles Martinot (1658–1726), while the enamel plaque beneath the dial bears the name of Julien Le Roy. The clock in the Wallace Collection, London, has a movement signed by Mynüel (active 1693–circa 1750); the plaque beneath the dial also bears his name. The movement of the clock in the James A. de Rothschild Collection at Waddesdon Manor, which is a later replacement, is by George Graham (member of the Clock Makers' Company, 1695–1751). Graham's name is engraved below the dial. The enamel plaque on this clock was replaced, after 1730, with the cipher of the fourth Earl of Chesterfield (1694–1773) in gilt bronze. A fourth clock in the Detroit Institute of Arts (which was unknown at the time of the acquisition of the Getty Museum's example) has a movement that is unsigned, while the plaque beneath the dial bears the name of Julien Le Roy.[5]

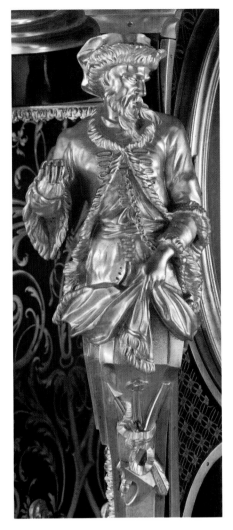

21D Europe

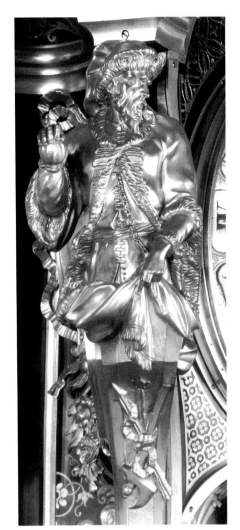

21E Figure representing Europe, Paris, circa 1720, from a clock of the same model in the Wallace Collection, London, inv. F42.

The first three clocks have provenances which extend back to the eighteenth century. That of the Arsenal clock is the most well documented. It appears in an inventory taken at the death of Gilles Martinot in 1726:

Item. Une grande pendulle dans sa boete de marqueterie garnye de bronzes sur scabelon, le tout de douze à quinze pieds de haut ou environs, le cadran de lad. pendulle ovalle, le mouvement de la lad. pendulle sonnant heures, demies et quarts lad. pendulle garnye de toutes ses glaces et les bronzes non dorez ny en couleur, prisées et estimée à sa juste valeur et sans crüe la somme de cinq mille livres.[6]

The fact that the mounts on this clock are described as neither gilded nor lacquered may indicate that the piece was not yet finished, and one could therefore date its construction to shortly before its inclusion in this inventory, circa 1725. The clock was given in 1761 to the Abbaye Saint-Victor by Marguerite-Catherine Boucher Duplessis, the widow of François-Louis Martinot, the son of Gilles Martinot. At the time of the French Revolution, in 1791, it was found in the chamber of Father Lagrenée and was then transferred to the Arsenal.[7]

The clock in the Wallace collection was given in 1770 to the municipality of Yverdon, Switzerland, by M. Perrinet de Faugnes, the manager of the Administration des Sels de Franche-Comté. It remained in the Hôtel de Ville at Yverdon until 1866, when it was sold to the dealer Barlier and removed to Lyons. The following year it was taken to Paris and was probably sold to Lord Hertford soon after.

The enamel plaque beneath the dial of the clock at Waddesdon Manor has been replaced with the cipher of Philip Dormer Stanhope, 4th Earl of Chesterfield. The cipher contains the Order of the Garter, granted to him in 1730. The original French movement has been replaced with one made by George Graham, who was active between 1711 and 1751.

It is very probable that this model of clock case was designed by Gilles-Marie Oppenord (1672–1742). It incorporates the same mounts representing the Four

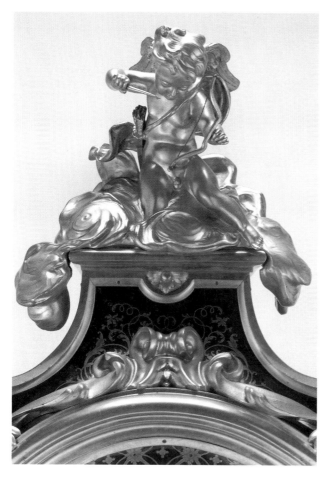

21F

21G The interior of the back door of the clock case.

Continents that were used on the earlier long-case clock in the Getty collection (cat. no. 5), which has been shown to have been designed by Gilles-Marie Oppenord and almost certainly executed by his father, Alexandre-Jean Oppenordt (circa 1639–1715). As his father's sole heir, Gilles-Marie Oppenord had control and ownership of the models of the Four Continents and was able to have them modified for reuse. A close inspection of the figures on the Wallace clock shows that the mounts were cast from models whose pilasters had been partially cut through horizontally in numerous places to allow them to be bent into the slightly curved shape necessary to fit the curved profile of the clock case.

A shorter version of the long corner mounts of the pedestal had originally been used, reversed, as corner mounts and contiguous feet on a commode in the London market in 1991.[8] The commode bore a top veneered with brass and tortoiseshell which incorporated much of the design that is found decorating the top of a *bureau* made for Louis XIV in 1685, which has been shown to have been made by Oppenordt *père*.[9]

At the death of his father in 1715, Gilles-Marie Oppenord seems to have turned to André-Charles Boulle and his sons for the construction of the cases and their marquetry. The design of the marquetry on the interior surface of the clock-case door of the Wallace example is of the same design as that found on the right front door of an *armoire à regulateur* also in the Wallace Collection.[10] This piece is described as being under construction in Boulle's *Acte de Delaissement* of 1715.[11] There is, however, a difference in size between the two panels, showing that the one intended for the clock door had been especially adapted to fit.

Small panels of marquetry on the sides of the hood of the Arsenal clock are closely related to the design of those found on the chapter ring of the so-called Father Time clock, which again is documented as being by Boulle (see cat. no. 4).

It is apparent that the bronzes on the cases and the pedestal, in addition to those of the Four Continents as well as the corner mounts, were not made in Boulle's workshop. No such mounts are described in the inventory

156 PEDESTAL CLOCK

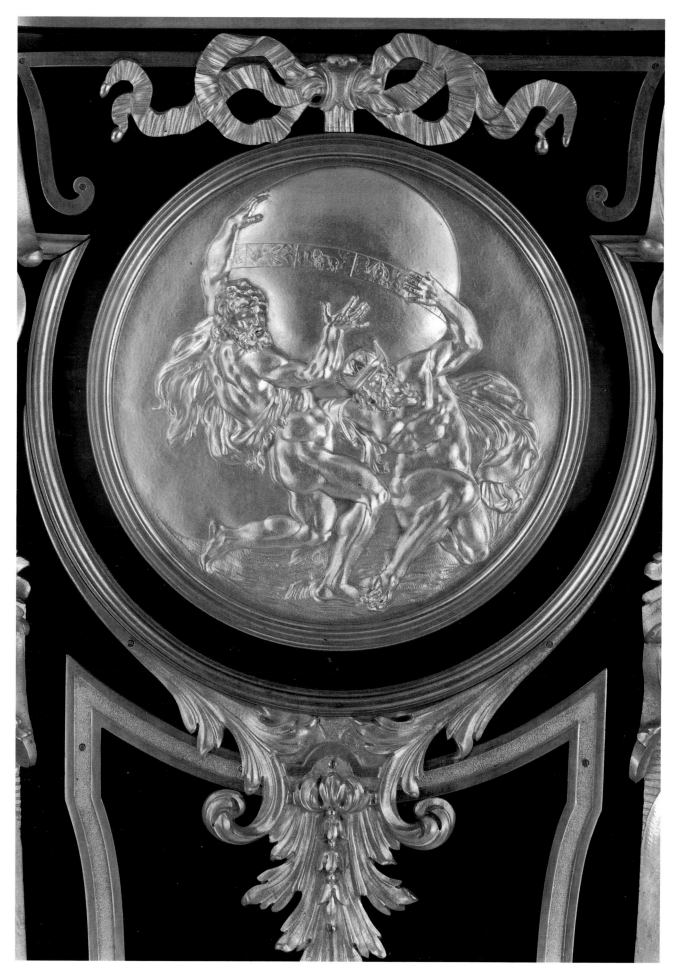

21H

PEDESTAL CLOCK 157

21I

21J

taken after the fire in his workshop in 1720 or in any other documents relating to Boulle, nor do they appear on any of his known or attributed works. They were probably designed by Gilles-Marie Oppenord, but the name of his *bronzier* is not known.

By 1720–1725, when the Arsenal clock was completed, the evolution of taste was turning away from metal *rinceaux* and arabesques, which may well account for the use of plain tortoiseshell on the pedestal.

When the Getty clock was dismantled for inspection in 1992 it became apparent that the clock case is of late nineteenth-century date. It was found that a band saw had been used in the course of its manufacture, while a screw-tipped auger bit had been used to drill holes for the dowels used in the case's construction.[12] X-rays revealed that the interior screws, beneath the tortoiseshell veneer, are machine cut, and wire nails had been employed throughout. The sides and the front of the pedestal are held together merely by the means of screws, and the corner blocks were milled to dimension on a joiner, a machine which was not invented until the second half of the nineteenth century. The bottom of the pedestal is modern and attached with modern nails.

An inspection of the back of the upper surface of the base, which is two inches thick, shows that the tortoiseshell is backed by an oak substratum three-eighths of an inch thick, glued to a frame of cherry one and a half inches thick, as well as a layer of poplar veneer one-sixteenth of an inch thick, the latter sawn with a band saw.

The back door of the clock case is of board and batten construction, rather than frame and panel. The bottom of the case and the side uprights are of alder faced with oak; the upper part of the clock is also made of alder. The brass stops for the back door and the glass panels are also of recent manufacture, as are the clock-door hinges, and all are held in place with modern nails.

Further evidence that the clock is a copy is the fact that the heavily gilded bronze mounts are very finely chased, and the bodies of the figures representing the Four Continents are smooth and lack muscular definition in comparison to the figures found on the four other clocks of the same model. Three mounts, the figure of Europe, the large mount of a cupid on the top, and one of the floral side mounts on the pedestal, were removed and taken to Europe. They were closely compared with those mounts on the Wallace, Waddesdon, and Arsenal clocks. It was immediately apparent that the figure of Europe from the Getty clock is less vigorously modeled and was not cast from the same mold. The features of the face differ, as does the arrangement of the folds of the drapery (fig. 21e).

In comparison to those on the other clocks, the side mount of the pedestal—consisting in the main of a pendant of flowers—is overchased to the point of sharpness (fig. 21j) and like all the mounts of the Getty clock has a smooth back, characteristic of late nineteenth-century bronze mounts.

The uppermost mount of a winged cupid seated on clouds is found only on the Arsenal clock and on the Detroit model, but on the latter the wings are absent. Here again a comparison revealed a certain smoothness and overchasing on the Getty example, the wings of which are carefully cast with feathers, above and below. The wings on the Arsenal model are however quite smooth and unfeathered on their upper surface which cannot be seen by the viewer.

The Arsenal clock case differs in a number of small ways from the Wallace and Waddesdon clocks,[13] and the Getty clock shows these same variances in design. Clearly the Arsenal clock was the source for the Getty example. Differences between the Arsenal and Getty clocks are probably the result of the copier not having access to the back of the original clock, for the copy lacks a door at the back of the pedestal. He was also unaware that the back of the Arsenal movement is signed by Gilles Martinot and not by Julien Le Roy, whose name, however, inexplicably appears on the enamel plaque beneath the dial. Therefore the copier has signed the movement "julien Leroy Paris." This signature is incorrectly inscribed, for Le Roy consistently used the form "Julien Le Roy *Paris*" on all his known movements (see cat. nos. 9 and 12).

The maker of the Getty clock obviously could not see that the wings of the Arsenal Cupid are unfeathered on their upper surfaces, and the brass cartouche on the lowest molding of the clock case, which is inscribed *Ex Dono Dominice Boucher Viduae Duplessis Anno 1765*, is here left blank. The same area on the Wallace, Waddesdon, and Detroit examples is filled with a small oval of tortoiseshell and brass marquetry.

In many cases, the small panels of marquetry on the clock case, though they follow the design of those on the Arsenal example, have been slightly simplified and are not as well drawn.

Other nineteenth-century copies of the clock and pedestal exist. One, stamped "J. Zwiener," is in Schloss Charlottenburg, Berlin.[14] It is of inferior quality and very obviously a late nineteenth-century pastiche. Two other clocks of this model made by Zwiener passed through the Amsterdam and Paris art markets in 1988 and 1990.[15] A fourth clock, of the same design but with a round dial and veneered with wood, was sold in London in 1995.[16]

A further model, presumably of nineteenth-century date, once belonged to the *bronzier* Vian (dates unknown) and stood in the vestibule of the Hôtel Sallé, Paris.[17] Nothing is known of its present whereabouts.

MOVEMENT
Brass and iron, partly blued

Note: The number in parentheses represents the number of teeth on each wheel. These numbers are repeated again in the drawings of the movement.

The movement (figs. 21k and l) consists of three trains driven by mainsprings, each of which runs for one week. The going train provides power for the hands which indicate the hours in roman numerals and the minutes in arabic numerals on the main dial. The clock strikes every full hour on one large bell and each quarter hour on two smaller bells. The dial of this clock is oval, and the

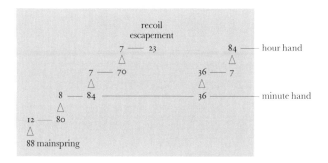

Going train

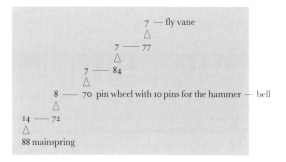

Striking train for the hours

Striking train for the quarters of an hour

hour hand changes its length as it rotates, being short at three and nine o'clock and expanded at six and twelve.

The going train has one rotating barrel (88), which holds the mainspring and four pinion wheels (12/80–8/84–7/70–7/23), the last being the escape wheel. This train is regulated by a deadbeat Brocot escapement in connection with a pendulum. Originally the pendulum could be adjusted while the clock was running by lifting or lowering it via its Brocot suspension. However, this mechanism does not function; the teeth of the wheels for the suspension mechanism have been ground off. The arbor of the third wheel holds the cannon pinion (36), a part of the motion work (36–36/7–84), and the minute hand. The hour wheel (84) holds the hour hand. The cannon pinion (36) rotates once every hour; it has four pins that release the striking trains every quarter of an hour.

This clock has two striking trains. The striking train for the quarter hours is to the right of the going train. To the left of the going train is the striking train for the hours. They are both arranged upside down. Both striking trains use locking plates (count wheels). The striking train for the quarter hours has a rotating barrel (88), which holds the mainspring, four pinion wheels (14/72–8/70–7/84–7/77), and a fly vane (7). The third wheel (8/70) has ten pins that move the striking hammer. Every full hour the locking plate of this train releases the striking train for the hours. This train also has a rotating barrel (88), which holds the mainspring, four pinion wheels (14/72–8/70–7/84–7/77), and a fly vane (7). The third wheel (8/70) has ten pins that move the striking hammer.

There are several reasons why the movement is probably a product of the nineteenth century: (1) The signature on the back plate is poorly engraved and may have been made with a rotating cutter. (2) The type of escapement in this clock was invented in the nineteenth century by Achille Brocot. There is no hint that this escapement is a later addition; all the parts are made in the same style as the rest of the clock, and there are no holes which would indicate that there had once been a different escapement. (3) The four pillars are not of early eighteenth-century date. (4) All the wheels of this clock appear to be machine cut, that is, they are too regular to have been made in the eighteenth century, and the spokes are of nineteenth-century shape. (5) Finally, the hammers and all three bells date to the nineteenth century. They are not mounted to the movement in the normal way (one mount for the hour bell and one mount for the two quarter bells), but are mounted one above the other.

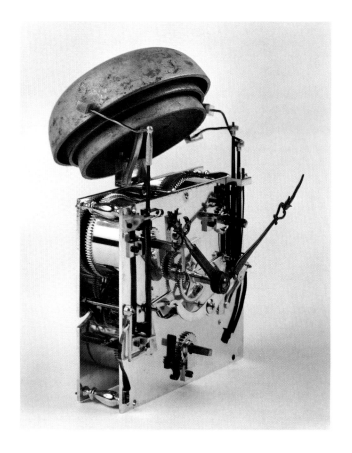

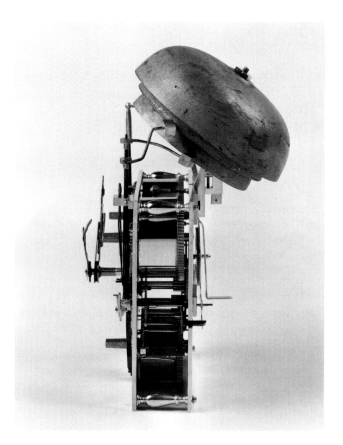

21L Side view of the movement.

EXHIBITIONS

Madrid, Sociedad Española de Amigos del Arte, "El Reloj en el Arte," May-June 1965, no. 10.

PUBLICATIONS

L. Montañés, "Un péndulo desconocido de Julien Le Roy," *Dersa* (July 1967), pp. 8–16, no. 34, ill. p. 1; G. de Bellaigue, *The James A. de Rothschild Collection at Waddesdon Manor: Furniture, Clocks and Gilt Bronzes*, vol. 1 (London, 1974), p. 54; Wilson, *Clocks*, pp. 12–17, no. 2, ill.; A. Smith, ed., *The Country Life International Dictionary of Clocks* (New York, 1979), p. 87, fig. 7; L. Montañés, *Relojes en ABC* (Madrid, 1983), pp. 96–99; G. Wilson, *Selections from the Decorative Arts in the J. Paul Getty Museum* (Malibu, 1983), pp. 18–19, no. 9; *The J. Paul Getty Museum Handbook of the Collections* (Malibu, 1986), p. 150; P. Verlet, *Les Bronzes*, p. 114, fig. 141 (caption); Bremer David et al., *Decorative Arts*, pp. 84–85, no. 131.

PROVENANCE

English collection, nineteenth century. (?) Duke of Medinaceli, Spain.[18] Smolen [dealer], Paris, circa 1962. Manuel Gonzáles, Galería Velázquez, Madrid, circa 1965. French and Co., New York, 1972. Bought by J. Paul Getty in 1974.

NOTES

1. The name Karel Solle is also found inscribed on the movement of the long-case musical clock (cat. no. 5), along with the date 1888. In June of that year that clock was sold from the collection of the Marquess of Exeter to the London dealer Charles Davis. It is therefore known that Solle was working in England at that time. If the movement of the clock needed repair in 1846, one could assume that it had been made at least a few years earlier. It is possible that at that time Solle was working in Paris. It is apparent that the movement was not made at the same time as the case, which is considerably later in date.
2. F. J. B. Watson, *Wallace Collection Catalogues, Furniture* (London, 1956), pp. 19–20, no. F42, pl. 48 (left), and P. Hughes, *French Eighteenth-Century Clocks and Barometers in the Wallace Collection* (London, 1994), pp. 28–29.
3. G. de Bellaigue, *The James A. de Rothschild Collection at Waddesdon Manor: Furniture, Clocks and Gilt Bronzes*, vol. 1 (London, 1974), pp. 51–55, no. 3.
4. Illustrated in *Les Vieux Hôtels de Paris*, vol. 10 (Paris, 1920), p. 22, pl. 37.
5. "European Sculpture and Decorative Arts Acquired by the Detroit Institute of Arts, 1978–87," *The Burlington Magazine* 130, no. 1023 (June 1988), p. 497, figs. 106, 107.
6. A.N., Min., XCVII-206, February 13, 1726, inventory after the death of Gilles Martinot.
7. I am grateful to Daniel Alcouffe for this information.
8. Christie's, London, June 13, 1991, lot 88. Another commode, veneered with floral marquetry on an ebony ground, which bore the same corner mounts at its forecorners, was sold at Sotheby's, New York, May 20, 1992, lot 55; another example, veneered with *contre-partie* marquetry was sold at Christie's, London, June 15, 1995, lot 50.
9. New York, Metropolitan Museum of Art (inv. 1985.61): J. N. Ronfort, "Le mobilier royal à l'époque de Louis XIV, 1685, Versailles et le Bureau du Roi," *L'Estampille* (April 1986), pp. 44–51.
10. Watson (note 2), pp. 227–229, F. 429, pl. 117, and P. Hughes, *French Eighteenth-Century Clocks and Barometers in the Wallace Collection* (London, 1994), pp. 24–25.
11. J.-P. Samoyault, *André-Charles Boulle et sa Famille* (Geneva, 1979), p. 65, n. 1 on p. 79.
12. The band saw was introduced circa 1830.
13. The cupid and clouds on the top of the clock are of a different model, as is the arched mount below it. On the Waddesdon and Wallace examples, gilt-bronze medallions, containing a rearing horse and a salamander, have been added to the sides of the case. These are suspended from elaborate ribbon bows, while pendants of leaves hang below. The smoking *cassolette* attached to the inner surface of the back door on the two latter examples is of different form and is decorated with swags of flowers and acanthus scrolls. Flames issue from the mouth of the urn.

 The design of all the small panels of marquetry differs from the Arsenal example, with the exception of the large panel on the interior of the back door on the Waddesdon clock, which is the *contre partie* of that found on the Arsenal model.
14. A. Geyer, *Geschichte des Schlosses zu Berlin: Vom Königsschloss zum Schloss des Kaisers (1698–1918)* (Berlin, 1992), p. 171, pl. 270. I am grateful to Winfried Baer for pointing this out to me.
15. Sotheby's, Amsterdam, May 31, 1988, lot 237; Drouot Richelieu, Paris, December 5, 1990, lot 111.
16. Christie's, London, June 2, 1995, lot 190.
17. J.-P. Babelon, "La Maison du Bourgeois gentilhomme l'Hôtel Sallé, rue de Thorigny, à Paris," *Revue de l'Art* 68 (1985), p. 34, pl. 45.
18. Information supplied by Manuel Gonzáles.

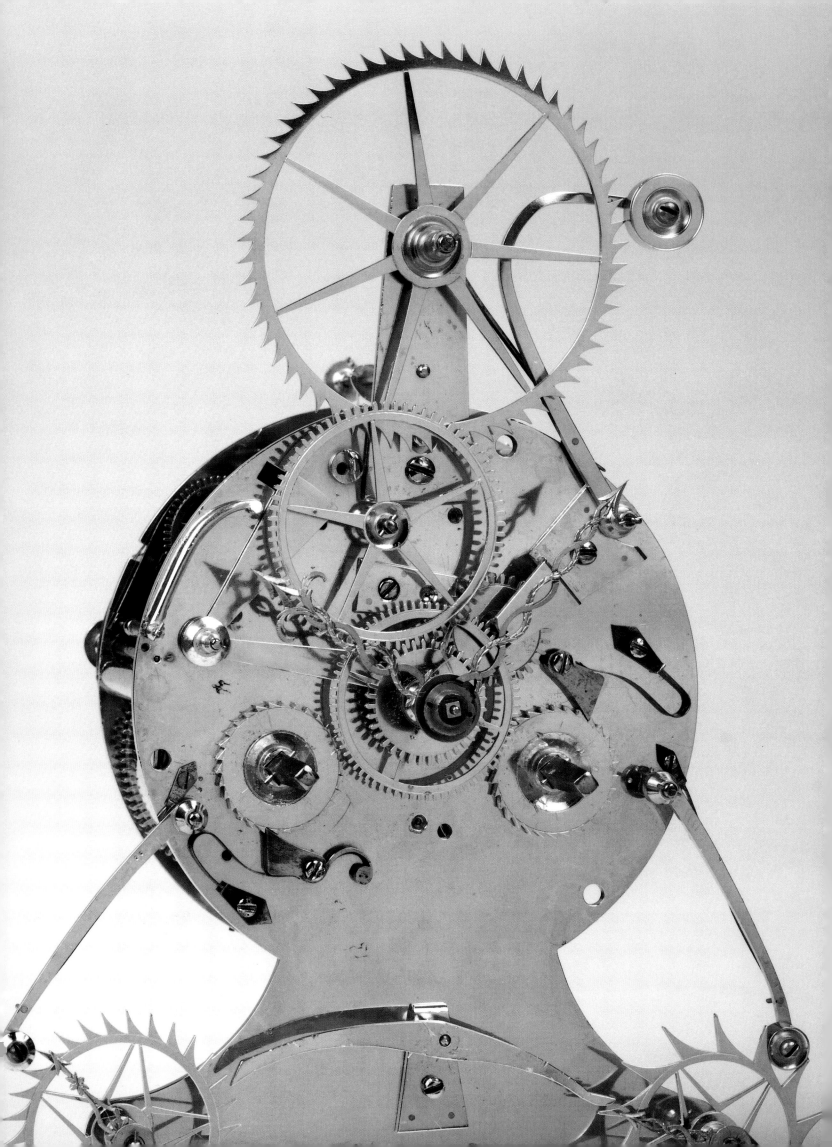

Introduction to the Biographies

The J. Paul Getty Museum's collection of clocks affords historians of Parisian clock-making a broad field of inquiry. Although few in number, the makers or repairers of the clocks listed in the catalogue are representative both of the circle of eighteenth-century Parisian clock-makers and of its social structure.

In this biographical section, we have taken as our basis the definition of the word *horloger* (clock-maker) given by Ferdinand Berthoud in the *Encyclopédie*:

> *those whose profession is clock-making are commonly called clock-makers. But one should make a distinction between the clock-maker, as intended here, and the artist who is familiar with the principles of the art: these are two quite different individuals. The former practices clock-making in general without having mastered its basic philosophy and calls himself a clock-maker because he devotes himself to one aspect of this art. The latter, on the contrary, embraces the full scope of this science: he might be referred to as an architect-mechanic; such an artist is not concerned with one field alone but rather with creating the overall design for watches and clocks, or for any other machine he might wish to build. He determines the position of each part, its direction, the forces required and all the dimensions; in short, he devises the entire structure. As for the assembly itself, he chooses workmen capable of making each part.*

Later Berthoud adds, "Clock-making being the science of movement... the task of the superior mind is to invent a machine according to the principles and laws of movement by the simplest and most assured means."

Using Berthoud's definition, it is appropriate to include here the name of Alexandre Fortier who, though a notary, nonetheless exemplifies the architect-mechanic. Fortier is considered an archetype of the learned man of the eighteenth century, who pursued serious research in the realm of science while at the same time assuming a more traditional function within society.

It should, however, be stressed that Parisian clock-makers of this period were, on the whole, skilled craftsmen, even when they were not learned men, and that from the outset of the reign of Louis XV, French clock- and watch-making became preeminent in Europe, a situation which was to remain unchanged for several decades. English craftsmen came to spend time in French workshops; for example, the clock-maker known only as Davenport, who was apprenticed to Jean-François Dominicé in 1747. And even though clock-makers such as the Le Noirs, Charles Le Roy, Jean-Jacques Fieffé, and Charles Voisin were hardly technically inventive, their art was nonetheless highly developed and the quality of their work beyond reproach.

A systematic study of the movements of the Getty Museum's clocks has revealed the names of other individuals involved in the clocks' manufacture, such as enamelers and spring-makers, and has led us to take an interest in these somewhat neglected craftsmen. We have also discovered facts about Antoine-Nicolas Martinière, Georges-Adrien Merlet, and H. Fr. Dubuisson that had not been known until now, as well as information about a most interesting personality, William (II) Blakey, clock-maker and spring-maker.

The clock-makers represented in the collection of the Getty Museum are significant in that they span a fairly broad range in terms of social circumstances and levels of financial success; thus their careers illustrate the varied

paths that led to a mastership in clock-making. The disparity among the fortunes of eighteenth-century clock-makers in Paris was great and quite unrelated to their talent, depending rather on their commercial skills. There is, for instance, no comparison between the few thousand *livres* that represent the estates of Jean-François Dominicé or Jean-Jacques Fieffé and the 200,000 *livres*, 204,000 *livres*, and 320,000 *livres* that represent, respectively, the estates of Julien Le Roy, Charles Voisin, and Etienne (II) Le Noir.

There can be no doubt that the social connections enjoyed by Julien Le Roy and the Lepautes and likewise Jean Romilly's friendships with Jean-Jacques Rousseau, Diderot, and d'Alembert lifted these clock-makers above the status of craftsman, which in such a hierarchical society would normally have been assigned to them as a result of their manual activities.

Regarding the general organization of the clock-maker's profession in Paris, we have been able to establish that between January 7, 1744, and January 30, 1776, the Parisian clock-makers' guild admitted 438 masters, 43 percent of whom (189) were accepted *hors statuts*, i.e., in exception to the rules.[1] Such exceptions were made because the clock-makers could not satisfy the demands of guild regulations, in particular the requirement that they must have followed a regular apprenticeship. Thus 83 individuals, including Michel Stollenwerck, were granted exceptional masterships in 1746, 1767, and 1770, at the initiative of the Crown, and 106, one quarter of the total, including William (II) Blakey and Jean Romilly, benefited from a special decree of the Conseil d'Etat du Roi, thanks to which the requirement of having followed a regular apprenticeship was waived. The decree in favor of Jean Romilly also shows that the matter of religion, in his case the fact that he was a Calvinist, had ceased to be an obstacle to the exercise of the clock-maker's profession in the sight of the Parisian guild at the turn of the eighteenth century. Finally, a certain number of clock-makers were never admitted as masters and exercised their craft in premises outside those stipulated by the corporate regulations; they were known as *ouvriers libres* (independent craftsmen).[2] This was the case with Jean-François Dominicé and Digue, as well as Stollenwerck (until 1746).

While it would be impossible here to go into all the implications and situations covered by the title *Horloger du Roi*, a brief discussion may help clarify the use of this term throughout the following biographies. The title *Marchand Horloger Privilégié du Roi . . .* was often shortened by its bearers to *Horloger du Roi suivant la Cour, Horloger Privilégié du Roi,* and even, improperly, to *Horloger du Roi.*

The title *Horloger du Roi* meant that the bearer belonged to an old and original institution of the French monarchy, which assembled the various professions into a single body, with a single legal structure: the *Marchands Privilégiés suivant la Cour*. This body was founded in 1485, during the reign of Charles VIII, by the regent Anne de Beaujeu.[3] It originally included only tradesmen whose business it was "to provide foodstuff, wares and commodities required by followers of the Court," in other words to ensure a regular supply to the king's table and that of his escort during their constant moves about the country. Its members were required to open shop wherever the ruler happened to be and to close down within three days after his departure. Two clock-makers were added to the group under Henri III.[4] In 1672 the number of clock-makers was definitively set at four.[5] This body survived until the Revolution, although once the court had settled in Versailles this arrangement lost whatever usefulness it had once possessed.

In exchange for fulfilling their obligations, the privileged merchants enjoyed legal and fiscal advantages, which were subject to the special jurisdiction of the Conseil d'Etat du Roi. In principle, they were required to display the arms of the *Prevôté de l'Hôtel*, a cloth decorated with fleur-de-lys, in front of their shops and on their workbenches.[6]

The *marchands privilégiés* were in theory required to be both French and Roman Catholic, those who were naturalized citizens being at one time excluded.[7] They were also required to have followed an apprenticeship according to the rules of the guild of their trade. If their apprenticeship had been irregular, they had to undergo an examination before a commission composed of two "*privilégiés* and two masters exercising their profession." Even this examination did not allow such individuals to be considered members of a guild, and therefore apprenticeships served under them were not accepted by the tradition-bound guilds.

The *marchands privilégiés*, in fact, owned their titles, the value of which exceeded that of the fees imposed upon others for the acquisition of the mastership required by the same guild. This value was justified to the extent that the potential purchasers of this patent in the eighteenth century had usually not undergone a regular apprenticeship. Because the privilege was property, it could be passed on from father to son or to some other heir; thus the existence of families of clock-makers, *bronziers*, etc.

Concerning the clock-makers discussed below, we note that Julien Le Roy and the Lepaute brothers were only awarded this title after having obtained lodgings in a royal residence, Le Roy in the Galleries of the Louvre and the Lepautes first at the Palais de Luxembourg, then in

the Galleries of the Louvre. Neither the Lepautes nor Le Roy had obtained a patent actually granting them any such title, nor had they acquired one of the four offices of *Valet de Chambre/Horloger du Roi*. Etienne-Augustin Le Roy, son and successor of Charles, became entitled to this designation only through direct and regular deliveries to Louis XVI—although again no patent had actually awarded him this distinction. Finally, William (II) Blakey improperly assumed this title in certain deeds, combining his position of master clock-maker and the patent he had been granted to exploit an invention.[8]

We hope that the above discussion and the biographies that follow will serve to define for the reader the characteristic traits of the circle of Parisian clock-makers in eighteenth-century France.

ACKNOWLEDGMENTS

We owe our thanks to Christian Baulez, Chief Curator at the Musée National du Château de Versailles et des Trianons; Catherine Cardinal, Director of the Musée International d'Horlogerie de La Chaux-de-Fonds; Evelyne Chevalier, Curator of the Bibliothèque des Musées Nationaux de Paris; Professor Lise Moor; Jean-Etienne Genequand, Archiviste d'Etat Adjoint de la République et Canton de Genève; Julien and Jean-Claude Gendrot; Michel Henry-Lepaute; Bill B.G. Pallot; Laurent Prévost-Marcilhacy; Jean-Claude Sabrier; and Jacques Van Damme.

NOTES

1. Augarde 1996.
2. Ibid.
3. Lespinasse 1888, pp. 102ff.
4. Ibid.
5. In application of a *don de nomination* Louis XIV granted to the Maréchal de Plessis-Praslin, on January 20, 1658 (Bibliothèque Nationale F 21043 [47]). In effect, the king sold a certain number of offices to the Marshal who, in turn, sold them at a somewhat higher price to the parties concerned.
6. Lespinasse 1888, decree of the Conseil d'Etat du Roi of January 30, 1625.
7. Mentioned in a decision of the *Prévôté de l'Hôtel* taken on September 20, 1760 (A.N., V³ 78A).
8. Augarde 1995 and Béliard 1767.

WILLIAM (II) BLAKEY

William (II) Blakey was born in London in the parish of Saint-Martin-in-the-Fields in Westminster, shortly before 1714[1] and died after 1788.[2] He was the son of William (I) Blakey, a clock- and spring-maker (*fabricant de ressort*) (ca. 1688–1748),[3] and Elisabeth Slade. In 1746 he married Marguerite-Elisabeth Aumerle,[4] who became *marchande quincaillière privilégiée du Roi suivant la Cour et Conseils de Sa Majesté*. He was naturalized as a French citizen in May 1758.[5]

Although known as Guillaume in France, Blakey himself always used the name William. He was trained by his father both "in the science of clock- and watch-making which he made his chief study, and in his second study which concerned springs."[6]

His father, described in his son's death certificate[7] as a spring-maker, was apprenticed to Samuel (II) Vernon in London in 1701.[8] He came to Paris at the beginning of the Régence and introduced Henry Sully to Julien Le Roy. The latter described him as "a mutual friend" and "a gifted maker of springs"[9] and was later instrumental in his admission to the Société des Arts. Blakey's father settled in Paris and introduced a special technique of spring-making that had been developed in England by Vernon. His customers included Pierre Gaudron, Julien Le Roy, and Jean-Baptiste Masson. In 1719, thanks to the protection of the regent, Philippe d'Orléans (1674–1723), he founded the Manufacture Royale de Ressorts de Montres à l'Anglaise at Charleval in Normandy. The venture declined after the regent's death.[10] In 1727 the elder Blakey established a second manufactory of watch-springs, which in 1729 also began to produce clock-springs. Success enabled him to build water mills at Crécy-en-Brie in 1733 in order to forge and polish his springs. After 1733 William (II) Blakey was closely involved in his father's activities. The latter's second son, Nicolas (died 1758), was a painter and engraver and the author, among other things, of a very fine portrait of Louis XV.[11]

In addition to making springs for clocks and watches, Blakey was equally competent as a tradesman and hydraulic engineer, as witnessed by his publication *L'Art de faire les ressorts de montres* . . . (Amsterdam, 1775). He designed various types of mills for making steel and iron blades, as well as for wire-drawing. A number of descriptions of the latter are found in his book on springs, including one for a *trai-fillerie* (drawing-mill) used to make a type of wire known as *fil à pignon*, which was submitted to the Académie Royale des Sciences and granted approval

upon the report of its commissioners on July 15, 1744.[12] The text of the approval states that "the discovery of [M.] Blakey deserves to be rewarded by granting him the exclusive privilege for which he has applied," and on this basis the privilege was indeed awarded to Blakey on July 17. Blakey also developed various other machines, the designs for which were published in his *Observations sur les Pompes à Feu, à Balancier, & sur les Nouvelles Machines à Feu*.[13]

The date 1758 inscribed on the spring of Jean Romilly's clock in the J. Paul Getty Museum (cat. no. 7) and the mention of Blakey in the bankruptcy proceedings of the clock-maker Joachim Bailly in 1759 establish that he produced springs at least until that date.[14]

Blakey was admitted to the Parisian guild as a master clock-maker on April 11, 1750,[15] following a decree by the Conseil d'Etat du Roi on March 24, 1750, which waived the requirement that he undertake a regular apprenticeship.[16] At that time, he somewhat improperly assumed, in notarized deeds, the title *Horloger Privilégié du Roi*. His production of clocks and watches appears to have been limited. The only items which can definitely be attributed to him include a wall clock veneered with tortoiseshell marquetry,[17] a gilt-bronze wall clock, the so-called Venus model, by Edme Roy,[18] and a clock with a rhinoceros by J.-J. de Saint-Germain.[19] He also used Nicolas-Pierre Severin for marquetry cases.[20]

In 1759 Blakey became the director of the Manufacture Royale de Limes de toutes Espèces façon d'Allemagne et façon d'Angleterre et autres ouvrages de fer et d'acier (Royal Manufactory of Files of every Kind, in the German and English fashion, and of other works in iron and steel),[21] the workshops of which were established in Essonnes while the offices were in Paris in the rue des Prouvaires.[22] He acquired ten percent of the capital and then immediately resold half his shares.[23] By 1761, after disagreements with his associates, he had resigned from his position.[24]

In 1760 he became director of the Bureau des Bandages Elastiques, which was also located in the rue des Prouvaires before it was transferred to the rue Saint-Thomas-du-Louvre.[25] He was probably the founder of this venture, which specialized chiefly in the manufacture of bandages for hernias according to a method that Blakey appears to have elaborated himself.[26] This endeavor lent an international scope to his activities.[27]

Blakey traveled to purchase goods for his wife to sell at their Magasin Anglais, which beginning in 1746 was located in the cul-de-sac de Rouen and then, starting in 1767, in the rue des Prouvaires.[28] The establishment was what is now generally termed a bazaar. The record of the Magasin's bills shows that its considerable trade was mainly devoted to metal objects: vises, various sorts of tools, knives, compasses, clock hammers, scientific instruments, and corkscrews, but also included gauze, fishing rods, saddlery, small pieces of furniture (*tric-trac* tables), marcasite jewelry, fans, silver-gilt snuffboxes, etc. Among Blakey's suppliers were Huntsmann and Asline of Sheffield; Jacob Levy (pencils); Dollond *père*; P. J. G. Gregory "at the Dial and Fish"; Handscombe; Edward Ford of London; Oppenheim of Birmingham; and Glover and Charrot of the same city.[29]

Little is known of Blakey's activities during the 1770s and after. He presumably pursued his commercial activities for a while. He mentions a number of business trips to England and Holland after 1772.[30] In 1778 he was living in the rue Beaubourg;[31] two years later (1780) he was living in Liège.[32] Finally, the terms of a document concerning a change of lease, signed in Paris by his wife on his behalf in 1788, lead one to assume that he was still alive at that time.[33]

One can hardly resist mentioning one particular trait of his character. In 1760 an advertisement for his elastic bandages, concludes thus: "the poor can come to his shop every morning until noon; he will give them all necessary assistance."[34]

NOTES

1. His letter of naturalization merely indicates that he had been "brought to France in his earliest youth." His father's arrival in Paris can be dated to late 1714 or early 1715.
2. A.N., Min., LXXXIX, 840, April 27, 1788, transfer of a lease by William Blakey's wife.
3. Bibliothèque Nationale, Manuscrit Français, Fichier Laborde, certificate copied from the register of burials at the Church of Saint André-des-Arts, in which he is referred to as "aged about sixty."
4. A.N., Min., LXXIII, 744, December 5, 1746.
5. A.N., O¹* 232, letter of naturalization dated simply "May 1758." It specifies that Blakey "professes the Catholic, apostolic, and Roman faith."
6. Quoted in his petition to the king. See note 16.
7. See note 3.
8. Baillie 1929 and Blakey 1780.
9. J. Le Roy, "Mémoires pour servir à l'Histoire de l'Horlogerie depuis 1715 jusqu'en 1729," in Le Roy 1737.
10. Blakey 1780.
11. Engraved in color, in 1739, by J. C. Leblond (1661–1741). See *Louis XV, un moment de perfection de l'art Français*, exh. cat. (Paris, Hôtel de la Monnaie, 1974), no. 204.
12. *Histoire* 1748, Gallon 1776, and Blakey 1780.
13. This publication, along with *Remarques sur la situation de la Hollande, & les machines propres à épuiser les eaux des marais*, was published in Amsterdam by Marc-Michel Rey in 1780.
14. Paris, Archives de la Seine, D4 B⁶, cart. 17, July 24, 1759, Joachim Bailly's balance sheet. His production was considerable and was not restricted to clock-springs. Between 1753 and 1758, he shipped over 12,000 *livres* worth of merchandise to San Domingo, including 2,000 springs at 30 *sols* apiece (one *livre* = 20 *sols*). See A.N., Y 13702.

15. A.N., Y 9327.
16. A.N., E* 1261. When a candidate to the mastership did not fulfill the required conditions in regard to his apprenticeship (by having begun, before the age of twenty, an eight-year apprenticeship to a master of the Parisian guild), he could, with the tacit agreement of the jury, submit a petition to the king with the aim of obtaining a decree from the Conseil d'Etat du Roi explicitly allowing the *Gardes Visiteurs* to receive him, in spite of the statutes, on the condition that he produce a masterpiece and pay higher fees. On this subject, see J.-D. Augarde 1996, pp. 20–27.
17. David Falcke sale, Christie's, London, April 19, 1858, lot 2068.
18. Paris, private collection.
19. Partridge Fine Arts, London, 1990.
20. A.N., Min, LXXXV, 556, April 28, 1759, inventory after the death of the wife of the *fondeur* Charles Bénard. The papers include a note for 190 *livres* owed by Blakey to Severin, dated December 18, 1758.
21. This manufactory was founded in 1751 to exploit patents, obtained by Pierre Cherpitel and extending over ten and twenty years, for a machine that produced twelve files at a time in less than half an hour (A.N., E* 1266A, September 1, 1750) and for a water wheel-activated rolling mill and drawing plate that produced molded metal strips for banisters and balconies (A.N., E* 1271B, June 29, 1751).
22. A.N., Min., LXXIII, 818, May 25, 1758.
23. A.N., Min., LXXIII, 818, May 25 and 28, 1761.
24. A.N., X2B 1025, judgment of the Parlement de Paris, May 20, 1761.
25. The address of the Bureau des Bandages Elastiques in 1771 (*Annonces, Affiches et Avis divers*, November 16, 1771, pp. 179, 180, and *Liste* 1772).
26. A.N., Y 13701, papers of Blakey, merchant of Paris (1763–1771), and *Affiches, Annonces et Avis divers*, dated January 21, 1760. He had no doubt earlier been admitted to the College of Surgery as an expert. Roze de Chantoiseau in *Tablettes* 1791, under the article "Collège de Chirurgie," states that the statutes require "those who would wish to manufacture hernial bandages... to undertake this and be admitted to the College of Surgery in the capacity of expert." See also *L'Avant-Coureur*, no. 49 (1763), and Blakey 1780. Blakey also assumed the titles *Expert et Auteur des Bandages Elastiques* and *Entrepreneur Général de la Fourniture des Bandages Militaires* (see *L'Avant Coureur*, 1758). He was active in this area for thirty years.
27. On February 15, 1764, Count von Kaunitz-Rietberg, chancellor of Empress Maria-Theresa of Austria, ordered some "bandages pour la chûte de l'anus." A.N., Y 13701.
28. *Affiches, Annonces et Avis Divers*, February 5, 1767, gives the new address. It is not certain that Blakey actually resided in the rue des Prouvaires. He may simply have had his various businesses, and that of his wife, at that address. The latter subsequently rented a large house built against the walls of the Bastille (see note 2).
29. A.N., Y 13702, *Registre de Factures des marchandises tirées d'Angleterre, commencé le 27 may 1766 et finy le . . .* The advertisement mentioned in note 28 is very detailed in respect to the merchandise sold by Madame Blakey.
30. Blakey 1780. The lists of master clock-makers in Paris in 1781, 1783, and 1789 no longer mention him.
31. *Liste* 1778.
32. A.N., Marine, G 117, dos. 1, fol. 8, letter dated May 7, 1781.
33. See note 2.
34. See note 26.

Charles Buzot

Charles Buzot was already active as a spring-maker (*fabricant de ressort*) in Paris in 1740 and died before 1772. He was married to Catherine-Geneviève Feret, who bore him two sons, Jean-Charles (1740–after 1784), a spring-maker,[1] and Joseph, admitted to the guild in Paris as a master clock-maker on August 21, 1770.[2] Charles Buzot himself was never admitted to the guild as a master clock-maker. He was established in the rue du Chat qui Perche in 1740 and then in the rue de la Huchette "*A l'Enseigne de l'Ange*" in 1754.[3]

Nothing is known of the details of Buzot's activities. The only clock-makers with whom it is certain he collaborated are Etienne Le Noir (after 1741), Jacques-Mathieu Lepers, Jean-Philippes Gosselin, and in all likelihood Ferdinand Berthoud, to whom his son Jean-Charles was apprenticed in 1754.[4] The latter took over his father's workshop in the rue de la Huchette, at which address he is mentioned under the name of "Buzot *fils*" in the *Tablettes Royales de la Renommée* of 1772 and 1773.

NOTES
1. A.N., Min., XXXIV, 594, February 7, 1754, record of Jean-Charles Buzot's apprenticeship to Ferdinand Berthoud, and the Archives Brateau (Musée National des Techniques), which mention a spring signed "Buzot, 1784."
2. A.N., Y 454, no. 105, December 19, 1778, registration of Joseph Buzot's marriage contract.
3. See note 1.
4. See note 1.

Debruge

Debruge was an enameler active in Paris during the first half of the nineteenth century. In addition to works in the Classical style, which he produced for contemporary clock-makers, he executed a certain number of dials in the style of the eighteenth century, of which the one in the J. Paul Getty Museum (cat. no. 14) is a fine example.

Jacques Decla

Jacques Decla was admitted as a painter to the Académie de Saint-Luc on January 30, 1746.[1] He was still alive in 1764, when he was living in the rue du Chevet-Saint-Landry.[2]

On August 6, 1746, the jury of the guild of master *fayanciers* had part of his stock seized. It was returned to him by a ruling of the Lieutenant Général de Police dated April 21, 1747. This ruling also confirmed that the enamel-painters of the Académie de Saint-Luc, as well as the *fayanciers*, were entitled to make enamel dials.[3]

The inscriptions on a clock in the Getty Museum (cat. no. 11) show that Jacques Decla worked for Etienne Le Noir.

The only other dial by Decla known today belongs to a wall clock by Alexandre Le Faucheur. It is signed on the back and dated 1742.[4] Made prior to his reception as a master by the Académie de Saint-Luc, the dial's inscription reveals that Decla first exercised his craft as an *ouvrier libre*.

NOTES
1. Guiffrey 1915.
2. Guiffrey refers to the *Liste Générale de tous les noms et surnoms de tous les maîtres peintres etc. . . .* of the Académie de Saint-Luc, published in 1764.
3. Raillard 1752, pp. 19–20. It appears likely that this document was known to Emile Molinier, who mentions Decla with the single date of 1747. See Molinier 1885.
4. Sotheby's, London, May 19, 1972, lot 15.

Jean-François Dominicé

Jean-François Dominicé was born in Geneva on August 23, 1694[1] and died after 1754.[2] He was the son of Denis Dominicé (1661–1721) and Pernette Terroux (died 1734). He was married, before 1729, to Anne-Marguerite La Fosse, who bore him a single daughter, also named Anne-Marguerite.[3]

Dominicé enjoyed the privileges associated with the Enclos de l' abbaye de Saint-Germain-des-Prés and never applied for admission to the guild as a master.[4] He first resided in the cour des Moines, then, after 1732, in the cour Abbatiale (Abbey Court). Several notarized deeds of the 1750s show that he was involved, as a third party, in various trades outside his own specialty.[5]

Dominicé belonged to a prominent dynasty of goldsmiths and clock-makers from Geneva which, between 1670 and 1770, counted ten masters, including his father, his uncle Bernard (1651–1727) and two of his first cousins, François (1683–1758) and Etienne (1690–1761). He undoubtedly received his training in the workshop of his father, who, in his sister's marriage contract, promised to give him all his tools after his own death.[6] Apparently his parents were wealthy, since his sister received a dowry of 1,000 florins.[7] He inherited one third of his father's wealth, amounting to at least 1,000 florins, in addition to the sum of 50 silver *écus* bequeathed "par préciput et hors part" (before distribution of the shares, inheritance taxes being paid by the estate).[8]

Dominicé in all likelihood moved to Paris before 1721, since he did not sign his sister's wedding contract, and she was married in Geneva on March 10, 1721.[9] He had in any event settled in Paris before 1724, as can be seen from promissory notes made out to his order but not collected, which give his residence as being in that city.[10]

On April 17, 1732, he bought up the stock and took over the lease of Nestor Helms, clock-maker to James II of England and later to the prince de Condé.[11] A 1747 inventory of his belongings shows that he possessed a clock by Helms and also one by Edward East (perhaps the most famous English clock-maker of the end of the seventeenth century), the values of which were estimated at the relatively high sum of 100 *livres* each (considering that they had been made quite a number of years earlier). The same document shows other links with England and English clock-making, mentioning that he had an apprentice from London, named Davenport, the costs of whose apprenticeship were being paid for by the duc d'Orléans.[12] This same apprentice is mentioned in other records as having repaired two English clocks for private customers.[13] Dominicé's dials definitely show a British influence, possibly resulting from an early collaboration with Nestor Helms. Some are made of painted cardboard rather than enamel.[14]

Dominicé's mechanical talent extended beyond simple clock-making to the making of complicated movements. In 1747 he repaired a late Renaissance clock showing the planets and the Zodiac and in the same period created an equation clock (*une pendule à seconde à grande équation*) for Monseigneur Durini, archbishop *in partibus* of Rhodes, and papal nuncio, which was billed at 1,400 *livres*, a price indicative of the object's importance.

The inventory of his workshop in 1747 indicates that while his fortune was modest, his business was healthy. His stock was valued at 450 *livres* by his colleague Jean-Isaac Godde. His credits amounted to 4,829 *livres* and his debts to 1,405 *livres*. In addition to the papal nuncio, the comte de Schomberg, and certainly the duc d'Orléans, he numbered among his clients the ducs de Bouillon and de

Montmorency, the comtesse de Bercy, and the marquis d'Arancourt. He was on good terms with his colleagues: he lent money to Pierre de Rivaz, the famous clock-maker and mechanic, and repaired clocks belonging to Antoine (II) Gaudron.[15]

His signature on a clock belonging to the Getty Museum (cat. no. 5) shows that he collaborated on musical mechanisms with Michel Stollenwerck, who then resided, as he did himself, in the abbey of Saint-Germain des Près. His cases were made by Louis Reinders, Adrien Dubois,[16] Antoine Foullet,[17] Jean-Pierre Latz,[18] Jean-Joseph de Saint-Germain,[19] and Balthazar Lieutaud.[20] He also provided movements for bronze cases decorated with Meissen porcelain figures.[21] This type of work may conceivably have been made for Lazare Duvaux, whose name appears in connection with a note for 240 *livres* (dated 1747) for the purchase of a watch.[22] Some of his watchcases were provided by Jean-Isaac Godde.

NOTES

1. *Receuil Généalogique Suisse, première série* (Geneva, 1907), vol. 2, s.v. "Dominicé."
2. He is last mentioned in the posthumous inventory of J.-P. Latz, see H. H. Hawley, "Jean-Pierre Latz Cabinetmaker," *Bulletin of the Cleveland Museum of Art* (September-October 1970).
3. A.N., Y 4441, document dated March 31, 1729, designating Dominicé as the tutor of Louis-Alexandre Blondeau, his wife's nephew.
4. A.N., Y 9379, January 20, 1739, notice of the *Procureur du Roi* referring to Dominicé as a "self-styled clock-maker." He does not appear in the printed list of clock-makers who were members of the Paris guild in 1748.
5. A.N., Min., XCVII, 522, May 4, 1753; A.N., Min., VIII, 1105, June 29, 1753; A.N., Min., XCI, 905, May 7, 1754, etc.
6. Archives d'Etat de Genève, Pierre Vigniet, notary, vol. 8, wedding contract, March 10, 1721.
7. Ibid.
8. Archives d'Etat de Genève, Jean Anne Comparet, notary, vol. 70, testament of Denis Dominicé and his wife, November 9, 1721.
9. See note 6.
10. A.N., Z² 3528, February 21, 1747, inventory after the death of Dominicé's wife (a note dated June 3, 1724, from the *ébéniste* Louis Reinders and another, dated November 13, 1724, from a Sieur Hubert in Rouen).
11. A.N., Min. XCII, 671. Nestor Helms was a Catholic clock-maker, an apprentice of the Clock-makers' Company in London in 1674, who followed James II into exile in France. Described in 1702 as clock-maker to the king of England, he was a protégé of James's wife, Mary of Modena. He then became the object of attacks by the guild (A.N., O¹* 363, fols. 187, 212). He nonetheless worked in Paris; "a small clock made by Nestor Helms in Paris" is mentioned as being in the room of the duc de Bourbon in the Hôtel du Grand Maître in Versailles (A.N., Min., XCII, 504, February 17, 1740, fol. 108r).
12. See note 10.
13. A.N., Z² 3528, February 21, 1747, *scellé* (preliminary inventory) of J.-F. Dominicé's wife.
14. Sale, Nicolaÿ, Paris, July 11, 1984, lot 86.
15. See note 13.
16. Sale, Sotheby's, Monaco, December 9, 1984, lot 1084 (a mantel clock by J.-F. Dominicé; while the case is stamped *A. Dubois* and *F. Goyer*, it is probably by J.-P. Latz).
17. See note 10.
18. See note 6.
19. H. Göbel, "Ein Cartel aus der Manufaktur des Jean-Joseph de Saint-Germain und seine Varianten," *Sonderdruck aus dem Cicerone* 22 (1930) (a clock marked with a crowned C).
20. Sale, Sotheby's, Florence, May 24, 1983, lot 1515.
21. Sale, Ader, Picard, Tajan, Paris, November 22, 1987, lot 224.
22. Unfortunately this cannot be confirmed by reference to the daybooks of Lazare Duvaux, of which only the parts after September 17, 1748, have been preserved.

DUBUISSON

Henri-François Dubuisson (active 1769–1823) was admitted as a master to the Corporation des Verriers, Fayanciers, Emailleurs et Patenôtriers de Paris on July 16, 1769.[1] He resided in the rue du Roule (1772), the rue de la Huchette (1795), the rue de la Barillerie (1799), and finally at 17, rue de la Calandre, in a house belonging to the old Barnabite convent (1812).

The earliest dial dated by Dubuisson appears to be that of a skeleton clock by Dieudonné Kinable, which is inscribed 1787 and reveals an already mature talent.[2] Dubuisson may also have created the enamel plaques relating the adventures of Telemachus that decorate this clock. The last items he is known to have produced are the dials of the clocks exhibited by Antide Janvier at the Exposition des Produits Industriels in 1823.

Dubuisson belonged to the same generation as Joseph Coteau (1740–1801) and was among the most gifted enamelers of his day. The dials of five clocks by Louis-François Godon and of a long-case clock by Jean-Simon Boudier exhibited in Spain in 1987 display the diversity of his compositions and the scope of his talent.[3] He was the equal of Coteau, with whom he shared a certain number of clients, including Kinable, Janvier, Godon, Bourdier, Robert Robin, Jacques-Pierre-Thomas Bréant, and François Drouot.

He worked extensively for the *fondeurs-ciseleurs* Claude Galle[4] and Pierre-Etienne Romain,[5] as well as for the clock-makers Louis Bréguet, Edme Coeur, C. Caillaud, Jacques-François Vaillant, Jean-François de Belle, Joseph Revel, Félix Thiaffet (in Lyon), the Baillys (father

and son), the Berthouds (uncle and nephew), the firm of Berthoud Frères, and for various members of the Lepaute dynasty.

Louis Berthoud often solicited the talent of Dubuisson and in writing about an enameled dial Dubuisson had made for a decimal clock, he declared "his clock-face, which displays both the old and the new time [the new decimal time briefly imposed by the Revolution] may be regarded as a masterpiece of outstanding craftsmanship."[6] Janvier also paid him a touching compliment, adding the following note to the manuscript of his *Description d'une Sphère Mouvante* (Description of an Orrery Clock), written in 1800: "The dials were executed by the citoyen Dubuisson who, in addition to having the greatest skill in his art, is possessed with a knowledge which assures the success of the most difficult pieces; it is a true service to all amateurs to inform them of this modern and hard-working artist."[7] When Janvier's text was published by Ferdinand Berthoud in *L'histoire de la Mesure du Temps par les Horloges* in 1802, Berthoud suppressed the note about Dubuisson. In 1813 Janvier completed his manuscript, writing of the cut effected by Berthoud, "this suppression pained me. I loved Mr. Dubuisson as an artist, before having learned to appreciate him as a good father, a good friend, and a good citizen. He is deserving of respect in every way."[8]

NOTES

1. *Catalogue des Maistres et Marchands Verriers-Fayanciers-Emailleurs-Paternostriers de la Ville et Fauxbourgs de Paris, suivant l'Ordre de leur reception, pour l'année mil sept soixante-douze* (Paris, n.d.). Rather curiously his admission to the rank of master is not mentioned in the registers kept in the Archives Nationales.
2. Sale, Christie's, Monaco, June 19, 1988, lot 36.
3. J. Ramón Colón de Carvajal, *Catálogo de Relojes de Patrimonio Nacional*, exh. cat. (Madrid, 1987), nos. 57, 59, 64, 89, 91, 117.
4. D. Ledoux-Lebard, "Bronziers de l'Empire," in Ottomeyer and Pröschel, *Vergoldete Bronzen*, vol. 2, p. 720.
5. Sale of the collection of the comte de Villafranca, Paris, March 19, 1873, lot 175; also a clock kept in the Elysée Palace in Paris.
6. C. Cardinal, *La Révolution dans la Mesure du Temps, Calendrier Républicain, Heure Décimale, 1793–1805*, exh. cat. (La Chaux-de-Fonds, Musée International d'Horlogerie, 1989), pp. 30, 32, 76.
7. A. Janvier, *Description d'une Sphère Mouvante . . . , 1800–An VIII, augmentée en 1813/1814 de plusieurs notes interessantes, de nouveaux calculs de rouages, & etc. . . .* (manuscript, Jacques van Damme Collection, Antwerp).
8. Ibid.

Jean-Jacques Fiéffé

Jean-Jacques Fiéffé was born about 1700 and died in Paris on August 14, 1770.[1] He was the son of Nicolas Fiéffé, *bourgeois de* Paris and Marie-Madeleine Roussel.[2] In 1728 he married Jeanne-François Leré,[3] who died on April 13, 1758, after having given birth to five sons and a daughter. Four of his sons, Jean-Nicolas (died 1762), Nicolas (died before 1778), Jean-Alexandre (died before 1781), and Jean-Claude (died after 1789), were master clock-makers in Paris,[4] and his daughter, Marie-Louise, married Jean-Adrien Jean, also a master clock-maker.[5]

Fiéffé was admitted to the Paris guild as a master clock-maker on October 1, 1725.[6] He served as *Garde Visiteur* from 1747 to 1749,[7] and *Garde Visiteur Comptable* from 1750 to 1752.[8] He lived first on the quai de l'Horloge, also known as the quai des Morfondus (1728), then in the rue de la Vieille Draperie (from at least 1741 until his death).

Fiéffé used the title "Clock-maker of the [Paris] Observatoire," which probably simply meant that he was responsible for maintaining that establishment's clocks.[9] This activity gained him a number of scholars such as the duc de Chaulnes as customers.[10]

Unlike many of his colleagues, Fiéffé did not become wealthy. His fortune was modest, amounting to no more than about 10,000 *livres*, including the value of a small house and a few acres of agricultural land he owned in Noisy-le-Sec near Paris.[11]

The fact that he retired early, probably after the death of his wife in 1758, makes it difficult to gather facts about his activities. The contents of his workshop, appraised six years later by his colleagues Thomas Lefebvre and Toussaint-Marie Le Noir, amounted to no more than three clocks, the worth of which was estimated at 355 *livres*, and 36 *livres* worth of tools, His only known collaborators are the spring-maker Vidal[12] and a *compagnon*, Pierre-Henry de La Chaussée.[13]

Fiéffé installed his movements in cases of very high quality, such as the imposing wall clock in the Getty Museum (cat. no. 8). Some of his cases were made by Nicolas-Pierre Severin,[14] others by the Caffieris[15] and Jean-Joseph de Saint-Germain. The reputation of these artists and the important position Fiéffé held in his guild suggest that his work was held in high esteem.

NOTES

1. A.N., Min., XXIV, 617, August 20, 1770, inventory after the death of Jean-Jacques Fiéffé.
2. A.N., Min., CXIX, 213, April 11, 1728, Jean-Jacques Fiéffé's marriage contract.

3. Ibid.
4. A.N., Y 9327 and 9328, admitted on April 5, 1752, December 30, 1754, and December 22, 1757, respectively.
5. A.N., Min., XXIV, 582, May 27, 1751, Jean-Adrien Jean's marriage contract.
6. *Liste* 1748.
7. A.N., Y 9326.
8. A.N., Y 9327.
9. The archives of the Paris Observatoire contain no trace of a formal nomination.
10. A.N., Min., XXIII, 704, October 10, 1769, inventory after the death of Michel-Ferdinand, duc de Chaulnes.
11. A.N., Min., XXXIV, 642, February 1, 1764, inventory after the death of Jean-Jacques Fiéffé's wife; A.N., Min., XXXIV, 648, February 7, 1765, partition of property between Jean-Jacques Fiéffé and his children; A.N., Min., XXXIV, 677, August 20, 1770, inventory after the death of Jean-Jacques Fiéffé; A.N., Min., XXXIV, 678, November 15, 1770, partition of the inheritance of Jean-Jacques Fiéffé.
12. London, Wallace Collection (inv. F91), and P. Hughes, *French Eighteenth-Century Clocks and Barometers in the Wallace Collection* (London, 1994), pp. 38–39.
13. A.N., E* 1418 B, decree of the Conseil d'Etat du Roi in favor of Pierre-Henry de La Chaussée.
14. Anonymous sale, Paris, February 13, 1771, lot 83.
15. A clock with an elephant by Caffieri and a movement by Jean-Jacques Fiéffé. Fulda, Schloss La Fasanerie, collection of the Landgrave of Hesse-Kassel.

NICOLAS-ALEXANDRE FOLIN, CALLED FOLIN L'AÎNÉ[1]

Nicolas-Alexandre Folin was born about 1750 and died after 1815. He was married to Marguerite Merlet[2] and assumed the designation *l'aîné* to distinguish himself from his brother Silvestre-François (1755–1795), who was also a clock-maker.[3] Folin resided first in the rue Salle-au-Comte in 1784,[4] then in the rue Saint-Martin, from at least 1793[5] to 1815, at which date he was succeeded by a clock-maker named Sarazin.[6]

As shown by his accession to mastership as a *Trinitaire* in 1789, Folin was active long before being admitted to the guild as a master. The term *Trinitaire* was applied to the *ouvriers libres* who worked within the Enclos de l'Hôpital de la Trinité. The hospital was under an obligation to teach, free of charge, a craft to the children accepted there, for a length of time equal to that prescribed for an apprenticeship—eight years. At the end of this period, the young craftsmen acquired the right, by privilege, to be received as masters with no further formalities.[7]

Folin's activity was considerable. In 1783 he was already working for Jean-Gabriel Imbert.[8] But it was during the Revolution and the years of the Empire that his business flourished, producing items with movements of good quality in cases of original design. He worked closely with the enameler Georges-Adrien Merlet, possibly an in-law of his, especially on skeleton clocks which were decorated with bronzes by Etienne Martincourt. He also used *ébénisterie* cases by Ferdinand Schwerdfeger and bronze cases by François Vion.

He quickly established a secure financial position. He acquired two buildings during the Terror, the first in Paris, in the rue du Chemin Vert, on approximately February 20, 1794, for 14,500 *livres*,[9] the second in Gentilly, on December 14, 1794, for 7,725 *livres*.[10]

NOTES
1. A.N., Min., X, 810, June 26, 1793, deed signed "N. A. Folin Lainé."
2. His wife was no doubt a relative of the enameler of the same name.
3. A.N., Y 9334.
4. Archives de la Seine, D4 B6, cart. 64, dos. 4132, balance sheet of Jean-Gabriel Imbert, 1784.
5. A.N., Min., X, 810, June 8, 1793.
6. The *Almanach Azur* of 1815 shows "Sarazin, successor of Folin," at that same address.
7. Privilege confirmed by an act of the Parlement de Paris on May 3, 1712. The Hôpital de la Trinité was founded by François I in 1545. See E. Levasseur, *Histoire des classes ouvrières et de l'Industrie avant 1789* (Paris, 1900).
8. See note 4.
9. A.N., Min., XXII, 103, 2 Ventose An II.
10. A.N., Min., XVI, 916, 24 Frimaire An III.

ALEXANDRE FORTIER

Alexandre Fortier was born in Paris about 1700 and died there on January 26, 1770.[1] He was the son of Jean Fortier (died before 1744), *marchand bourgeois* of Paris and of Marie Fressant (died before 1729). In 1729 he married Jeanne-Madeleine Cressat (died 1737),[2] the daughter of a *Syndic des rentes* of the Paris Town Hall, who bore him four children: Michelle-Jeanne (1731–1757), wife of Prosper Cavalier, counselor to the king and *Maître particulier des eaux et forêts de Paris*; Nicolas-Alexandre (1735–1752); Catherine; and François (the last two died young).

In 1744 he was remarried to Thérèse, daughter of Pierre (II) Le Roy and widow of Denis (II) Gault.[3] They had two children: Pierre-Michel and Alexandrine-Marie, both of whom were still living in 1770.[4] He lived his entire life in the same house located on the corner of the rue de Richelieu and the rue Neuve des Petits Champs.

Fortier was the offspring of a Parisian merchant family, whose members held various royal offices. One of his

first cousins was Pierre Nivelle de la Chaussée (1692–1754), a playwright, a member of the Académie Française, and the creator of a literary genre known as *comédie larmoyante* (sentimental domestic drama).[5]

Fortier obtained a bachelor's degree in law, while simultaneously pursuing studies in mathematics, perhaps under the guidance of Jacques Ozanam (1640–1718). Fortier was a lawyer at the Parlement de Paris and then became *Conseiller du Roi Notaire, Garde Nottes et du Scel au Chêtelet de Paris* upon the resignation of his uncle Romain Fortier, on November 9, 1728.[6] At his uncle's death, he became dean of this body.

Fortier was an *honnête homme* (gentleman). He belonged to the fairly broad circle of individuals who, like Michel-Ferdinand, duc de Chaulnes (1714–1769), Lieutenant-Capitaine des Chevau-Légers de la Garde; Achille-Pierre-Dionis du Séjour (1734–1794), counselor at the Parlement de Paris; or Antoine, marquis de Lavoisier, *fermier-général*, in addition to their administrative or military duties, were involved in various significant scientific ventures. This group's activities were of considerable importance for the development and dissemination of scientific knowledge throughout the period of the Enlightenment.[7] Fortier may also have belonged to the Société des Arts.

The contents of Fortier's library testify to the diversity of his interests, and the inventory of his collections shows that he was perfectly attuned to his age: in 1770, the shelves of his study contained scientific publications, treatises on jurisprudence, historical memoirs, biographies, travel narratives, books on religion, and a large number of literary works, ranging from Petronius to Voltaire by way of Montaigne and Montesquieu.[8]

A comfortable fortune (about 280,000 *livres* in 1770), allowed him to assemble a small collection of about thirty paintings,[9] including two works by Boucher, *Autumn, or Five Children Playing with a Goat* and *Summer, or the Bird-catching Children*, painted in 1731,[10] and *Le Bénédicité* by Chardin, which was shown at the salon of 1761.[11] He also owned works by Pater, Grimou, Restout, Verdier, Lemoyne, Lagrenée, Deshayes, and Loir. The Italian school was represented in his collection by a small Veronese, a Francesco Solimena, and an Albani; the Northern school by paintings by Netscher, Miel, and Van der Nerff as well as a sketch by Rubens, *The Adoration of the Magi*.[12] Also included were a few sculptures, including a *Vestal* by Clodion dated 1766, some prints, and a small number of medals, cameos, and intaglios.

His collection also included some scientific curiosities of particular interest, including a rare silver and vermeil celestial globe supported by Pegasus, which was made by Gherard Emmoser in 1579 for Holy Roman Emperor Rudolph II and which at one point belonged to Queen Christina of Sweden.[13] Fortier also took an interest in music and owned several instruments, including a small organ.

Fortier's first research, as early as 1720, concerned thermometers and barometers. His results were published under the title "Traité de la Construction des Nouveaux Baromètres," in the second volume of the 1725 edition of Ozanam's *Récréations Mathématiques*, an enlarged version of which was published in 1745. In that same year his own *Traité du mouvement diurne de la terre suivant le système de Copernic contenant le calcul juste de sa révolution, & ou il est démontré que son mouvement journalier est différent de celui des étoiles fixes* (Treatise upon the diurnal movement of the earth according to the system of Copernicus, containing the accurate calculation of its revolution, and in which it is demonstrated that its daily movement is different from that of the fixed stars) was published in Paris.[14] This book was followed, the next year, by his *Mémoire sur la manière de déterminer exactement la révolution des planètes sur leurs oves* (Memoir on the manner of exactly determining the revolution of the planets on their orbits), which was written in collaboration with M. Verdier.[15]

Fortier became interested in designing *sphères mouvantes* quite early in his career: "When I had determined to build a *sphère mouvante* according to Copernicus, I assumed that the simplicity of this system would give me much less trouble in execution than the others on which I had already worked."[16] In his cabinet he displayed a *sphère mouvante* that he had completed in 1736. Based on Copernicus's system, it is described in a 1744 inventory as "A small bronze *sphère mouvante* one foot in diameter, placed on a marquetry stand, ornamented with bronze *en couleur*, its yellow copper lantern fitted with nine mirrors, all set on a stand of wood painted in imitation of marble."[17]

Fortier made daily notations of the indications of the *sphère mouvante* before he published his observations. He declared that the movement of the earth must, on a *sphère mouvante*, be equal to 23 hours, 52 minutes, 8 seconds, and on an orrery to 23 hours, 56 minutes, 4 seconds.

The execution of this first Copernician *sphère mouvante* had been preceded by his creation of one based on Tycho Brahe's system that was two feet in diameter (an exceptionally large example) and topped by an astronomical clock with four dials. This superb instrument was executed for Bonnier de La Mosson's cabinet of mechanical objects, in which it became the central ornament.[18] Reproduced in a drawing by Jean de Cortonne[19] and engraved by Eisen on Alexis Magny's trade card, it is also the subject of a drawing now in the Berlin Kunstbibliothek, which seems to be an extremely faithful repro-

duction.[20] The *sphère mouvante* may have belonged to Magny after the Bonnier de La Mosson sale; it then passed into the collection of the baron de Thiers, where it could be seen in 1770.[21]

Only after 1744 did Fortier undertake the conception and construction of "planispheres," a project he announced in his treatise on diurnal movement: "a Planisphere of the planets following the System of Copernicus & in which the earth would be represented only by a simple dial divided into 24 hours." Three of his planispheres have survived, and the perfection of their mechanisms is equaled only by the refinement of their cases.[22] The earliest of these belongs to the Getty Museum (cat. no. 13). It can be dated toward the end of the 1740s and reasonably identified as the one which belonged to the prince de Conti.[23] The next in date, now in the Wallace Collection in London, is certainly the one that belonged to Jean Paris de Montmartel, who had it fitted with an exceptionally luxurious case.[24] The last, dated 1760, which we believe belonged to Fortier personally, was formerly in the collection of Barbara Piasecka Johnson.[25] These last two planispheres, on which the dials are set in the same way and the astronomical indications couched in the same terms, also bear the signature of Michel Stollenwerck, who displayed the 1760 planisphere in his shop.[26]

The presence of this last signature raises the question of the collaborators to whom our scholarly inventor may have turned. Fortier's first workshop was on the fourth floor of his house in the rue de Richelieu. He then moved to a small lodge in the garden of a country house in the faubourg du Roule, which he had acquired on September 24, 1744.

It appears likely that Fortier himself took a hand in making some of the mechanical parts for his orreries. However, our knowledge of the tools he possessed, even if we include the famous machine for cutting the teeth in watch wheels created by Henri Enderlin, which he purchased at the sale of Bonnier de La Mosson's cabinet, does not allow the assumption that he executed the works in their entirety.[27]

We can be fairly sure that Michel Stollenwerck worked on the last two planispheres, both of which bear his signature, but the name of the mechanic who assisted Fortier with the first one does not appear on any document. One must therefore be very cautious in mentioning Stollenwerck's collaboration in this connection however plausible it may seem. The identification of Fortier's assistants in the creation of the *sphères mouvantes* raises much the same problem. Only the names of Denis (II) Gault and of Enderlin are found in documentary sources concerning these items.

Enderlin, who belonged to a famous family of clockmakers from Basel, settled in Paris during the Régence. Although he was never admitted to the guild as a master, he contributed substantially, by his innovations, to the progress of chronometry. Several of his inventions were described by Antoine Thiout in his 1741 *Traité d'Horlogerie Mécanique*. Enderlin was probably Stollenwerck's master. The character of his work, his connections with Stollenwerck, and the fact that Fortier acquired one of his machines show an obvious connection with the latter. Concerning Gault, one should note that Fortier was his notary and that he married his widow. And lastly, the fact that Gault signed one of the *sphères mouvantes*, dated 1741 and today in the collection of P. P. D. Palmer at Dorney Court,[29] points to him as another likely collaborator.

NOTES

1. A.N., Y 10899, January 26, 1770, *scellé* (preliminary inventory) of Alexandre Fortier.
2. A.N., Min., CXVII, 366, March 27, 1729. The bride's dowry amounted to 4,000 *livres*.
3. A.N., Min., XX, 584, April 18, 1744.
4. See note 1.
5. J. Bédier and P. Hazard, *Histoire de la littérature française* (Paris, 1923–24) and J.-F. Michaud, *Biographie Universelle Ancienne et Moderne* (Paris, 1843). He was the nephew of the *fermier-général* and banker Pierre Nivelle de la Chaussée (died 1712).
6. A.N., Min., CXVII, 365. The *notaires* of the Châtelet in Paris could draw up deeds in any part of France. In August 1673, Louis XIV decreed that the nobility did not lose their rank by exercising such an office.
7. Ronfort 1989.
8. A.N., Min., CXVI, 324, September 28, 1744, inventory after the death of Fortier's first wife; A.N., Min., LIII, 461, February 14, 1770, Alexandre Fortier's inventory.
9. Alexandre Fortier's inventory (see note 8) and Fortier sale, Paris, April 2, 1770.
10. P. Ananoff, *François Boucher* (Paris, 1976), nos. 60, 61.
11. P. Rosenberg, *Chardin* (Paris, 1979), p. 268.
12. Mention should be made of several paintings "in the manner" of Raphael, or copies of his works, including one of his *School of Athens*.
13. New York, Metropolitan Museum (inv. 17.190.696). Mentioned in the inventory of 1770, the globe was listed as no. 162 in the sale of Fortier's belongings in Paris on April 2, 1770. Bosset bought it for 384 *livres*. See also *Prag um 1660: Kunst und Kultur am Hof Rudolfs II*, exh. cat. (Vienna, 1988), vol. 2, no. 445.
14. Bibliothèque Nationale (R 25845 and V39469). A small publication in sixteen folios, it contained sixty-four pages and an illustration and was dedicated to the financier and amateur scientist Le Riche de La Popelinière. Its contents were analyzed in the *Journal des Savants* (1745), pp. 534ff.
15. Bibliothèque Nationale (Rp 2050). Published by Babuty (Paris, 1746); twelve folios, twenty-one pages, and an illustration.
16. A. Fortier, *Traité du mouvement*... (Paris, 1745).
17. Mentioned in the first inventory (see note 8), it does not appear in the second.

18. Bonnier de la Mosson sale, Paris, March 8, 1745, and following days, lot 599.
19. Paris, Bibliothèque d'Art et d'Archéologie.
20. Inv. Hdz 509.
21. A.N., Min., LXXIII, 925, December 22, 1770, inventory after the death of Louis Crozat, baron de Thiers.
22. In view of the complexity of the parts it seems unlikely that he built any others.
23. The two other planispheres do not indicate the time of the tides.
24. Inv. F98. F. J. B. Watson, *Wallace Collection Catalogues, Furniture* (London, 1956), pp. 65–67, and P. Hughes, *French Eighteenth-Century Clocks and Barometers in the Wallace Collection* (London, 1994), pp. 44–45.
25. Mentioned in the 1770 inventory (see note 8), it appears in the Fortier sale as lot 161 (see note 9). It was bought by his son Pierre-Michel for 3273 *livres, 2 sols*.
26. See Stollenwerck biography in this volume.
27. See note 18, lot 541.
28. He was never admitted as a master.
29. Sotheby's, London, "Treasured Possessions at Sotheby's," December 21, 1983–January 20, 1984.

Antoine (I) Gaudron

The signature "Gaudron à Paris" appeared as early as 1660. From then until 1710, it was used by the workshop of Antoine (I) Gaudron and after 1710 by that of his sons Pierre and Antoine (II) Gaudron. The *pendule à secondes* at the Getty Museum (cat. no. 1) is, on the basis of its date, the exclusive creation of Antoine (I), to whom this study will be restricted.

Antoine (I) Gaudron was born about 1640 and died in Paris on August 3, 1714.[1] In 1671 he married Anne Baignoux, the daughter of a family of goldsmiths from Blois, who died on April 6, 1713.[2] The couple had three children. Pierre Gaudron (died May 19, 1745) was admitted to the Paris guild as a master clock-maker on March 7, 1691.[3] He was clock-maker to the duc d'Orléans from December 29, 1717, to August 24, 1739,[4] and a member of the Société des Arts. Antoine (II) Gaudron (1675–1748) was admitted as a master clock-maker on March 7, 1691.[5] He is cited in the records as a *marchand-mercier-joaillier-grossier* before 1704, and on June 26, 1741, was appointed *Conseiller, Secrétaire du Roi, Maisons et Couronne de France* at the Chancery of the Parlement de Metz on June 26, 1741. Marie-Anne (died after 1754) married Guillaume Hubert, a goldsmith in Paris, who was later goldsmith by appointment to the queen of England.

Gaudron was a member of the clock-makers' guild of the faubourg Saint-Germain circa 1660–1665. When the guild was unified with the Paris guild he then automatically became a master of the Corporation de la Ville et Faubourgs de Paris on June 5, 1675.[6] He served as *juré* of the guild from June 27, 1690, to June 26, 1692.[7]

In 1698 he lived in the place Dauphine "A l'Enseigne de la Perle," then, in 1706, he moved to another building, "A l'Enseigne de la Renommée," on the same square.

Nothing is known of the origins of Gaudron's family, nor of the beginning of his activities, nor, finally, of the date and circumstances of the transfer of his workshop from the faubourg Saint-Germain to the Ile de la Cité. He seems to have become prosperous in a short time, as indicated by the dowries he gave his children. After his death his estate amounted to over 174,000 *livres*,[8] including, among other things, the building on the place Dauphine purchased from Isaac Thuret in 1706. The apartment he lived in at the time was pleasantly furnished and contained numerous pieces of Chinese porcelain, mostly blue and white ware.

In 1698 Gaudron brought his sons into his business. The firm thus created traded in "ouvrages d'orlogerie, pierreries, tableaux, glaces, porcelaines, bronzes, bijoux" (clock-works, precious stones, paintings, mirrors, porcelain, bronze, jewels). The elder Gaudron retired on December 28, 1710, at which time his share was estimated at 36,000 *livres*.[9] Together his sons continued to run the firm. To the dismay of historians, the inventories of the wares at that time were established by private treatise rather than by a notary and thus have not come down to us. The only knowledge we have concerning his stock is found in a statement he signed after the promulgation of the "Edit Somptuaire" of March 20, 1700,[10] and by an investigation of the premises of the clock-makers of the Ile de la Cité, undertaken in December of the same year by Commissaire Delamare.[11] In a statement registered on April 20, 1700,[12] Gaudron lists thirty-four clocks, both large and small, the gilt-bronze ornaments for ten clock cases, six marquetry consoles, together with eleven consoles as well as thirty gilt-wood stands for displaying porcelain. On the occasion of his visit, Commissaire Delamare confiscated nine clocks and five consoles. A comparison between these figures and those concerning the other clock-makers living in the Ile de la Cité shows that Gaudron was, in 1700, in third position behind Balthazar (II) Martinot and Gilles (II) Martinot.

Following the example of Nicolas Hanet, Gaudron was, along with Isaac Thuret, one of the first Parisian clock-makers of the faubourg Saint-Germain to adopt the pendulum invented by Christiaan Huygens.[13] He also invented some interesting clocks with both simple and complicated astronomical indications.[14] According to his son Pierre, in 1688 Gaudron executed "a clock whose pendulum marked the seconds . . . , following the equations according to a curve which causes the pendulum to

rise and fall,"[15] in which case he would be the inventor of the first French equation clock. It appears very likely that his invention, the existence of which is not confirmed by any other source, was still imperfect, since historians hold that the first French equation clocks were developed, almost simultaneously, by Charles Le Bon and Julien Le Roy in 1717. It is interesting to note, in this respect, that Julien Le Roy and Charles Le Bon were extremely close to Gaudron. Gaudron was Le Bon's witness when he was married on August 18, 1707,[16] while Pierre Gaudron stated in his will that Julien Le Roy "always showed the most perfect gratitude and the most sincere veneration for my late father," and for this reason bequeathed him the clock made in 1688.[17] It is unlikely that Le Bon and Le Roy could have been Gaudron's apprentices, and while they may not have been his *compagnons*, they could at the very least be considered his followers and friends.[18] Gaudron's other collaborators are not known, with the exception of his sons, one of whom (Antoine II) very soon gave up clock-making to devote himself to the jeweler's trade within the family firm, and his daughter Marie-Anne who, before she got married, worked as an engraver in the family workshop.

Gaudron's workshop was one of André-Charles Boulle's main customers for clock cases throughout the latter's entire career.[19] But Gaudron was also supplied with clock cases by a group of *ébénistes* that included Léonard Consenne (ca. 1650–ca. 1724), his brother Jean (died prior to 1724), and Consenne's nephews, Henry Hahn, also known as Le Cocq (1668–1731), and Jean Mathieu (born before 1672–1740).

The Gaudrons marketed their own productions, as did the great majority of clock-makers during the seventeenth and the beginning of the eighteenth centuries, though they also sold their work to such powerful *marchands-merciers* as the Verani de Varennes brothers.[20]

The Gaudron workshop was one of the most outstanding of its time, and from the very outset it enjoyed the sort of clientele one might expect. Customers of note included the chevalier d'Angouléme, the ducs d'Aumont, Beauvilliers, and Tresmes, the duchesses de Ventadour and Rohan, the princess of Mecklenburg, the marechaux Fabert, de Contades, and de la Feuillade, Cardinal de Polignac, the marquis de Chavagnac, de Saint-Romans, de Coentanfan, and des Yvetaux, the comte d'Estaing, the Controleur Général des Finances, Nicolas Desmarets, and the famous financier and collector Pierre Gruyn.

NOTES

1. A.N., Min., XXIX, 319, inventory after the death of Antoine (I) Gaudron, August 6, 1714.
2. The marriage contract was signed on September 12, 1671, at Médan, near Saint-Germain-en-Laye. This document is mentioned in the 1714 inventory (see note 1).
3. A.N., Y 9322.
4. He resigned in favor of Jean Godefroy. A. N., V³ 192, fol. 152v. Pierre Gaudron had stopped production in 1728 because of his blindness.
5. A.N., Y 9322.
6. A.N., Y 9318. He is mentioned "as entering from the Guild of faubourg Saint-Germain."
7. A.N., Y 9322.
8. A.N., Min., XXIX, 319, September 24, 1714, distribution of the estate of Antoine Gaudron.
9. A.N., Min., CXV, 338, February 9, 1711.
10. The Sumptuary Edict of 1700 forbade the use of gold and silver, whether pure or applied on furniture, bronze mounts, mirror backs, etc. It was seriously enforced for at least three years. Just after the promulgation, private individuals had to declare any belongings made of gold and silver, and traders were required to identify any stock that contained these precious metals. They were allowed to sell existing items but not to make any new products.
11. Bibliothèque Nationale, Manuscrit Français 21267, Delamare Papers, fol. 6v.
12. Bibliothèque Nationale, Manuscrit Français 21267, Delamare Papers, fol. 313.
13. Sale, Christie's, New York, April 18, 1984, lot 90.
14. J. Abeler, *5000 Jahre Zeitmessung, Dargestellt an den Uhren des Wuppertaler Uhrenmuseum und der J.u.G. Abeler Uhrenwanderaustellung*, exh. cat. (Wuppertaler Uhrenmuseum, 1988), p. 56, no. 98.
15. A.N., Y 64, fol. 37r, July 19, 1746, insert to the will of Pierre Gaudron, dated August 18, 1742.
16. Bibliothèque Nationale, Manuscrit Français, Fichier Laborde, extract from the registers of the church of Saint-Germain de l'Auxerrois.
17. See note 15.
18. See Julien Le Roy biography in this volume.
19. Ronfort 1986.
20. A.N., Min., LXX, 329, October 31, 1713, assets of the firm of Paul and André Veráni de Varennes. The Veranis of Varennes were probably the greatest merchants of their day and in 1713 counted among their clients four princes of the blood, ten princes, and twenty-one dukes and duchesses.

Paul Gudin, called Gudin le jeune

Paul Gudin, known as Gudin *le jeune*, was the son of Claude Gudin, a merchant in Saint-Cyr-en-Bourgogne,[1] and Jeanne Brézard.[2] He was the brother of Jacques Gudin (1706–1743), a master clock-maker in Paris. He married Elisabeth Durand.[3]

He was at first an *ouvrier libre*, then became *Marchand-Horloger Privilégié du Roi suivant la Cour et Conseils de Sa Majesté* (Clock-maker by appointment to the King following his Court and Councils) on June 1, 1739, upon the resignation of Charles Le Bon.[4] He resigned his patent in favor of François Dufour on December 1, 1755.[5] In 1743 he resided on the quai de l'Horloge (also known as the quai des Morfondus), but by the following year had premises on the quai des Orfèvres.[6]

Only three clock-makers named Gudin worked in Paris during the eighteenth century: Jacques, who was admitted as a master in 1725 through the acquisition of one of the twelve special offices established by Louis XV on the occasion of his wedding, and whose workshop continued to be run by his widow, under her husband's name, for about thirty years; Paul, who was Jacques's brother; and Jacques's son, Jacques-Jérôme, who became a master in 1762.[7]

All the works signed "Gudin *le jeune*" are in the rococo style, and some bear the mark of a crowned C. Consequently they cannot be by Jacques-Jérôme, who was born in 1732 and did not set up shop until 1754.[8] The qualifier "le jeune" can only apply to Paul Gudin. There is no instance in eighteenth-century France, no matter the line of activity, of a son assuming this qualifier to distinguish himself from his father.

Having in all likelihood worked as an *ouvrier libre* until the day he bought his royal patent, Gudin then had to choose a signature that would distinguish him from his brother. It should also be observed that clock-makers entitled to the designation *Marchand-Horloger Privilégié du Roi suivant la Cour et Conseils de Sa Majesté* did not make any mention of their title on the dials of their clocks until the second half of the eighteenth century. Mynüel, Ducorroÿ, and Le Bon always signed with their surnames alone. It is therefore not surprising, in view of the custom of the period, that Gudin should have assumed the surname "Gudin *le jeune*," without adding his title, to distinguish himself from his brother.[9]

The activity of Gudin *le jeune* appears to have been considerable, since the quarters he rented on the quai des Orfèvres included a shop on the ground floor, a mezzanine and first floor consisting of two rooms, the third and fourth floors, each containing three small rooms, and an attic.[10]

Gudin *le jeune*'s production consisted of excellent movements set in bronze cases of high quality, generally decorated with porcelain figures or animals from various manufactories. One may note, among his clients, the prince de Bauffremont,[11] Paris de Montmartel,[12] and Horace Walpole.

NOTES

1. It has not been possible to establish the whereabouts of this village, which has presumably since been incorporated into some larger township.
2. A.N., Min., CXV, 472, May 15, 1731, marriage contract of Jacques Gudin.
3. A.N., Min., CXV, 551, January 5, 1745, lease to Paul Gudin and his wife.
4. A.N., V3 192, fol. 151r.
5. A.N., V3 77A. He was appointed deputy guardian of his nephews on August 28, 1743 (A.N., Y 4614B) and replaced in this function on April 23, 1755 (A.N., Y 4754B).
6. In the deed appointing his children's tutors, Paul Gudin is shown to be residing in the place Dauphine (see note 4). But the lease on the premises on the quai des Orfèvres of 1745 shows that he was already living there at that date and that he was authorized to use "the exit onto the place Dauphine by the common alley." It is therefore not unusual that either address should appear in legal documents.
7. Gudin's case is a typical example of the state of confusion in which the entries for Tardy's *Dictionnaire des Horlogers Français* were established, using a cursory and simplified compilation of archives assembled by Paul Brateau. The *Dictionnaire* mentions two Jacques-Jérôme Gudins, one of whom (supposedly *l'aîné*, master in 1750, died in 1784) never existed. Another one of Tardy's creations *ex nihilo* is Abraham Gudin, who is supposed to have been admitted as a master in 1726. This is merely the result of Tardy's hasty reading of a court decision of March 12, 1726 (A.N., Y 9377), concerning "Abraham Gilbert . . . and Paul Gudin." And lastly, Tardy was unaware of the existence of Paul Gudin, since Paul Brateau did not know of it.
8. A.N., Min., XCVII, 346, June 7, 1755, distribution of the estate of Jacques Gudin.
9. In the leases mentioned in notes 3 and 6, Paul Gudin describes himself as *Maître Horloger*, a title to which he was not, in fact, entitled.
10. See note 3 and A.N., Min., CXV, 582, December 6, 1749.
11. A.N., Min., XX, 784, 16 Pluviose An VIII, inventory after the death of the princesse de Bauffremont.
12. A.N., Min., CVII, 534, September 23, 1766, inventory after the death of Paris de Montmartel.

The Etienne Le Noir Workshop

The signature "Etienne Le Noir" was used throughout the eighteenth century by two clock-makers of that name and by their grandson and son Pierre-Etienne. From 1750 to 1771, it referred to the firm established by the latter and his father Etienne (II). From 1770 until about 1820, it was used by Pierre-Etienne alone, then by his son Etienne (III) Alexandre. The clocks in the Getty Museum are the work of Etienne (II) and Pierre-Etienne Le Noir, and the present study will be restricted to these two.

Etienne (II) Le Noir was born in Paris on November 7, 1699[1] and died in Paris on August 20, 1778.[2] He was the son of Etienne (I) Le Noir (ca. 1675–1739), master clock-maker in Paris, and of Marie-Anne Gamonet (died 1739). He had four brothers, Jean-François, Jacques, Claude, and Isaac, all of whom were master clock-makers, and two sisters, Anne-Emilie, wife of the engraver Jean-Baptiste Adam du Tillet, and Marie-Anne, wife of Pierre Albaton, a *monteur de boîtes* (clock-maker specializing in the making of watchcases). He married Marguerite Huré in March 1723 at Lizy-sur-Ourcq.[3] They had two children, Pierre-Etienne, and Françoise-Marguerite (died 1753), who married Etienne Cluzed, apothecary to the duc d'Orléans. Etienne (II) became a master (as the son of a master) on November 26, 1717.[4]

Etienne (II) was in partnership with his son Pierre-Etienne until his retirement in 1771.[5] After that he continued to manage his estate and divided his time between his Paris apartment and his house in Bel-Air, Montmartre.

Etienne (II) amassed a considerable fortune. He was already comfortably wealthy when his father died in 1739, and in 1745 he refused his inheritance.[6] He gave both his daughter and his son dowries of 11,000 *livres*.[7] His company was established in 1750 with capital amounting to 48,000 *livres*, which had grown to 62,000 *livres* by 1751, and was reduced to 41,157 *livres* in 1753 (equally divided between father and son).[8] From 1754 to 1756, Etienne (II) purchased two offices of *Conseiller du Roi* and *Inspecteur sur les Vins, Eaux de Vie et autres Liqueurs à Paris*[9] and a farm in Chaunes-en-Brie (which he leased out)[10] for 82,000 *livres* cash. Upon the death of his wife, in 1759, his personal fortune amounted to 176,000 *livres* and the clear assets of the firm were 54,239 *livres*.[11] At his death in 1778, he was worth 320,904 *livres*.[12]

Pierre-Etienne Le Noir was born in Paris about 1725. He married Jean-Henriette Brevet in 1750,[13] and they had three children, Etienne-Alexandre, Jean-Marie, and Jean-Henri, all of whom were still living in 1779. Pierre-Etienne became a master in Paris on February 22, 1743.[14] He worked with his father and was in partnership with him from 1750 to 1771. In that year, he took over the family workshop, which he later left to his son Etienne (III) Alexandre, who continued the business under the Consulate and the Empire. Pierre-Etienne always lived and worked on the quai des Orfèvres.

The Le Noir family, like the families Martinot and Thuret, is a perfect example of the great dynasties of Parisian clock-makers. Their ancestors are first mentioned in the sixteenth century, and the family continued to work in the profession well after the end of the ancien régime. The family, of which Etienne (II) was a fourth-generation member, had three active branches. The Le Noirs were allied by marriage to several of the foremost clock-making families, including Dugrand-Mesnil, Dutertre, Furet, and Berault. Etienne (II) was also related to the renowned engravers and publishers Gournay and Bailleul through the marriage of his sister Anne-Emilie to Jean-Baptiste Adam du Tillet.[15]

The workshop reached its peak during the association between Etienne (II) and Pierre-Etienne. Under the signature "Etienne Le Noir à Paris" the two clock-makers sold a large number of clocks and watches, executed in all sorts of materials, which were distributed all over Europe. Their reputation was such that even during their lifetimes fakes were being sold under their name. (This was also the case with watches by Julien Le Roy and Ferdinand Berthoud.)

The scope of the Le Noirs' workshop led them to split their subcontracting for mechanical parts. The names of only a few of their collaborators are known. The springs were provided by the best makers, Claude and Etienne-Claude Richard, Charles Buzot, and Pierre Masson, and the dials by Antoine-Nicolas Martinière and Jacques Decla. Some of their watchcases were made by the *monteurs de boîtes* François Gervais, Pierre Alberton, Moyse Du Cloux, and Xavier Gide. Others were decorated by the *miniaturiste-emailleur* Hubert, with chatelaines by the goldsmith Jean-Marc-Antoine Ecosse.

In 1759 the value of the firm's stock was estimated by the master clock-makers Etienne Galois and Louis-François Herbault at over 28,000 *livres*. The firm's most lucrative activity at the time was the production of watches. Sixty of these are listed, forty-five with gold cases, and fifteen with silver ones, as against twenty-two clocks of various sorts, fourteen of these with bronze cases and eight with cases veneered with marquetry.[16]

The Etienne Le Noir workshop sold its production in two ways: finished clocks and watches were sold directly to the public or to dealers; movements (to be placed

in cases) were sold as well to case-makers or other middlemen.

The firm was connected with a number of *marchands-merciers*; among these were Thomas-Joachim Hébert (who supplied clocks by Le Noir to the Royal Garde Meuble in at least 1745, 1747, and 1749),[17] Claude and Claude-François Julliot,[18] Lazare Duvaux,[19] and François Darnault.[20] To these names should be added those mentioned in the inventory of 1759 as owing the firm money:[21] Jean-Bertin Tesnier,[22] Jean-Jacques Allain,[23] François Herbaut,[24] Henri Le Brun,[25] the two La Fresnayes, father and son,[26] Jean-Jacques-François Machart,[27] the Noyaux brothers in Amsterdam,[28] and Claude Le Noir, established in Lyon as a clock-maker.[29]

It was most certainly at the request of some of these *marchands-merciers* that the Le Noirs inserted their works in complex gilt-bronze cases decorated with flowers, animals, and porcelain figures from Meissen, Saint-Cloud, Mennecy, Chantilly, or the Far East (such figures could at that time be seen in the Gaignat, Boullongne, Sainte-Foy, and Aranc de Presles collections). They also provided the *marchands* with clocks decorated with bronze figures japanned by the brothers Martin, like those on the clock on the *cartonnier* by Bernard (II) van Risenburgh in the Getty Museum (cat. no. 11).

Documents also mention a collaboration with the *ébéniste* Charles Cressent on, among other things, a cartel with the Four Winds and dragons that belonged to Marin de La Haye in 1753,[30] and with the *fondeur* Nicolas Bonnet.[31]

It cannot be established who initiated the collaboration between Etienne (II) Le Noir, Bernard (II) van Risenburgh,[32] and Jacques Dubois for the production of the pieces now in the Getty Museum—a collaboration that was probably only occasional. The same holds true for the work undertaken in common by Etienne (II) and Jean-Pierre Latz, attested to by two clocks, one of which is now in the Schloss Moritzburg and the other in the Museum für Kunsthandewerk in Dresden.

With the exception of the *ébénistes* cited above, one may assume that the relationship between the Le Noirs and the case-makers was that of customer to supplier. This is beyond doubt as far as Jean Goyer and Jean-Joseph de Saint-Germain are concerned, since their names appear in the creditor column of the 1759 inventory.[33] It is most certainly true for the *ébénistes* Balthazar Lieutaud, Adrien Dubois, Antoine Foullet, and Joseph de Saint-Germain, as well as for the *bronziers* Jacques and Philippe Caffieri.[34] It is also true for Michel Poisson and Robert Osmond, who provided the Le Noirs with several clock cases, including one representing the Rape of Europa, which at one time belonged to the duc de Richelieu and which may be the one now in the Getty Museum (cat. no. 14).[35]

The list of owners of clocks or watches by Etienne (II) Le Noir is an impressive one. In France, the nobility, the financiers, the *noblesse de robe,* and the church are all represented. A full enumeration would soon become tedious, so we mention only a few: the Garde Meuble de la Couronne,[36] the duc and duchesse d'Orléans,[37] the marquises de Pompadour, de Flavecourt, and de Brignolles, the comtes de Merle, de La Marck, and d'Egmont, the comtesse du Barry,[38] Lord Albermarle, and Count Carl Gustaf Tessin of Sweden. Works bearing this prestigious signature were also acquired by the courts of Spain, Naples, and Sweden,[39] and many German courts, including those of Saxony and Hesse-Kassel.

The members of the Le Noir family did not contribute to the progress of chronometry from a theoretical point of view, but the quality and precision of the works produced by their workshop is unsurpassed. Above all those of Etienne (II) Le Noir and his son Pierre-Etienne made the signature "Etienne Le Noir à Paris" among the most prestigious "trademarks" of the eighteenth-century Parisian clock-making industry.

NOTES

1. Bibliothèque Nationale, Manuscrit Français, Fichier Laborde, extract from the baptismal registers of the church of Saint-Barthélémy, dated November 8, 1699.
2. A.N., Y 12, 478, August 20, 1778, *scellé* (preliminary inventory) of Etienne Le Noir.
3. Contract signed on March 27, 1723, before Maître Martin, *Tabellion royal,* in Lizy-sur-Ourcq, quoted in the inventory of Marguerite Huré (see note 11).
4. *Liste* 1748.
5. A.N., Min., LXII, 422, October 11, 1750.
6. A.N., Min., LVII, 377, June 1, 1745.
7. A.N., Min., XCIX, July 7, 1746 (see also note 5).
8. The firm's variations in capital and conditions are described in an annex to the deed of establishment (see note 5).
9. A.N., Min., CIX, 601, May 14, 1774, and CIX, 601, May 17, 1756.
10. A.N., Min., LXVIII, 457, May 29, 1756, and LXVIII, 459, December 5, 1756.
11. A.N., Min., LXVIII, 469, March 3, 1759, inventory after the death of Marguerite Huré.
12. A.N., Min., XCIII, 129, September 24, 1778.
13. A.N., Min., LXII, 422, October 4, 1750.
14. A.N., Y 9325.
15. The Bailleul engraved the gores of the Abbé Nollet globes in the Getty Museum (86.DH.705); see Ronfort 1989.
16. See note 11.
17. A.N., O^1 3314.
18. A.N., Min., X, 540, inventory after the death of Claude Julliot (which mentions three clocks by Etienne Le Noir), and A.N., Min., X, 666, November 5, 1777, inventory after the death of the wife of Claude François Julliot (in which nos. 371 and 373 describe two Chinese porcelain clocks with movements by Etienne Le Noir).

19. Duvaux's widow is listed among the "good debts" for the amount of 96 *livres* in the inventory of 1759 (see note 11). Le Noir appears as a creditor for the same amount in the posthumous inventory of Duvaux's belongings (A.N., Min., XCIV, 290, November 29, 1758). Duvaux's daybooks mention three clocks (nos. 581, 752, and 2700) and a watch (no. 2274), sold respectively to the princess of Naples, the marquises de Brignolles and de Pompadour, and the king for the château de Choisy.
20. A.N., Min., LXXXVIII, 629, August 28, 1753, inventory after the death the wife of François Darnault.
21. Annexed to the inventory of 1759 (see note 11) is a "Statement of the amounts remaining due to the firm" listed under four different headings: "Good debts, most of which have been settled," "Good debts which are subject to reduction," "Doubtful debts," and "Unrecoverable debts." This last heading is mainly composed of remainders of accounts of negligible value.
22. Listed for 1,590 *livres* under the heading of good debts and for 522 *livres* under that of debts subject to reduction. On the back of a document included in the *scellé* (preliminary inventory) of the clock-maker Daillé (A.N., Y 11341, February 3, 1760) appears a copy of the following note: "At the end of the coming month of January I shall pay to the order of M. Lenoir the amount of three hundred *livres*, being the value of goods received in Paris today, 19 June 1759" and "Pay to the order of M. Osmond value in account in Paris 24 December 1759. [Signed] *Lenoir le fils*. Pay for me to the order of M. Forestier value received in goods in Paris 26 January 1760 [Signed] *R. Osmond*."
23. Listed under the heading of doubtful debts for the amount of 2,853 *livres*. On May 30, 1761, the Le Noirs, father and son, requested an attachment on the estate of Jean Allain in the amount of 3,200 *livres*, which were owed to them by his son (A.N., Y 11578, May 29, 1761).
24. Listed for the amount of 1,725 *livres* under the heading of debts subject to reduction. They recovered only 14 percent on March 2, 1762. See *Direction des créanciers de Louis-François Herbault, md* [marchand] *mercier bijoutier*, A.N., XXIII, 643, March 2, 1762.
25. Listed for the amount of 5,053 *livres* under the heading of good debts.
26. La Fresnaye *père* was included for 2,454 *livres*, 10 *sols* in the list of good debts, and his son for 400 *livres* under the same heading.
27. Listed for 2,562 *livres* under the heading of doubtful debts.
28. This is the first name to appear, on January 23, 1750, on the register of deliveries described in the inventory under no. 22.
29. Listed for 516 *livres* under the heading of debts lost before the establishment of the firm.
30. A.N., Min., LVII, 408, October 12, 1753.
31. Archives de la Seine, D5 B6, 447, Nicolas Bonnet's daybook.
32. In 1955 P. Cailleux owned another *cartonnier* by Bernard van Risenburgh, which incorporated a clock with a movement by Etienne Le Noir. See *Grands Ebénistes et Menuisiers Parisiens du XVIIIème siècle, 1740–1790*, exh. cat. (Paris, Musée des Arts Décoratifs, 1955), no. 30.
33. Goyer is listed for 36 *livres* and Saint-Germain for 60 *livres*. The Le Noirs dealt with the latter for many years. See Augarde 1986.
34. A clock with an elephant by Caffieri and clockworks signed "Etienne Le Noir à Paris," formerly in the collection of the comtesse de Maistre, had a chimes spring signed "Buzot, 9bre 1741" and a clock spring signed "Masson, 20 janvier 1741."
35. Duc de Richelieu sale, Paris, December 18, 1788, lot 692.
36. The inventory of January 1, 1788, of the king's clocks and of the Garde Meuble mentions seven clocks and wall clocks by Etienne Le Noir (A.N., O¹ 3371).
37. *De Versailles à Paris: Le Destin des Collections Royales*, exh. cat. (La Mairie du V*ᵉ* arrondissement de Paris, 1989), no. 88.
38. Archives de la Seine, D5 B⁶, 325, daybook of the clock-maker Henri Waltrin (on November 4, 1772, the repair of a clock by Etienne Le Noir belonging to the comtesse du Barry is mentioned).
39. The Le Noirs had long-established connections with Sweden. Etienne Le Noir, incidentally, suffered from the bankruptcy of Jean Fredman, clock-maker to the king of Sweden, in 1741. See Tessin 1963, pp. 136, 141, n. 4.

The Lepaute Workshop

The signature "Lepaute Horloger du Roi" corresponds to the business association formed by the brothers Jean-André and Jean-Baptiste (II) Lepaute during the second half of the reign of Louis XV, which was continued by Jean-Baptiste and his two nephews, Pierre-Bazile Lepaute and Pierre Henry. This signature was used between 1750 and 1789. One cannot always distinguish the individual role of each of the associates in the production of this workshop. This is particularly true of the two founders, who were in turn directors of the firm.[1]

Jean-André Lepaute was born at Thonne-la-Long in 1720 and died in Saint-Cloud on April 11, 1789.[2] He was buried in the church of Saint-Germain-de-l'Auxerrois in Paris. He was the son of André Lepaute, a locksmith, and Elisabeth Doulct. On August 27, 1747, he married Nicole-Reine Etable de La Brière (1723–1788), the daughter of an officer of the house of Marie-Louise d'Orléans, the widow of Louis I of Spain. The couple was childless. The famous astronomer and academician Jérôme de Lalande drew a splendid portrait of Madame Lepaute, who was a distinguished astronomer.[3]

Sometime before October 1751, Jean-André was granted lodgings in the Palais du Luxembourg and as a result was able to use the title *Horloger du Roi*.[4] He received lodgings in the Galleries of the Louvre on December 24, 1756.[5] Jean-André was admitted to the Paris guild as a master clock-maker on June 2, 1759, by decree of the Conseil d'Etat du Roi of March 13, 1759, which released him from the obligation of following a regular apprenticeship.[6] He formed a business

association with his brother on October 28, 1759.[7] He retired from business in 1775[8] and went out of his mind around 1781.[9]

Jean-André was the author of various publications, including his exemplary *Traité d'horlogerie*, published in 1755, which he wrote with the help of Jérôme de Lalande.[10]

Jean-Baptiste (II) Lepaute was born in 1727 at Thonne-la-Long and died in Paris on 29 Pluviose An X (March 18, 1802).[11] He was the son of André Lepaute and Elisabeth Doulet. In 1759 he married Marie-Thérèse-Victoire Chardon, daughter of the printer Jacques Chardon and great-granddaughter of the famous *ébéniste* and *fondeur* to Louis XIV, Domenico Cucci.[12] She bore him three children: Louis-Alexandre (1765–1845), an administrator of the Languedoc canal, Alban-Louis (died 1807), a goldsmith-jeweler, and Catherine-Henriette.

In the mid-1740s, he joined his brother in Paris, who trained him and made him his associate on October 28, 1759. He became *Horloger du Roi* under the same conditions as Jean-André and was allowed to succeed the latter in his lodgings in the Galleries of the Louvre on September 11, 1775.[13] He was admitted to the guild as a master clock-maker on December 20, 1776.[14] Jean-Baptiste retired on May 14, 1789.[15]

Pierre Henry (called Pierre Henry-Lepaute) was born August 22, 1749, at Thonne-la-Long and died in Paris in July 1806. He was the son of Jean Henry, a farmer, and Elisabeth Lepaute, sister of Jean-Baptiste and Jean-André Lepaute.[16] He himself had only one son, Augustin-Michel Henry (born 1800), who also became a clock-maker.[17]

In 1763 Pierre Henry became the apprentice of Jean-André Lepaute.[18] It seems he was never admitted to the guild as a master. As of 1774 he was the de facto partner of Jean-Baptiste as well as the partner of his cousin Pierre-Bazile Lepaute. On May 14, 1789, the two cousins acquired their uncle's shares in the workshop. Pierre Henry parted from his cousin on December 3, 1795, to found his own firm in the rue Nicaise, at which time he began to use the signatures "Henry à Paris" and "Henry-Lepaute à Paris." As of January 1, 1800, Pierre Henry was living in the house of Jean-Baptiste Lepaute in the rue Saint-Thomas-du-Louvre. He later moved to number 1, rue du Doyenné.[19]

Pierre-Bazile Lepaute (called Sully-Lepaute) was born in Thonne-le-Thil on June 14, 1750, and died in Paris on August 2, 1843. He was the son of Joseph Lepaute and Marie Collignon. Around 1766 he joined his uncles and cousins in Paris and completed his apprenticeship in the family workshop. He became a partner of Jean-Baptiste and his cousin Pierre Henry in 1774, probably without a formal contract.

After his cousin decided to establish his own workshop, Pierre-Bazile associated himself with his nephew Jean-Joseph Lepaute, who was known as Collignon. Their partnership lasted until 1811, at which date Jean-Joseph established an independent workshop under the signature "Lepaute neveu à Paris," which he later ceded to his son-in-law and cousin Augustin-Michel Henry.

In 1811 Pierre-Bazile and his son Pierre-Michel (1785–1849) established the firm of "Lepaute & Fils," which continued to use the signature "Lepaute à Paris" and to exploit the title of *Horloger de l'Empereur* under the Empire and *Horloger du Roi* under the Restoration and the July Monarchy.

Very little information is available on the early stages of Jean-André Lepaute's career. It is believed that his father taught him casting and the locksmith's trade when he was still a child. His father probably taught him clock-making too, since the upkeep of large clocks in the countryside was entrusted to the locksmiths.

Jean-André is believed to have settled in Paris circa 1740, at which time he may have presented his first ventures into the making of *échappement à repos* (deadbeat escapements) to the clock-maker Louis Amant.[20] He may well have improved his knowledge thanks to the clock-makers of the Enclos de l'abbaye de Saint-Germain-des-Prés, among whom there were such excellent artists as Jean-François Dominicé, Michel Stollenwerck, Henri Enderlin, and Pierre de Rivaz, who were only belatedly or indeed never admitted as masters.

Jean-André's first documented undertakings included commissions from the Crown. The horizontal clock of the château de la Muette had already been ordered in 1748.[21] In 1750, with the assistance of his brother Jean-Baptiste, he executed a monumental clock for the Palais du Luxembourg,[22] a commission which earned them lodgings in that building. The two brothers also executed horizontal clocks for the Verrerie Royale (Royal Glassworks), for the châteaux of Saint-Hubert, Bellevue, and Choisy, and for the Ecole Militaire. Jean-Baptiste and his nephews completed clocks for the Pavillon de Bagatelle in 1778, for the Hôtel des Invalides in 1784, and for the Hôtel de Ville in 1781/86. This last clock was to become the object of a financial litigation between them and the city government.

Along with these monumental clocks, Jean-André also took an interest in ordinary clocks and in watch-making, and he undertook various experiments (particularly on the *pendule polycamératique*) in these areas. Some of his experiments were undertaken with his brother, others with the help of Pierre (III) Le Roy, with whom he had "contracted . . . to create a firm by which [Jean-André] is entitled to execute and sell clocks of a new

conception in accordance with clauses and conditions established by said firm."[23] A conflict concerning the authorship of various inventions covered by this contract ultimately degenerated into a battle of pamphlets.[24]

The Lepautes produced a large number of clocks and watches, both simple and complicated, and the quality of their works, together with their careful choice of cases, earned them a superior reputation. In 1766 they published the *Description de plusieurs ouvrages d'Horlogerie*.[25] The facts provided by this treatise, together with what can be learned from other sources provide some information concerning the Lepautes' collaborators.

For bronze cases, they turned to such sculptors as Clodion, Jean-Antoine Houdon, Jean-Baptiste Stouf, Gilles-Paul Cauvet,[26] and Augustin Pajou (for models).[27] (In making clocks for the duc de Bourbon with movements by Lepaute, Houdon followed drawings by the architects Le Carpentier and de Wailly.)[28] Jean-Jacques Etable de La Brière provided them with a drawing for the case of a *pendule polycamératique*,[29] and François-Joseph Bélanger a drawing of a clock for the comte d'Artois.[30] The Lepautes bought or commissioned cases from the *fondeurs-ciseleurs* (and sometimes also modelers) Luc-Philippe Thomire *le pére*,[31] Robert and Jean-Baptiste Osmond,[32] Etienne Martincourt,[33] François Vion,[34] Jean-Claude Duplessis,[35] Louis-Barthélemy Hervieu,[36] Nicolas Bonnet,[37] Jean-Joseph de Saint-Germain, Michel Poisson, Jean-Pierre Cottin, and the widow Gallois. They had some of their own cases cast by the *fondeur* Charles Bénard.[38] They also called upon the gilders and case-makers Louis-François Gobert,[39] Jean Goyer, and François Rémond.[40]

When marquetry cases were called for the Lepautes turned chiefly to the *ébéniste* Nicolas Petit for long-case clocks. Etienne Martincourt provided Petit with bronzes for long-case clocks with a sunflower. Lepaute also ordered cases from Antoine Foullet, Adrien-Jérôme Jollain, Bernard (II) van Risenburgh (among other items for a long-case clock ordered by Monsieur Bonnemet),[41] Jean-Baptiste Lependu, François Goyer, Philippe-Claude Montigny, Balthazar Lieutaud, Jean-François Leleu, and Charles-Antoine Stadler. They also decorated their cases with gilt bronze and with oriental or Sèvres porcelain, as well as with terra cotta. For watchcases they turned, among others, to Louis-François Lefèvre.

The Lepautes' subcontractors for the mechanical parts included the clock-makers Pierre-Henry Malyvoire,[42] Joseph Tavernier, Jean Pucelle, David-Louis Courvoisier, Privet, Jean Argand, Jacquet-Droz, Jean Fol *fils*,[43] Georges Roger,[44] Jean Forcher,[45] and Joseph Sylvestre.[46] Most of their springs were provided by Claude Richard, and many of their dials were enameled, at first by Arrouard, then by Elie Barbezat (until 1777), and later by Henri-François Dubuisson and Georges-Adrien Merlet. In 1759 they used the dial-maker David and imported blank movements from Switzerland through the Courvoisier brothers in Le Locle, and through Viguier in Geneva.

The Lepautes' customers belonged to both city and court and included Louis XV, Madame du Barry,[47] the comtes de Provence[48] and d'Artois,[49] Mmes Victoire and Adélaïde, the duc de Bourbon, the duchesse de Mazarin, the prince de Salm, the marquis de Brunoy, de Courtanvaux, de La Rochefoucauld, de Marigny, and de Pange, M. Beaujon, François Boucher, Grimod de La Reynière, Radix de Saint-Foy, Randon de Boisset, and Vassal de Saint-Hubert. They also provided astronomical clocks for the Paris Observatoire,[50] for the king's Cabinet de Physique at La Muette,[51] and for Jean-Sylvain Bailly's personal observatory in the Galleries of the Louvre.[52] Outside France, Madame Infante, the duchess of Parma,[53] Prince Charles of Lorraine, Ferdinand VI, Charles III, and Charles IV of Spain, and Queen Louise-Ulrique of Sweden owned examples of their work.[54]

The Lepautes sold most of their production directly, but occasionally, particularly at the outset of their career, they went through *marchands-merciers*, such as S. H. de La Hoguette[55] or Cosi,[56] as well as providing clocks to their cousin Lepaute de Bellefontaine.[57]

Their accommodations in the Galleries of the Louvre were so cramped that the Lepautes could not hope to establish a real workshop there.[58] Their lodgings entailed other advantages, however, allowing them to enjoy the privileges that were associated with these grants by the Crown. The Lepautes opened an annex in the rue de Sèvres at La Croix-Rouge, which soon became their main workshop. They later moved it to the rue Saint Honoré, on the corner of the rue de l'Arbre Sec, and, finally, from 1776 to 1789, to the place du Palais Royal.

They also received the titles of *Horloger de S.A.S. le duc de Bourbon*[59] and *Horloger de Monseigneur, comte d'Artois*.[60]

THE PUBLICATIONS OF JEAN-ANDRÉ LEPAUTE

*Copie d'une lettre écrite à Monseigneur le duc de *** par le Sieur Le Paute Horloger du Roi, au palais du Luxembourg, servant à la justification dudit Sieur Le Paute, contre différentes imputations du Sieur Le Roi, fils aîné du Sieur Jullien le Roi, Horloger du Roi* (Paris, 1752). Bibliothèque Nationale V 8736.

Réplique du Sieur Lepaute Horloger du Roi au Luxembourg à un écrit intitulé Reflexion de M. Le Roy L'Aîné, Fils (Paris, 1752). Bibliothèque Nationale V 8738 (not cited by Baillie 1951, wrong date in Tardy 1980).

Mémoire sur l'echapemens à repos, Donné à l'Académie des Sciences, le 4 août 1753, par Lepaute Horloger du Roi au Luxembourg à Paris (Paris: Jacques Chardon, 1753). Bibliothèque Nationale V 8741 (not cited by Baillie 1951 or Tardy 1980).

Description d'un echapement a repos et a chevilles dont les leviers sont égaux & naturels, mis à son point de perfection par Lepaute, Horloger du Roi, au Luxembourg à Paris & présenté par lui à Sa Majesté, à Marly, le 23 mai 1753 (Paris: Veuve Lottin, 1754). Bibliothèque Nationale V 8739.

Réponse du Sieur Le Paute, Horloger du Roi, au Luxembourg, à une lettre du Sieur Caron fils (Paris: Veuve David, 1753). Bibliothèque Nationale V 8742.

Traité d'Horlogerie contenant tout ce qui est nécessaire pour bien connaître and pour régler les Horloges et Les Montres . . . (Paris: Jacques Chardon *père*, 1755).

Description d'une nouvelle pendule policameratique; pour servir de Supplément au Traité d'Horlogerie (Paris: Chardon, 1760). This small publication appeared in the catalogue of the Librairie Thomas-Scheler, n. s. 13 (Paris, 1989), no. 756 (not cited by Baillie 1951 or Tardy 1980).

Description de plusiers ouvrages d'Horlogerie (Paris: Jacques Chardon, 1766).

Traité d'Horlogerie contenant tout ce qui est nécessaire pour bien connaître et pour régler les Horloges et Les Montres . . . accompanied by *Description d'une pendule policamératique* and *Description d'une pendule à seconde qui marque le temps moyen et le temps vrai sans être exposée aux inconvéniens qu'on a remarqués jusqu'à présent dans les pendules à équations* (Paris: Samson, 1767).

NOTES

1. See in particular A.N., Min., LXIV, 366, October 28, 1758, and A.N., O¹ 1673, dos. 11 (memoranda of 1775).
2. Gabriel-Joseph Lepaute [1793–1882; son of Pierre-Bazile Lepaute], "Notice Historique sur la Famille Lepaute." The information in this manuscript was kindly communicated to the authors by Michel Henry-Lepaute. Unless otherwise noted, all biographical material is derived from this source.
3. Lalande 1803, pp. 676–681.
4. A.N., Y 11567, Jean-André Lepaute's complaint of October 26, 1751, against Pierre Le Roy *fils*. This is the period during which he produced the various clocks bearing the signature "Le Paute, Horloger du Roi au Luxembourg." Concerning the various applications of the term *Horloger du Roi* and the distinctions between them, see Augarde 1996.
5. A.N., O¹ 1069.
6. A.N., E* 1340 A, no. 6, and A.N., Y 9328.
7. A.N., Min., LXIV, 366.
8. See note 1.
9. See note 3, p. 677.
10. Ibid.
11. A.N., Min., XVIII, 982, 5 Ventôse An X, inventory after the death of Jean-Baptiste Lepaute.
12. A.N., Min., LXIV, 366, October 28, 1759, Jean-Baptiste Lepaute's marriage contract.
13. See note 1. Patent dated September 27, 1775 (A.N., O¹ 1673, dossier 12).
14. A.N., Y 9393. They satisfied the demands of the Corporation des Horlogers. On this point, see A.N., O¹ 1673, dos. 12.
15. A.N., Min., XCVI, 553, May 14, 1789, deed of transfer.
16. A.N., Min., XXXIV, 640, August 4, 1763.
17. He married his cousin Anaïs Lepaute, daughter of Jean-Joseph Lepaute (called Collignon) and maintained his father-in-law's workshop until 1834 under the business name of "Henry neveu Lepaute." In 1850 he merged his business with the factory of his cousins Lepaute & Fils, under the name "Henry-Lepaute." Only in 1854 did he receive permission from the Conseil d'Etat to use the name "Henry-Lepaute."
18. See note 16.
19. A.N., Min., XCVI, 553, attachment to the contract of association of May 14, 1789, "lease by private treatise delivered by J. B. Lepaute to the citizen Henry on 7 Vendemiaire An VII" (quoted in the inventory, see note 11). See also the *Almanach Azur* (1806) and the *Almanach Indicateur pour les Etrangers* (1806).
20. "Already in 1740, the late M. Amant, to whom I communicated my thoughts . . ." in J.-A. Lepaute, *Mémoire sur l'echapemens à repos . . .* (Louis Amant, master clock-maker on October 1, 1725, invented an *échappement à repos* and a *cadrature de pendule*, which were published by Thiout in his *Traité d'Horlogerie*.)
21. A.N., O¹ 2249, fol. 239.
22. Ibid., fol. 238.
23. See note 4.
24. See J.-A. Lepaute, *Copie d'une lettre écrite à . . .* ; P. Le Roy, *Réflexion de M. Le Roy L'Aîné fils, sur un Ecrit intitulé, Copie d'une lettre . . .* (Paris, 1752) (Bibliotheque Nationale Impr. V 8737); and J.-A. Lepaute, *Réplique du Sieur Lepaute . . .*
25. This book is not mentioned in Baillie and Tardy's bibliographies regarding the measurement of time, but Tardy does quote a passage from it in his *Dictionnaire des Horlogers Français* (1974), pp. 378, 379, 384, dating it 1766. This publication is extremely rare and is not found in the major libraries. We used the copy in Jean-Claude Subrier's collection.
26. J.-A. Lepaute, *Description de plusiers ouvrages d'Horlogerie* (1766).
27. Ibid.
28. The marquis de Marigny's *pendule polycamératique* was crowned with a putto representing Time by Houdon (sale, Paris, May 4, 1785, lot 12).
29. J.-A. Lepaute, *Description d'une nouvelle pendule polycamératique*. Jean-Jacques Etable de la Brière (1716–1785) was Jean-André Lepaute's brother-in-law.
30. A.N., R1 324, and A.N., Min., LXIV, 366, October 28, 1759.
31. See note 7 and Archives de la Seine, B5 B6, 4571, Luc-Philippe Thomire's daybook.
32. See note 7.
33. See note 26.
34. Ibid.
35. Ibid.
36. A.N., Min., XXVII, 407, December 19, 1779, and A.N., Min., XXVII, 427, November 11, 1782.

37. Archives de la Seine, D5 B6, 447, Nicolas Bonnet's daybook.
38. See note 7 and A.N., Min., LXXXV, 582, September 8, 1764.
39. Sale, Paris, February 17, 1777, lot 337.
40. Information kindly provided by Christian Baulez.
41. Bonnemet's equation clock was housed in a case by Bernard, which, in the eighteenth century stood for Bernard (II) van Risenburgh (sale, Paris, April 12, 1771, lot 127). The description of the case corresponds to that of a longcase clock now at the Gulbenkian Foundation in Lisbon (inv. 195).
42. Malyvoire worked as a finisher for Julien Le Roy and the Lepautes. See J.-A. Lepaute, *Mémoire sur l'échapemens* . . .
43. See note 7. With the exception of Argand, none of these clock-makers had yet been received as masters in 1759.
44. Archives de la Seine, D4 B6, balance sheet of October 25, 1767. Georges Royer, *compagnon horloger*, also worked for Delunesy and Biesta.
45. A.N., E* 1391B, decree of the Conseil d'Etat du Roi of August 28, 1764, document 18.
46. A.N., O¹ 1673, dos. 10, letter from the marquis de Marigny to the architect Jacques-Germain Soufflot, March 21, 1757.
47. Bibliothèque Nationale, Manuscrit Français, 8258, fol. 32, receipt for a watch valued at 5,000 *livres* delivered in 1770.
48. A.N., F¹⁷ 1266–1.
49. A.N., R¹ 317, R¹ 324, R¹ 379 and O² 470.
50. Jacques Dominque Cassini, *Mémoires pour Servir à l'Histoire des Sciences* . . . (Paris, 1810), p. 208.
51. A.N., O¹ 1584, doc. 44, memorandum by Lepaute concerning an astronomical clock intended for a cabinet at La Muette, see Ronfort 1989.
52. *Mémoires de l'Academie des Sciences pour l'année 1766* (Paris, 1768).
53. Archives of Parma, CBf, cart. 46, letter from Lepaute, 1752.
54. See note 50 and J.-A. Lepaute, *Mémoire sur l'échapemens* . . . , in which he describes himself as "overwhelmed with work from the courts of Naples and of Spain."
55. A.N., Min., XCVII, 346, May 15, 1755.
56. A.N., V³ 77B, contract of December 20, 1758.
57. See note 11. This inventory contains a note concerning a delivery of clocks by Jean-Baptiste Lepaute to Lepaute de Bellefontaine and back interest owed by the latter to Nicole Etable, wife of Jean-André Lepaute.
58. See note 46. The letters of Soufflot and the marquis de Marigny dwell upon the small size of the space located above the archways of the Louvre, which constituted Jean-André Lepaute's fourth lodging, obtained upon the resignation of the goldsmith Jacques Roettiers.
59. Chantilly, Condé Archives, AC 7, authorization of January 4, 1773.
60. See note 30.

THE CHARLES LE ROY WORKSHOP

The signature "Charles Le Roy" was in use between 1734 and the end of the eighteenth century. Until about 1770, it identified movements produced by the workshop of Charles Le Roy. After that date, it was used by his son, Etienne-Augustin Le Roy.

Charles Le Roy was born in 1709[1] and died on October 2, 1771.[2] He married Marie-Madeleine Bercher (died on April 8, 1776),[3] who bore him at least four sons: Michel-Nicolas (1734–1803), a lawyer at the Parlement de Paris, who later became a parish priest in Nanterre; Etienne-Augustin, *Horloger du Roi* (from 1737 until after 1792); Norbert, a priest; and Jacques Prosper (died after 1790), a *marchand-mercier*.[4]

He was admitted to the Paris guild as a master clockmaker on August 16, 1733.[5] His workshop was located first in the rue des Prêcheurs,[6] then, starting in 1745 at the latest, in the rue Saint-Denis, on the corner of the rue du Signe, opposite the church of Saint-Leu.[7]

Etienne-Augustin Le Roy was born in 1737[8] and died after 1792. He was admitted to the Paris guild as a master clock-maker on November 22, 1758.[9] He assumed or received the title of *Horloger du Roi* at an uncertain date.[10] In all likelihood he worked with his father before continuing his activities under the name of "Charles Le Roy" in the same premises.[11] He sold his stock, between 1792 and 1799, to Gaspard Cachard, who pursued his trade in the same premises under the trade name "Cachard, Succr. de Ch. Le Roy."[12]

The absence of notarized deeds of the kind cited in connection with the other biographies in this book does not preclude the contention that Charles and Etienne-Augustin Le Roy were both brilliantly successful and wealthy.[13] Three factors support this conclusion: the Charles Le Roy family's rise in society, the location of the Le Roy's workshop, and its activities.

The family's rise in society can be established by four observations. The first of these is the fact that Michel-Nicolas, elder son of Charles Le Roy, was in a position to become an *advocat* (lawyer) at the Parlement de Paris, an obvious sign of accrued wealth. The second is the decision by Charles Le Roy, as early as 1764, to establish for his wife and himself a perpetual foundation for the saying of masses.[14] The third is the title of *Horloger du Roi*, which Etienne-Augustin Le Roy was allowed to assume as a result of his delivering clocks and watches directly to Louis XVI.[15] The last is the appearance of Etienne-Augustin Le Roy on the electoral lists at a time when a man's right to vote depended on the state of his fortune.

Another consideration is the location of the workshop, which stood, by 1748, in the rue Saint-Denis, where it was to remain for over sixty years. At that time this street and the rue Saint-Honoré were the two thoroughfares on which all the luxury trades of the capital were assembled. Charles Le Roy's choice of location is indicative of an ambition deservedly rewarded, since his establishment is mentioned with praise on a par with that accorded to Julien Le Roy, Ferdinand Berthoud, or the Voisins in the principal almanacs of the second half of the eighteenth century.

The Charles Le Roy workshop was mostly devoted to watches. By 1765, the number produced had reached 2,340.[16] This implies an annual production of about eighty items and was practically equivalent to that of Julien Le Roy or Jean-Baptiste Baillon. The workshop's production grew swiftly after the arrival of Etienne-Augustin, reaching 4,000 before 1772.[17] The number 10,347 is found on a watch *à complications* (with the days of the week and other indications) from the mid-1790s.[18] These figures do not include a group of unnumbered watches for which it is hard to determine whether the signatures are apocryphal or whether the absence of numbers was intentional.[19] It appears that the Le Roys used many watchcases imported from Switzerland; the only suppliers in Paris that we have been able to identify are Moyse Ducloux and Pierre de Monchanin.

The Le Roys' production of clocks was unusually small until about 1760. Case-makers who supplied the workshop include Joseph de Saint-Germain, Antoine Foullet, Jean Pécourt, François Duhamel, and François Goyer for wood cases veneered with marquetry, the Caffieris and Jean-Joseph de Saint-Germain for those in gilt bronze. Later on in the century, probably at the initiative of Etienne-Augustin, this production would noticeably increase.[20] The workshop's suppliers at that time included the *fondeurs-ciseleurs* Jean-Louis Beaucourt, François Vion, Jean-Joseph de Saint-Germain, Etienne Martincourt, Pierre Viel, Robert and Jean-Baptiste Osmond, Jean-Baptiste Zaccon, Jean-Nicolas Frémont, Augustin Le Mire, Etienne Blavet, and François Rémond.

Little is known about the collaborators who provided mechanical parts. Charles Le Roy had at least two apprentices, Philippe Armand[21] and Jacques-Denis Lemazurier.[22] He also employed the clock-makers Antoine François[23] and Florent Lecomte.[24] For clock-springs the Le Roys chiefly turned to the Richards, father and son.

The workshop's clientele was like that of the other great clock-makers of the day. It included Louis XVI, his brother, the comte de Provence, Mlle de Clermont (a princess of the blood), Messieurs Bergeret, de Montholon, and de Bonneval, as well as the courts of Sweden and Saxony among others.

The inventory of the king's clocks and the Garde Meuble of January 1, 1788, lists nine clocks signed "Charles Le Roy," which were all, at the time, in Louis XVI's private apartments in Versailles.[25] At least three of these were models by Vion and two were by Osmond. An inventory of the clocks belonging to the Menus Plaisirs undertaken by Robert Robin in 1793 mentions a tenth clock, which can be identified as the one in the Getty Museum (cat. no. 16).[26]

Six of the nine clocks on the first list undoubtedly correspond to those mentioned in the personal accounts of Louis XVI (payments made to Le Roy between 1773 and 1777). These accounts also mention a watch from the same workshop.[27] It has not been determined how Etienne-Augustin Le Roy entered the personal service of Louis XVI, who was then Dauphin. He had an official position, since he received a salary of 474 *livres* and a pension of 200 *livres* annually. The salary came to an end when Louis XVI ascended the throne in 1774. The king nonetheless put his trust in the clock-maker since he regularly dispatched him on various errands until 1791 (in particular to settle several bills sent by the librarian Blaizot). It appears in any event that Etienne-Augustin Le Roy was clearly entitled to assume the title *Horloger du Roi*.

NOTES

1. A large number of clock-makers with the name Le Roy or Leroy plied their trade in Paris in both the seventeenth and eighteenth centuries. They were often unrelated. The artist under discussion, for instance, was unrelated to the family of Julien Le Roy (see biography in this volume), although one of the latter's brothers was named Charles and was also a clock-maker.
2. His tomb is in Saint Geneviève's cathedral in Nanterre. His epitaph reads: "Here, awaiting the glorious Resurrection, lies Charles Le Roy, Clock-maker in Paris, Bourgeois of Nanterre, Deceased on 2 Octob. 1771. aged 62 years. Religion loses one of its most faithful disciples. Filled with its Spirit, he revered all the Mysteries, he knew its True Maxims and put them into practice. This temple loses an edifying model of fervor and piety, the Poor and the Unfortunate a recourse and a comforter, the Parish, an exemplary man, who assembled all the civil and moral virtues, an obliging man who sought only to do good, Christian Youth, a father who encouraged it to Science and to Virtue by kindnesses of various sorts. *Hocce amoris & reverentice Monumentum Plaudente Pago, Pusuerunt Moerentes Fului, 1778.*" (Epitaph by R. P. Bern).
3. Archives Brateau.
4. Death certificate of Nicolas-Jacques Julliard, dated April 20, 1790, published by J. J. Guiffrey, *Etat-Civil des tapissiers des Gobelins . . .* (Paris, 1897), p. 38.
5. *Liste* 1748.
6. A.N., Min., XXX, 259, March 6, 1734.
7. A.N., Min., XX, 587, July 21, 1745.
8. E. Chavaray, *Assemblée Electorale de Paris (10 nov. 1790–15 juin 1791)* (Paris, 1880), p. 25.
9. A.N., Y 9386.

10. *Tablettes* 1791.
11. *Tablettes* 1775 to 1791.
12. Paris, Bibliothèque d'Art et d'Archéologie, Fondation Jacques Doucet. Cachard's bill, dated 26 Floréal an X.
13. Already in 1745, Charles Le Roy was in a position to invest 3,000 *livres* in stocks. See note 7.
14. The contract establishing this foundation, though mentioned in the epitaph in the cathedral of Nanterre, could not be found in the Archives Nationale. Such a foundation implied a gift of capital, the revenue from which was used to pay for the masses. A *De Profundis* was to be said perpetually on the Tuesday of Quinquagesima, after the mass of the Blessed Sacrament, and after vespers in the evening.
15. Concerning the use of the title *Horloger du Roi*, see Augarde 1996.
16. Cardinal 1984, no. 224.
17. Paris, Archives de la Seine, D4 B^5, 323, C. H. Waltrin's repair book. On December 4, 1772, a gold watch by Charles Le Roy was listed as number 4041.
18. Christie's, New York, April 28, 1990, lot 146.
19. Cardinal 1984, no. 243.
20. The Getty Museum's clock has a particularly high number on its movement: "2417." It appears likely that the numbering of movements of clocks turned out by the workshop was begun well above "1."
21. A.N., Min., XXX, 259, March 6, 1734.
22. A.N., Min., XXXIV, 617, June 7, 1759.
23. A.N., E* 1409 B, March 25, 1766. Antoine François also worked for Julien Le Roy, André-Charles Caron, Joly *fils*, François Viger, François Filon, Jean Arthur, and Jean-Antoine Lépine.
24. Archives de la Seine, D5 B6, 2816, Florent Lecomte's daybook.
25. A.N., O^1 3371.
26. One might certainly find a trace of its delivery in the accounts of the Menus Plaisirs.
27. Comte de Beauchamps, *Les Comptes de Louis XVI* (Paris, 1909).

JULIEN LE ROY

The signature "Julien Le Roy" was used from 1714 to 1783. Up to 1759 it designated items produced by the workshop of Julien (II) Le Roy. It is now quite certain that after that date it was used by Pierre (III) Le Roy. Not only did the latter use his father's signature, "Julien Le Roy," he was almost exclusively known by this name, to the point that Louis XVI lists him under that name in his personal accounts concerning the purchase of a marine chronometer in 1776.[1] While it is sometimes difficult to distinguish between the work of Julien (II) and Pierre (III) Le Roy for certain clocks, the distinction is quite easy to make as far as watches are concerned. Those produced by the latter's workshop are all inscribed with a cock and the monogram JLR. The Getty clocks were all made by Julien (II).[2]

Julien Le Roy was born in Tours on August 6, 1686,[3] and died in Paris on September 20, 1759.[4] He was the son of Pierre (I) Julien Le Roy, a master clock-maker in Tours, and Perrine Tante.[5] In 1714 he married Jeanne Delafond (died 1769),[6] who bore him four sons: Pierre (III) (1717–1785),[7] Jean-Baptiste (1720–1800),[8] Charles (1726–1779), and Julien-David (1728–1803).[9] He was admitted to the guild in Paris as a master clock-maker on June 16, 1713.[10] He was first a member, then director of the Société des Arts[11] and *juré* of his guild from 1735 to 1737.[12]

He was made *Horloger du Roi* and given lodgings in the Galleries of the Louvre by a warrant dated August 23, 1739, and posted on September 6 of the same year.[13] He never lived in the Louvre but gave his lodgings to his son Pierre.[14] He lived first in the rue des Petits Augustins (1714) on the left bank of the Seine, then in the rue du Harlay, and finally on the Ile de la Cité, beginning in 1717.[15]

Le Roy belonged to the fifth generation of a family of clock-makers who had moved from Paris to Tours at the end of the sixteenth century.[16] He was the eldest in his line, and his father naturally expected him to be a clock-maker. He moved to Paris in 1703 and remained there throughout his career. He seems to have had a highly developed sense of family and fostered the formation of a powerful clan. Two of his brothers, Pierre and Charles, and three of his brothers-in-law, Pierre Sénard, Jean Carré, and Pierre Delafond, came in turn to receive their *lettres de maîtrise* in Paris during the 1720s. Two of his five known apprentices, René Sénard and Louis-David Carré, were his nephews.[17]

Le Roy was seventeen years old when he first came to Paris, having received his first training in his father's workshop in Tours. Although some of his biographers maintain that his formal apprenticeship was served under Charles Lebon,[18] this is unlikely. While there may have been bonds of friendship or spiritual sponsorship between the two clock-makers, and Le Roy may have worked for a short time in Lebon's workshop, there is no proof—in the absence of a contract of apprenticeship—that he was apprenticed to Lebon. The question of how the young man entered the milieu of Parisian clock-makers is unanswered. It should be noted that his association with Antoine Gaudron's workshop may be regarded as a potential means of access to this society.[19]

In 1715 Le Roy was presented by William (I) Blakey to Henry Sully, the renowned English clock-maker, who had been summoned to France by the duc d'Arenberg. Le Roy and Sully became good friends and collaborated closely until Sully's death in 1728, working together on the reconstitution of the Société des Arts, of which Le Roy would later become the director.[20]

In 1728 Le Roy made a wall clock for Louis XV, for

which he invented a special repeating mechanism, and two repeating watches, "which are the first to have been made with a feature that allows His Majesty to remove the clock-face in order to see the clockworks revealed."[21] The following year he applied the same invention as in the king's wall clock to simplified repeating clocks, the first of which was intended for the comte de Clermont.[22] From then on he never ceased producing works of high technical quality, including three astronomical clocks, one of which, "whose accuracy appeared marvelous," was used by Pierre-Louis Moreau de Maupertuis during his voyage to the Arctic Circle in 1736.[23] The other two astronomical clocks were made for Jacques (II) Cassini at the Paris Observatoire and for Jacques (III) Cassini for use in his astronomical and geodesic operations in the south of France.[24] In 1740 Le Roy invented the "bâte levée," by suppressing the *bâte* of the case for the repeating watches, while adding a *bâte* to the dial, within which the train of the movement was lodged.[25] In 1755 he added to the works of the repeating watches a small anchor escapement, the function of which was to regularize the train of the carillon.[26] Meanwhile, together with his son Jean-Baptiste, he wrote several articles on clock- and watch-making for the *Encyclopédie*.

Le Roy's workshop produced a large number of ordinary watches and clocks to satisfy the heavy demand resulting from his reputation. While it is impossible to determine the number of clocks which Le Roy himself or his assistants may have made, it is known that he produced over 3,500 watches.[27] This amounts to an average of one hundred movements a year and, taking holidays into account,[28] implies that he produced a watch in less than three days. By comparison, the workshop of Jacques Gudin produced no more than fifty a year[29] and that of Ferdinand Berthoud thirty to fifty.[30] The number of watches attributed to Le Roy, to which should be added the movements of his clocks, allows for the fact that he subcontracted all or part of this ongoing activity, which was nonetheless carried out under his supervision.

His collaborators for the mechanical parts included not only his apprentices, who sometimes became his *compagnons*, Antoine Campary,[31] René Senard,[32] Louis-David Carré,[33] Jean Vernède,[34] and Joseph Sylvestre,[35] but first and foremost his sons Pierre and Jean-Baptiste,[36] his brother-in-law Pierre Sénard, his nephews Sénard and Delafond, and his cousin François Béliard, as well as Pierre-Henri Malyvoire,[37] Abraham Bartholony,[38] Marc Yver,[39] Amy Dentan,[40] Jean-Philippe Plan,[41] Daniel-Samuel Plattel,[42] Antoine François,[43] and François Dubois.[44] For springs he mostly turned to the Blakeys, father and son.[45] Antoine-Nicolas Martinière was already providing him with dials,[46] as was Nicolas Jullien[47] and possibly Elie Barbezat,[48] in 1731.

There is no known instance, with the exception of a few prototypes, of movements by Le Roy being without a case of good quality. Thanks to his reputation, he was very soon in a position to free himself from the demands of the commercial circuits in order to sell his production directly. As a result, his relationship with the makers of clock- and watchcases and with the *marchands-merciers* was regulated exclusively by the principle of supply and demand.

It can be assumed that he freely chose his cases except when the client imposed his own taste. Such was the case with the cartel created for Louis XV in 1728. The marquis de Beringhem, who commissioned the piece, reserved the right to have the case made at his convenience and according to his drawings. The clock-maker accepted this condition, and "he so well succeeded that it has been generally approved and admired, both by connoisseurs and by people of good taste."[49] Made of gilt bronze and crowned with a figure symbolizing Dawn,[50] it was executed by the *fondeur-doreur* Nicolas Le Sueur,[51] who made a copy of it for Bonnier de La Mosson.[52] A clock with a case by Caffieri, now in Waddesdon Manor in England, was also the result of a special commission,[53] as was that belonging to the marquis de Puyseult with a case by François-Thomas Germain, which was described thus in 1770: "Item one large clock, by Julien Leroy, in its case, made by Germain, Sculpteur Ordinaire du Roy, representing the Fates, estimated . . . 3000 L."[54]

With these exceptions, as far as clocks are concerned, Julien Le Roy seems to have had a continuous relationship with André-Charles Boulle[55] and his son André-Charles (II) Boulle,[56] with whom he shared the custom of the prince de Carignan.[57] During the 1730s, he installed equation movements in pedestals and wall cases by Charles Cressent.[58] Henry Hahn, who was called Le Cocq,[59] Nicolas-Jean Marchand, Jean-Pierre Latz, Adrien Dubois,[60] Antoine Foullet, Antoine Gosselin, and Balthazar Lieutaud also provided him with cases.

Somewhat before and also during the Neoclassical period, the signature "Julien Le Roy" was regularly associated with gilt-bronze cases, the dates of which often indicate that they were executed after his death; in other words, as we initially pointed out, they were made for Pierre (III). These works are the result of collaborations between Pierre and Philippe and Jacques (II) Caffieri,[61] Jean-Joseph de Saint-Germain,[62] Edme Roy,[63] and Robert Osmond.[64] As far as watches are concerned, only the clock-maker Joseph Quétin[65] has so far been identified as a supplier of watchcases.

Only one *marchand-mercier* is known to have been a customer of Le Roy: Lazare Duvaux, to whom he supplied movements for clocks decorated with Vincennes

porcelain flowers and Meissen porcelain figures. These items were sold to Louis XV, to the duc de Parme, to Madame de Pompadour, to the duc de Bourgogne, and to the comte du Luc.[66]

Le Roy's features are known to us through a painting by Perronneau, which was engraved by Moitte.[67] His haughty visage hardly does justice to the cordial character of the man as revealed by the testimony of his contemporaries.[68]

His ability to assimilate the most advanced scientific knowledge of his day should be stressed. His membership in the Société des Arts allowed him to meet numerous scholars and dilettanti of varying social origins, opinions, and specializations, and his theoretical treatises gave him entrée into scholarly circles.

It appears certain that he collected objects related to his art, but the lack of an inventory after his death prevents a determination of the scope of his collection and of the nature of his other tastes.[69] We do know that Pierre Gaudron wanted him to inherit the first French equation clock (produced in 1688 by his father Antoine Gaudron) and a duplicate of one he himself had built for the Regent in 1717, as well as an equinoctial sundial by Michel Butterfield, which was no doubt rare.[70] He also acquired a long-case clock *à complications* by Claude (III) Martinot in a case by Juste-Aurèle Meissonnier,[71] and he acquired from his colleagues various examples of their inventions.[72]

Le Roy's fortune amounted to about 200,000 *livres* at the time of his death. His investment in stocks amounted to 108,000 *livres*, which yielded an annual income of 6,126 *livres*. Most of the remainder is accounted for by two houses in Paris, one in the rue Saint-Martin "A l'Enseigne de la Cloche," the other in the rue de Hurepoix, which was rented for a total of 3,050 *livres* per year, and one half of a house in Verneuil near Chatellerault (the other half of which belonged to his wife).[73] The tools and stock of the workshop were valued at only 8,422 *livres*. This relatively low figure, together with the fact that the only credit appearing in his accounts consisted of a note from the chevalier de L'Hôpital dated May 8, 1751, implies that Julien had in fact retired, in favor of his elder son Pierre, some years before his death in 1759. This seems plausible since he was then seventy-three.

Julien Le Roy must be acknowledged as the most famous French clock-maker of the eighteenth century. His reputation rests upon the fundamental contribution he made to the precision of watches and clocks. His mechanical discoveries, adopted by the most able of his colleagues, contributed not only to the renewal of Parisian clock production but also to a healthy rivalry in the pursuit of research related to the measurement of time. The numerous solutions that were thus found gradually raised France to the front rank of all clock-making nations, depriving England of the primacy it had enjoyed in this area under the last Stuarts, and which it was never to recover.

Le Roy's work encompassed the three classic divisions of his art: large monumental clocks, ordinary clocks, and watches. In the first field he perfected horizontal works so that they would mark both mean time and solar time. The monumental clock of the Hôtel des Missions Etrangères was a brilliant example of this.[74] As far as smaller clocks were concerned, he devoted his research to equation movements, showing and striking solar time, and to repeating movements. As for watches, his activity has been perfectly summarized in the *Encyclopédie*: "He took all that was best in French and English watch-making. He suppressed the latter's *doubles boîtes*, chimes, and all the secrets which made the works more difficult to take apart and repair; in the former he eliminated the pointless ornaments which decorate the piece without improving it. And finally he created a composite form of watch-making, if one can express the matter in such terms, making it simpler in its effects, more convenient to build, and easier to repair and to maintain."[75]

Le Roy's works were often presented at either the Académie des Sciences or the Société des Arts and were published in various journals, including the *Mercure de France*, the *Journal de Trévoux*, or the *Mémoires de l'Académie Royale des Sciences*. A few reports made before the Société des Arts seem to have remained in part unpublished.[76] In 1741, upon the publication of one of his discoveries in the *Mercure de France*, he declared "its usefulness to all the most complicated watches appears so considerable to me that I hasten to publish it so that my colleagues may take advantage of it sooner rather than later."[77] This utterly modern open-mindedness, so contrary to the notion of protecting one's technical secrets, no doubt explains the strength of his influence in the pre-encyclopedic circle in Paris.[78]

His contemporaries praised both the man and his work. In England, George Graham paid him a cordial compliment in speaking of one of his works: "I wish I were not so old in order that I might make watches after this model."[79] In France his talent was hailed by men of letters like Voltaire who, in 1745, told one of Le Roy's sons, "the maréchal de Saxe and your father have beaten the English."[80] The scientist Jacques (II) Cassini, writing in 1739, declared that he regarded "le Sr Julien Le Roy" as "the ablest clock-maker we have in France."[81] In 1776 Paul-Philippe Gudin de La Brenellerie reminded his readers that Le Roy "was the first to overtake the English and who permitted (clock-making) to attain its present level."[82] Nor were his colleagues sparing in their

compliments. Ferdinand Berthoud praised his merits in the *Encyclopédie*[83] and in his *Histoire de la Mesure du Temps par les Horloges*: "Julien Le Roy, this able artist to whom French clock-making owes its outstanding reputation."[84] François Béliard also mentioned him as the "ablest clock-maker in France and possibly in Europe,"[85] while Pierre Gaudron, in his will, written as early as 1742, made a significant bequest "to a gentleman (*un honnête homme*) so rightly renowned for his very great ability" who "stands among those . . . who have most contributed to the perfection of our art."[86] Jean-André Lepaute dwelt upon his open-mindedness: "M. le Roy, far removed from any jealousy so unworthy of a true Citoyen, has only sought to give all Clock-makers the opportunity of seeing his work, of benefiting from his knowledge, and of enlarging it with their own."[87] Berthoud went even further, noting that "Julien Le Roy enjoyed great consideration in his lifetime; he deserved it, not only because of his talents, but above all because of his love for the Art he cultivated, and as a result of his personal qualities."[88] After his death, many clock-makers, for commercial reasons, thought it advantageous to present their works as "ouvrier de Julien Le Roy," a practice which Béliard had already begun to criticize vigorously in 1767.

An enumeration of Le Roy's clientele, which was incredibly extensive and included all the most elegant members of French and European aristocracy, would go far beyond the normal scope of the present book. An anecdote worth mentioning concerns Ferdinand VI of Spain, who was one of his most demanding customers. In 1747 the king instructed his ambassador, the duke of Huescar, not to leave the clock-maker's house until he had finished the knob for a cane decorated with a watch and with diamonds; nor was he to do so, even if the king of France summoned him to Versailles to sign the peace treaty.[89] In soliciting his lodgings in the Louvre, the clock-maker wrote to Philibert Orry on July 24, 1739: "The supplicant . . . has the honor of working for His Majesty, Mr le duc d'Orléans, the Princes and Princesses of the Court, and for H.E. Monseigneur the Cardinal de Fleury . . ."[90] These assertions are corroborated by the inventories of the princes of the blood. Besides those already mentioned, the duc de Bourbon,[91] the prince de Conti,[92] the comtes de La Marche[93] and de Clermont,[94] and Mlle de Sens[95] all owned one or several of his works. We may well wonder, in view of this impressive list, whether Le Roy might not have been entitled to paraphrase the motto of the house of Rohan thus: "Roy ne puis, prince ne daigne, Le Roy suis."[96] The technical, artistic, and social success of Le Roy was a consequence of his innovative spirit and is in itself proof of the perfect balance achieved by the civilization of his day.

NOTES

1. Comte de Beauchamps, *Les Comptes de Louis XVI* (Paris, 1909), p. 51: "Month of December. I have paid Julien Le Roy for a marine chronometer . . . 2,400 *livres*."
2. Julien (II) Le Roy was the second of his line to bear this Christian name (see the genealogical table below). Since he cannot be confused with his ancestor, he will be referred hereafter simply as Julien Le Roy. His son Pierre is designated III to distinguish him from his uncle, Pierre (II), who was active in Paris during the same period.
3. He was christened in that city on August 8 in the church of Saint-Clément.
4. A.N., Min., LXXXV, 559, October 15, 1759, record of the private partition of the estate of Julien Le Roy, to which is attached an attested affidavit of the same date.
5. Cardinal 1987.
6. *Annonces, Affiches et Avis divers*, notice dated October 26, 1769.
7. Pierre (III) was admitted to the guild as a master clockmaker on July 9, 1737. He was a member of the Académie des Sciences in Angers and *Horloger du Roi* as a result of his being lodged in the Louvre, having succeeded his father in his lodgings in the Galleries. His research in marine chronometry quite rightfully made him as famous as his father.
8. Jean-Baptiste was a physician and a member of the Académie Royale des Sciences, Garde du Cabinet de Physique du Roi at La Muette. He submitted to the Académie several chronometric inventions, which were put into application by his father and his brother Pierre (III). He was appointed to the Académie on August 30, 1751, and on July 1, 1770, was given the rank of *Pensionnaire-Mécanicien* to replace the recently deceased Abbé Nollet. After their father's death, he shared with his brother the title to the lodgings in the Galleries of the Louvre. He was a close friend of Benjamin Franklin and corresponded with him for over forty years (see C.-A. Lopez, *Le Sceptre et la Foudre, Benjamin Franklin à Paris, 1776–1785* [Paris, 1990]). He served as a clearinghouse for correspondence between British and French partisans of American independence (see the letter of Lord Stormont to Lord Waymouth, dated November 6, 1776, published in G. and M. von Proschwitz, *Beaumarchais et le Courrier de l'Europe* [Oxford, 1990]).
9. Charles was a chemist, a professor of medicine at the University of Montpellier, a corresponding member of the Académie Royale des Sciences (1752), and a member of the Royal Society in London (A.N., Y 15677, *scellé* [preliminary inventory] of December 10, 1779). Julien-David served as architect to the king and was a member of the Académie des Inscriptions et Belles-Lettres, of the Académie Royale d'Architecture, of the Académie de Marine, and of the Royal Society of Antiquarians in London. He was also a historiographer at the Academia in Bologna. Information concerning the life of Charles and Julien-David Le Roy can be found in Michaud, *Biographie Universelle Ancienne et Moderne*, rev. ed., vol. 24.
10. *Liste* 1748.
11. Possibly even before 1719 (see Cardinal 1987, p. 17); in any event, he was director when this Société was reinstated in 1726–1729. Concerning the Société des Arts, see Ronfort 1989.
12. A.N., Y 9323. On July 24, 1737, he was replaced as *juré* by Antoine de Saint-Martin. The list of guild members pub-

lished in 1748 mentions Julien Le Roy as *juré* in 1731, but further investigation has shown that this must be a transcription error.

13. A.N., Maison du Roi, O¹ 1057 (p. 182) and O¹ 1672. The nomination of Julien Le Roy as one of the king's clockmakers was accepted by Philibert Orry, *Contrôleur Général des Finances* since 1730. Despite the contention of G. de Bellaigue (Bellaigue 1974, vol. 2, pp. 855–886), one should note that Julien Le Roy was never *Valet de Chambre-Horloger du Roi*, a title corresponding to four offices then occupied by Claude (III) Martinot (first quarter, from 1725 to 1743); Jean-Jacques Aubert (second quarter, from 1736 to 1745); Jean-Pierre Delacroix (third quarter of 1737); and Jean (V) Martinot (fourth quarter). For an explanation of the various positions entitling a person to use the title *Horloger du Roi* and the prerogatives attached to it, see Augarde 1996.
14. A.N., O¹ 1672, memorandum of August 10, 1744, presented by the *Visiteurs* and *Gardes* of the Communauté des Horlogers.
15. For the first address, see "Mémoire pour servir à l'Histoire de l'Horlogerie depuis 1715 jusqu'en 1729," in Le Roy 1737. The second one appears on the certificate of baptism of Pierre (III) Le Roy (A.N., O¹ 681).
16. J. Prieur, "Les Le Roy, Horlogers de 1550 à 1785," in Cardinal 1987, pp. 37–40.
17. See the genealogical tables on pages 201–203. Louis-David Carré was doubly his nephew: he was the son of one of his wife's sisters, and he married Thérèse Le Roy, daughter of Pierre (II) Le Roy.
18. Bellaigue 1974 and Cardinal 1987. Both refer to an assertion made by Ferdinand Berthoud. Charles Le Bon, known for his work on equation clocks, was *Marchand Horloger privilégié du Roi suivant la Cour* from May 9, 1707 (A.N., V³ 191, fol. 37v) to June 1, 1739 (A.N., V³ 192, fol. 151r). This particular designation implies that an apprenticeship carried out under his supervision was not recognized as acceptable by the Paris clock-makers' guild, of which he was not a member.
19. Both the bonds which existed between Pierre Gaudron and Julien Le Roy, and the almost filial respect shown to Pierre by Julien, according to Gaudron himself, argue in favor of this eventuality.
20. See Le Roy 1737 (note 15).
21. J. Le Roy, "Mémoire contenant les moyens d'augmenter le Commerce et la Perfection des ouvrages d'horlogerie," manuscript, Paris, Conservatoire National des Arts et Metiers (8° KA 13).
22. Ibid.
23. P. L. Moreau de Maupertuis, *La Figure de la Terre déterminée par les Observations . . . faites par ordre du Roy au Cercle Polaire* (Paris, 1739), pp. 195–198.
24. A.N., Maison du Roi, O¹ 1672, letter from Julien Le Roy to Philibert Orry, July 24, 1739.
25. Cardinal 1987.
26. Ibid.
27. Ibid.
28. Taking into account Sundays and religious holidays on which one did not work, public holidays numbered about one hundred in eighteenth-century France.
29. Based on calculations made by the present authors.
30. Augarde 1984, p. 69.
31. A.N., Min., LXXXV, 403, September 29, 1723.
32. A.N., Min., XXXIV, 531, March 2, 1741.
33. A.N., Min., LXXXV, 497, October 23, 1743.
34. A.N., Min., XXXIV, 567, November 9, 1747.
35. A.N., Min., LXXXV, 524, April 16, 1750, and A.N., O¹ 1672.
36. J.-C. Sabrier, "Eclaircissements sur la contribution de la famille Le Roy aux progrès de l'horlogerie," in Cardinal 1987.
37. See Lepaute biography in this volume, note 42.
38. A.N., V³ 76B, July 8, 1754.
39. This clock-maker is one of the two witnesses who signed the attested affidavit made out after the death of Julien Le Roy. See note 4.
40. A.N., E* 1293, decree of the council of March 5, 1754, doc. no. 32.
41. A.N., E* 1409, decree of the council of March 25, 1766, doc. no. 32.
42. A.N., E* 1409, decree of the council of March 25, 1766, doc. no. 29.
43. A.N., E* 1409, decree of the council of March 25, 1766, doc. no. 31.
44. A.N., E* 1391, decree of the council of August 28, 1764, doc. no. 16.
45. Le Roy 1737 (note 15) and Blakey 1780.
46. W. Edey, *French Clocks in North American Collections* (New York, 1982), no. 44.
47. Nicolas Jullien, *peintre-émailleur*, was a member of the Société des Arts. He worked at first as an *ouvrier libre*, having only been received as master painter at the Académie de Saint-Luc on September 23, 1743.
48. According to the Archives Brateau, Elie Barbezat was admitted as a master painter into the Académie de Saint-Luc on November 6, 1777. He resided in the rue Bertin-Poirée. It is most likely that he worked only for Pierre (III) Le Roy, unless he worked before that as an *ouvrier libre*.
49. J. Le Roy, "Nouvelle manière de placer les quadratures des pendules à répétition," in Le Roy 1737.
50. A.N., O¹ 3371, inventory of the king's clocks, January 1, 1788.
51. Nicolas Le Sueur, master *fondeur* before 1718, added to his title that of *Marchand Doreur, Graveur, Damasquineur Privilégié du Roi suivant la Cour* (A.N., V³ 192, August 9, 1730), as would Philippe Caffieri later on. He kept this patent until 1770, thus assembling in the same workshop two specializations that normally belonged to two different guilds and could not be accrued to the same person.
52. Bonnier de la Mosson sale, Paris, March 8, 1745, and following days, lot 938.
53. Bellaigue 1974, no. 10. This may be deduced from the fact that the model was not present when inventories were made of the Caffieri workshop, before and after 1749.
54. A.N., Min., XCII, 736, December 14, 1770.
55. Ronfort 1986, pp. 475–494.
56. A.N., Y 13232, July 28, 1745, *scellé* (preliminary inventory) of André-Charles (II) Boulle.
57. A.N., Min., LXXXVIII, April 11, 1741, assembly of the creditors of the prince de Carignan.
58. Edey 1982 (note 46), no. 47, for instance.
59. A.N., Min., XXXVIII, 258, August 8, 1731, inventory after the death of Henry Le Coq.
60. The existence of this collaboration allows one to assume that an earlier one existed between Julien Le Roy and Bernard (I) van Risenburgh (about 1670–1738), a specialist in

the making of clock cases, whose *contremaître* was Adrien Dubois. See J. N. Ronfort and J.-D. Augarde, "Le Maître de Bureau et l'Electeur," *L'Estampille-L'Objet d'Art* (December 1990), pp. 47–75.

61. A large number of Caffieri's clocks have movements by Julien Le Roy.
62. Augarde 1986, pp. 523, 534, 536–538.
63. C. Baulez, "La Pendule à la Geoffrin: Modéle à succès," *L'Estampille* 224 (April 1989), pp. 34–41. This author's dating of the *pendule à la Geoffrin* shows that most of the examples of this model which are equipped with a dial signed "Julien Le Roy" are also equipped with movements by Pierre (III) Le Roy.
64. Several of Osmond's clocks with dials signed "Julien Le Roy" were obviously made after 1759.
65. Joseph Quétin, master clock-maker and *monteur de boîtes*, used a stamp bearing the initials JQ and a six-toothed cogwheel.
66. L. Courajod, *Le Livre Journal de Lazare Duvaux* (Paris, 1865), nos. 1922, 2173, 2316, 2700, 2784, 3240, 3260. The duc de Bourgogne was Louis XV's grandson. The comte de Luc was his illegitimate and unrecognized child.
67. The painting appears to have been lost.
68. For descriptions of Julien Le Roy, see P. Le Roy, *Etrennes Chronométriques . . .* (Paris, 1760); Abbé de Fontenai, *Dictionnaire des Artistes* (Paris, 1776); and F. Prevot d'Exmes, *Julien Le Roy, Horloger* (Geneva, 1809). The two last-named authors have generally drawn their inspiration from the first.
69. His widow and children decided not to make an inventory and to make a private partition of the property held in common (see note 4).
70. A.N., Min., XVII, 757, May 19, 1745, will of Pierre Gaudron.
71. He made this acquisition at the sale that followed the death of the painter Charles Coypel in April 1753 (lot 579, paid 725 *livres*).
72. See Prevot d'Exmes (note 68).
73. See note 4. The partition of his estate gave 25,000 *livres* to each of his sons. The widow kept the remainder, including full title to the three houses. Pierre (III) Le Roy received as his share all the equipment and the entire stock of the workshop, excepting one clock which was given to his brother Charles.
74. See P. Le Roy (note 68). This town house was on the corner of the rue du Bac and the rue de Babylone.
75. *Encyclopédie ou Dictionnaire Raisonné . . .* (Paris, 1772), introduction to the illustrations in the section devoted to clock-making.
76. The library of the Conservatoire National des Arts et Métiers in Paris has some of his manuscripts.
78. Cardinal 1987.
79. R. Hahn, "Science and the Arts in France: The Limitations of an Encyclopedic Ideology," *Studies in Eighteenth-Century Culture* 10 (1981), pp. 77–93.
80. See Prevot d'Exmes (note 68).
81. Ibid.
82. A.N., O¹ 1672, letter of July 23, 1739, to Philibert Orry.
83. *Aux Mânes de Louis XV et des Grands Hommes qui ont vécu sous son règne. Essai sur le Progrès des Arts et de l'Esprit humain sous le règne de Louis XV* (Deux Ponts, 1776), pp. 80, 81.
84. *Encyclopédie ou Dictionnaire Raisonné . . .* (Paris, 1772), articles titled "Horloge" and "Horlogerie."
85. Vol. 1, p. 207.
85. *Réflexion sur l'Horlogerie en général et sur les Horlogers du Roi en particulier* (The Hague, 1767).
86. See note 70.
87. J.-A. Lepaute, *Traité d'Horlogerie* (Paris, 1755, re. ed. Paris, 1767), p. 101.
88. See note 85, vol. 2, p. 267.
89. Y. Bottineau, *L'Art de Cour dans l'Espagne des lumières, 1746–1808* (Paris, 1986), p. 146.
90. See note 24. Cardinal de Fleury was then prime minister.
91. A.N., Min., XCII, 504, February 11, 1740.
92. Prince de Conti sale, Paris, April 8, 1777.
93. A.N., Min., XCI, 1116, October 22, 1773.
94. A.N., Min., LXXIII, 929, June 25, 1771.
95. A.N., Min., XCII, 665, April 23, 1765.
96. The motto of the House of Rohan, one of the most celebrated families of France, was: "Roy ne puis, prince ne daigne, Rohan suis" (king I cannot be, prince I deign not, Rohan I am).

ANTOINE-NICOLAS MARTINIÈRE

Antoine-Nicolas Martinière was born in Paris in 1706[1] and died there on September 2, 1784. He was the son of Nicolas Martinière (died before 1736), master *émailleur* and *patenôtrier* in Paris and Marie Dumergue.[2] In 1736 he married Geneviève Larsé, daughter of Jean-François Larsé, a master clock-maker in Paris, and Louise-Catherine Brézaguez.[3] She bore him at least one son, Jacques-Nicolas (born 1738).[4]

He was admitted to the guild in Paris as master and *Marchand verrier-fayancier-émailleur-patenôtrier* on July 3, 1720.[5] From 1741 on, he bore the title *Emailleur et Pensionnaire du Roi*. He was *juré* of his guild from 1744 to 1746.[6] He resided successively in the rue Neuve Nôtre Dame (1736), the rue Haute des Ursins (1738), the rue Dauphine (1740), and the rue des Cinq Diamants (from 1741 to his death).

Martinière belonged to a family of enamelers which included not only his father but also, conceivably, two of his brothers, Jacques-Nicolas and Charles-André Martinière,[7] and certainly three of his first cousins, Jacques-Nicolas, Jean, and Jacques-Antoine Boullé.[8]

In the eyes of posterity Martinière is the most renowned enameler of clock dials of the reign of Louis XV, even though, in his own day, an artist like Nicolas Jullien, enameler of the Société des Arts, was in a position to claim the title for himself.[9]

A text entitled "Letter written from Paris to a provincial clock-maker concerning enamel dials" and printed in the *Mercure de France* of April 1740 describes his training and his production:

The King commissioned a clock and desired that the dial be made entirely of enamel and fourteen inches in diameter. The person receiving the order to make it replied that he could only assume responsibility for the attempt to produce such a dial, but could not guarantee success. M. Martinière, Enameler, rue Dauphine, undertook it and was so successful in every respect that he had the honor of presenting it himself to His Majesty, who was pleasantly surprised and who demonstrated His satisfaction with such kindness,[10] *that he returned to Paris, delighted by such a happy success, and resolved to undertake new studies to advance in his Art, as far as was possible. We have all the more reason to assume that M. Martinière will be able to progress yet further because he embodies in himself various talents which are necessary for him to succeed; A pupil of Messrs. Bousseau and Coustou père, Sculptors to the King, he spent a long time drawing at the Académie; he was even awarded three prizes, two of them in 1727 and the third in 1728. He is also the son of an able Enameler. You may well conceive, Monsieur, that with such assistance he will be able to produce works of excellent taste, such as clock-faces of fifteen to sixteen inches in diameter, blazoned with coats of arms, numbered Cartouches for Libraries and even dials for church clocks composed of several parts, yet appearing, from a distance, to be of one piece; he also intends to decorate Bronzes and other Works with colored Enamel, encrusted with gold. I am convinced, Monsieur, that you will be pleased to have the information I have the honor of giving you.*[11]

Martinière soon realized these hopes by executing for Louis XV, between 1741 and 1742, the exceptional "Almanac perpétuel et toujours nouveau" now in the Wallace Collection in London.[12] He displayed his talents as a draftsman by executing, in 1747, a painting of the battle of Fontenoy in enamel.[13] It appears likely that he also executed the decoration of several watches.

He supplied dials for the best clock-makers of his day, in particular to Julien Le Roy, perhaps as early as 1731,[14] to Melchior Bonnaventure Balthazar,[15] Louis Jouard,[16] and Jean-Baptiste Baillon, beginning in 1740,[17] and also to Etienne Le Noir, Gilles *l'aîné*, Joachim Bailly, Jean Moisy, Lange de Bourbon (a maker of barometers),[18] and to provincial or Swiss clock-makers such as Fonck in Berne.[19]

In 1775 the Supplement to the *Tablettes de la Renommée* mentions him as being still active.[20]

NOTES

1. The perpetual calendar of the Wallace Collection in London (Inv. F76) bears the inscription *Martinière age de 36 ans 7tembre 1742*.
2. In 1701 Nicolas Martinière, painter on enamel, resided in the rue du Harlay (A.N., Min., XXXIV, 313, October 22, 1701). His widow was living in Soissons in 1736.
3. A.N., Min., LXVII, 498, September 23, 1736. Louis-Catherine Brézaguez was the sister of two master clock-makers. The bride's dowry amounted to 2,000 *livres* and the groom's fortune to 4,000 *livres*.
4. A.N., Min., XXXIV, 593, October 4, 1753. Contract relative to the apprenticeship of Jacques-Nicolas Martinière to the master clock-maker Jean Moisy.
5. *Catalogue des Maistres et marchands Verriers-Fayenciers-Emailleurs-Patenostriers de la Ville et Fauxbourgs de Paris* (1772). Private collection, Paris.
6. Ibid.
7. See note 4. They were admitted as masters during the *jurande* of Antoine-Nicolas Martinière; the eldest on September 12, 1743, the other on June 1, 1745.
8. Ibid. Jacques-Nicolas Boullé was a witness at Martinière's wedding and godfather to his son. His brother Jean is mentioned in 1775 as being renowned for his dials, see *Tablettes 1775*.
9. See Julien Le Roy biography in this volume.
10. It was presumably on this occasion that Louis XV granted him a pension, which allowed Martinière to assume the title *Emailleur et Pensionnaire du Roi*.
11. This document was not known to other authors who undertook this study. The beginning of this text is important for the history of enamel dials and reads thus: "You ask me, Sir, to find out from the Manufacturers of Porcelain, whether they would be able to make you a clock-dial one foot in diameter, knowing, as you say, that it is impossible to make them of that size all in enamel as in the case of watch dials. It is true that until recently this was impossible both in town and at Court: here is an example."
12. Inv. F64 to F67. See F. J. B. Watson, *Wallace Collection Catalogues, Furniture* (London, 1956), pp. 34–35.
13. Versailles, Musée National du Château.
14. See W. Edey, *French Clocks in North American Collections* (New York, 1982), no. 44. In this case, the signature "Mre 1731" might conceivably refer to Martinière's father.
15. A.N., Y 15592, May 4, 1737, *scellé* (preliminary inventory) of Melchior Bonnaventure Balthazar.
16. A.N., Min., X 440, June 28, 1737, inventory after the death of Louis Jouard's wife.
17. Signature and date noted by M. Gendrot in Paris.
18. Metropolitan Museum of Art, New York, Gift of the Samuel H. Kress Foundation, 1958 (inv. 58.75.61).
19. Signature noted by M. Gendrot in Paris.
20. *Tablettes 1775*.
21. J. Guiffrey, *Histoire de l'Académie de Saint-Luc* (Paris, 1915), p. 385.

Pierre Masson

Pierre Masson was born in 1714 and died in Paris on December 16, 1788.[1] In 1739 he married Françoise Delanoy,[2] sister of André Delanoy, a spring-maker and master clock-maker in Paris. She bore him three daughters: Marie-Jeanne, wife of Jean Damour, a master sword-maker;[3] Madeleine-Jeanne, wife of Etienne-Claude Richard, a spring-maker;[4] and Françoise-Geneviève, unmarried in 1788.[5]

Masson was a *fabricant de ressort* (spring-maker) who was never admitted to the guild as a master clock-maker. He does not appear to have been related to the various Parisian clock-makers bearing the same surname. He lived first in the rue Saint-André-des-Arts (1760), then in the rue de la Huchette (1784).

Masson was first independently active toward the end of the 1730s and began working for Etienne Le Noir at the latest in 1741.[6] In 1744, on the behalf of Jean Goyer, he bought a clock from the *ébéniste* Claude-Joseph Desgodets, for which the bronzes had been specially designed by Jean-Joseph de Saint-Germain and of which Goyer had copies made.[7] Aside from this (except for the names of Jean-Baptiste Dutertre,[8] Germain Admyrault,[9] and David-Louis Courvoisier[10]), little is known about his clientele, although it was no doubt considerable. His reputation was well established, as can be seen from the mention of his name in the *Tablettes Royales de la Renommée* in 1772 and 1773, where he appears as a maker of watch- rather than of clock-springs.

Masson retired many years before his death. At that time he is described as a former *officier mesureur du granier à sel*, an office he relinquished February 14, 1782.[11] His inventory shows that he was reasonably well off. His fortune then amounted to about 50,000 *livres*, composed mainly of stocks and bonds.[12]

NOTES

1. A.N., Y 11206, December 17, 1788, *scellé* (preliminary inventory) of Pierre Masson.
2. A.N., Min., CXII, July 1, 1739, marriage of Pierre Masson.
3. A.N., Min., CIX, April 8, 1765, marriage of Marie-Jeanne Masson.
4. A.N., Min., LXXII, 450, November 20, 1768, marriage of Madeleine-Jeanne Masson.
5. A.N., Min., XXXVI, 604, December 31, 1788, inventory after the death of Pierre Masson.
6. See Le Noir biography in this volume, note 34.
7. A.N., Y 10989, complaint of March 6, 1745.
8. See note 5.
9. Archives de la Seine, D4 B⁶, cart. 25, balance sheet of August 12, 1767.
10. A.N., Min., XXXIV, 692, July 27, 1773, assembly of David-Louis Courvoisier's creditors.
11. See note 5.
12. Ibid.

Georges-Adrien Merlet

The *émailleur* Georges-Adrien Merlet was born in 1754. He was the son of Jean Merlet, a grocer, and Angelique Boyelledieu. He started his apprenticeship with Elie Barbezat, an enameler and member of the Académie de Saint-Luc, on October 30, 1767.[1] Active circa 1780, and probably the successor to Barbezat, in 1784 he was living in the rue Bertin-Poirée,[2] where he remained at least until 1802.[3] He then resided in the rue des Lavandières-Sainte-Opportune, where he was said to have been living in 1812.[4]

Merlet was, together with Joseph Coteau and H. Fr. Dubuisson, one of the three great enamelers of clock dials of the end of the eighteenth and the beginning of the nineteenth centuries. His oldest datable works are the dials for the clock "aux sultanes," with a movement by Urbain Jarossay, executed for the comte d'Artois by François Rémond in 1783.[5] Merlet supplied a great number of clock-makers with dials, including the Lepautes, Louis Berthoud,[6] Nicolas Collard, Darlot, Jollin *l'aîné*, Jean-Antoine Lépine, Liesse (in Rouen), Pierre Gavelle *l'aîné*, Charles-Guillaume Manière, Mugnier, Robert Robin, Léonard Roque, Simon Roy, and Nicolas Sotiau.

He also enameled skeleton clocks, the gilt-bronze friezes of which were made in the manner of Etienne Martincourt, and put them on the market under his own name along with various other highly decorated clocks. As can be seen from the clock by Folin *l'aîné* at the Getty Museum (cat. no. 19), Merlet's art is characterized by great delicacy. The dial of the clock "aux sultanes" demonstrates that even at the outset of his career he was the equal of Coteau and Dubuisson.

NOTES

1. A.N., Min., XXXIII, 566.
2. Archives de la Seine, D4 B⁶, dos. 3727, April 7, 1784, balance sheet of Jean Georges Imbert *l'aîné* mentioning a current account and a note dated May 1783.
3. Archives de la Seine, D11 U3, cart. 14, dos. 1032, 14 Nivose an X, balance sheet of Jean-Baptiste Georges.
4. *Almanach Azur*, 1812.
5. Information provided by Christian Baulez.
6. Paris, Musée National des Techniques, Ms. 8° 187, account book of Louis Berthoud. Merlet's name appears on October 26, 1784.

The Richard Workshop

The signature "Richard" on clock-springs corresponds to that of a family workshop run in turn by Claude, Etienne-Claude, and Gaspard Richard. Claude Richard died after 1789.[1] He married Marie-Anne Collot, who bore him three children: Pierre-Joachim, *marchand-mercier* and clock-maker,[2] Marie-Françoise, wife of the *marchand-mercier* Antoine-Marie Ménard, and Etienne-Claude. He was active as a *fabricant de ressort* (spring-maker) before 1747 and was admitted to the guild as *maître marchand-mercier* in Paris on November 16, 1759.[3] He relinquished his business to his son Etienne-Claude Richard on January 1, 1769.[4]

Etienne-Claude Richard was born in Paris in 1747[5] and died there before 1785. He was married first to Madeleine-Jeanne Masson, daughter of the spring-maker Pierre Masson,[6] who bore him a daughter, Madeleine-Françoise.[7] His two sons, Claude and Antoine-Marie, were the result of his second marriage, to Marie-Anne-Geneviève Maupoil (died 1787).[8] Etienne-Claude was apprenticed to the clock-maker Jerôme-François Regnault in 1767. Claude's grandson Gaspard Richard (son of Pierre-Joachim Richard) is mentioned as a spring-maker in 1787.[9]

The Richards' workshop was among the most important producers of clock- and watch-springs of the second half of the eighteenth century. First established in the rue Zacharie (1747), it was transferred before 1767 to the rue de la Huchette, the location at which it is mentioned in all the commercial almanacs of the day. Relinquished by Claude Richard to his son Etienne-Claude, the workshop was subsequently run by the latter's widow, until 1787,[10] with the help of his nephew Gaspard who, in due course, took it over.

The Richards supplied the best clock-makers of their day: André-Georges Guiot,[11] Etienne Le Noir, Charles Le Roy, Pierre (II) Le Roy, the Lepautes,[12] Lepaute de Bellefontaine, Simon Ridereau,[13] Antoine Crosnier,[14] Louis Mathieu Delagardette, Jean-Gabriel Imbert *l'aîné*,[15] Robert Robin, Denis Masson,[16] David-Louis Courvoiser,[17] Jean-Baptiste Furet,[18] and Ferdinand and Louis Berthoud,[19] as well as clock-makers from the provinces, such as J. H. Varin in Troyes.

NOTES

1. A.N., Min., XXXVI, 604, December 31, 1788, inventory after the death of Pierre Masson.
2. Admitted as *marchand-mercier* on November 15, 1774 (A.N., Y 9332). In the *acte de tution* of his nephews he is described as a clock-maker (A.N., Y 5160 A, December 1, 1787). He resided in the cour des Moines of the Enclos de l'abbaye de Saint-Germain-des-Près.
3. A.N., Y 9328.
4. A.N., LXXXII, 450, November 20, 1768. Marriage contract of Etienne-Claude Richard. Claude Richard left to his son "the business . . . consisting in steel merchandise, clock-springs both finished and unfinished . . . , the said Sr. Richard *père*, will forego the exercise of said profession throughout the city, faubourgs, and suburbs of Paris."
5. Certificate of baptism in the church of Saint-Séverin, February 28, 1747, attached to the contract of apprenticeship of February 23, 1767 (A.N., Min., XXXIV, 660).
6. See note 4 and the Pierre Masson biography in this volume.
7. A.N., Y 5610 A, February 1, 1787, appointment of a tutor for Richard's minor children.
8. Ibid.
9. See note 6.
10. Paris, Musée National des Techniques, Ms 8° 187, account book of Louis Berthoud, December 3, 1784: "To Mme Richard for springs, 64 *livres*."
11. André-Georges Guiot (died 1747) was one of Charles Cressent's favorite clock-makers.
12. A.N., Min., LXIV, 366, October 28, 1759.
13. A.N., Min., LXXXV, 584, August 7, 1764.
14. *Orologio* 3 (1988), p. 104.
15. Archives de la Seine, D4 B6, 4132, Jean-Georges Imbert's balance sheet of June 9, 1784. Richard appears in settlement of current accounts, for the amount of 155 *livres*.
16. A.N., Min., LXXXV, 556, April 28, 1759.
17. A.N., Min., XXXIV, 692, July 27, 1773.
18. Archives de la Seine, D4 B⁶, cart. 96, dos. 6657, Jean-Baptiste Furet's balance sheet of March 8, 1786.
19. See note 10.

Jean Romilly

Jean Romilly was born in Geneva on June 27, 1714, and died in Paris on February 16, 1796.[1] He was the son of Pierre Romilly (1681–1717), a master clock-maker in Geneva, and Jacqueline Balexert (died 1735). He married Elisabeth Jolly, granddaughter of Jean Jolly (died 1751), a master clock-maker in Paris.[2] Romilly had two children, Edme-Jean (1739–1779), a pastor of the Reformed Church, and Elisabeth (1742–1814), wife of Guillaume Olivier de Corancez (1734–1810), owner and editor of the *Journal de Paris*.

Romilly was admitted to the guild in Paris as master clock-maker on May 4, 1752, under the terms of a decision of Conseil d'Etat du Roi of April 4, 1752, which gave him a dispensation from the obligation of following a regular apprenticeship.[3] He was the technical director of the Manufacture Royale d'Horlogerie from 1787 to 1790. Romilly resided in turn in the rue Pelletier (1752), the

quai des Orfèvres (1760), the place Dauphine (1772), and the rue Poupée (1787).

The offspring of a family which boasted thirteen clock-makers in the years between 1670 and 1810, including his father (who was the most famous of his line), his uncle, and his three brothers, Romilly was initiated into clock-making in the family circle in Geneva. The circumstances of his move to Paris, about 1734,[4] are not known, but it appears likely that he trained himself by working among Protestant clock-makers such as Jean Jolly.[5] For springs, he collaborated with William (II) Blakey.

Romilly is the author of several theoretical publications on chronometry that are exclusively devoted to watches. He perfected the deadbeat escapement with twin pallet that had been developed by Caron de Beaumarchais and presented it at the Académie des Sciences in 1755.[6] Jean Jodin made reference to this invention: "Mr. Romilly has just made the most fortunate addition possible to this escapement."[7] As a result Romilly was one of the first clock-makers to produce watches capable of running eight days. On May 10, 1758, he appeared before the Académie to present a watch that had been running for 378 days without being wound.[8] It lacked precision, however, and even though he reduced the period to six months, this watch failed to obtain the degree of precision found in ordinary watches. It was finally Ferdinand Berthoud who managed to combine long duration with the precision Romilly had been seeking.[9] In the realm of clocks, Romilly seems to be the only clock-maker to have used the compensation pendulum invented by Grenier.[10]

Romilly was on friendly terms with Jean-Jacques Rousseau and was part of the intellectual circle of the capital. He contributed various articles on clock- and watch-making to the *Encyclopédie ou Dictionnaire Raisonné des Arts* . . . (Paris, 1772), including those on "Arc de Levée," "Frottements," "Pivots," and "Régulateurs," and also provided captions for the illustrations. He was on good terms with Diderot and d'Alembert, to whom he introduced his namesake, Sir Samuel Romilly, in 1781. The latter described him in the following terms: "He was a man of very great merit in his business, had seen a great deal of the world, and was not without a considerable portion of literature."[11] In 1779 he became an associate member of the committee of the Salon de la Correspondance.[12] In 1786 he was, together with Ferdinand Berthoud, Abraham-Louis Breguet, Jean-Baptiste Lepaute, and Jean Gregson, a member of the commission formed to study François-Jean Bralle's proposal for the establishment of a Manufacture Royale d'Horlogerie, which was finally created by the *lettres patentes* of Louis XVI dated January 17, 1787.[13] He served as the manufactory's technical director until 1790.

Romilly, who had encouraged his son-in-law to found the *Journal de Paris*, the first daily literary newspaper in the capital, assumed responsibility for the weather section. This allowed him to claim with some humor that "j'y fais la pluie et le beau temps" ("I make fair weather and foul," in other words, "I control everything here"). He published various texts in the *Journal*, including a letter, in 1778, in which he demonstrated that perpetual motion was impossible.[14]

The major part of his clock-making activity was devoted to watches, their mechanism being generally set in extremely fine cases. Some of these were supplied by André-Louis Levacher *l'aîné* and decorated with enamels by such well-known artists as the painter Jean Prévaux. He delivered one to the Menus Plaisirs on the occasion of the wedding of the Dauphin, the future Louis XVI.[15]

Romilly produced only a small number of movements for clocks, which were placed in cases by Balthazar Lieutaud, Charles Cressent, Robert Osmond, or Jean-Joseph de Saint-Germain. These were in all likelihood executed at the request of such clients as the financier Jean-François de Laborde, the comte du Luc, the marquis de Pange, Madame de Montesquiou, and the prince de Monaco. For Madame de Pompadour, in 1762, he made the works for a Sèvres porcelain clock which was part of a garniture of five pieces for a mantelpiece. It later entered the collection of the duc de Praslin.

Romilly was the progenitor of a line of political figures, scientists, and generals who distinguished themselves in France in the nineteenth century. His son Jean-Edme, first destined for the clock-maker's profession, was ordained a pastor in Geneva on March 14, 1763, and became a famous preacher, exercising his ministry first in London, then in Switzerland. At the age of twenty-two, he wrote the articles "Tolérance" and "Vertu" for the great *Encyclopédie*. He also contributed to Charles Palissot's *Mémoires Littéraires*, for which, among other things, he wrote an article on Jean-Jacques Rousseau.[16] Romilly's son-in-law, Guillaume Olivier de Corancez, was a protégé of Anne-Robert-Jacques Turgot and Armand-Thomas de Miromesnil. Thanks to the *Journal de Paris* as well as to interests he held in a hired carriage business, his economic situation was, according to his daughter, "close to opulence when the Revolution occurred."[17] Corancez's son, Louis-Alexandre Olivier de Corancez (1770–1832), followed Napoleon to Egypt and was a distinguished scholar, historian, and diplomat. In 1797 his daughter, Marie-Julie Olivier de Corancez, married Jean-Baptiste Cavaignac, a member of the National Convention and a regicide, who became Prefect under the Empire. Their elder son, Godefroy Cavaignac (1801–1845), was an opponent of the July Monarchy and became one of the

presidents of the Société des Droits de l'Homme.[18] Their youngest son, Louis-Eugène (1802–1857), was first a major-general, then gouverneur-général of Algeria. In 1848 he was chief executive of France ("chef du Pouvoir exécutif") and presented himself as a candidate for the presidency against Prince Louis-Napoléon. Louis-Eugène's son Jacques (1853–1905) was several times a minister under the Third Republic, most notably Minister of War at the time of the Dreyfus affair. Jacques's son Eugène was one of the most renowned French Hellenists of the beginning of the century, while his son-in-law, General Mangin, became a military hero during the First World War.

NOTES

1. *Recueil Généalogique Suisse* (Geneva, 1994), vol. 3, article on Romilly.
2. Jean Jolly belonged to a line of Parisian clock-makers. He was admitted as master on June 9, 1698, and was elected *Garde Visiteur* in 1716.
3. A.N., Y 9327 and A.N., E* 1278 B. On this matter, see Blakey biography in this volume, note 16.
4. The decree of the Conseil d'Etat du Roi cited in note 3 states that "from the age of twelve he has been brought up by his family in the art of clock-making and has worked since the age of eighteen as a *compagnon* together with the master clock-makers of Paris..."
5. On the occasion of her marriage, Elisabeth Gribelin, Jean Jolly's granddaughter, received a 200-*livre* annuity from the king, "since she was educated in the catholic, apostolic and Roman faith at the Nouvelles Converties," although her mother was christened on October 27, 1694, in the church of Saint-Barthélemy (A.N., Min., XXXIV, 589, 1.10.1752).
6. J. Romilly, "Une montre présentée par M. Romilly, citoyen de Genève," *Histoire*, Année 1755 (Paris, 1761).
7. J. Jodin, *Les Echappemens à repos comparés aux Echappemens à recul, ... suivi de Quelques reflexions sur l'état présent de l'Horlogerie ...* (Paris, 1754), p. 224.
8. *Encyclopédie, seconde section, horlogerie* (1766) and *L'Almanach Dauphin* (1772).
9. F. Berthoud, *De la mesure du temps...* (Paris, 1787).
10. Christie's, New York, June 5, 1986, lot 143. Grenier's pendulum was published by J.-F. Pilatre de Rozier, *Observation sur la physique*, vol. 16 (Paris, 1780), and again, with modifications, in vol. 29 (Paris, 1786).
11. S. Romilly, *Memoirs of the life of Sir Samuel Romilly, written by himself, edited by his sons* (London, 1840).
12. J. Chatelus, *Peindre à Paris au XVIIIème siècle* (Nimes, 1991).
13. Augarde 1984, pp. 66–79, and A.N., E* 1650 B.
14. *Magasin Encyclopédique (Journal des Sciences, des Lettres et des Arts)* VI (An IV) (1795), pp. 533–534.
15. A.N., O¹ 3044, item no. 311.
16. E.-J. Romilly, *Sermons recueillis par le pasteur Juventin, précédé d'un Eloge Historique*, 3 vols. (Geneva, 1788).
17. M.-J. Cavaignac, *Mémoire d'une Inconnue, 1780–1816* (Paris, 1896).
18. His tomb by François Rude, in the cemetery of Montmartre, is one of this sculptor's finest works.

Michel Stollenwerck

Michel Stollenwerck was a native of Germany, probably from the duchy of Jülich. He died in Paris in July 1768.[1] His first wife was Marie-Elisabeth Bodart. They had at least eight children,[2] including: Pierre-Hubert (about 1740–after 1805), a clock-maker,[3] Pierre-Martin (died after 1805), a clock-maker who settled in the United States of America after 1769,[4] Catherine-Elisabeth (1739–after 1810), who married Charles-Dominique Pesière, *Huissier audiencier en la juridiction des Eaux et Forêts à Paris*, then a lawyer at the Parlement de Paris;[5] Françoise-Angélique (died after 1804), who was married in turn to Louis-Alexandre de Villiers (died before 1772) and Alexandre-Pierre d'Antibes;[6] Marie-Anne (died after 1808); and Jean-François (born 1753).[7] In 1764 he married his second wife, Marie-Anne Courcelles (died after 1777).[8]

Active in Paris as an *ouvrier libre*, Stollenwerck was admitted to the guild as a master clock-maker in that city on April 14, 1746,[9] in accordance with a decree of the Conseil d'Etat du Roi given on February 1 of the same year.[10] He lived first in the Enclos de l'abbaye de Saint-Germain-des-Prés, then in the rue de la Comédie Française (1747) and in the rue Guénégaud (1753), and finally in the rue du Harlay on the place Dauphine (1757).

The date and circumstances under which Stollenwerck settled in Paris are unknown, as are the origins of his family. A clock-maker by the same name was active in Aix-la-Chapelle (Aachen) in the middle of the eighteenth century.[11] Stollenwerck's contemporaries spelled his name in a variety of ways making it particularly troublesome to scholars. Families of the same name living in Germany today spell it without the letter "c." What is known is that Stollenwerck settled in Paris around 1730. His first marriage took place prior to 1739, and he already owned an independent workshop in 1740.

One can give only an indirect assessment of his property. The marriage contract of his daughter in 1762 seems to imply that Stollenwerck was relatively wealthy for a man of his position. This impression of financial ease is confirmed by the location of the establishment he then occupied: the rue du Harlay and the buildings of the place Dauphine onto which it opened were in the quarter in which the most fashionable and wealthiest clock-makers of the capital were to be found. That he was probably well off financially is also confirmed by the fact that Pierre-Hubert Stollenwerck's stock was acquired by his stepmother for 8,463 *livres*, paid in cash,[12] an amount certainly provided by Michel Stollenwerck, since Marie-

Anne Courcelles's dowry, declared three months earlier, included little more than furniture of negligible value.[13] The settlement of the clock-maker's estate, on the other hand, was obviously quite a complicated matter since, eighteen months after his death, no guardian had yet been appointed for his minor children (as a result of which a notarized inventory could not be made),[14] and it was still not settled in 1805.[15] In any event, various clues allow an estimation of Stollenwerck's estate at about 77,000 *livres* at the time of his death.[16]

His contemporaries regarded Stollenwerck as an artist with an exceptional mechanical talent. In 1754 Jean Jodin wrote that "the Enderlins, Carus, Stollenwercks, Berthouds, &c. have been reduced to a furtive exercise of their superior talents in favored places . . ."[17] The scope of such praise can be measured in terms of the prestige and importance of the works of Enderlin and Berthoud. On February 16, 1761, *L'Avant-Coureur* declared that: "Le sieur Stollewerk, clock-maker, whom we mentioned on the occasion when the beautiful astronomical clock was to be seen in his shop, also has a particular gift for arranging carillons of singular accuracy and exact tone. This artist combines great theoretical ability with a perfect execution, & his hand is always guided by prior calculation."[18] Speaking of his musical cylinders in 1776, Père Engramelle gave him some vibrant posthumous praise, "As for the instruments with chimes, or carillons . . . those of Stolkverck have enjoyed the highest reputation . . . products of this kind, which can be transported into the remotest lands, will complete the taming of barbarian Nations, who have already been filled with admiration upon seeing some instruments by Marchal & Stolkverck . . . Some carillons by Stolkverck transported to China, Mongolia, Turkey and amongst the Hurons, have left the sovereigns of those vast countries enchanted with admiration."[19] And finally the editors of the *Encyclopédie* chose to represent one of his works in the plates devoted to clock- and watch-making, in order to illustrate the article on the carillon (plates XXVII and XXVIII of the first section).

One may assume that Stollenwerck was first taught by Henri Enderlin, whose train he later used,[20] and who, like him, resided in the abbey of Saint-Germain-des-Prés. In any event, Thiout associated their names in mentioning an escapement invented by Enderlin.[21]

The first known movement by Stollenwerck inscribed with a date was made in 1740,[22] and the assertions of Jean Jodin show that his reputation was established long before he was admitted to the guild as a master in April 1746. Two legal documents and a surviving specimen of his work confirm this. The inventory made after the death of the duc de Mortemart in August 1746,[23] mentions that in his Paris town house were two clocks by Stollenwerck, one of them *à secondes*, and two watches, one of gold and one large silver *de campagne*. The inventory of the marquis de Ferrière, in 1747, also mentions a clock *à secondes* by Stollenwerck estimated at the high price of 600 *livres*.[24] Finally, the sumptuous long-case clock in the Cleveland Museum of Art, the case of which bears the date 1744,[25] gives tangible proof of the artistic excellence of the work he was already putting on the market.

Besides clocks and watches with traditional works, Stollenwerck applied his talents in the highly technical fields of equation clocks, planispheres, and carillons. In the case of the carillons, it appears that he made them not only for himself but also for his colleagues. At least five specimens of his carillons have come down to us. One of the oldest, executed at the abbey of Saint-Germain, before his mastership, was made for Jean-François Dominicé's clock now in the Getty Museum (cat. no. 5). The second was placed, together with works signed by Etienne Le Noir *fils*, in a clock attributed to Jean-Pierre Latz. This clock was not originally intended to contain a carillon, but the addition may actually have coincided with its execution.[26] The third was combined with the astronomical works of the long-case clock by Latz now in Cleveland. The fourth, dated 1756, belongs to an exceptional clock for which Stollenwerck also executed a complicated movement. Created for the marquis de Brunoy, son of Jean Pâris de Montmartel,[27] this clock's gilt-bronze case representing the Death of Adonis is one of the most refined works of Jean-Joseph de Saint-Germain. The fifth belongs to a clock by Pierre Daillé, dated 1763, now in the Wallace Collection in London.[28] Other clocks with carillons created by Stollenwerck could be found, in the eighteenth century, in the collections of M. Mallet,[29] the marquises de Pange[30] and de Courtanvaux,[31] M. Duclos-Dufresnoy,[32] and later in that of M. Coblentz.[33] One last clock, with astronomical movements and a carillon, housed in an exceptional case (possibly by Jean-Pierre Latz) made of brass and tortoiseshell marquetry lavishly decorated with gilt bronze, was acquired by Frederick II of Prussia.[34]

The second field to which Stollenwerck gave his attention was that of astronomical clocks. He made at least two of the three surviving planispheres that belonged to Alexandre Fortier and may have been responsible for the changes made in the position of the secondary dials that distinguishes the last two from the first.[35] For the equation clocks and those with astronomical indications he sometimes used Enderlin's train,[36] which has already been mentioned, or that which Thiout referred to as a *cadrature anglaise*.[37]

With the exception of his son Pierre-Hubert, another son, possibly Pierre-Martin, mentioned as a *horloger*

mécanicien around 1775/1778,[38] and David-Louis Courvoisier,[39] the names of his collaborators in the clockmaking field are not known.

Stollenwerck probably bought the production of Pierre-Hubert and sold it under his own name: "The Sr. Stollenwerck has acknowledged that said effects ... belong to said P. his son ... that since the age of eighteen years he has granted him freedom to work on his own account."[40]

As far as marquetry cases are concerned, Stollenwerck collaborated with Jean-Pierre Latz.[41] For bronze cases, he often used Jean-Joseph de Saint-Germain[42] and Robert Osmond, who made a clock with a vase and lion masks intended for the duc de Brissac,[43] and Edme Roy, one of whose so-called "à la Geoffrin" models he fitted with a movement.[44] He occasionally provided decorative bronze elements to gilders, in particular to Ignace-Pierre Gobert.[45]

It seems likely that Stollenwerck sold most of his production himself. His clientele included rich dilettanti and connoisseurs of fine mechanical pieces. Besides the names already mentioned, one may add those of the amiral-marquis de Massiac[46] and the barons de Thiers[47] and de Bezenval. It was for the latter that he executed the works of a wall clock, the pendant of which was a thermometer signed "Michel Bourbon," as well as the works of an extraordinary clock of gilt and patinated bronze representing an allegory of History: "On a cluster of clouds run through by the scythe of Time, there appears a winged globe half covered by a veil and circled by a snake; the hours are marked upon it and a putto points them out, while another one, surrounded with attributes of the sciences and seated on the clouds, writes upon a book he is holding."[48]

NOTES

1. A.N., Y 11736, lawsuit brought against his widow for the delivery of meats to the couple through July 30, 1768.
2. A.N., Min., XXXI, 173, February 11, 1762, marriage of Catherine-Elisabeth-Nicolle Stollenwerck. In this contract, she is named as inheriting from her mother an amount equal to one eighth of her estate. It is no easy matter to trace the children of Stollenwerck. A *horloger mécanicien*, not a master, exercised his craft in Paris under the name of Stollenwerck *fils* (see note 38). This may possibly have been Pierre-Martin. See note 4.
3. A.N., Min., XXXI, 177, June 8, 1764, transfer, by Pierre-Hubert Stollenwerck, of his clock-maker's stock, to his stepmother, Marie-Anne Courcelles. The circumstances of this sale suggest that Pierre-Hubert may have been the M. Stollenwerck who, in 1801, published a translation of Fischer's book entitled *Recherches Historiques sur les Principales Nations Etablies en Sibérie et dans les Pays Adjacens, lors de la Conquête des Russes*. The translator's name is preceded solely by the letter M, and it is impossible to establish whether this is intended as the initial of a first name or an abbreviation of "Monsieur." In the preface the author wrote the following: "originating from the land of Juliers but born in Paris where I received my education, I was still young enough, when I went to Russia, to be able to learn the language of that country." After having taken part as an officer in the campaign against the Turks, under the orders of Marshal Count Riumianzowski, Pierre-Hubert married Elisabeth Abrahamovna of the princely house of Volkonsky in Moscow in September 1776 and returned to settle in France, in the Berry, during the 1780s.
4. Pierre-Martin Stollenwerck is mentioned as being in New York in 1805 (A.N., Min., XX, 808, 6 Nivose An XIV [documents missing]). His sons were no doubt the founders of the firm of Stollenwerck Brothers, also in New York after 1820. G. H. Baillie (1929), mentions a P. M. Stollenwerck in Philadelphia in 1813, who may be the same Pierre-Martin or one of his sons. Pierre-Martin was designated the godfather of his niece Sophie de Villiers on September 22, 1769, together with his stepmother, Marie-Anne Courcelles (A.N., Min., CI, 584, deed of March 17, 1772). We thank Christian Baulez for having drawn our attention to this deed.
5. See note 2. Charles-Dominique Pesière was the son of Dominique Pesière, master clock-maker and great-grandson of Nicolas (I) Hanet, Christiaan Huygens's agent in Paris. The property of the groom amounted to 42,400 *livres*; that of the bride to her unspecified share in her mother's estate. She received a *douaire préfix* consisting of a life annuity of 600 *livres* (representing a capital of 12,000 *livres*) and a donation of 3,000 *livres par préciput et hors part* (before distribution of the shares, inheritance taxes being paid for from the estate). Finally, Catherine-Angélique De Walle made a donation of 6,000 *livres* to the future couple, wholly devolving upon the survivor.
6. A.N., Min., IX, 884, 17 Nivose An XIII, power of attorney given by Alexandre-Pierre d'Antibes to his wife.
7. Paris, Bibliotheque Nationale, Manuscrit Français, Fichier Laborde, extract from the baptismal register of the church of Saint André-des-Arts dated May 4, 1753.
8. A.N., Min., XXXI, 177, March 2, 1764.
9. A.N., Y 9326.
10. A.N., E* 1228B. In February 1745 the government created the offices of *Inspecteurs et contrôleurs des Jurés* in all the arts and crafts communities of the kingdom. This placement of hereditary officers at their head went against the desire of these communities to freely elect their own representative officers. Consequently each guild offered to buy back these offices and "H(is) M(ajesty), in order to show the continuation of his affection and benevolence, allowed them to do so." Being unable to borrow the required capital, the Parisian clock-makers decided to ask the king's permission to admit as masters twenty unqualified workers who would execute masterpieces and pay increased admission fees amounting to 2,000 *livres*. They were allowed to do this on February 1, 1746, by the aforementioned decree.
11. See *La Mesure du Temps dans les Collections Belges* (Société Générale de Banque, Brussels, 1984), no. 244.
12. See note 3.
13. See note 8.
14. See note 1. Legal statement of October 8, 1769. One must also take into account various debts contracted by Stollen-

werck which were not settled after his death; for instance those claimed by the clock-maker David-Louis Courvoisier and the gilder Ignace-Pierre Gobert.

15. See note 6. This was certainly due to the fact that the estate of his father-in-law Bodart had not yet been settled.

16. This figure fits well with a comparative study of the wealth of clock-makers such as the Le Noirs, Le Roys, Lepautes, or Voisins. It is also consistent with the estimation of the property of Stollenwerck's first wife and of the liquid assets he disposed of in 1764 to buy back the stock of his son Pierre-Martin.

17. J. Jodin, *Les Echappemens à repos comparés aux Echappemens à recul, . . . suivi de Quelques reflexions sur l'état présent de l'Horlogerie . . .* (Paris, 1754).

18. The reference to the astronomical clock refers to Alexandre Fortier's personal orrery.

19. Père Marie-Dominique-Joseph Engramelle, *La Tonotechnie ou l'Art de Noter les cylindres et tout ce qui est susceptible de Notage dans les instrumens de Concert méchaniques* (Paris, 1775), pp. 35–64.

20. Thiout 1741. This train is in a long-case clock now in the Museum für Kunsthandwerk in Dresden, the case of which, according to Henry Hawley, may be attributed to Jean-Pierre Latz. Reproduced in R. Muhe and H. Vogel, *Horloges Anciennes* (Paris, 1979), fig. 575.

21. Thiout 1741.

22. On a wall clock formerly in the collection of Jean-Baptiste Diette. See *Maison et Jardin* (November 1961). Information kindly communicated by Christian Baulez.

23. A.N., Min., XXIII, 545, August 31, 1746.

24. A.N., Min., VI, 707, December 18, 1747.

25. H. Hawley, "Jean-Pierre Latz, Cabinetmaker," *Bulletin of the Cleveland Museum of Art* (September-October 1970), no. 1.

26. Sale, Sotheby's, Monaco, June 16, 1990, lot 821.

27. Anonymous sale, Paris, August 28, 1775, lot 3. This clock, formerly in the collection of the comtesse de Béhague, is now in the Ganay collection. We are obliged to Christian Baulez for communicating the seller's identity.

28. Inv. F96. The dial bears the double signature of Joseph Coteau and Louis-André Thil, which suggests that the two enamelers were, at one time, associates. An identical clock, with Stollenwerck's signature on the dial, is now in the Palais de l'Elysée, in the Salon des Portraits.

29. Sale, Paris, May 12, 1766, lot 107. The carillon plays thirteen different tunes.

30. Sale, Paris, March 3, 1781, lot 136; Boileau sale, Paris, March 4, 1782, lot 308. The marquis de Pange was a great collector of clocks. He owned, among other things, the long-case clock by Ferdinand Berthoud, Balthazar Lieutaud, and Philippe Caffieri now in the Château de Versailles. See C. Baulez, "Il Luigi XVI," in *Il mobile francese dal Luigi XVI all'art déco* (Milan, 1981), p. 6.

31. Sale, Paris, December 1782, lot 11 (*effets precieux*). The marquis de Courtanvaux was one of the most famous scientific dilettanti of the end of the eighteenth century. Besides his collection of scientific instruments, he owned a complete clock-makers workshop, splendidly equipped with machines and instruments of every kind. Twenty-four clocks appeared in his sale, seven by Berthoud, six by Lepaute, three by Stollenwerck, and one by Robert Robin. Six of these are equation clocks, one of them being by Stollenwerck. On this matter see Augarde 1996.

32. Sale, Paris, August 18, 1795. This collection was assembled at the end of the ancien régime and M. Duclos-Dufresnoy could not have been the first owner of the Stollenwerck clock.

33. Sale, Paris, March 13/14, 1908, lot 207.

34. P. Seidel, *Les collections d'oeuvres d'art françaises du XVIIIème siècle* (Berlin, 1900), pp. 59, 199.

35. See Fortier biography in this volume.

36. See note 20.

37. See note 25.

38. *Tablettes* 1775: "Stollenwerck *fils*, rue Neuve Saint-Meri, opposite the Cul de Sac du Boeuf, makes simple clocks to which he adjusts carillons which repeat at each hour the tunes one has chosen." Around 1778/79 he lived in the rue de la Verrerie (A.N., Y 10929 A).

39. A.N., Min., XXXIV, 691, May 24, 1773, inventory after the death of David-Louis Courvoisier; per note of June 2, 1766, still not settled.

40. Pierre-Hubert Stollenwerck does not appear in the registers of admission to mastership, nor does his brother Pierre-Martin.

41. Hawley 1970 (see note 25), pp. 215ff.

42. Augarde 1986, p. 521.

43. A.N., Min., XCI, 1295, December 28, 1792, inventory after the death of the duc de Brissac. The clock was confiscated during the Revolution.

44. Baulez 1989, and sale of vicomte Melchior de Vogüé, Paris, June 27, 1910, lot 107.

45. A.N., Min., XXVIII, 400, August 26, 1766, inventory after the death of Ignace-Pierre Gobert, and A.N., XXVIII, 402, February 8, 1767, marriage of his widow to Louis-Nicolas Gérard.

46. A.N., Min., LXXIII, 989, October 7, 1777, inventory after the death of the marquise de Massiac.

47. A.N., Min., LXXIII, 925, December 22, 1770, inventory after the death of baron de Thiers. The Stollenwerck clock, which is listed as no. 567 in the inventory, did not appear in the sale of this collector's belongings.

48. Sale, Paris, August 10, 1795, lot 176. The gilt-bronze wall clock and its pendant have been identified by Christian Baulez as numbers F 255 and 256 of the Wallace Collection in London. Number 191, the clock with a globe, could be seen, in the nineteenth century, in the collection of Baron Gustave de Rothschild. See A. Jacquemart, *Histoire du Mobilier* (Paris, 1876), p. 84.

CHARLES VOISIN

Charles Voisin was born in Paris in 1685 and died there on February 24, 1761.[1] He was the son of François Voisin (died prior to 1725) and Geneviève Cosson (died 1739). In 1712 he married his first wife, Denise Fortier (died 1722),[2] who bore him four children: Antoine (1717–after 1789), who was admitted to the guild in Paris as a master clock-maker on February 19, 1743; Denise-Marguerite (born 1719), who married the *marchand-mercier* Etienne-François Santilly; Michelle (born 1720), who died young; and Geneviève (born 1722, died before 1745), who married the *marchand-mercier* Augustin Bonnemain. His remarriage in 1725 to Marie-Antoinette Convers (1708–1763) resulted in five children: Geneviève-Antoinette (born 1726), who died young; Antoinette-Charlotte (born 1731), who married François-Ambroise Didot, founder of the famous Didot publishing firm; Antoine-Henry (1733–1815), who was admitted to the guild in Paris as a master clock-maker on August 31, 1755; Catherine (born 1734); and Charles (1739–1781), *Ecuyer Valet de Chambre du Roi*.[4]

Voisin was admitted to the guild in Paris as a master clock-maker on August 6, 1710[5] and functioned as *Garde Visiteur* from 1726 to 1728. He also acquired the honorific title *Grand Messager Juré de l'Université de Paris*.[6] He resided in the rue de Sèvres and in the rue Dauphine (after 1713).

Voisin was a product of the Parisian middle class. His family boasted another clock-maker in the person of his uncle Nicolas. One of his uncles, whose name was also Charles, was gardener to the king. The famous *tourneurs en ivoire* who served Louis XV and Louis XVI were members of his family. He amassed a fortune which, at his death amounted to over 204,000 *livres*,[7] most of this consisting in the freehold of four houses and half of a group of five others, all of them located in Paris. This financial success is confirmed by his daughters' prestigious marriages and the social ascent of his immediate descendants. His last son, Charles, acquired the office of *Valet de Chambre Ordinaire du Roi* which raised him to the nobility[8] and, in 1772, one of his grandsons was a lawyer in the Parlement de Paris.[9]

The picture we can form of his workshop under the Régence, as shown by the inventory made after the death of his first wife in 1722,[10] is that of an already remarkably active business. His property was then estimated at 60,000 *livres*. The stock alone, according to the estimation of two clock-makers, Henry Balthazar and Benoît Gérard, serving in the capacity of experts, was valued at 22,308 *livres* and included over eighty watches of different kinds, with gold, silver, or metal cases, twenty-six clocks in their brass and tortoiseshell marquetry cases, together with chains of precious metal, various blank movements, and tools. In 1725 his fortune had increased by 15,000 *livres*.[11] When he relinquished his business as a going concern to his son Henry on December 18, 1760, its worth was estimated at 23,000 *livres*.[12]

Voisin produced mostly luxury items that are better characterized by the quality of their cases than by the interest of their movements, which are mostly simple in conception but excellently crafted. Voisin specialized in clocks decorated with porcelain from a broad variety of origins, the most noteworthy of which include the porcelain wall clock from Chantilly now in the Getty Museum and a clock with African figures in Chinese porcelain framing a Japanese porcelain case, formerly in the collection of the Elector of Bavaria.[13]

Hardly any of Voisin's collaborators are known to us,[14] with the exception of Adrien Dubois for cases veneered with marquetry, Jean-Joseph de Saint-Germain for gilt-bronze cases,[15] François Dubois for movements,[16] and Jean-Jacques Gavelle for watchcases.[17] Voisin also provided movements for cases decorated with lacquered oriental figures by the Martin brothers. He was in communication with a large number of *marchands-merciers*, including Henri Lebrun, Jean-Jérôme Allain, François Bailly, Bonneau, and Duhamel *père*.[18] His elder son worked with him for a while, then set up an independent workshop before retiring in 1772.[19] His younger son always remained with him; he essentially ran the business in the rue Dauphine from about 1758.[20] It was this shop that was regularly mentioned with high praise by the various commercial almanacs of the second half of the eighteenth century.

Voisin used two signatures: "Charles Voisin à Paris," and "Voisin à Paris" (the latter after the death of his uncle Nicolas). Antoine Voisin chose the signature "Voisin *fils*," while Antoine-Henry signed his works "Henry Voisin."

The scope of Voisin's clientele was the mark of his success. It included individuals of royal blood such as the duchesse du Maine, her son, the comte d'Eu, and the duchesse de Brunswick, countless members of the most renowned families of the French aristocracy, and such dilettanti as the duc de Chevreuse, prince Ferdinand de Rohan, the princesse d'Armagnac, the marquises de Furcy, de Tahout, and d'Arcy, the marquis de Castrie, de Ponts, and de Pérensc, the comtes de Montrond and d'Argeval, Madame de Pomponne, Présidente Delisle, the baron de Montmorency, the amiral-comte d'Estaing, and the amiral-marquis de Massiac. Voisin's reputation, firmly established from an early date, was upheld by his sons.

NOTES

1. Paris, Bibliothèque Nationale, Manuscrit Français, Fichier Laborde, from the burial register of the church of Saint André-des-Arts, February 24, 1761.
2. A.N., Min., XXIX, 307, September 22, 1712.
3. A.N., Min., XII, 389, April 3, 1725.
4. He was also a freemason. He was *Vénérable* of the Lodge of the United Brothers (*Fréres Unis*) and later of its prolongation, the Lodge of Saint Charles of the United Brothers.
5. *Liste* 1748.
6. Concerning this function, see M. Marion, *Dictionnaire des Institutions de la France aux XVIIème et XVIIIème siècles* (Paris, 1972), and Thiery, *Almanach du voyageur à Paris* (Paris, 1784).
7. A.N., Min., CXIX, 351, March 11, 1762, partition of the property of Charles Voisin.
8. His advance on fee was dated May 8, 1765. See A.N., Min., XCI, 1108, February 1, 1773, inventory after the death of the wife of Charles Voisin *fils*.
9. A.N., Min., XCI, 1104, September 16, 1772, marriage of Charles Voisin *fils*.
10. A.N., Min., CXIX, 192, October 20, 1722, inventory after the death of Denise Fortier.
11. See note 3.
12. A.N., Min., CXIX, 346. Unfortunately, a detailed inventory of the stock established by private treatise was not attached to the deed.
13. Inv. K. V. C.210, Residenzmuseum, Munich.
14. On April 15, 1989, a wall clock in gilt bronze attributed to Charles Cressent with a movement by Charles Voisin was put up for sale (lot 90) by Ader, Picard, Tajan in Paris. The attribution of the case to Cressent is quite unfounded in view of the information available.
15. J.-D. Augarde 1986, pp. 521–538.
16. A.N., E* 1391B, decree of the council of August 28, 1764, doc. no. 16.
17. A.N., Min., XXXIV, 642, January 11, 1764, inventory after the death of the wife of J. J. Gavelle.
18. A.N., Min., CXIX, 347, inventory after the death of Charles Voisin.
19. See note 9. Antoine Voisin is described in this document as an *ancien maître horloger*.
20. See note 12.

Genealogy of the Delafond and Carré Families

Genealogy of the Le Roy, Sénard, Hoguet, and Béliard Families

1. Daughter of Nicolas Pelletier, Master Clock-maker
2. Daughter of Jérome Martinot, Valet de Chambre, Clock-maker to the King
3. Apprenticed in 1741 to Julien Le Roy
4. Apprenticed in 1743 and resigned in 1748
5. Son of Pierre Béliard, Master Clock-maker and elder brother of François Béliard

NICOLAS
Master Clock-maker, Paris
m. Jeanne Berthon
|
DAVID
(1557?–1635)
Master Clock-maker to the King, Tours (1586)
m. Rebecca Rouer
|
JULIEN (I)
(d. 1691)
Clock-maker, Tours
|
GATIENNE
(d. before 1728)
m. François Hoguet

GATIEN
(d. 1762)
Master Clock-maker
(after 1748)
m. Marie-Françoise Pelletier
(see note 1)

FRANÇOIS (I)
(d. before 1766)
Master Clock-maker
(after 1748)
m. 1 Suzanne Gérin
m. 2 Marie-Elisabeth Martinot
(see note 2)

ANNE-FRANÇOISE
m. François Béliard
(d. 1795)
Clock-maker to the
King (1749),
Garde-Visiteur* (1771),
Syndic* (1778),
Valet de Chambre,
Clock-maker to the
King (1781)

JEAN-GATIEN
(d. after 1789)
Master Clock-maker
(1774)

TOUSSAINT-FRANÇOIS
(1743–after 1804)
Master Clock-maker
(1779)
m. Julie Le Provost

1 JEANNE
m. 1 Thomas
Ardesoif
Master Clock-maker
(1753)
m. 2 François-René
Arnauld

1 ETIENNE
(d. 1741)
Clock-maker

2 FRANÇOIS (II)
(d. after 1766)
Master Clock-maker

PIERRE-FRANÇOIS
(before 1750–
after 1790)
Master Clock-maker
(1774)

JULIEN-ANTOINE
(1758–?)
Master Clock-maker
(1786)
m. Marie-Amélie
Arnault

FRANÇOIS-ALEXANDRE
Clock-maker

2 MARIE-AMÉLIE
m. Julien-Antoine
Béliard

Only members of those families connected to clock-making are included here.

*A position in the Guild of Clock-makers

Glossary to Movement Terms

Anchor-escapement, see also *escapement*

In combination with a pendulum the anchor escapement regulates the speed of the going train. It is called an anchor escapement because the shape of its pallets resembles an anchor. Its invention is attributed to William Clement (1638–1704), and it is therefore also called a Clement escapement.

Barrel

A wheel composed of a toothed disk and a cylindrical box. The barrel turns freely on an arbor and contains the mainspring, which is hooked to the barrel at its outer end and to the arbor at its inner end. The barrel meshes with the first pinion of a train.

Brocot suspension

A spring system, consisting of one or two strip springs clamped between two brass plates. It was invented by the Parisian clockmaker Achille Brocot (1817–1878).

Cannon pinion, see also *motion work*

The pinion that drives the motion work. It is made to complete one revolution per hour and is driven by the center arbor; it carries the minute hand.

Count wheel

A wheel that is driven by the striking train and determines the number of bell strokes for each hour or part thereof. The count wheel has a given number of notches spaced at increasingly wider intervals to permit the clock to strike in the correct sequence. At the quarter hour, half hour, or full hour, a lever is lifted from a given notch, and, after the requisite number of strokes on the bell, the lever drops into the next notch of the count wheel and stops the striking train.

Crown wheel escapement, see also *escapement*

This escapement has two pallets fixed on an arbor at right angles to each other. It was used in the early clocks of the Renaissance period in combination with a foliot or a balance. In the clocks described in this catalogue it is used in combination with a pendulum to regulate the speed of the going train. The crown wheel escapement, sometimes also called a verge escapement, is the oldest known escapement.

Endless-rope winding mechanism

A mechanism that maintains power to a train as the clock is wound. This device was invented by Christiaan Huygens.

Escapement, see also *anchor escapement, crown wheel escapement, verge escapement*

A mechanism that alternately checks and releases the driving force of a timepiece. The mechanism includes the escape wheel, which provides impetus to the balance or pendulum.

Fly vane

In striking clocks the last wheel of the strike train is fitted with a fly consisting of two vanes. The friction between these and the air slows down the train.

Going train

The wheel and pinions that transmit the driving power from the weight or mainspring to the escapement.

Hour wheel, see also *motion work*

Part of the going train, it rotates in normal clocks once in twelve hours. The hour wheel holds the hour hand.

Locking plate, see *count wheel*

Minute wheel

Part of the going train, it rotates once an hour; it carries the cannon pinion and the minute hand.

Motion work, see also *hour wheel, cannon pinion*

The three wheels—cannon pinion, minute wheel and pinion, and hour wheel—directly behind the dial that transmit the rotation of the minute wheel to the hour wheel.

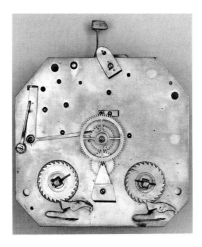

Pinion

A small toothed wheel with six to fourteen teeth.

Quarter-repeater, see also *repeater*

Repeats the quarter of an hour in addition to the hours.

Rack striking work, see also *snail*

A striking train in which the number of blows struck is controlled by the position of a rack, the teeth of which lift the hammer. Miscounting cannot occur.

Recoil escapement, see also *anchor escapement*

A specially designed escapement with a heavy recoil. As the wheel turns, the pallets oscillate more or less quickly, with no supplementary arc.

Repeater

A clock that strikes hours, quarter hours, or even minutes when a cord connected to the striking train is pulled. There are various types of repeaters; a quarter repeater sounds a low note for the hours and a "ting-tang" for each of the quarters.

Repeating train, see also *repeater*

The striking train of a repeater.

Silk suspension

A silk thread wound around a squared rod, which can be turned to adjust the length and therefore the period of the pendulum. Lengthening the pendulum causes the clock to run slower, shortening it, to run faster.

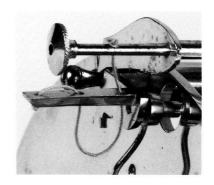

Snail, see also *rack striking work*

A notched cam that controls the striking of the hours or quarters.

Striking hammer

A mallet that strikes the hours and half hours on a bell or a gong.

Striking train

The wheel and pinions that transmit the driving power from the weight or mainspring to the striking hammer for striking the hours.

Verge escapement, see *crown wheel escapement*

Index

Page numbers in bold face refer to extended biographies.

A
Adélaïde, Madame, 181
Admyrault, Germain, 192
Albani, Francesco, 172
Albaton, Pierre, 177
Albermarle, Lord, 178
Alembert, Jean Le Rond d', 164, 194
Alexander and Berendt, 113
Alibert, 102
Allain, Jean-Jacques, 178
Allain, Jean-Jérôme, 199
Amant, Louis, 180
Angouléme, chevalier d', 175
Anne de Beaujeu, regent of France, 164
Arancourt, marquis d', 169
Arcy, marquise d', 199
Arenberg, duc d', 185
Argand, Jean, 181
Argeval, comte d', 199
Armagnac, princesse d', 199
Armand, Philippe, 184
Arnold, Edward, 106
Arrouard, 181
Artois, comte d', 144, 181, 192
Ascaffenberg, Schloss Johannisburg, 106
Asline, 166
Audinet, 55
Aumerle, Marguerite-Elisabeth, 165
Aumont, duc d', 175
Aveline et Cie, 139

B
Baden-Baden, Zähringer Museum, 25
Bagatelle, Pavilion de, 180
Bailleul, 177
Baillon, Etienne, 55
Baillon, Jean-Baptiste, 55, 184, 191
Bailly, François, 199
Bailly, Jean-Sylvain, 181
Bailly, Joachim, 166, 191
Balthazar, Henry, 199
Balthazar, Melchior-Bonnaventure, 191
Barbedienne, Ferdinand, 120
Barbezat, Elie, 181, 186, 192
Barlier, 155
Barry, Madame du, 178, 181
Bartholony, Abraham, 186
Bartlett-Burdett-Coutts, William Ashmead, 85
Bath, Marquess of, 129
Beaucourt, Jean-Louis, 184
Beaujon, M., 181
Beaumarchais, Caron de, 194
Beauvilliers, duc de, 175
Bélanger, François-Joseph, 181
Béliard, François, 186, 188, 203

Bellaigue, Geoffrey de, 89
Belle, Jean-François de, 169
Bellefontaine, Lepaute de, 181, 193
Bellevue, Château de, 180
Bénard, Charles, 181
Bénézech, Pierre, 120
Benisimon Collection, 144
Beo, Johann Andreas, 148, 150
Berain, Jean (I), 12, 16
Berault (family), 177
Bergeret, Monsieur, 184
Beringhem, marquis de, 186
Berlin
 Kunstbibliothek, 37, 38, 118, 172
 Kunstgewerbemuseum at Köpenik, 137
 Schloss Charlottenburg, 159
 Schloss Potsdam, 150, 151
Bernard, Samuel, 23, 55
Berry, comtesse de, 169
Berthoud Frères, 170, 196
Berthoud, Ferdinand, 163, 167, 170, 177, 184, 186, 188, 193, 194
Berthoud, Louis, 170, 192, 193
Bezenval, baron de, 197
Blaine Jewellers, 34
Blaizot, 184
Blakey, Nicolas, 165
Blakey, William (I), 165, 185
Blakey, William (II), 163, 164, **165–66**, 194
Blavet, Etienne, 184
Boizot, Louis-Simon, 128, 135
Bonemain, Augustin, 199
Bonneau, 199
Bonnefont *neveu*, 116
Bonnet, Henri, 112
Bonnet, Nicolas, 178, 181
Bonneval, Monsieur de, 184
Bordeaux, Chambre de Commerce, 89
Boucher, François, 172, 181
Bouchez, 34
Boudier, Jean-Simon, 169
Bouillon, duc de, 168
Boulard, 55
Boullanger, 111
Boulle, André-Charles, 2, 7, 10, 12, 16, 17, 20, 23, 25, 156, 158, 175, 186
Boulle, André-Charles (II), 186
Boulle, Jacques-André, 190
Boulle workshop, 152
Boullé, Jacques-Antoine, 190
Boullé, Jacques-Nicolas, 190
Boullé, Jean, 190
Boullongne Collection, 178
Bourbon, duc de, 82, 181, 182, 188
Bourbon, Lange de, 191

Bourbon, Louis-Henri, duc de, seventh prince de Condé, 45, 168
Bourbon, Michel, 197
Bourbon, Palais de, 45
Bourgogne, duc de, 187
Bousseau, Monsieur, 191
Brahe, Tycho, 172
Bralle, François-Jean, 194
Branicka, Christine, 77
Branicki, Jan Clemens, Count, 75, 77
Bréant, Jacques-Pierre-Thomas, 169
Bréguet, Abraham-Louis, 194
Bréguet, Louis, 169
Bréthous, Léon de, 62
Brice, Germain, 16
Brignolles, marquis de, 178
Brissac, duc de, 197
British Royal Collection, 55, 106, 143
Brocot, Achille, 58, 120, 124, 154, 160, 201
Brodon, Nicholas, 55
Brunoy, marquis de, 181
Brunswick, duchesse de, 199
Burdett-Coutts, Angela, Baroness, 85
Burrell, Peter, 1st Lord Gwydir, 41
Burrell, Peter, 2nd Lord Gwydir, 41
Butterfield, Michel, 187
Buzot, Charles 73, 78, 82, **167**, 177
Buzot, Jean-Charles, 167
Buzot, Joseph, 167

C
Cachard, Gaspard, 183
Caffieri, Jacques (II), 86, 89–90, 170, 178, 186
Caffieri, Philippe, 89, 170, 178
Caffieri, workshop, 184, 186
Caillaud, G., 169
Campary, Antoine, 186
Campbell, Richard James, 128
Carignan, prince de, 186
Caron *fils*, 182
Caron *père*, 111
Carré, Jean, 185, 201, 202
Carré, Louis-David, 185, 186, 202
Carus, 196
Cassini, Jacques (I), 186
Cassini, Jacques (II), 186–187
Castrie, marquis de, 199
Catherine the Great, empress of Russia, 135
Cauvet, Gilles-Paul, 118, 181
Cavaignac, Eugène, 195
Cavaignac, Godefroy, 194
Cavaignac, Jacques, 195
Cavaignac, Jean-Baptiste, 194
Cavaignac, Louis-Eugène, 195
Cavalier, Prosper, 171

Chainaut, Madame, 106
Chantilly porcelain manufactory, 42, 45–46, 178
Chantilly, Château de, 17, 45, 82, 199
Chardin, Jean-Baptiste-Siméon, 172
Chardon, Jacques, 180, 182
Charles III, king of Spain, 181
Charles IV, king of Spain, 181
Charles VII, king of France, 164
Charles, prince of Lorraine, 181
Chaulnes, Michel-Ferdinand, duc de, 170, 172
Chavagnac, marquis de, 175
Chesterfield, Philip Dormer Stanhope, 4th Earl of, 154, 155
Chevreuse, duc de, 199
Choiseul-Praslin, comte de, 12
Choisy, Château de, 180
Christina, queen of Sweden, 172
Ciechanowiecki, Andrew, 128
Cirou, Ciquaire, 45
Clement, William, 201
Clermont, comte de, 186, 188
Clermont, Madamoiselle de, 184
Cleveland Museum of Art, 99, 196
Clodion, 172, 181
Cluzed, Etienne, 177
Coblentz, M., 196
Coentanfan, marquis de, 175
Coeur, Edme, 169
Colbert, Jean-Baptiste, 16, 23
Collard, Nicolas, 192
Collignon [Jean-Joseph Lepaute], 180
Consenne, Jean, 175
Consenne, Léonard, 175
Contades, maréchal de, 175
Conti, Louis-François de Bourbon, prince de, 100, 173, 188
Copernicus, Nicolaus, 173
Corancez, Guillaume Olivier de, 193
Corancez, Louis-Alexandre Olivier de, 194
Cornu, Jean, 16
Cortonne, Jean de, 172
Cosi, 181
Coteau, Joseph, 169, 192
Courtanvaux, marquis de, 181, 196
Courvoisier (brothers), 181
Courvoisier, David-Louis, 181, 192, 193, 197
Coustou *père*, 191
Cressent, Charles, 48, 52, 55, 61, 178, 186, 194
Crosnier, Antoine, 193
Cucci, Domenico, 180

D
Daillé, Pierre, 196
Dalva Brothers, 18, 55,
Darlot, 192
Darnault, François, 178
Dasson, Henri, 120
Davenport, 163, 168
David (dialmaker), 181
David, Jacques Louis, 128
Davis, Charles, 41, 100
Debruge, 102, **167**

Decla, Jacques, 78, 82, **168**, 177
Delafond, Pierre, 185, 201
Delafontaine, 120
Delagardette, Louis-Mathieu, 193
Delamare, *Commissaire*, 174
Delanoy, André, 192
Delisle, Présidente, 199
Denière, 120
Dentan, Amy, 186
Desgodets, Claude-Joseph, 192
Deshayes, Jean-Baptiste-Henri, 172
Desmarets, Nicholas (Mr. Desmarais), 23, 175
Detroit Institute of Arts, 26, 35, 40, 57, 91, 107, 113, 120, 122, 146, 154, 159
Diderot, Denis, 164, 194
Didot, François-Ambroise, 199
Digue, 164
Dodge, Anna Thomson 52, 57
Dolland *père*, 166
Dominicé, Bernard, 168
Dominicé, Denis, 168
Dominicé, Etienne, 168
Dominicé, François, 168
Dominicé, Jean-François, 28, 34, 37, 163, 164, **168–69**, 180, 196
Donjeux, Vincent, 41
Dresden
 Museum für Kunsthandewerk, 178
 Schloss Moritzburg, 99
Dreyfus, 195
Drouot, François, 169
Droz, Abraham-Louis-Humbert, 111
Dubois, Adrien, 169, 178, 186, 199
Dubois, François, 186, 199
Dubois, Jacques, 73, 75, 178
Dubuisson, Henri-François, 124, 163, **169–70**, 181, 192
DuChesne, Pierre, 7
Duclos-Dufresnoy, M., 196
Ducloux, Moyse, 177, 184
Ducorroy, 176
Dufour, François, 176
Dugourc, Jean-Démosthène, 118
Dugrand-Mesnil (family), 177
Duhamel, François, 184
Duhamel *père*, 199
Duplessis, Jean-Claude, 181
Duplessis, Marguerite-Catherine Boucher, 155
Durier, Jean, 8
Durini, Monseigneur, 168
Dutertre (family), 177
Dutertre, Jean-Baptiste, 192
Duvaux, Lazare, 169, 178, 186
Duveen Brothers, 52, 57

E
East, Edward, 168
Ecosse, Jean-Marc-Antoine, 177
Egmont, comte d', 178
Eisen, Charles-Dominique-Joseph, 172
Elector of Bavaria, collection of, 199
Emlyn, Viscount, 18
Emmoser, Gherard, 172
Enderlin, Henri, 173, 180, 196

Engramelle, Père, 196
Ephrussi, Maurice, 100
Espirito Santo, José and Vera, 85
Espirito Santo, Ricardo, 90
Estaing, amiral-comte d', 199
Estaing, comte d', 175
Etable de La Brière, Jean-Jacques, 181
Etable de La Brière, Nicole-Reine, 179
Eu, comte d', 199
Exeter, Brownlow Henry George, 4th Marquess of, 34, 41
Exeter, William Alleyne Cecil, 3rd Marquess of, 41

F
Fabert, maréchal de, 175
Fabre *et fils*, B., 52, 57
Faucheur, Alexandre le, 168
Faugnes, M. Perrinet de, 155
Ferdinand VI, king of Spain, 181, 188
Ferrière, marquis de, 196
Feuillade, maréchal de la, 175
Fiéffé, Jean-Alexandre, 170
Fiéffé, Jean-Claude, 170
Fiéffé, Jean-Jacques, 58, 163, 164, **170**
Fiéffé, Jean-Nicolas, 170
Fiéffé, Nicolas, 170
Flavecourt, marquis de, 178
Fleury, Cardinal de, 188
Fogg, Samuel, 41
Fol *fils*, Jean, 181
Folin, Nicolas-Alexandre, called Folin *l'aîné*, 140, 143, **171**, 192
Folin, Silvestre-François, 171
Fonck, 191
Fontainebleau, Château de, 36, 55, 118
Forcher, Jean, 181
Ford, Edward, 166
Fortier, Alexandre, 92, 94, 163, **171–73**, 202
Fortier, Jean, 171
Fortier, M., 100
Fortier, Romain, 172
Foster, John, 34
Foullet, Antoine, 108, 111, 112, 169, 178, 181, 184, 186
Foullet, Pierre-Antoine, 112
François, Antoine, 186
Frankenthal porcelain, 46
Frederick II, king of Prussia, 196
Frederick Wilhelm III, king of Prussia, 150, 151
Frémont, Jean-Nicolas, 184
French and Company, 13, 26, 41, 91, 122, 146, 161
Fritzsche, 46
Furcy, marquise de, 199
Furet (family), 177
Furet, Jean-Baptiste, 193

G
Gaignat Collection, 178
Galle, Charles, 169
Gallois *veuve*, 181
Galois, Etienne, 177
Gaspard, 16
Gaudreau, Antoine, 89

Gaudron, Antoine (I), 2, 5, 7, **174–75**, 185, 187
Gaudron, Antoine (II), 169, 174
Gaudron, Pierre, 165, 174–75, 187, 188
Gault, Denis (II), 171, 173, 202
Gavelle, Jean-Jacques, 199
Gavelle *l'aîné*, Pierre, 192
George IV, king of England, 144
Gérard, Benoît, 199
Germain, François-Thomas, 186
Gervais, François, 177
Gide, Xavier, 177
Gilles *l'aîné*, 106, 191
Girardon, François, 16, 23, 25
Glover and Charrot, 166
Gluck, Christophe Willibald, 138
Gobert, Ignace-Pierre, 197
Gobert, Louis-François, 181
Godde, Jean-Isaac, 168, 169
Godon, Louis-François, 169
Gonzáles, Manuel, 161
Gosselin, Antoine, 186
Gosselin, Jean-Philippe, 167
Gould, George Jay, 57
Gournay, 177
Goyer, François, 181, 184
Goyer, Jean, 178, 181, 192
Graham, George, 154, 155, 187
Grandperrins *fils*, 116
Gregory, P. J. G., 166
Gregson, Jean, 194
Grenier, 194
Grimou, Jean, 172
Gruyn, Pierre, 175
Gudin, Jacques, 176, 186
Gudin, Jacques-Jérôme, 176
Gudin, Paul, called Gudin *le Jeune*, 20, 23, 55, **176**
Guiot, André-Georges, 55, 193
Gwydir, *see* Burrell

H
Hacker, David, 135
Hahn, Henry, known as Le Cocq, 175, 186
Handscombe, 166
Hanet, Nicolas, 174
Hawley, Henry 17, 99
Héban, Claude-Bernard, widow of, 111
Hébert, Thomas-Joachim, 80, 178
Heller, P., 65
Helms, Nestor, 168
Henri III, king of France, 164
Henri IV, king of France, 12
Henry, Augustin-Michel, 180
Henry, Pierre, called Pierre Henry-Lepaute, 180
Herbault, Louis-François, 177
Herbaut, François, 178
Hertford, Marquis of, 12, 155
Hervieu, Louis-Barthélemy, 181
Hillingdon, Lord, 13
Hoguet, François (I), 203
Hoguet, Gatien, 203
Hoguet, Toussaint-François, 201, 202
Hongre, Etienne le, 16
Houdin *fils*, 144

Houdon, Jean-Antoine, 181
Hubert, Guillaume, 174, 177
Huescar, duke of, 188
Huntsmann, 166
Huquier, Gabriel, 61, 62
Huygens, Christiaan, 5, 174, 201

I
Imbert *l'aîné*, Jean-Gabriel, 171, 193

J
Jacquet-Droz, 181
James II, king of England, 168
Janvier, Antide, 169, 170
Jarossay, Urbain, 192
Jean, Jean-Adrien, 170
Jodin, Jean, 194, 196
Johnson, Barbara Piasecka, 173
Jollain, Adrien-Jérôme, 181
Jollin *l'aîné*, 192
Jolly, Jean, 193, 194
Joselin, 112
Joseph, Edward, 139
Jouard, Louis, 191
Journe, M., 78
Jullien, Nicolas, 186, 190
Julliot, Claude, 178
Julliot, Claude-François, 178

K
Kinable, Dieudonné, 169
Kinzing, Peter, 132, 135, 138
Kirchner, Johann Gottlieb, 46
Klingspor, baron de, 129
Kraemer & Cie, 120, 122
Kriegseissen, Mathieu, 100
Kugel, Jacques, 47, 69

L
La Brenellerie, Paul-Philippe Gudin de, 187
La Chausée, Pierre-Henry de, 170
La Chausée, Pierre Nivelle de, 170
La Fresnaye (father and son), 178
La Haye, Marin de, 17, 99
La Hoguette, S. H. de, 181
La Marche, comte de, 188
La Marck, comte de, 178
La Mosson, Bonnier de, 172, 173, 186
La Reynière, Grimod de, 181
La Rochfoucauld, marquis de, 181
La Tour, Maurice-Quentin de, 52, 55
Laborde, Jean-François de, 194
Lagrenée, 172
Lagrenée, Father, 155
Laissé, J. F., 12
Lalande, Jérôme de, 179, 180
Lamb, John, 34
Lanz, J. W., 46
Lapina, 107, 111
Larsé, Jean-François, 190
Latz, Jean-Pierre, 92, 99, 169, 178, 186, 196, 197
Lavoisier, Antoine, marquis de, 172
Le Bon, Charles, 25, 175, 176
Le Brun, Charles, 12

Le Brun, Henri, 178
Le Carpentier, Antoine-Mathieu, 181
Le Cocq [Henry Hahn], 175
Le Faucheur, Alexandre, 168
Le Gros, Pierre, 12, 16
Le Hongre, Etienne, 16
Le Lorraine, Robert, 16
Le Mire, Augustin, 184
Le Moyne, Pierre, 5
Le Noir, Claude, 177, 178
Le Noir, Etienne, 45, 73, 102, 106, 167, 168, **177–78**, 191, 192, 193, 196
Le Noir, Etienne (II), 70, 78, 102, 164, **177–78**
Le Noir, Etienne (III) Alexandre, **177**
Le Noir, Etienne, workshop, 163, **177–78**
Le Noir, Isaac, 177
Le Noir, Jacques, 177
Le Noir, Jean-François, 177
Le Noir, Pierre-Etienne, 102, 177
Le Noir, Toussaint-Marie, 170
Le Roy, Charles, 114, 118, 163, 165, **183–85**, 193
Le Roy, Etienne-Augustin, 114, 118, 165, 183–84
Le Roy, Jacques-Prosper, 183
Le Roy, Jean-Baptiste, 186, 202
Le Roy, Julien, 12, 25, 65, 86, 89–90, 152, 154, 159, 164, 165, 175, 177, 184, **185–88**, 191, 202
Le Roy, Michel-Nicolas, 183
Le Roy, Norbert, 183
Le Roy, Pierre (I) Julien, 185, 202
Le Roy, Pierre (I), 171, 202
Le Roy, Pierre (II), 120, 171 193, 202
Le Roy, Pierre (III), 180, 185, 186, 202
Le Roy, workshop, 165, **185–88**
Le Sueur, Nicolas, 186
Lebon, Charles, 185
Lebrun, Henri, 199
Lecomte, Antoine-François, 184
Lecomte, Florent, 184
Lefebvre, Thomas, 170
Lefèvre, Louis-François, 181
Leleu, Jean-François, 181
Lemazurier, Jacques-Denis, 184
Lemoyne, Jean-Baptiste, 172
Lepaute, Alban-Louis, 180
Lepaute, Augustin-Michel-Henry, 180
Lepaute, Jean-André, 116, 118, 120, **179–82**, 188
Lepaute, Jean-Baptiste (II), 143, 179, **180**, 194
Lepaute, Jean-Joseph, called Collignon, 180
Lepaute, Louis-Alexandre, 180
Lepaute, Pierre Henry [Pierre-Henri, called Henri-Lepaute], 34, 179, **180**
Lepaute, Pierre-Bazile, 34, 179, 180
Lepaute, Pierre-Michel, 180, 181
Lepaute, workshop, 164–165, 170, **179**, 181, 182, 192, 193
Lependu, Jean-Baptiste, 181
Lepers, Jacques-Mathieu, 167
Lépine, Jean-Antoine, 129, 192
Levacher *l'aîné*, André-Louis, 194
Lévy, Etienne, & Cie, 26

INDEX 209

Levy, Jacob, 166
Liesse, 192
Lieutard, Balthazar, 169, 178, 181, 186, 194
Linsky, Mr. and Mrs. Jack, 45
Lisbon, Gulbenkian Foundation, 25
Loir, Alexis, 172
London
 Victoria and Albert Museum, 7, 12
 Wallace Collection, 23, 25, 35, 89, 100, 154, 156, 158, 159, 173, 191, 196
Louis XIV, king of France, 7, 12, 16, 36, 156, 18
Louis XV, king of France, 89, 118, 163, 165, 176, 181, 185–86, 187, 190, 199
Louis XVI, king of France, 118, 122, 165, 183, 185, 194, 199
Louis, dauphin de France (Louis XVI), 184, 194
Louis, dauphin de France, 7
Louis-Napoléon, 195
Louis-Philippe, king of France, 120
Louise-Ulrique, queen of Sweden, 181
Louise Elizabeth of France, duchess of Parma, 181
Louvre, Palais du, 16, 23, 120, 164, 165, 180, 181, 185, 188
Luc, comte de, 12, 187, 194
Ludwigslust, Schloss, 137
Lullier, Monsieur, 77
Lully, Jean-Baptiste, 16
Luxembourg, Palais de, 120, 164, 180, 181
Lyons, 155

M

Machart, Jean-Jacques-François, 178
Madrid, the Royal Palace, 128
Magdeburg, Schloss Burgk, 138
Magny, Alexis, 172, 173
Maine, duchesse du, 199
Maison Coigny, 120
Malyvoire, Pierre-Henry, 181, 186
Mangin, General, 195
Manière, Charles-Guillaume, 192
Marchand, Nicolas-Jean, 186
Margraf & Company, 136
Marie-Antoinette, queen of France, 16, 128
Marie-Thérèse, Dauphine, 55
Mariette, Pierre, 23
Marigny, marquis de, 181
Marot, Daniel, 16, 19
Marsy, Balthazar, 16
Martin (brothers), 82, 178, 199
Martincourt, Etienne, 114, 116–18, 120, 171, 181, 184, 192
Martinière, Antoine-Nicolas, 65, 70, 75, 86, 177, 186, **190–91**
Martinière, Charles-André, 190
Martinière, Jacques-Nicholas, 190
Martinière, Nicolas, 190
Martinot (family), 177
Martinot, Balthazar (II), 7, 174
Martinot, Claude (III), 25, 187
Martinot, François-Louis, 155
Martinot, Giles (II), 154, 156, 159, 174
Massiac, amiral-marquis de, 197, 199
Masson, Denis, 193

Masson, Jean-Baptiste, 165
Masson, Joseph-Antoine, 104, 106
Masson, Pierre, 177, **192**, 193
Mathieu, Jean, 175
Maupertuis, Pierre-Louis-Moreau de, 186
Mazarin, duchesse de, 181
Mazzenumy, A., 65
Mecklenburg, princess of, 175
Medinaceli, duke of, 161
Meissen porcelain, 46, 104, 169, 178, 187
Meissonnier, Juste-Aurèle, 58, 61, 62, 187
Mellon, Harriot (Duchess of St. Albans), 85
Ménard, Antoine-Marie, 193
Mennecy porcelain, 178
Merle, comte de, 178
Merlet, Georges-Adrien, 120, 140, 143–44, 163, 171, 181, **192**
Miel, Jan, 172
Miromesnil, Armand-Thomas, 194
Moatti, Alain, 8
Moisy, Jean, 191
Moitte, Jean-Guillaume, 124, 128, 187
Mokronowski, General, 77
Möllinger, Christian, 148
Monaco, prince de, 194
Monchanin, Pierre de, 184
Montaigne, Michel, 172
Montargis, le Bas de, 36, 37
Montesquieu, baron de 172
Montesquiou, madame de, 194
Montholon, monsieur de, 184
Montigny, Philipe-Claude, 181
Montmartel, Pierre de, 12
Montmorency, baron de, 199
Montmorency, duc de, 169
Montrond, comte de, 199
Mortemar, duc de, 61, 62, 196
Moscow, the Kremlin, 135
Muette, Château de la, 180, 181
Mugnier, E., 143, 192
Munich
 Residenzmuseum, 55, 82
 Schloss Nymphenburg, 68
Musson [Masson], Louis, 111
Mynüel, Louis, 12, 154, 176

N

Netscher, Caspar, 172
Neuwied, Kreismuseum, 136
New York
 Cooper-Hewitt Museum, 120
 Frick Collection, 26, 122
 Metropolitan Museum of Art, 18, 45, 61, 100
Nice, Musée Masséna, 129
Noailles, de, family, 55
Noordanus, A. J., 52, 111, 143
Noyaux (brothers), 178

O

Ojjeh, Akram, 77
Oppenheim, 166
Oppenheimer Collection, 137
Oppenord, Gilles-Marie, 35–38, 41, 152, 155–56, 158
Oppenordt, Alexandre-Jean, 28, 35, 36, 156

Orléans, duc d', 128, 168, 177, 188
Orléans, duc et duchesse d', 178
Orléans, Marie-Louise d', 179
Orléans, Philippe d', regent of France, 165, 187
Orry, Philibert, 188
Osmond, Jean-Baptiste, 181, 184
Osmond, Robert, 102, 104, 106, 118, 178, 181, 184, 186, 194, 197
Ottoboni, Cardinal, 25
Ozanam, Jacques, 172

P

Paillard, Victor, 120
Pajou, Augustin, 118, 181
Pálffy, Graf János, 26
Palissot, Charles, 194
Palmer, P. P. D., 173
Pange, marquis de, 181, 194, 196
Paolini, G., 65
Paris
 Abbaye Saint-Victor, 155
 Académie de Peinture et de Sculpture, 7
 Bibliothèque de l'Arsenal, 35, 154, 156, 158, 159
 Bibliothèque Doucet, 120
 Conservatoire National des Arts et Métiers, 100
 Ecole Militaire, 180
 Ecole Supérieure des Beaux-Arts, 7
 Grand Palais, 122
 Hôtel de Menus Plaisirs, 184
 Hôtel de Ville, 180
 Hôtel des Invalides, 180
 Hôtel Sallé, 159
 Musée des Arts Decoratifs, 12, 23, 55, 126
 Musée du Louvre, 12, 25, 106
 Musée du Louvre, Grog-Carven Collection, 55
 Musée Nationale des Techniques, 36
 Palais de Tuileries, 118, 120, 128
 Paris Observatoire, 181
 Saint Sulpice, 61
Pâris de Montmartel, Jean, 100, 173, 196
Parme, duc de, 187
Pater, Jean-Baptiste-Joseph, 172
Pavlovsk, Palace of, 136
Pécourt, Jean, 184
Pérensc, marquis de, 199
Perronneau, Jean-Baptiste, 187
Pesière, Charles-Dominique, 195
Petit, Nicolas, 143
Petronius, Gaius, 172
Phillips, Neil, 55
Pineau, Nicolas, 70, 75
Plan, Jean-Philippe, 186
Plattel, Daniel-Samuel, 186
Poisson, Michel, 178, 181
Polès, Madame de, 104
Polignac, Cardinal de, 175
Pompadour, Madame de, 46, 55, 178, 187, 194
Pomponne, Madame de, 199
Ponts, marquis de, 199
Pordenone, Giovanni Antonio de, 23

Portela, Juan, 151
Pradère, Alexandre, 73
Praslin, duc de, 194
Presles, Aranc de, Collection, 178
Prévaux, Jean, 194
Privet, 181
Provence, comte de, 181, 184
Pucelle, Jean, 181
Puyseult, marquis de, 186

Q
Quétin, Joseph, 186
Quinault, Philippe, 16

R
Regnault, Jérôme-François, 193
Reinders, Louis, 169
Rémond, François, 132, 135, 144, 181, 184, 192
Restout, Jean, 172
Revel, Joseph, 169
Richard workshop, 78, 111, 116, 118, **193**
Richard, Claude, 177, 181, 193
Richard, Etienne-Claude, 177, 192, 193
Richard, Gaspard, 193
Richard, Pierre-Joachim, 193
Richelieu, Louis François Armand de Vignerot du Plessis, duc de, 107, 178
Ridel, 143, 144
Ridereau, Simon, 193
Rieux, Gabriel Bernard de, 23, 52, 55
Risenburgh, Bernard (II), van, 80, 83, 178, 181
Rivaz, Pierre de, 169, 180
Robin, Robert, 55, 63, 120, 169, 184, 192, 193
Roentgen, David, 132, 135, 137, 138
Rohan, duchesse de, 175
Rohan, House of, 188
Rohan, prince Ferdinand de, 199
Roland, Philippe-Laurent, 128
Romain, Pierre-Etienne, 169
Romilly, Pierre, 193
Romilly, Jean, 48, 52, 164, 166, **193–95**
Romilly, Jean-Edme, 194
Romilly, Sir Samuel, 194
Roque, Leonard, 192
Rosenberg and Stiebel, 41, 77, 100
Rothschild, Alexandrine de, 85
Rothschild, Alphonse, baron de, 58, 64, 77
Rothschild, Clarice, baroness de, 77
Rothschild, Edmond, baron de, 78, 85
Rothschild, Edouard, baron de, 64
Rothschild, Gustave, baron de, 100
Rothschild, Guy, baron de, 64
Rothschild, James A. de (see Waddesdon Manor), 99
Rothschild, Nathaniel, baron de, 77
Rouen, Musée des Antiquités, 25
Rousseau, Jean-Jacques, 164, 194
Roy, Edme, 166, 186, 197
Roy, Simon, 192
Rubens, Peter Paul, 172
Rudolph II, Holy Roman Emperor, 172

S
Sacramento, E. B. Crocker Art Gallery, 128
Saint Cloud, marquis de, 120, 122
Saint Petersburg
 Pachkevitch Collection, 136
 Pourtalès Collection, 136
 State Hermitage Museum, 135
Saint-Cloud, Château de, 178
Saint-Germain, Jean-Joseph de, 48, 52, 55, 57, 106, 166, 169, 170, 178, 181, 184, 186, 192, 194, 197, 199
Saint-Germain, Joseph de, 55, 57, 178, 184
Saint-Hubert, Château de, 180
Saint-Hubert, Vassal de, 181
Saint-Romans, marquis de, 175
Sainte-Foy Collection, 178, 181
Salm-Krybourg, prince de, 128, 181
Samoyault, Jean-Pierre, 23
Sans Souci, Neues Palais, 25
Santilly, Etienne-François, 199
Sarazin, 171
Sauvage, P., 5
Saxe, maréchal de, 187
Schomberg, comte de, 168
Scott, Sir E. H., 137
Schwerdfeger, Ferdinand, 171
Séjour, Achille-Pierre-Dionis du, 172
Sénard, Pierre, 185, 186, 202
Sénard, Rène, 185, 186
Sens, Madamoiselle de, 188
Severin, Nicolas-Pierre, 166, 170
Sèvres porcelain, 46, 128, 181, 194
Shalberg, Jon, 65
Simmons, H. and J., 84
Smolen, 161
Solimena, Francisco, 172
Solle, Karel, 34, 154
Sotiau, Nicolas, 192
St. Albans, Duchess of (Harriot Mellon), 85
Stadler, Charles-Antoine, 181
Stollenwerck, Michel, 28, 34, 100, 164, 167, 173, 180, **195–97**
Stollenwerck, Pierre-Hubert, 195, 196
Stollenwerck, Pierre-Martin, 195
Stouf, Jean-Baptiste, 181
Sully, Henry, 165, 185
Surmont, Lucien, 104
Sutten, W., 65
Swedish Royal Collection, Drottningholm Slott, 55
Sylvestre, Joseph, 181, 186
Széchényi, Countess Laszlo (née Gladys Vanderbilt), 41
Szymanowska, Marianna, 77

T
Tahout, marquise de, 199
Tamms, F., 151
Tavernier, Joseph, 181
Tesnier, Jean-Bertin, 178
Tessin, Carl Gustav, Count, 178
Thiaffet, Félix, 169
Thiers, baron de, 173, 197
Thiery, M., 34
Thiout, Antoine, 173
Thomire *père*, Luc-Philippe, 181
Thomire, Pierre-Philippe, 124, 126, 128, 144
Thuret (family), 177
Thuret, Isaac, 174
Thuret, Jacques, 7, 12, 25
Tillet, Jean-Baptiste Adam du, 177
Toulouse, comte de, 25
Tresmes, duc de, 175
Troy, Jean-François de, 23
Tubi, Jean-Baptiste, 16
Turgot, Anne-Robert-Jacques, 194

V
Vaillant, Jacques-François, 169
Van der Nerff, 172
Vanderbilt, Cornelius, II, 41
Vanderbilt, Gladys (Countess Laszlo Széchényi), 41
Vanderbilt, William K., II, 41
Varin, J. H., 193
Venice, Palazzo d'Anna, 23
Ventadour, duchesse de, 175
Verdier, François, 172
Verdier, M., 172
Verlet, Pierre, 82
Vernède, Jean, 186
Vernon, Samuel (I), 165
Veronese, Paolo, 172
Versailles, Bibliothèque de, 144
Versailles, Château de, 12, 16, 55, 89, 128, 164, 184, 188
Vian, 159
Vicentino, Nicoli, 23
Victoire, Madame, 181
Vidal, 170
Viger, 104
Viguier, 181
Villamarina, J. F., 58
Vincennes porcelain, 186
Vion, François, 171, 181, 184
Virgil, 5
Voisin, Antoine, 199
Voisin, Antoine-Henri, 199
Voisin, Charles, 42, 163, 164, 184, **199**
Voisin, Etienne-François, 199
Voltaire, François-Marie-Arouet, 172
Vulliamy, Benjamin, 106

W
Waddesdon Manor, Buckinghamshire, 25, 35, 99, 154, 155, 158, 159, 186
Wailly, Charles de, 181
Washington, National Gallery of Art, 12
Weyl, Johann Wilhelm [Jean Guillaume], 132, 135, 136, 138
Wildenstein, Georges, 77

Y
Yver, Marc, 186
Yverdon, Switzerland, Hôtel de Ville, 155
Yvetaux, marquis de, 175

Z
Zaccon, Jean-Baptiste, 184
Zweiner, J., 159